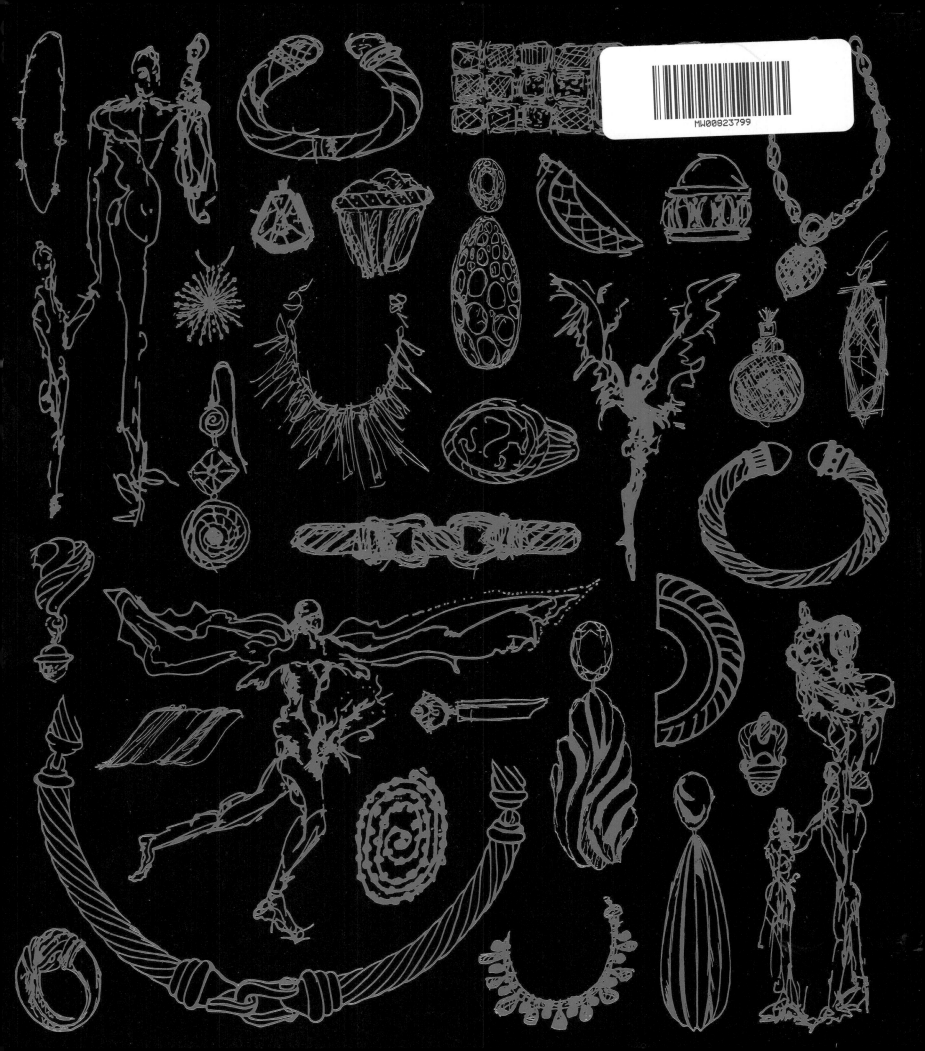

SYBIL AND DAVID YURMAN ARTISTS AND JEWELERS

EDITED BY
THIERRY-MAXIME LORIOT

SYBIL
AND
DAVID
YURMAN
ARTISTS
AND
JEWELERS

Φ

Journeys, like artists, are born
and not made. A thousand
differing circumstances contribute
to them, few of them willed or
determined by the will—whatever
we may think. They flower
spontaneously out of the demands
of our natures—and the best
of them lead us not only outwards
in space, but inwards as well.

Lawrence Durrell
Bitter Lemons, 1957

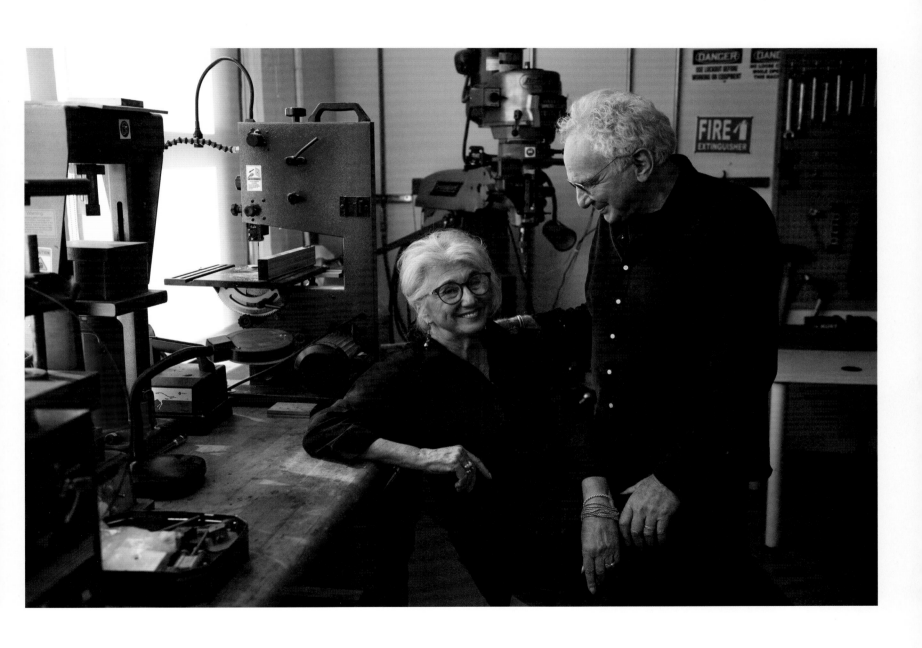

Sybil and David Yurman in their atelier, New York, 2023.
Photographed by Norman Jean Roy.

FOREWORD

This book is about our journey, two kids from the Bronx who believed they could make their way in the world by trusting themselves and others. We fearlessly entrusted that the universe was there for us to share in its bounty. It is about our passions, obsessions, struggles, and the extraordinary people we encountered along the way who nurtured, mentored, and guided us to where we are today.

When we met each other in 1969, our lives changed forever. Before that, we led parallel lives as part of the underground art world, drifting through Greenwich Village and Woodstock in New York, and San Francisco, Berkeley, Haight-Ashbury, Venice Beach, and Big Sur in California. Although traveling in the same circles and knowing many of the same people, we never met. At one point in time, we were both posting notices on the bulletin board at Lawrence Ferlinghetti's City Lights bookstore in San Francisco, the unofficial home of the Beat poets. It was where we went to look for a job, a lost friend, or a place to live, but we were really looking for each other—we just didn't know it yet.

After fifty years together, we've grown to understand that no dream is too big, no vision too idealistic, and a chance encounter can create the magic that makes all the difference. This book recalls our travels and celebrates the people we've met along the way—many in unexpected places—who made a difference in our lives, some never realizing their influence. In our story, perhaps they will recognize themselves through a painting, a sculpture, a piece of jewelry, or in the retelling of certain moments. We'd like to extend our heartfelt gratitude to all of you.

Leaving home as teenagers, we found mentors from the moment we arrived in Greenwich Village. There were poets Allen Ginsberg and Gregory Corso, and jazz musicians, such as Art Blakey and Horace Silver. Actor Lance Henriksen found us on both coasts. In San Francisco and Big Sur, we were befriended by philosophers, artists, photographers, writers, and many other figures in the 1960s counter-culture movement—Price Dunn, Dennis Murphy, Lenore Kandel, Neal Cassady, Jack Kerouac, and Dave Bohm, among many others.

We explored different ways of living, from communal houses to the abandoned Jordan mansion in Big Sur, with no roof and a working fireplace, overlooking the ocean. In San Francisco, we met and were influenced by philosopher Alan Watts and studied with Zen Buddhist monk Shunryu Suzuki. At the hot springs in Big Sur, which became the Esalen Institute, tai chi master and philosopher Gia-Fu Feng taught us to be in the moment, live through experience, and the Zen ideologies behind it.

This book is a testament to all those who believed in our vision: Jacques Lipchitz, who revealed one could dream in three dimensions; Shōji Hamada, who understood the transformation of materials into art is a meditative, contemplative experience well worth the effort; and the countless others who became our guides, both then and now.

At times, these guides directed our paths through their teaching and determination. Many introduced us to their crafts. Ernesto Gonzalez ignited the flame for direct welding, sculpture, and creating wearable art; an apprenticeship with Lipchitz was the beginning of defining an artistic language and learning discipline; leather artisan Roger Rilleau's generosity, sage advice, and skill became a model for developing a craft; sculptor Hans Van de Bovenkamp and artist-jeweler Bernard Kelly embraced the idea that passion can lead to great adventures and become your life's work, and, along with sculptor Theodore Roszak, believed that with focus you can create a business through your art.

And to our son, Evan. Instilled in his soul is a curiosity and appreciation for the beauty of jewelry and gems. As our chief creative officer and president and a connoisseur of quality, together with a refined aesthetic, he is constantly exploring, creating, and innovating.

For those of you who are reading this and have not seen your name— you know who you are. You all are our most precious gems, thank you.

Sybil Kleinrock · David Kleinrock

PASSIONS
INSPIRATIONS
OBSESSIONS

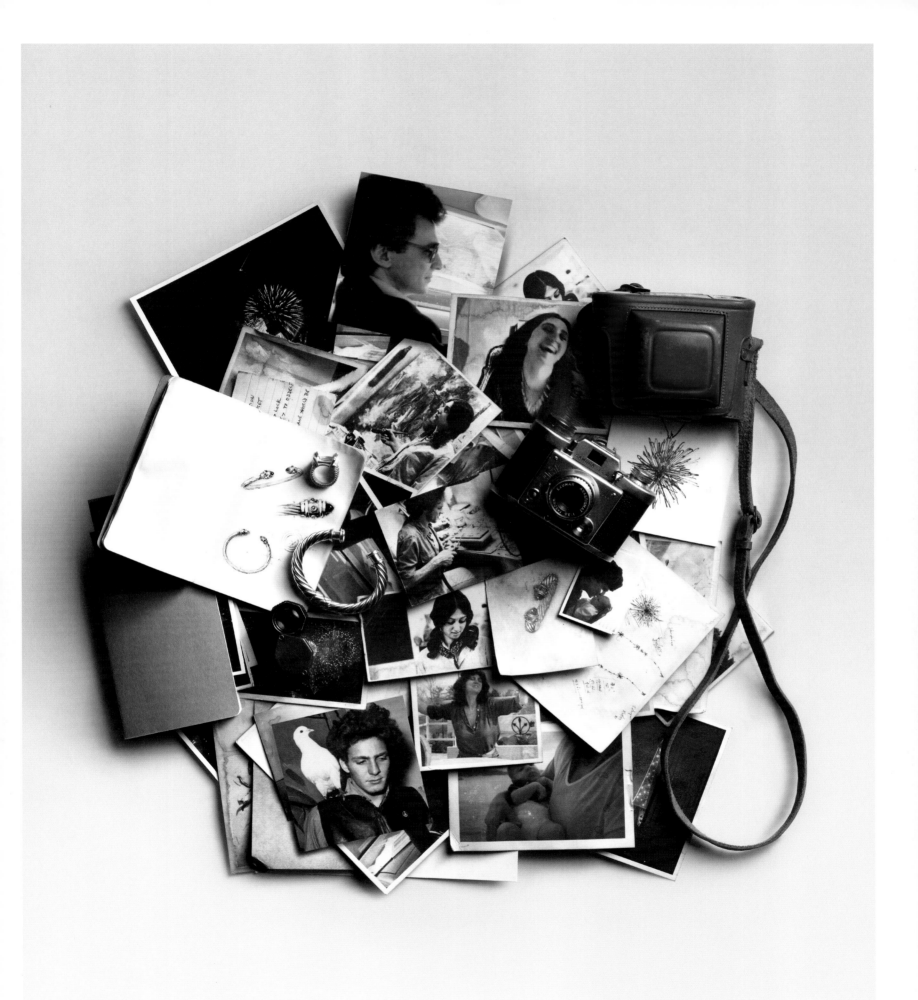

Thierry-Maxime Loriot: You have been living and working together for over five decades now, navigating an ever-changing personal, professional, technical, and cultural landscape. What have you discovered along the way?

David Yurman: There is a calm that comes from years of experience and a well-defined philosophy and language. I often tell Sybil that history is just made up. It's a story told by someone expressing their point of view on what they think is important. It's the perspective that guides you, but as you get older, you also tend to look back and reflect on life, asking, "What have I done? How did I get here?" And when you sit down to write your history, you face a lot of choices that you narrow down to those eureka moments—the serendipity that changed everything. One of those choices is sharing that journey with a partner. Those who share go far while those who don't just go alone.

TML: As two very independent artists with different approaches, do you find it difficult to be creative together?

DY: Well, movement brings friction! Sybil and I fiercely defend our positions when it comes to the creative process. We call it "the fight to get it right." Fortunately, we are two people who share a similar aesthetic.

TML: What are the challenges in your process from a design and collaborative point of view?

DY: The main challenges as an artist who creates and molds the work are: How do I share that experience with someone else? How do we respect the intent of the design, understand the process, and collaborate? In the world of jewelry making, communicating and integrating skills were probably the most difficult. I like to say, "Structure is your friend, and communication is your best friend." Initially, Sybil was the editor in our process. Later, she began to initiate design and create collections from her point of view, and I became the editor. I led on the mechanics front, and she was about designing for the customer. We had to bring all of that together.

TML: You've both said that art freed you. Have you always felt that you were artists first and that your path to jewelry was something of an accident?

DY: Maybe not an accident. I knew I was on a path to something somewhat defined by what I could and what I couldn't do. Being ADHD and dyslexic, I struggled in school. So I moved toward my bliss and a visual, nonverbal language. In a sense, toward what I felt I could do well. I was an athlete—a track star—and had credible national times in the mile and half mile. I loved dancing, and for a short time in high school, I was the only male in the Women's Modern Dance Club!

Sybil Yurman: I guess you could say that our path to jewelry was something of an accident. In my case, it started with the colors of a composition and became the canvas and ultimately the object or objective. David was creating jewelry and selling it to his classmates from the age of sixteen. So it was always an expression of his feelings, his language.

TML: You both had distinct approaches that converged into the brand, which you sometimes call your "art project." How have you been able to translate an artistic approach to a business?

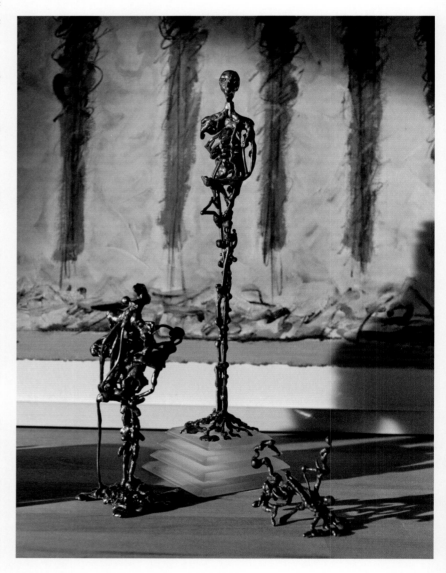

Previous page: Collage of Sybil and David Yurman's archives, 2014. Photographed by Nathan Copan.

David's sculptures and Sybil's painting in their Tribeca home, 2023. Photographed by Emil Larsson.

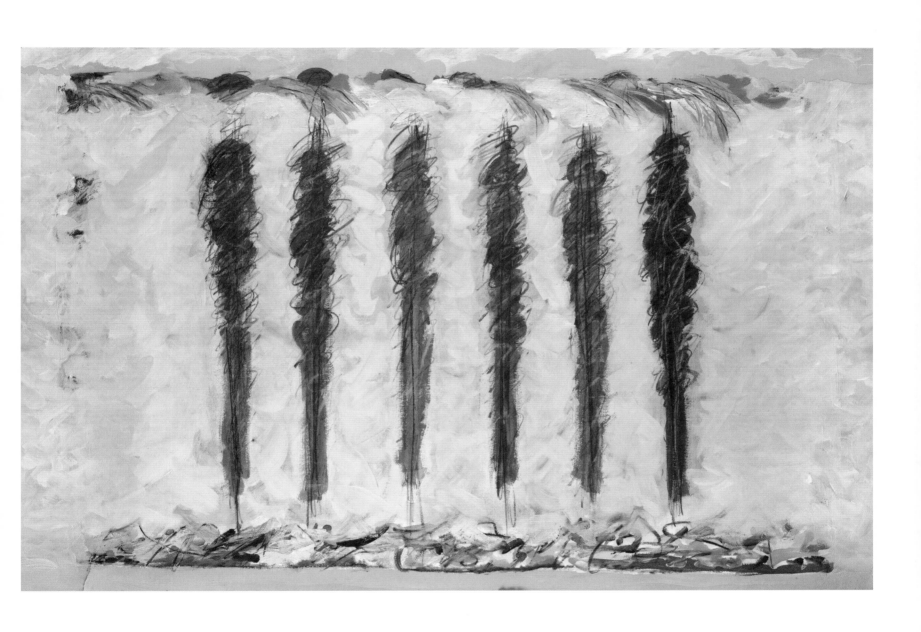

Sybil Yurman
Vertical Series, 2010
Acrylic and graphite on paper

DY: It really *has* been one long art project. Along the way, we realized we needed a structure and a company around us. The business wasn't an overnight success by any means. It was an evolution, with each new collection layered over its predecessors—one design's success would pave the way for those that followed. Unlike some luxury brands that have clients who will buy a single piece, we have customers who collect hundreds of pieces. We are not about a single item; we have a collective vision. We make styles interwoven over a fifty-year time span that can be worn together. The work must be beautiful and something that touches someone and evokes emotion. We also had to meet the challenge of scale while maintaining quality and the hand in the work. As artists, we applied these same values to the art of commerce, finding solutions without sacrificing what makes us who we are.

SY: In a way, it comes down to both of us having a sense of fulfillment from what we do together. While distinct in many ways, we can be interchangeable: I'm part male; David's part female.

DY: We *are* interchangeable. We can show up for half of a meeting and each get what we need from it. We can divide our responsibilities. One plus one is greater than two. Sybil and I have such a defined vision. Together we make one smart person.

David Yurman, New York, 2023.

Opposite: Hammered bronze with kiln-fired beads, an initial collaboration between David and Sybil in Putnam Valley, New York, early 1970s. Both photographed by Emil Larsson.

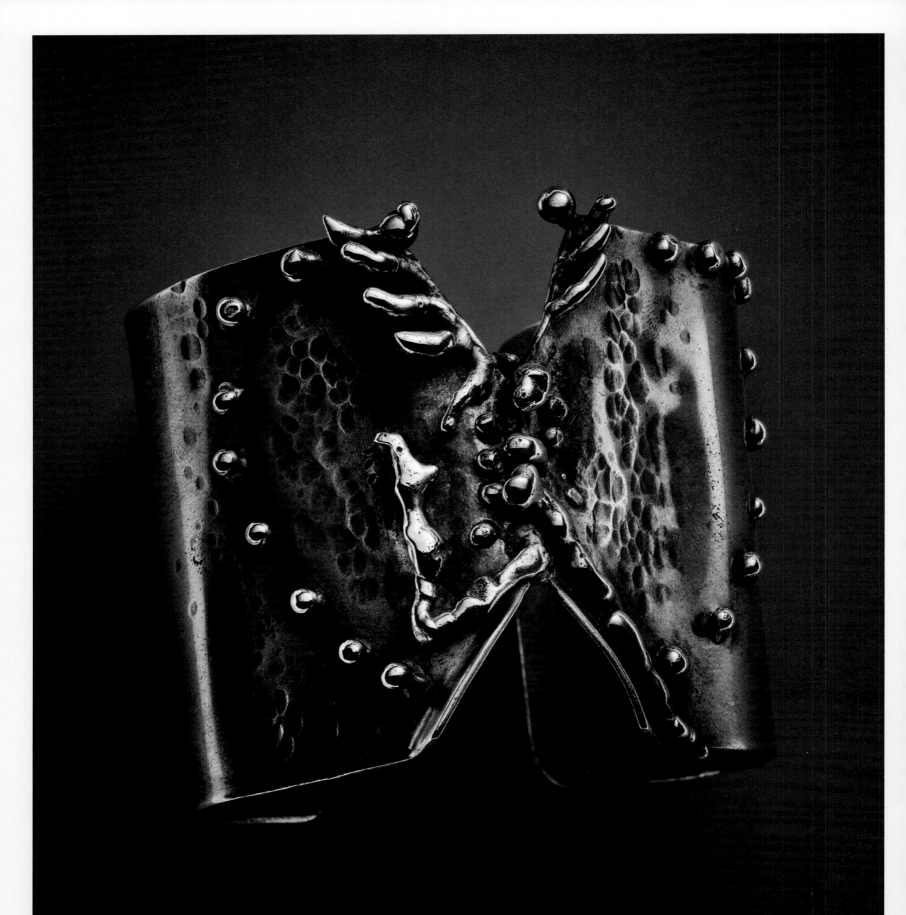

TML: With your focus on art, design, craftsmanship, and the uniqueness of your products, would you say that the design is as important as the value of the materials?

DY: Exactly. The work isn't valued only for the materials. We were leaders in establishing a new category of designer jewelry. Our approach was different: if a retailer wanted to buy our jewelry, they had to buy entire collections and merchandise them in a dedicated case with our name prominently displayed.

SY: Also, we worked and treated silver as fine jewelry. David often refers to silver as a noble metal. At first, it was difficult to get jewelers to make our silver jewelry at a gold or platinum standard—there was this notion that working with silver was beneath their skills. We had to change that perception of what silver jewelry could be.

TML: It's been said that luck is what happens when preparation meets opportunity. Do you believe that luck played a part—beyond the beauty and craftsmanship of your work—in helping you gain recognition?

DY: There are elements besides luck. Having a vision. Taking risks. And being willing to work all night and get it done. Beyond *how* we did it, there was the phenomenon of working *when* we did. When we started, there were huge changes happening in the culture and in the industry. The amount of crafted designer jewelry offered and accepted in the mainstream could only have happened then. We were there at the right time, at the right place. It's true that nothing is more powerful than an idea whose time has come.

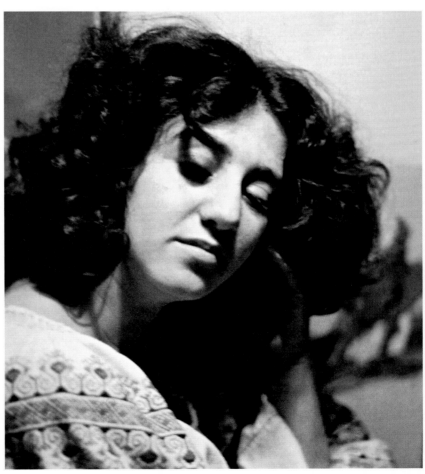

Opposite: Direct-welded bronze Angel cuff, Putnam Valley, New York, 1972. Photographed by Emil Larsson.

Sybil Yurman at her West 99th Street apartment, New York, 1969.

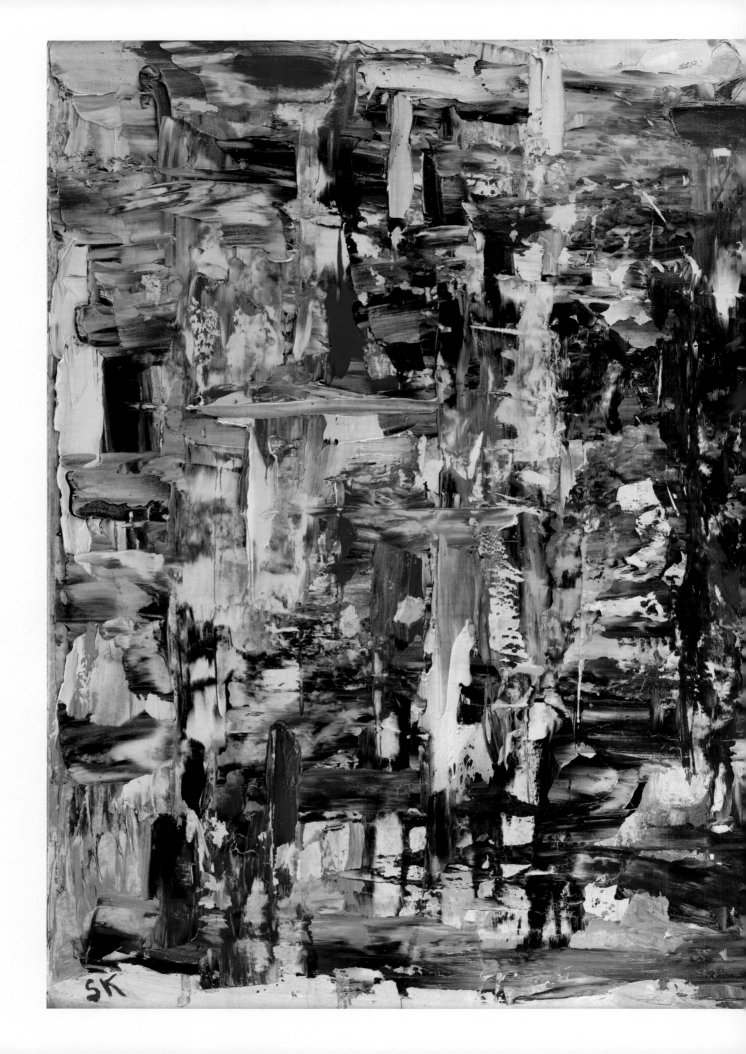

Sybil Yurman
Untitled, 1959
Oil with palette knife

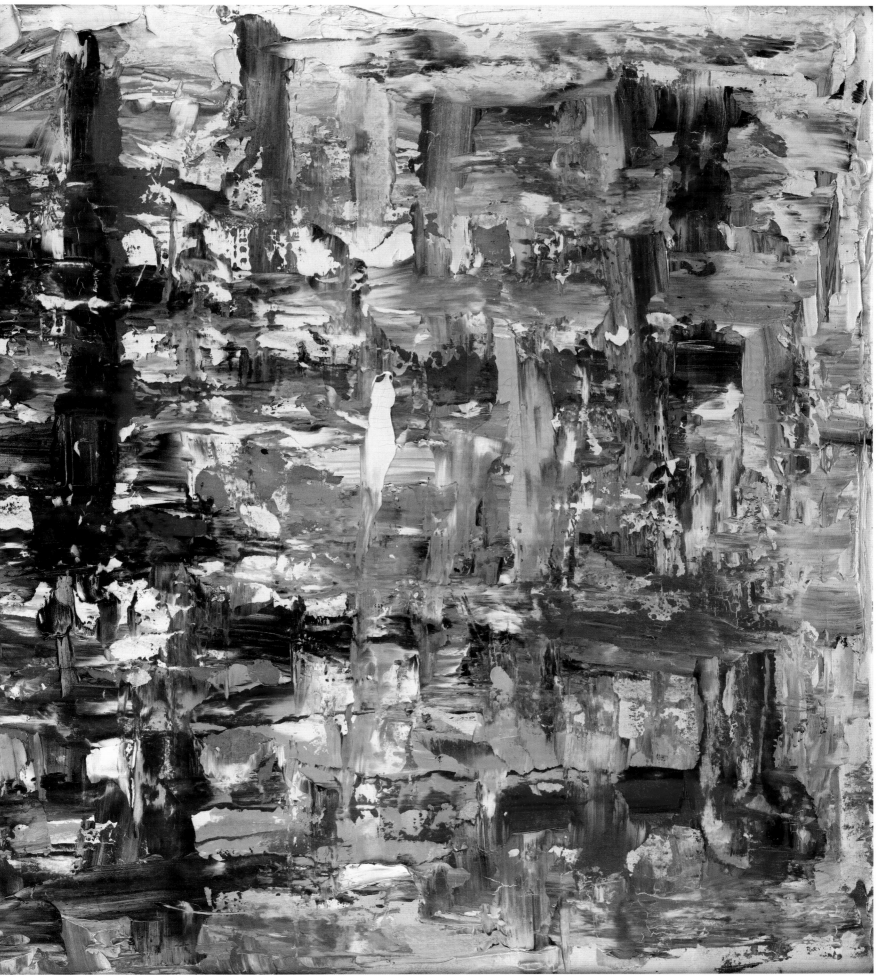

SY: I agree. What allowed us to do what we did was our ability to envision what was possible and, through instinct, to understand the ingredients. The most important thing was how both of us were fluid in accepting and being open to what came our way and having the timing and the pacing to absorb it. That's really it . . . and a little luck.

TML: Were your designs an instant success?

SY: Far from it! We approached Tiffany & Co., but in the end, they weren't enthusiastic about having David as part of their stable. Harry Platt was CEO of Tiffany then and brought in Elsa Peretti, Angela Cummings, and Paloma Picasso to the company to create jewelry exclusively for Tiffany. I was at a talk he gave about it, and I told him how pleased I was to see that he was doing this—that he was really bringing to the forefront what Tiffany had originally done with different artisans working under the umbrella of a design house. We were just chatting when he turned to everyone and said, "See, she understands what I just said. She understands exactly what I'm doing." David and I thought we could be part of that group. We didn't want a company; we thought David would design for them, and we'd be able to live in our own way—I would continue my art and he would continue sculpting. So we took a risk and designed a whole line of jewelry for Tiffany. We had a thirty-piece collection, but they passed on it. We had no idea what to do with it, so we had to learn how to sell it.

TML: As you say, the company came of age creating jewelry during a culturally significant time. How do you feel women and their relationship to jewelry have changed over the last decades?

DY: On a symbolic level, Woodstock was a defining moment that changed the perception of many things that were happening in popular culture. I went to Woodstock to sell jewelry. Few remember it was also an art-and-craft fair! The art, music, and fashion reflected a shift in how people thought. It was the counterculture. Women were no longer looking for big diamonds or heavy formal pieces. They wanted casual, relaxed jewelry that reflected the times.

SY: And at the time, very few women designed jewelry. At first, I wanted to create jewelry that I would enjoy wearing, to make it for myself and for our friends—something that had meaning and that emotionally touched a person. Women stepped up as self-purchasers of their own jewelry, buying for themselves.

DY: Then, in the 1980s, strong, outspoken women like Lady Diana and Elizabeth Taylor wore our jewelry, which was a statement. They had a voice that was heard—on AIDS, on poverty, on mental health, important issues they could elevate as celebrities. These powerful women inspired us, just like our customers inspire us today. We love meeting them and listening to their stories.

TML: When you started having an important following in the early 1980s, not only in North America but also in Europe, did you design differently for women on the East Coast versus the West Coast or Europe?

SY: For me, there's no difference. We weren't designing for one type of woman. She could be in Europe or in Texas, confident in what she wore. She appreciated our work, and she instinctively knew what she liked. Women like this are everywhere; they have an international sensibility.

Liz Taylor wow!
Finding out that she was
wearing a suite from our collections
and was a regular at our

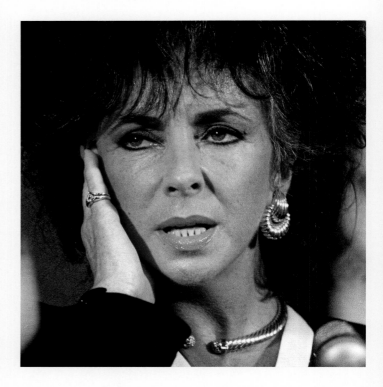

Mr memoir showcases in
Beverly Hills was a thrill.
a Icon . . . a Woman of
conviction and power.

Actress Elizabeth Taylor, wearing a David Yurman Cable necklace, addresses the National Press Club as part of her activities to raise funds for AIDS research, June 3, 1987, Washington, DC.

Opposite: Kate Moss wearing gold Hampton necklace and bracelet with sculpted Pinky ring, Turks and Caicos, 2014. Photographed by Peter Lindbergh.

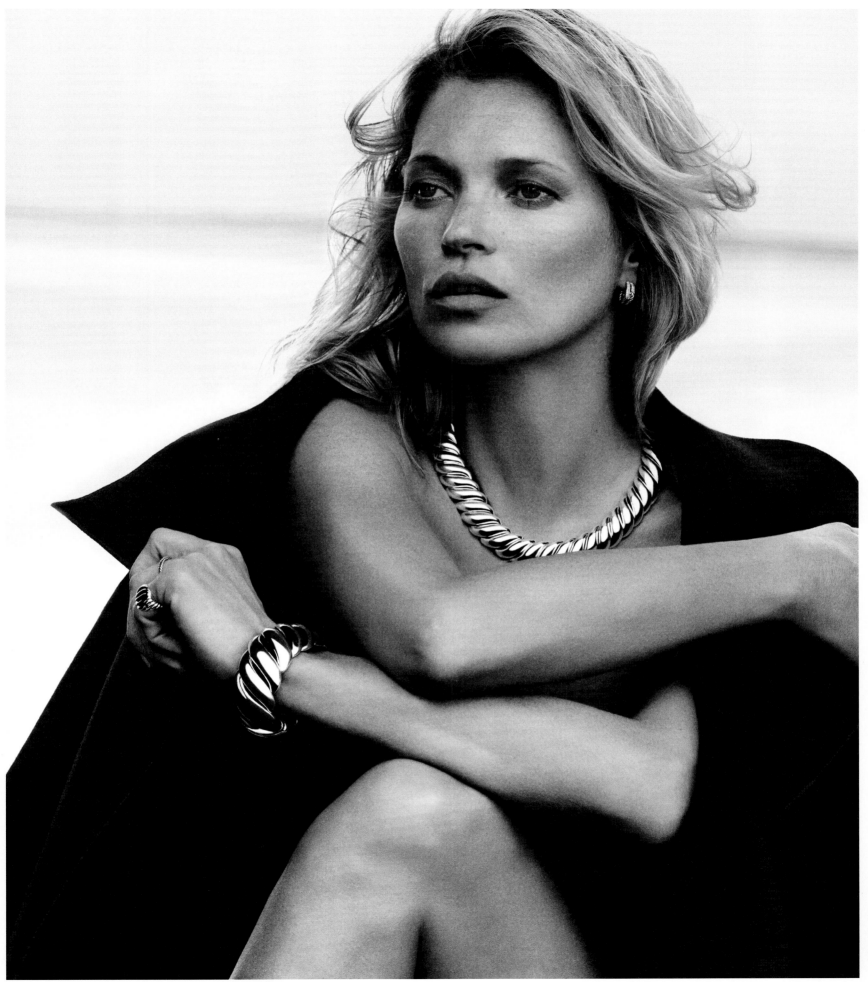

They buy jewelry for themselves and appreciate something well-made that's going to last forever. Often, they're style leaders.

DY: It's the same with celebrities. Many—from Rihanna to Brad Pitt and Madonna—wear our jewelry because they like the pieces and how they feel. We don't "sell" jewelry to clients and collectors—there's a difference—we're there to show them the possibilities of how to wear and style our jewelry. It's reciprocal—a piece of jewelry isn't finished until it's worn. Jewelry can be the mainstay and clothing the accessory. It goes beyond the brand experience. It's about a lifestyle . . . and having an American-designed product.

TML: Would you say it was women who inspired you to create jewelry that could be worn day and evening?

SY: One thing I realized is, when you look at our early jewelry, that it was as much daywear as evening wear—we were creating all-occasion elegance. It was also the transition from a time when women dressed for lunch, then dressed for dinner. There was something happening in the world, a progression of women who were working: they were politicians; they held executive positions. CEOs could be both feminine and strong, and also glamorous. Our jewelry was real, attainable, and fun at the same time.

DY: We didn't set out to create day-to-night jewelry. It just seemed to align with the times and worked out that way. It was serendipitous. You could wear dramatic color or diamonds in the day with a luxurious, relaxed American sensibility. It was just how we rolled.

TML: Fern Mallis, the "Godmother of Fashion," introduced you at a panel discussion at the Fashion Institute of Technology in New York, stating that the "famous Cable bracelet is the foundation of their combined talents. Like their relationship and their business, the Cable is intertwined: it requires at least two elements twisting together to create a harmonious tension. So do love and marriage and building a company." Can you tell us the story of this most iconic piece?

SY: The first bracelet David made for me was a lovely little bracelet like the Trail bracelet he designed during a horseback riding trip in the 1970s. He made it using six feet of twisted gold wire, with pink tourmalines and emeralds on the endcaps. I wore it every day, and I wore it everywhere. People just liked it—they'd see me wearing it and wanted to buy it. So David started making them for other people but became so busy that I'd never see him. At one point, I said, "You really have to find a way to make the bracelets to allow you more time to design." With its success, he was becoming a manufacturer, a maker of things, rather than a designer.

DY: It's a wonderful memory—one of those eureka moments I mentioned earlier. At the time, I wasn't thinking of Cable at all, I was thinking of a form that would come from twisting wire. Design comes from within. If you're tight and wound up, you don't have a way to receive creativity. You can't summon it. You need to be open to creativity. Horseback riding opens me up. I began riding with my father when I was eleven, every Saturday. It was something we shared. For over forty-five years, at least once every year, I go on a ten-day trail ride with my buddies, the Kosmic Kowboys. It gives me a way to be away from the business world. In 1978, I was on a trip with them when I sketched the Trail bracelet in

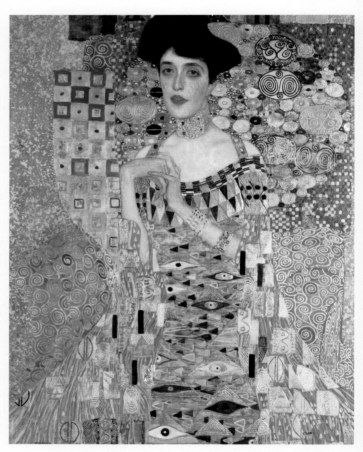

Top and bottom: David Yurman, Cable Coil Collection sketches, 2012.

Center: Gustav Klimt, *Adele Bloch-Bauer I* (detail), 1907; Oil, silver, and gold on canvas; 4 ft. 7 in. × 4 ft. 7 in. (1.4 × 1.4 m).

Opposite: Charm necklace in gold and diamonds with blackened silver, Cable Coil Collection, 2012. Photographed by Emil Larsson.

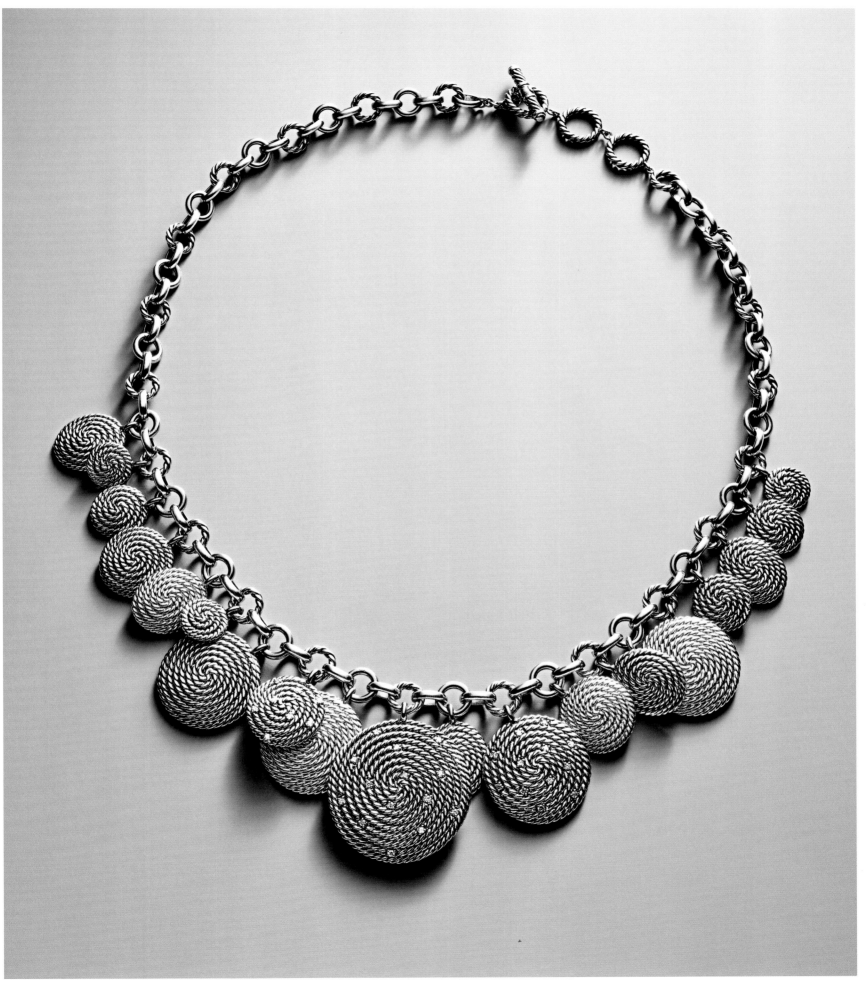

my tent. I twisted silver rods and made the Trail bracelet. It was the first Cable design. I still wear it today.

TML: And now your company is famous for its iconic Cable design. How would you describe your strengths in developing signature styles?

DY: Our strengths as a company come from the fact that we're never satisfied and always striving to make things better. We're always evolving. Everything connects, which is what makes it timeless and cohesive. As artists, we knew we had to develop a signature form. The choice was to focus on Cable. The Helix with our signature cushion stone became the grand hypothesis.

SY: To the world, yes, as the business grew, Cable connected David's designs. But to me, the heart and soul of the company are his sculptures of angels. They represented our freedom. Our company was built on David's talent as a sculptor and his ability to tap in to his subconscious and make forms that are very sensual. Whether it could be Icarus flying too close to the sun or Daedalus holding Icarus's body. It spoke to me in a physical form: how beautiful and lyrical the body was; how elegant and graceful the wings were in a very organic, human way. It was all about how David's subconscious flowed into the thin rods he was working with. Holding rods to the flame, moving the metal, unfolding shapes. The shapes weren't literal. They were feeling and emotion. So much of the work was about a connection to raw, sensitive feelings. A lot of the pieces also had great conflict, turmoil, and pain. The angels were very powerful figures. I wanted them in the world.

TML: What was it like approaching stores that carried established, historic brands? How did you position yourself?

SY: I wouldn't say we positioned ourselves—that sounds too deliberate—but much of what we were doing created opportunity. Back in the day, the stores we were in, like Neiman Marcus and Saks Fifth Avenue, had us split between two departments: gold and precious stones in fine jewelry, and silver and simpler pieces in fashion. Separate locations. Separate buyers. It didn't work to anyone's advantage. They realized that to carry David's work, they needed a separate department: designer jewelry.

TML: You showed in top specialty stores because you had both design and fashion relevance. As one of the pioneers and innovators of this new designer jewelry category, you bridged the gap between fashion and fine jewelry.

DY: Funny you should say that: bridging fine and fashion jewelry was our positioning statement for who we were in the market. We did it through the language of art. Beauty, form, and balance are always part of it. And that's very different from saying a piece has five carats of emerald or twenty carats of diamond. There are many ways of looking at a piece of jewelry.

SY: We live in design. We will often draw on the kitchen table—every piece of paper, napkin, receipt, or notepad can become a sketch that will end up in the shop! And we're always about technology and craft, about coming up with new ways to make the creative process interesting for us. But everything must remain in the vocabulary of the brand. There's both an evolution and consistency.

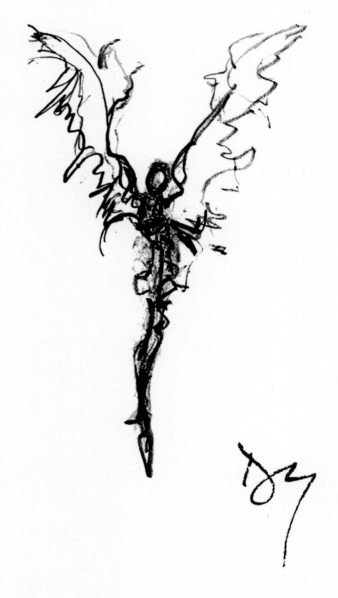

David Yurman, Angel sketch, 1972.

Opposite: Silver and gold Renaissance bracelets with cabochon amethyst and emeralds. Photographed by Emil Larsson.

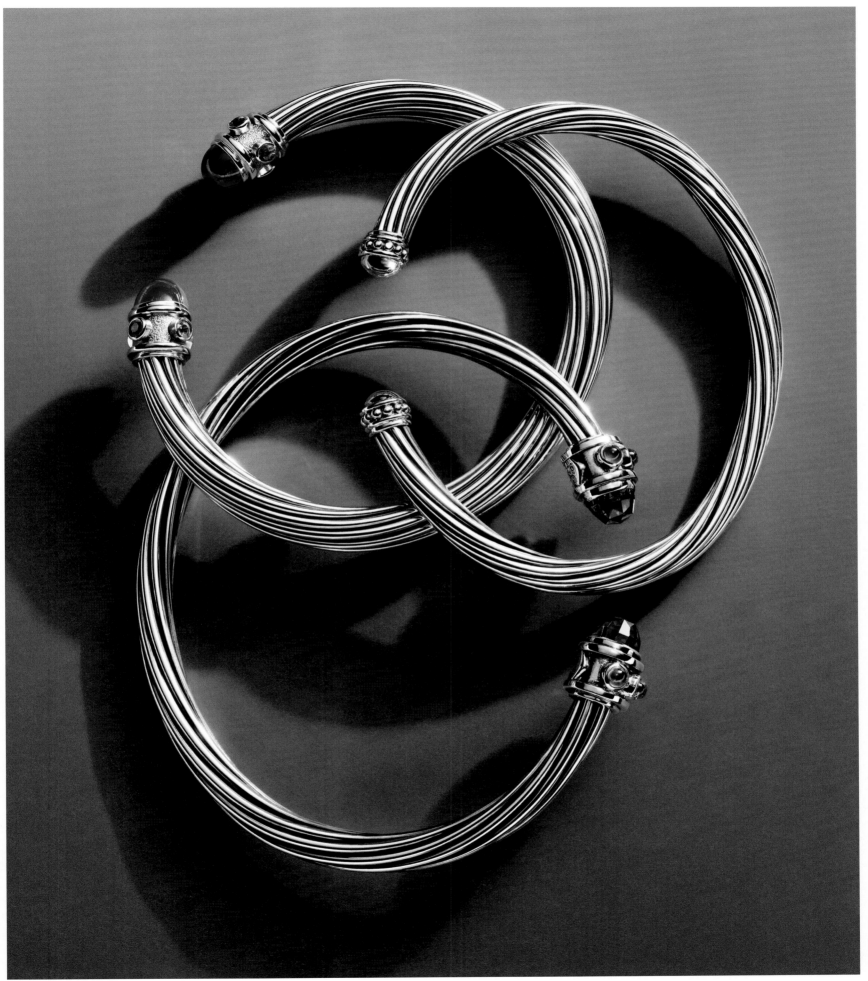

TML: When you travel, you often stop by your stores to meet your customers, understand what they appreciate, and get feedback from them. You mentioned that your first customers from the early 1980s had children who now have children of their own, and it has become a multigenerational affair. Do you now consider yourself a legacy brand?

SY: We are now on our third generation of customers. They bring their jewelry into our stores and say, "My grandmother gave me this piece," and they want to add something contemporary to it. We like the idea that people consider our pieces part of *their* legacy: we remember what our mothers or grandmothers wore. Jewelry has an emotional and generational link. It can also be your father's cuff links—men's jewelry is also gifted from generation to generation. Today, there are studies, demographics, and names for each type of customer, but our customer base is often entire families.

Bronze. Base.
Bronze Sculpture

9.10.99.

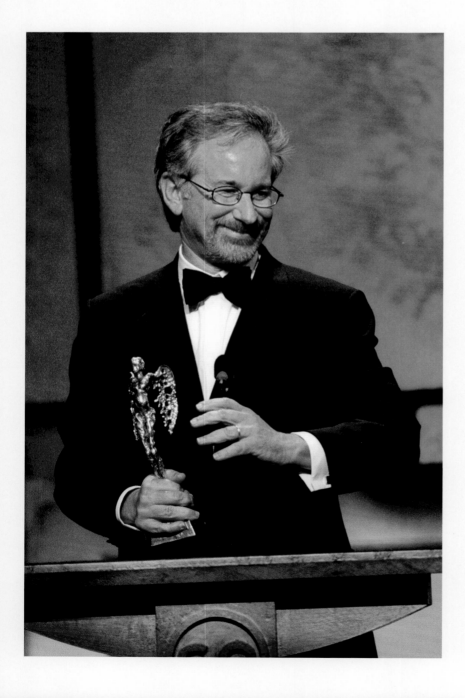

after the event Spielberg told me that he was surprised th the award was my sculpture and enjoyed having in his hand.

Top: David Yurman, GQ Man of the Year Award sketch, 1999.

Left: Director Steven Spielberg accepts his award created by David Yurman at the GQ Man of the Year Award ceremony at the Beacon Theater, New York, 1999.

Opposite: David Yurman, GQ Man of the Year Award, 1999, Bronze, Edition of 4. Photographed by Emil Larsson.

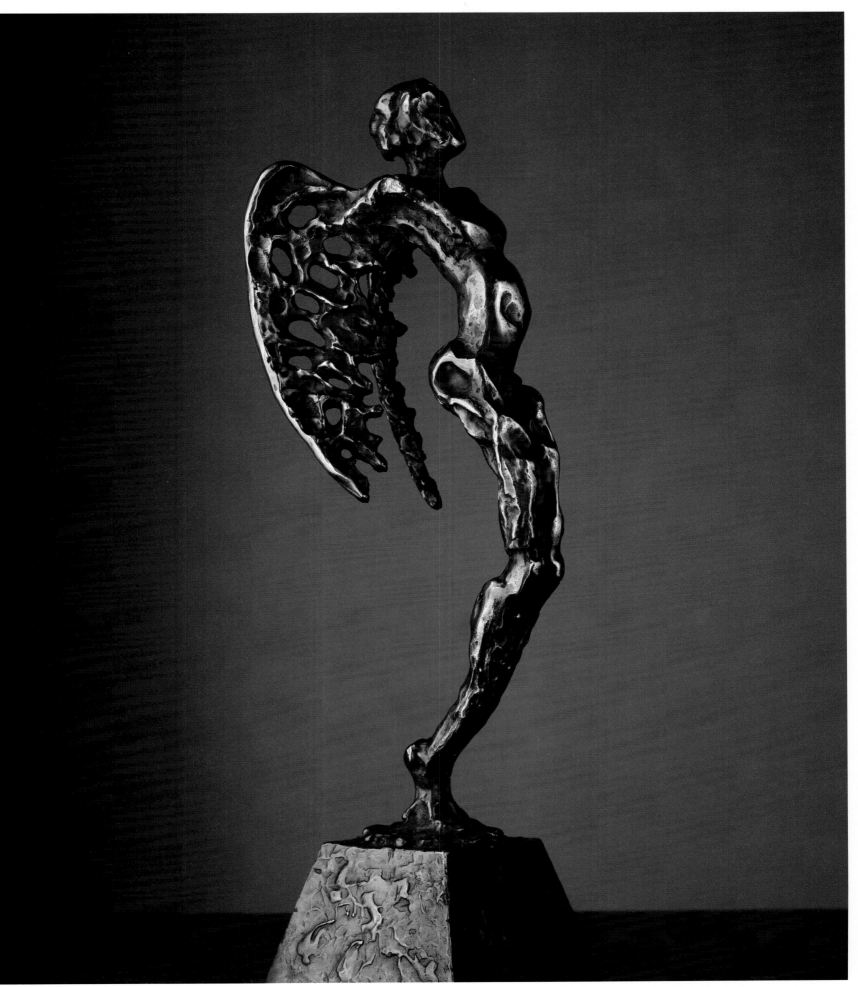

TML: How do you combine the creative process along with the constant demand for new products, as well as the need to be everywhere at once nowadays to stay relevant?

DY: From the beginning, it's been a balancing act. You want to be true to your design integrity. So what are your forms, your shapes? And then, what are some new materials or new design combinations that are unusual and interesting? You can't only follow the design or fashion worlds; you have to be aware of them. You have to know what's going on and be contemporary because you want to stay relevant, but you don't want to be a trend—or trendy. If you think of it, we're artists whose crafts are on display in the finest shops.

TML: You went from welding and painting to attending craft shows to being in and opening stores. Now, in the 2020s, the technology for creating jewelry is very different. How do you keep up with all the industry changes in designing, making, marketing, etc.?

DY: We believe in using technology but to add an artistic hand and eye. We use technology to augment the creative process. We find it very productive, if it doesn't compromise the look and feel of the pieces.

SY: For me, it explains why you get goose bumps when you look at Japanese pottery or Italian architecture, Murano glass, and art, which influenced our fragrance bottle—anything beautiful, really. When you see that level of craftsmanship, you feel the hand of the individual who made the piece, the art of the piece, and the soul of the individual that went into the piece. Like sculpture or painting, jewelry can be transformative.

DY: Technology allows us to play and invent. We have dozens of patents and trademarks. For example, we combine familiar materials, like gold and carbon fiber or aluminum and diamonds, in innovative ways. We're always inventing.

TML: How do you see the future of the family business?

DY: I'd start with our son, Evan, and his love of the business. He is a connoisseur with an incredible understanding of the beauty of gemstones. He likes to make things—it's in his DNA. At the Baselworld shows, when he was fourteen and fifteen, he would spend hours in our booth learning, but many more at the best high-jewelry stands. Today, twenty years later, he's not only the president of the company but also the chief creative officer of design and marketing. Apples don't fall far from the tree!

TML: As parents and founders, do you think it is a lot of pressure on Evan to carry the torch?

DY: Of course it's a lot of pressure, and he's doing an amazing job. He's exponentially expanded the men's line and added high jewelry and, in the process, completely elevated and expanded our "The Shop." We have a forty-person workshop, a team with some of the world's best craftsmen—who make our one-of-a-kind pieces and prototypes. He is a natural leader and has the hunger to realize his vision. Evan sees the big picture. He's very focused and organized in how he wants to develop the company.

SY: We never forced Evan to be in the business, although he was always a natural and has designed with us since his early teens. At one point, we asked him to think about if joining the business was something he'd consider. Like

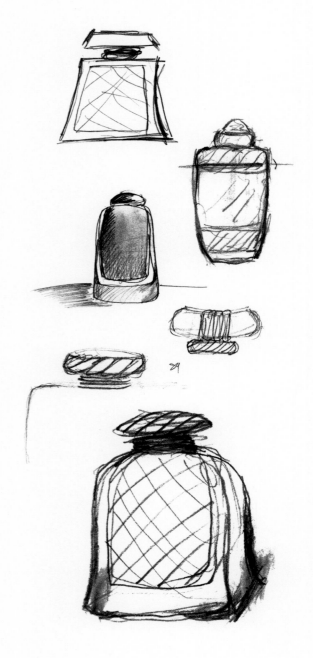

Sybil Yurman, Fragrance bottle sketches, 2007.

Opposite: David Yurman Fragrance, 2008. Photographed by Richard Burbridge.

David, he wanted time for apprenticeships and exploring to make his own path. Evan is a craftsman and a perfectionist. He has an incredible eye for beauty. From a very young age, he was attracted to rare and beautiful stones and made stone-centric, high-end jewelry. Some of Evan's precious gemstones are on display at the Smithsonian and American Museum of Natural History.

TML: Both of you have always been forward-thinking. It's been fascinating to look at what you've created and see how all the pieces came together like a puzzle. How would you sum up the experience?

DY: In putting together this book, Sybil and I began to understand our own story. We have achieved what many would consider the American dream. How did we get here? Was there a philosophy behind what we've done? There was not really a blueprint or master plan, but from the beginning, there was a conviction to follow our North Star as artists.

SY: Sometimes we look at each other and can hardly believe the path we have taken, never daring to dream of the life we have. Remembering and writing about what we did, why we did it, and what we discovered along the way was a journey that both David and I thought was important and cathartic. We've been inseparable for five decades, living, sharing, working, and creating together! We began this journey independently, but we continued it as a team. For half a century—and now with our son, Evan—we have been forging our own path. In looking back and forward, what comes to mind is something a friend once told us: "Jewelry brings joy. You're in the happiness business!"

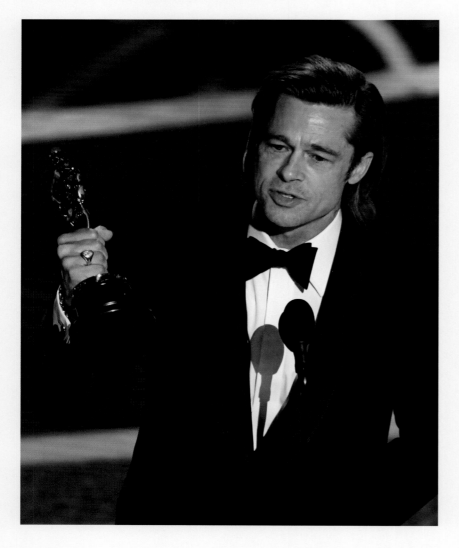

Brad has been a client of our Mens Collt for many years ... almost always creating custome versions f our Mens rings —
the Ring he is wearing when he received his Academy Award was produced for him by our mens shop in New York
.... 5 days to completion
What an honor !

Actor Brad Pitt, wearing a custom David Yurman ring, accepts the award for Best Supporting Actor for *Once Upon a Time . . . in Hollywood* at the 92nd Academy Awards, Hollywood, California, 2020.

Evan and David on set, Amagansett, New York, 2023.
Photographed by Garance Doré.

CREATING OUR IMAGE

American Beauty: Amber inside + out ♡

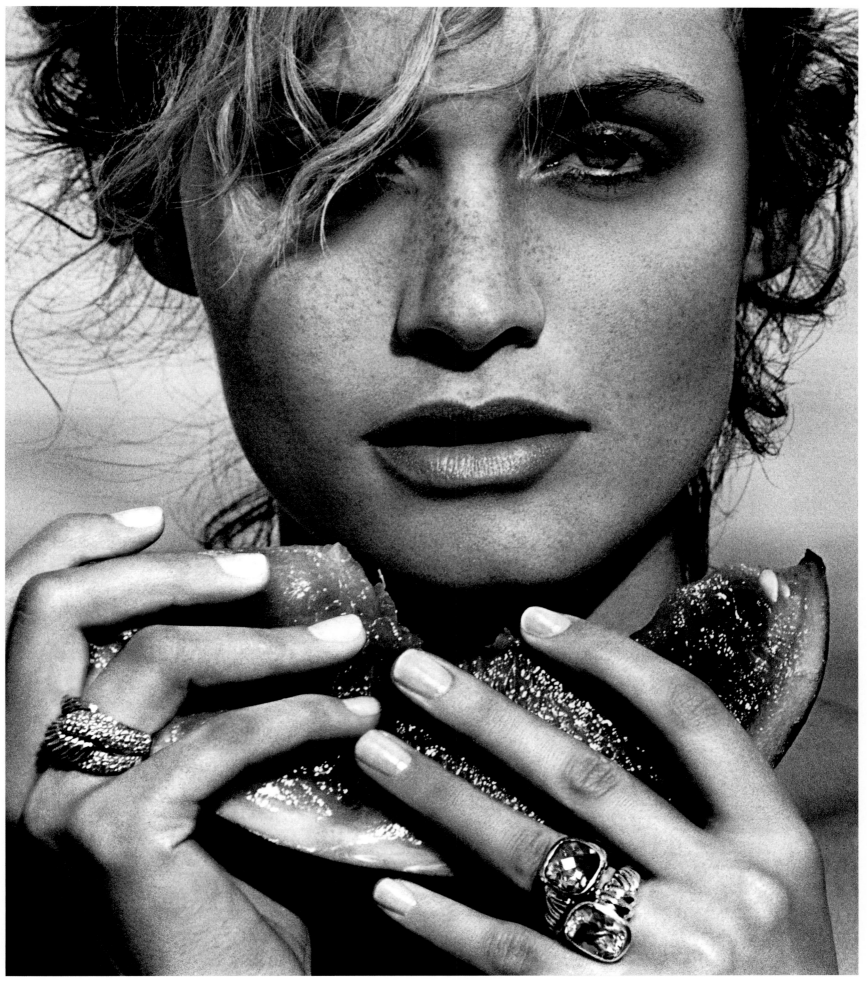

2004
2004
2004
2014
2014

lindbergh
Peter

2007
~~2010~~
~~2010~~
2008
2006
2005
2005
2009

On set with Peter & David Lipman
Now this is a true Collaboration !

Previous page: Amber Valletta wearing Rio Knot and Noblesse rings,
St. Barts, 2001. Photographed by Peter Lindbergh.

Top: Peter Lindbergh, David Lipman, and Sybil and David Yurman,
St. Barts, 2010. Photographed by Lewis Mirrett.

Bottom: Peter Lindbergh and David Yurman, Turks and Caicos, 2014.

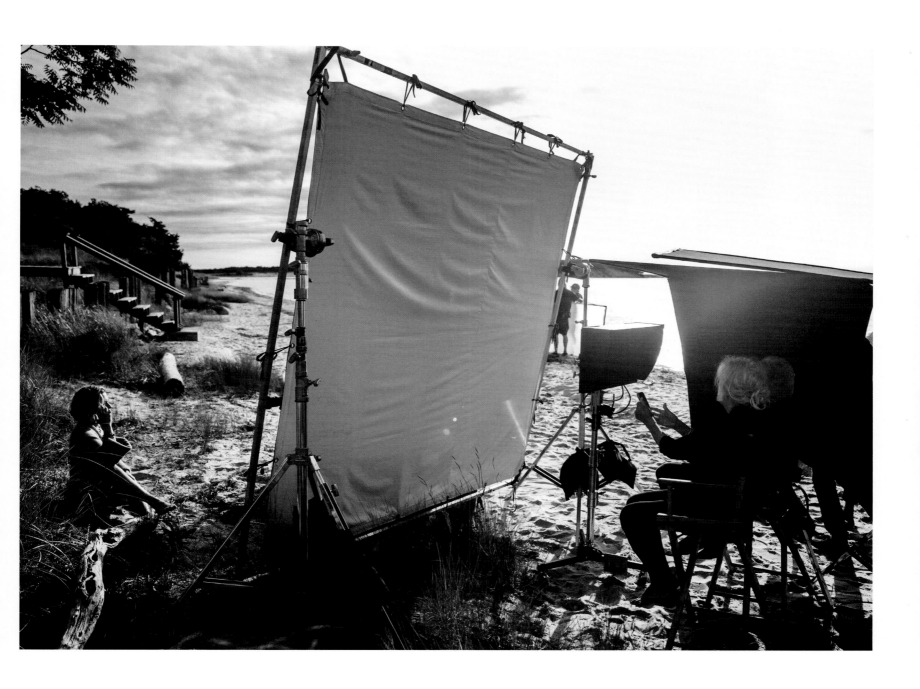

Sybil and David Yurman on set, Amagansett, New York, 2023.
Photographed by Lewis Mirrett.

Following spread, left to right: A young girl wearing Hampton necklace;
brunette girl wearing box chain with pearls as a bracelet; Amber
Valletta wearing Renaissance and Figaro bracelets, wide chain
necklace, and Cerise ring, St. Barts, 2001.

Amber Valletta wearing pearl Quatrefoil necklace, Cookie earrings,
and Hampton bracelet, St. Barts, 2001. Both photographed by
Peter Lindbergh.

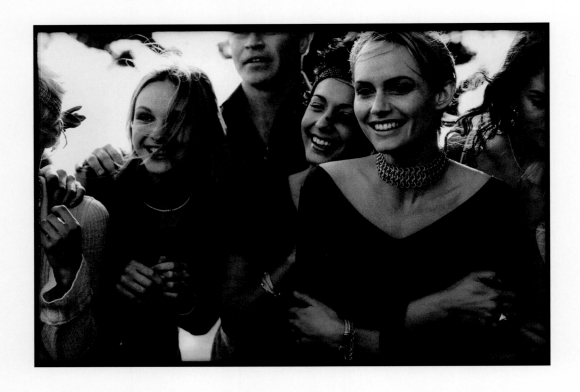

Power, seduction, beauty, and *ease.*
Those are the words that defined the image
of Yurman to me because it all works together.
Those were the words that helped us
create all those photographs. The only way you
could create that synergy was as a family
working toward those moments. It was never
a job. Peter Lindbergh was my closest
friend in the world; Sybil is my closest sister
in the world, so now—David is my brother.
That collaborative connection is what we gifted
to everybody on set.

David Lipman

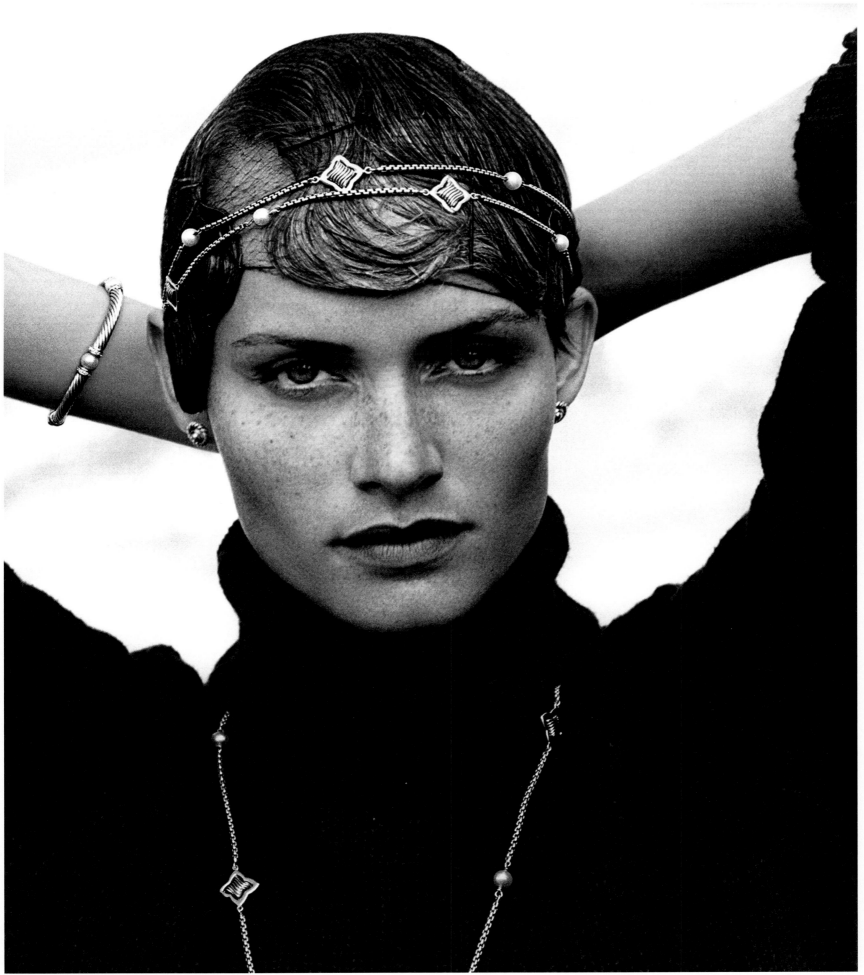

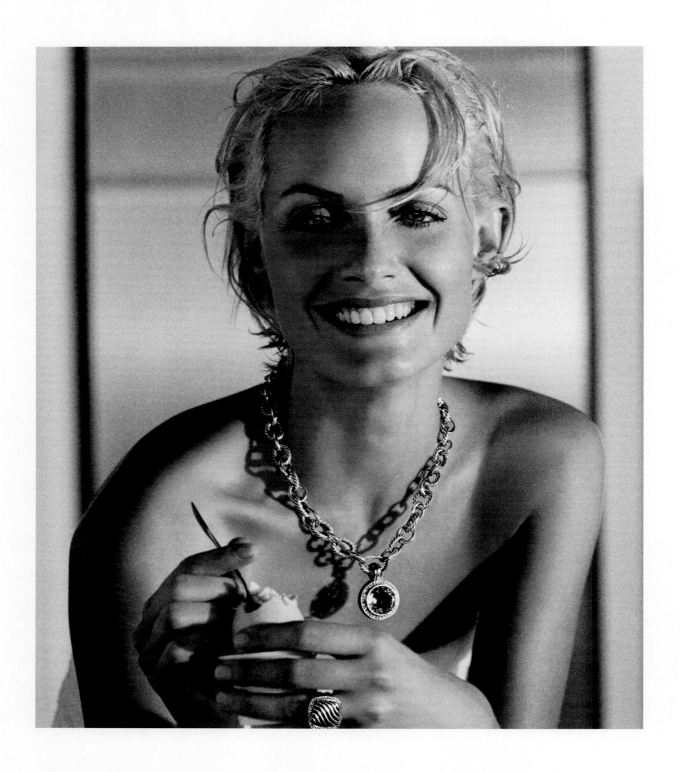

Amber was our choice for the most iconic American Beauty

Amber Valletta wearing Oval Link necklace with Cerise pendant in smoky quartz and pavé-set diamonds, and cushion-shaped Sculpted Cable ring with pavé-set diamonds, St. Barts, 2003.

Opposite: Amber Valletta wearing Thoroughbred timepiece with Crossover cuff, earrings, and rings, St. Barts, 2001. Both photographed by Peter Lindbergh.

and she is just that inside and out .. always a pro ... so much fun to be with.

He's Always in the Moment
Exploring to Capture the Moment
He's an Artist, We're Wired
Differently ... Exploring for
what is Magic. (Beyond Knowing)
Feeling.

Peter Lindbergh on set,
Turks and Caicos, 2014.

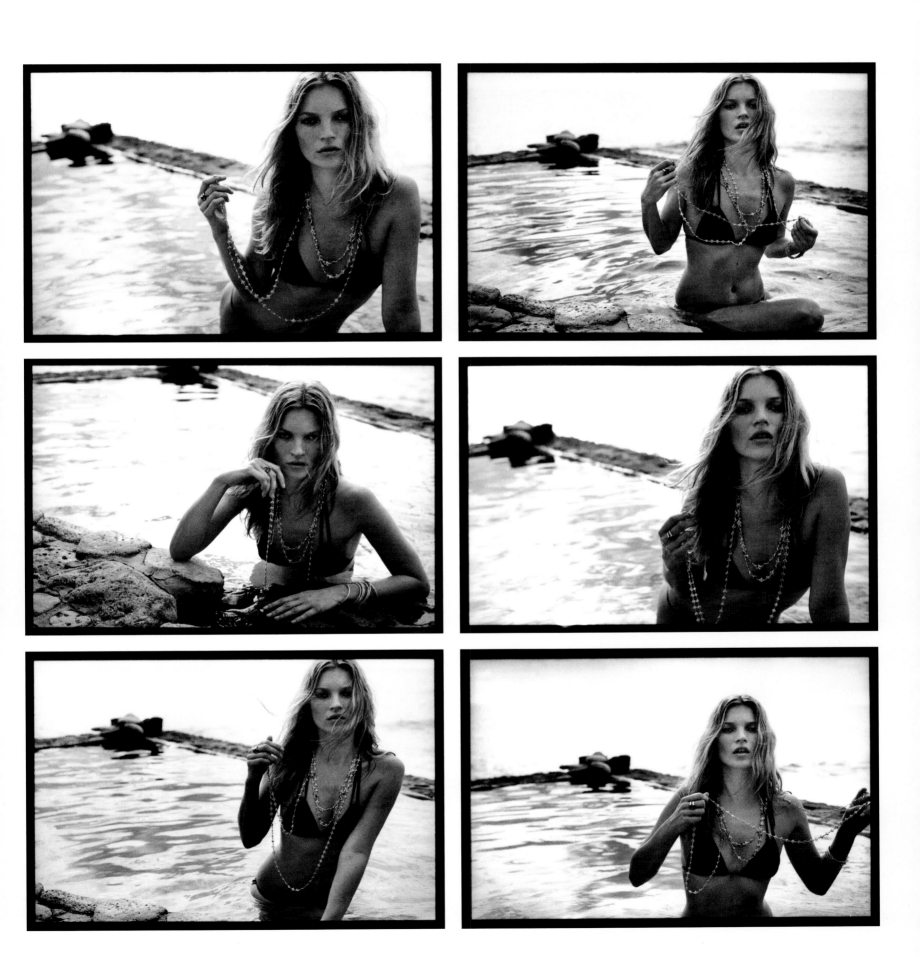

Kate Moss wearing DY Logo necklace, puffy logo necklace with bezel-set stones, and Color Classic ring, Rudolf Nureyev's house, St. Barts, 2004. Photographed by Peter Lindbergh.

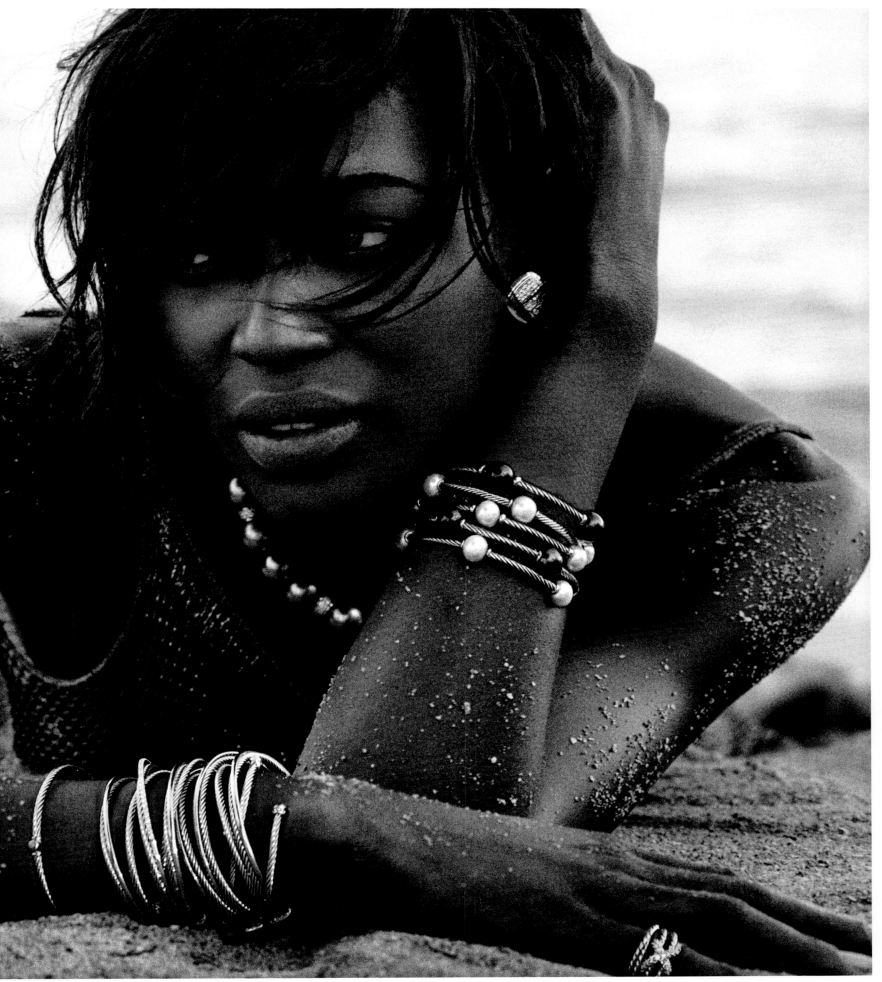

"We met creative director David Lipman in the late nineties, and he said, 'I have no idea how to advertise your jewelry; I have to decline.' And he did," recalls Sybil Yurman. A year later, the advertising mastermind came to their house in the Hamptons. When he arrived, he saw Sybil coming out of the pool casually with all her jewelry—rows of Cable bracelets on each arm and a chain worn as a belt—and her irreverent, cool attitude. He immediately thought, "*She* is the campaign!" To work with German photographer Peter Lindbergh was an obvious choice: they loved his work, which always felt emotional and cinematic. Sybil and David were greatly inspired by the elegant photographers of the 1930s, such as André Kertész and Brassaï: "Creating black-and-white images to advertise jewelry was very bold. It was more about a lifestyle and a casual attitude, not only about a product. What drew me to Peter was the warmth of his lighting that emanated out of the photographs. Tom Florio, former senior VP of publishing at American *Vogue*, said, 'It was always about creating imagery that captures the beauty in everyday moments of life.'"

The Yurmans have always worked to create imagery that evokes joy, lightness, and life—a spirit of playfulness yet sophistication—that signals empowerment and confidence. "Many people remember the iconic campaigns with a casting of strong empowered women full of inner joy like Amber Valletta, Kate Moss, Gisele Bündchen, Naomi Campbell, Daria Werbowy, Du Juan, Joan Smalls, Natalia Vodianova, Ashley Graham, and Sofia Richie, as well as actresses Naomi Watts and Scarlett Johansson," Sybil says. "Kate and Amber were instrumental in the development of the brand image. People would come to the store and say, 'I want to buy the Kate Moss ring, the Amber Valletta buckle necklace.' It had a *resonance*. Customers wanted to be that woman with jeans, T-shirt, and Yurman jewelry. It felt accessible and relatable; it was essential for the positioning of the brand. Every campaign was a celebration. We would work with the same team, host a dinner party the night we all arrived, dance and party all night, then stumble to breakfast at sunrise and shoot again! It was more of a holiday than a job!"

"I understand the Yurmans, but more than anything, I understood Sybil first," explains David Lipman. When asked about their synergy twenty-five years later, he answers that he considers Sybil to be the force behind the brand: "I connected with her because the advertising was about her vision. It always has been about her. I'm just an editor of information. I didn't invent anything. The first campaigns were really about a reflection of them. The designer is David, and he designs around his muse; Sybil is also the marketing bus. She always wants to drive the brand forward. Sometimes she would hit a wall, but she would get back in there and move forward. If she hit another wall, she would make a right turn, go above it, go around it, and then she would break through it. There's a tidal wave in her; she is a force of nature!"

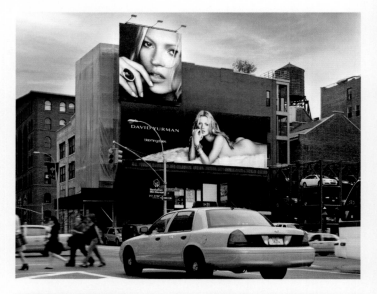

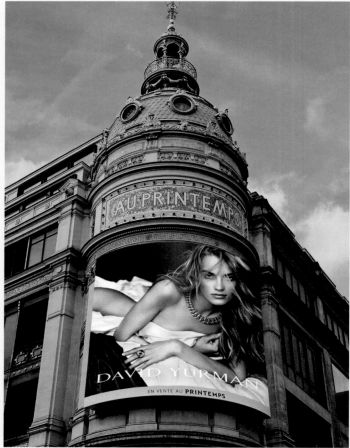

Previous spread: Naomi Campbell wearing Bangle bracelets with diamonds, cuff bracelet, pavé-set diamond coil X ring (right hand), Tahitian pearl Bangle bracelet, Tahitian pearl DY Signature with diamonds necklace, and Albion ring (left hand), 2003. Photographed by Peter Lindbergh.

Top: Model Kate Moss featured in a Peter Lindbergh photograph on a David Yurman billboard in SoHo, New York, 2006.

Bottom: Le Printemps department store with a campaign image featuring model Anna Jagodzińska by Peter Lindbergh, Paris, 2023.

Opposite: Facade of the Opera Garnier with a campaign image featuring Scarlett Johansson by Lachlan Bailey, Paris, 2022. Photographed by Eli Obus.

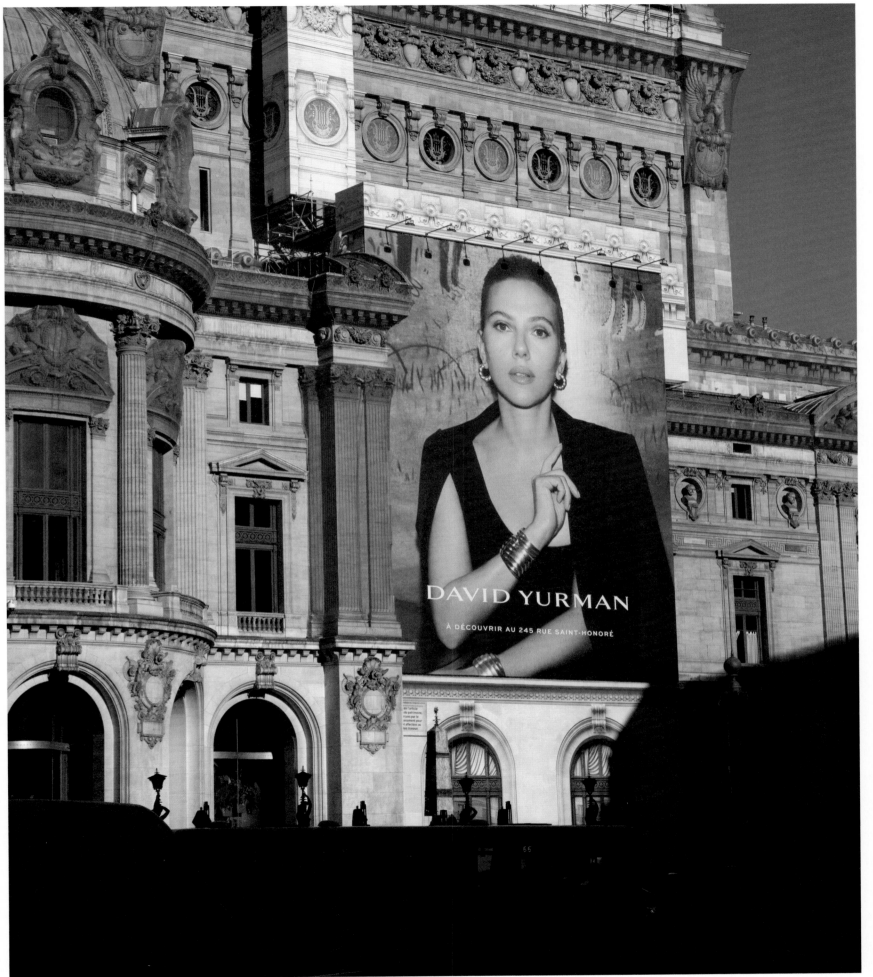

FashionNews

BY RANDI MOLOFSKY

Building the Yurman Brand
David and Sybil's Quest for Ubiquity

New York—You know David Yurman's name. Whether it's from his impeccable jewelry still-life advertisements stationed in the front of major fashion magazines or from his copyrighted Cable collection that has spawned as many imitators as admirers, Yurman's moniker is synonymous with fine jewelry

For more than 20 years, the company's namesake and his wife, Sybil, have been turning out classic American jewelry that not only appeals to the masses but to the creative epi center of accessory designers.

In fact, there is arguably no other jewelry designer who can rely on such a widely recognizable signature style as Yurman. Although updated, retooled and repositioned each year, his collections invariably make their mark by staying true to the specific artistic vision that has made the company what it is today.

It is that very recognizability that may cause one to ask Yurman why he would spend nearly $10 million to hire pre-eminent fashion photographers, directors and models to breathe new life into an already unstoppable industry force.

Don't they say, "If it ain't broke, don't fix it"?

Upon asking Yurman himself, he comes up with the biggest jewelry buzzword of 2001 branding.

This idea of branding has been evolving through the years for the Yurmans and has now come to a crossroads. The unwavering image of the jewelry and the Yurman name have become a style standard, but for David and Sybil, the idea of growth is equally as important as consistency

Thus, the new lifestyle campaign, Celebration, was imagined and implemented to redefine what the name David Yurman really means to the customer. The process has been somewhat cathartic for the couple as they, too, have been able to come a little closer to the heart of their business and what they stand for

"Sybil and I actually wanted to move to a lifestyle campaign over two years ago," David Yurman told NATIONAL JEWELER. "By developing a relationship with our agency, we were able to create a true ex-

pression of the spirit of our brand—not an easy task. After 20 years of developing the brand with tactical product advertising, it was time to put a face to the brand. We are an emotional, living brand, and we want to make the emotional connection to our customers. There seems to be a cultural shift to the way we live instead of what we own. It is what we call American 'authentic glamour '"

Armed with a framework of ideas and sizable funding, the Yurmans set out to create this perception of a brand. They hired Peter Lindbergh, a widely recognized fashion photographer; David Lipman, a director long admired in the business, and Amber Valetta, a supermodel whose credentials span every major magazine from A to Z. They then headed to St. Bart's, a lush island in the Caribbean, and joined forces to create some of the most stunning black-and-white images ever to grace the world of luxury goods.

What came to life was a set of exceptionally spontaneous and carefree images that capture that certain *joie de vivre* embraced by the world of fashion and luxury The jewelry, while still highly visible, now melds into the world of the wearer as she takes a walk on a beach.

While not necessarily a revolutionary concept in advertising, the photos are certainly groundbreaking within the world of fine jewelry

"I think we have been and continue to be revolutionary in our vision," Yurman said. "We are the first jewelry company that I know of that has ever branded themselves in this way Our choice in using Amber Valetta was not because of her face but rather the natural beauty deep in-

Continued on page 24

Do you have comments or questions about any articles in NATIONAL JEWELER? Do you have news or information you would like to share with us? If so, we would like to hear from you! Contact Randi Molofsky, FashionNews editor, at 212-615-3044, fax 212-279-3971, rmolofsky@bill-com.com.

Two images from David Yurman's 2001 lifestyle campaign. The ads, shot by famed photographer Peter Lindbergh, will be seen over the next 12 months.

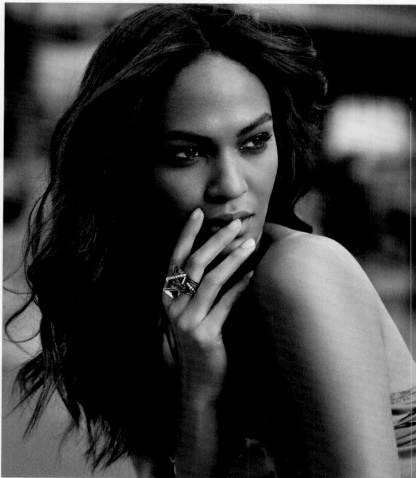

REFINED ARTISTS AND JEWELERS

BY FERN MALLIS

There is a timelessness to a David Yurman campaign. It's a quality captured in their designs—the transformative power of art through passion, creativity, and unwavering determination. David and Sybil viewed their signature Cable motif as a form both ancient and modern. During their first campaign, they envisioned that same universal message, told in the simplicity of beautiful black-and-white photographs by preeminent photographer Peter Lindbergh—images that chronicled the human condition with stories of life, love, and connection.

Coming of age during the vibrant and tumultuous era of the 1960s, drawn to a bohemian lifestyle, and immersed in the counterculture movement, Sybil and David embraced the ideals of freedom and self-expression. Their artistic journey from their free-spirited beatnik beginnings to their rise to the top of the world of fine jewelry was more than the impulse of a moment; it was a commitment to finding a way to fuse art, life, and their entrepreneurial spirit into a single, unified endeavor.

In the 1970s their unique wearable art continually evolved. They spent a decade traveling to juried craft fairs from Rhinebeck, New York, to Stowe, Vermont, to Las Olas, Florida, where they sold David's sculptural jewelry and belt buckles. Experimenting and exploring all that craft had to offer, but it was the Dante necklace David made as a gift for Sybil that would shape their lives and eventually transform their world of jewelry.

David and Sybil were designing for a new customer who wanted something different. At first, the mainstream jewelry industry didn't know what to do with these creations—who would buy an open-ended bracelet that went against all the conventions of the times, combining silver and gold with precious and semiprecious stones? The luxury department stores had to create a different approach to selling this new category of Designer Jewelry. The Yurmans' groundbreaking vision introduced a unique fusion of relaxed American style, traditional craftsmanship, and contemporary aesthetics, propelling their brand to international acclaim. It captured the hearts of discerning collectors and celebrities alike and brought American jewelry worldwide recognition.

This new category of jewelry needed a new voice, so David and Sybil began to envision how they would communicate their message to the world. It took more than a couple of years, and in 2001 they launched their pioneering David Yurman marketing campaign. It broke the mold with sophisticated black-and-white photographs featuring the most beautiful and successful models and actresses of the day in full-page national magazine ads and on billboards around the country. It was a groundbreaking success that elevated jewelry to a new level and enabled them to share their vision of what wearable art and relaxed American luxury could be.

Opposite, clockwise from left: "Building the Yurman Brand: David and Sybil's Quest for Ubiquity," by Randi Molofsky, *National Jeweler*, June 1, 2001.

Ashley Graham wearing Albion ring and Wellesley link and Thoroughbred bracelets, Jamaica, 2018.

Joan Smalls wearing Cable Wrap ring, New York, 2011.
Both photographed by Peter Lindbergh.

Daria Werbowy wearing Oval link necklace
in Renaissance silver and gold with smoky
quartz pendant, petite box chain bracelet, and
onyx Spiritual Beads bracelet, St. Barts, 2008.
Photographed by Peter Lindbergh.

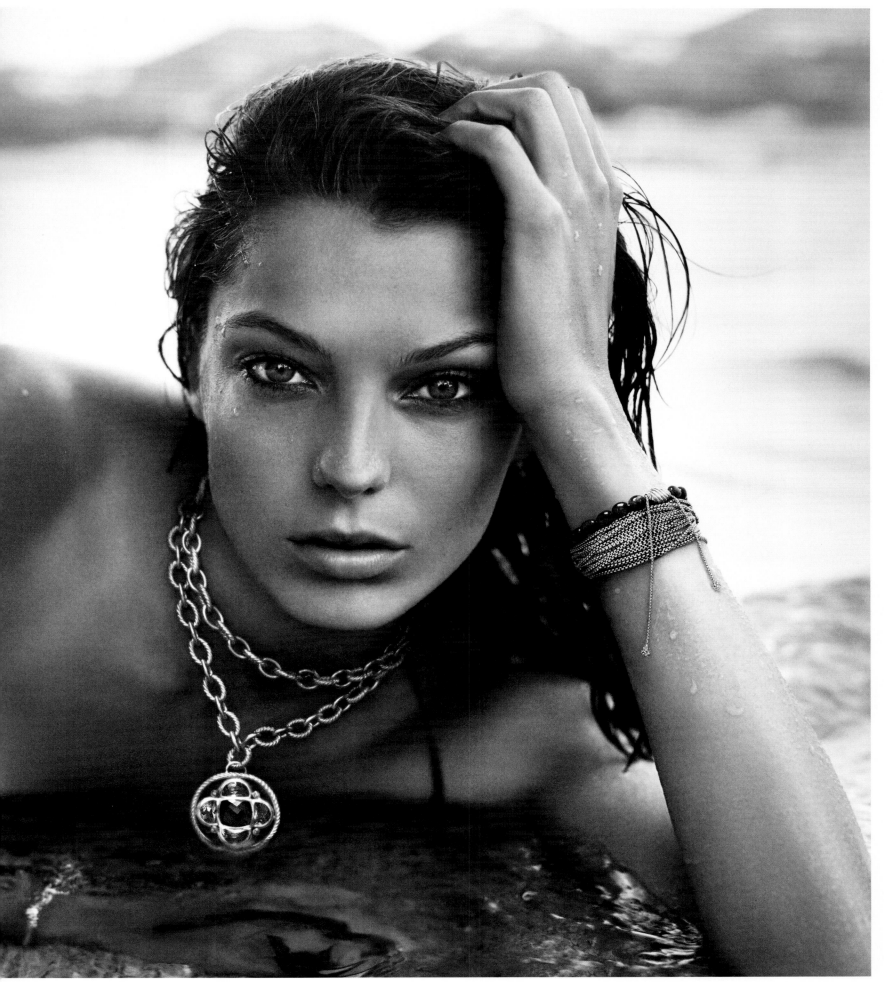

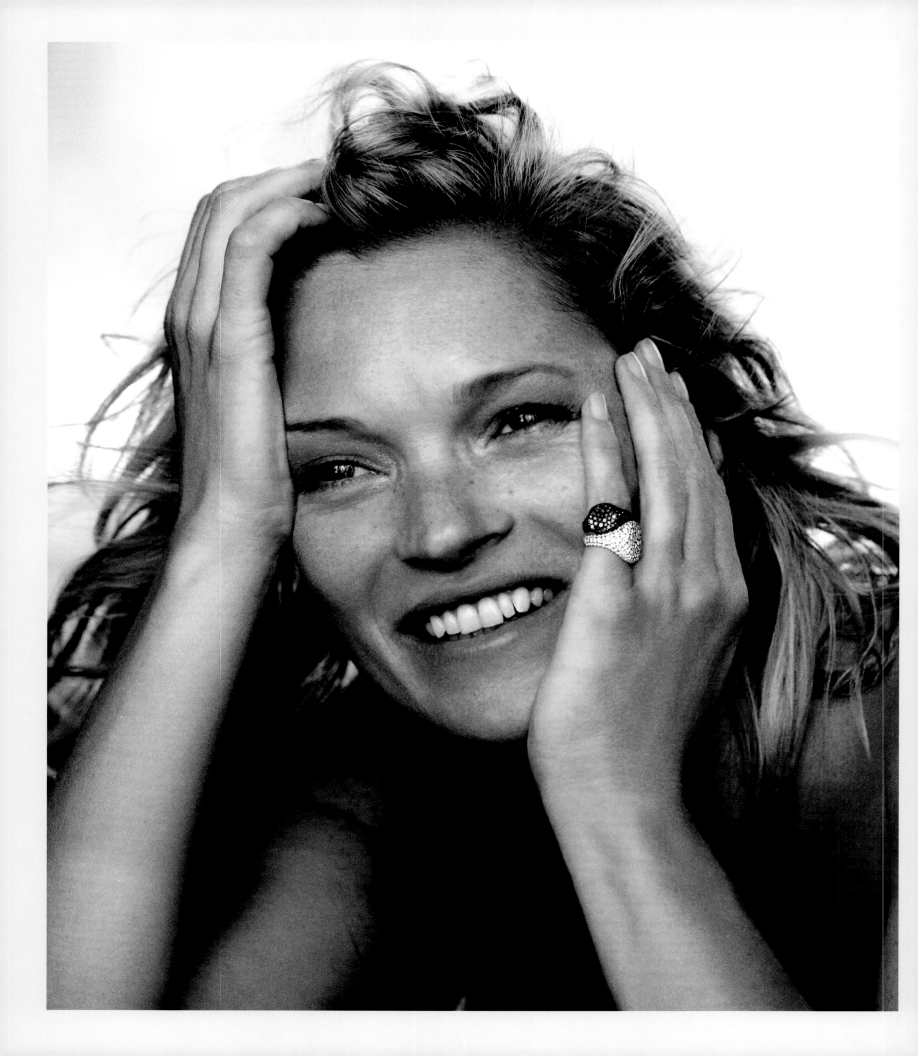

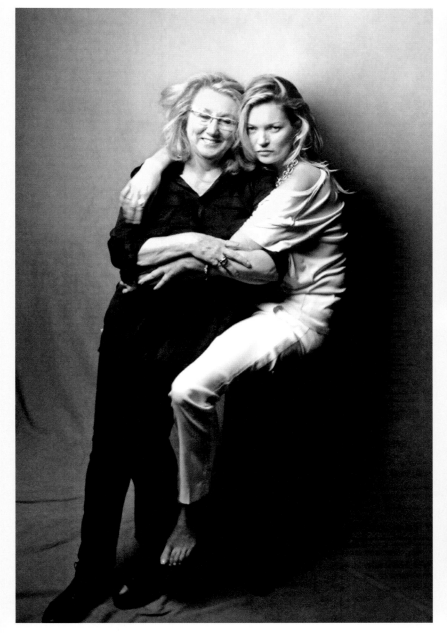

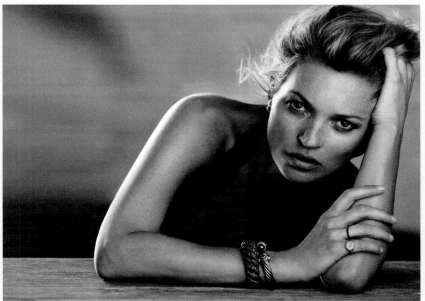

Opposite: Kate Moss wearing Pinky ring with pavé-set black and white diamonds, St. Barts, 2014. Photographed by Peter Lindbergh.

Left: Sybil Yurman and Kate Moss, Paris, 2015. Photographed by Tracy Squillante.

Top right: Kate Moss and David Yurman, London, 2014.

Bottom right: Kate Moss wearing Hampton diamonds and Renaissance bracelet, and black diamonds Midnight Mélange and Pinky rings, St. Barts, 2014. Photographed by Peter Lindbergh.

Following spread, left: Kate Moss wearing diamond bezel Cerise ring, St. Barts, 2008.

Following spread, right: Kate Moss wearing side-sculpted Midnight Mélange wide cuff bracelet with pavé-set white and black diamonds, and Starlight diamonds oval ring, St. Barts, 2010.

Pages 54–55: Kate Moss wearing Link curb chain necklace, oval ring with onyx and pavé-set diamonds, St. Barts, 2007.

All photographed by Peter Lindbergh.

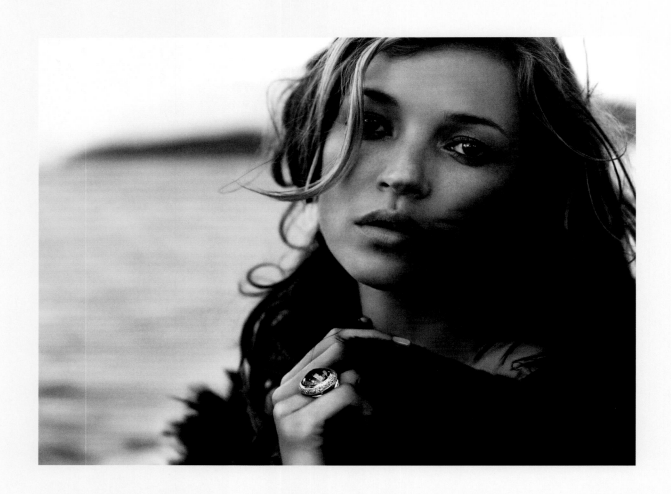

Kate reminded me of myself at her age.
She and I just clicked—we were just two cheeky girls!

Sybil Yurman

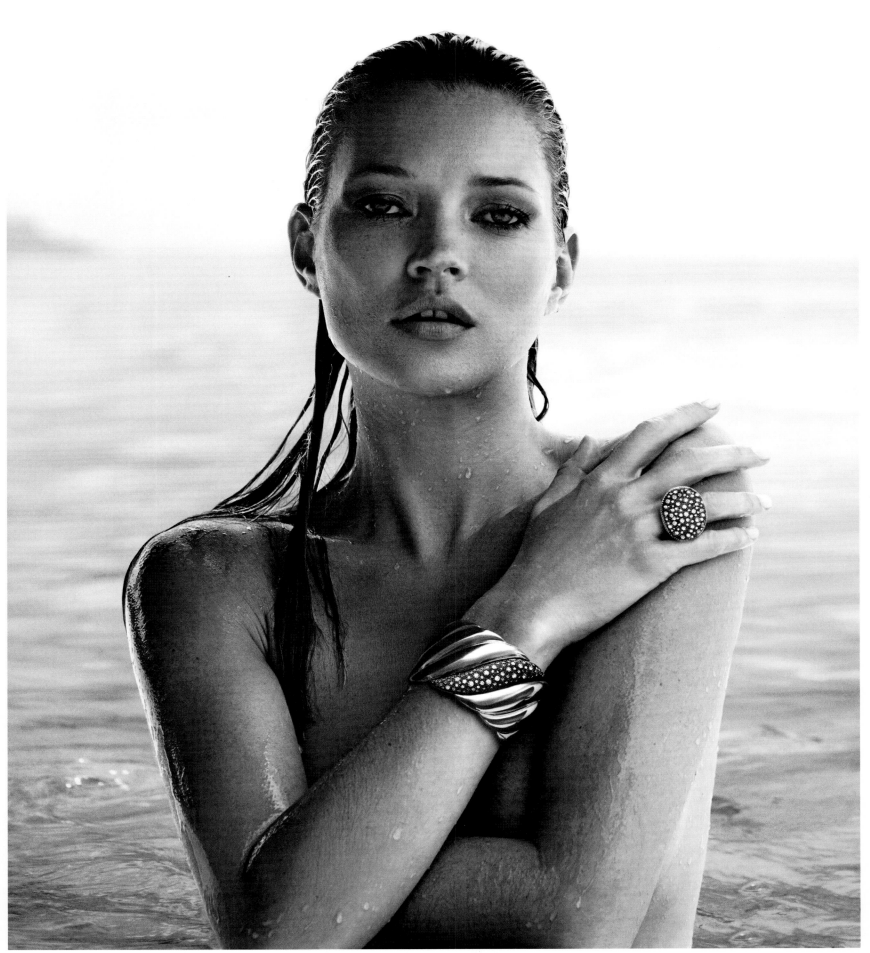

May 2007
St Barths

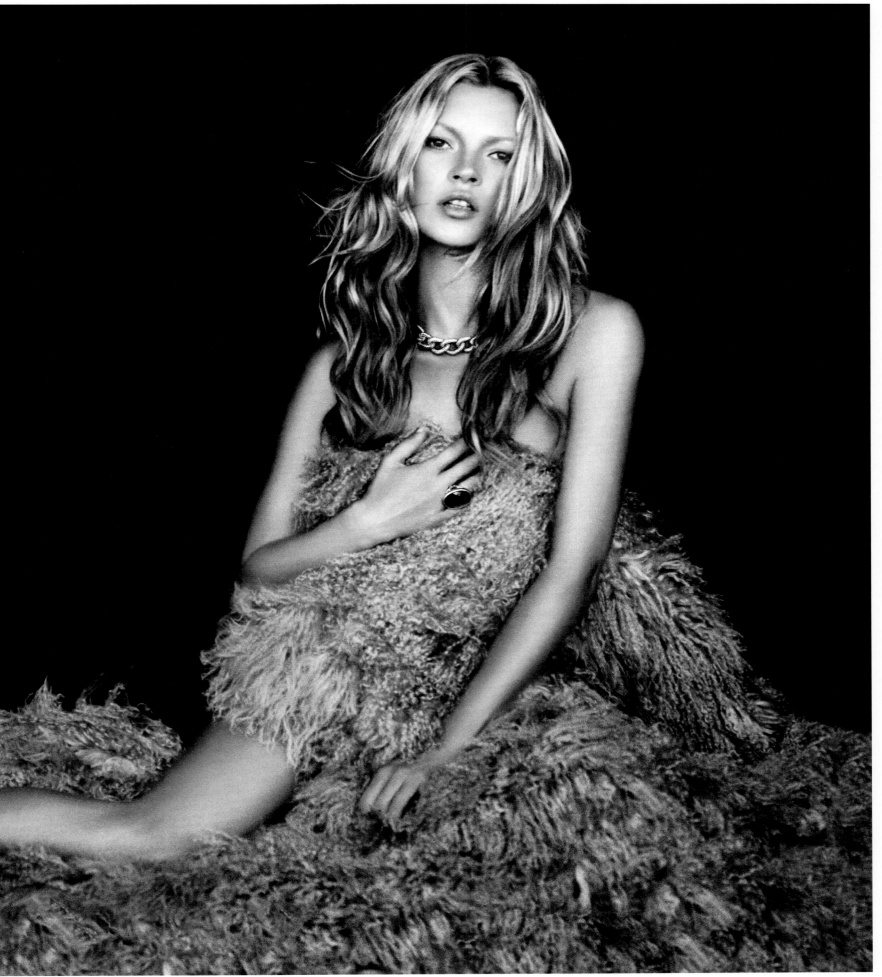

SYBIL
THE
RUNAWAY

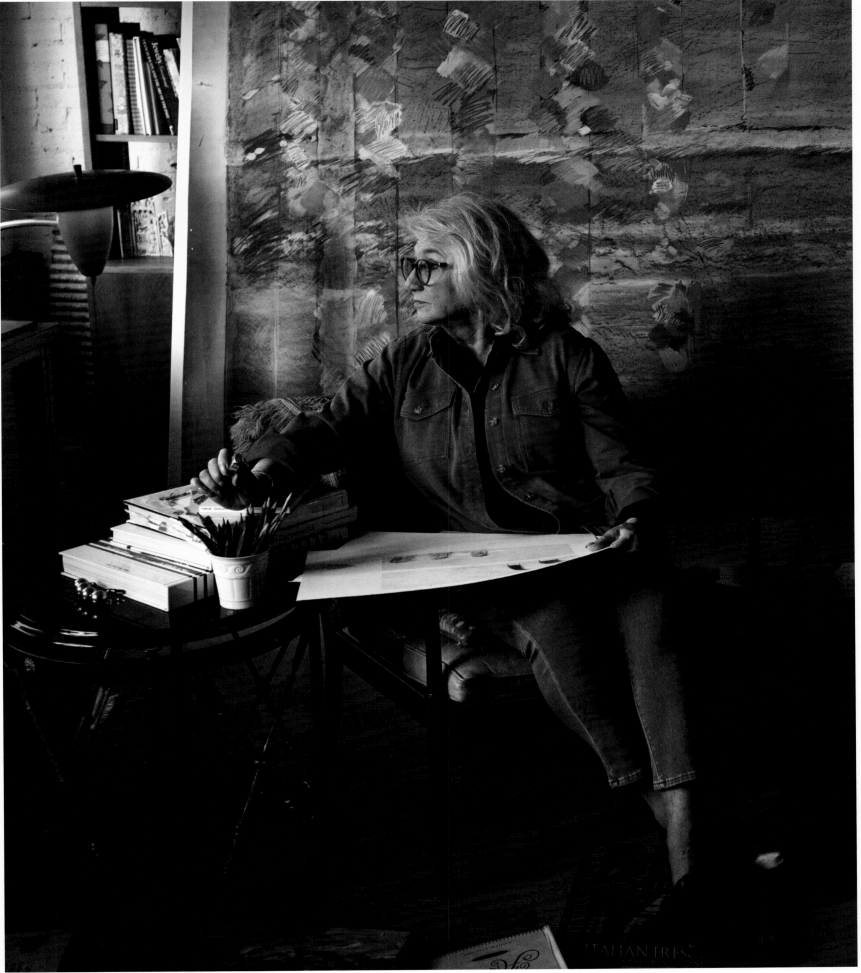

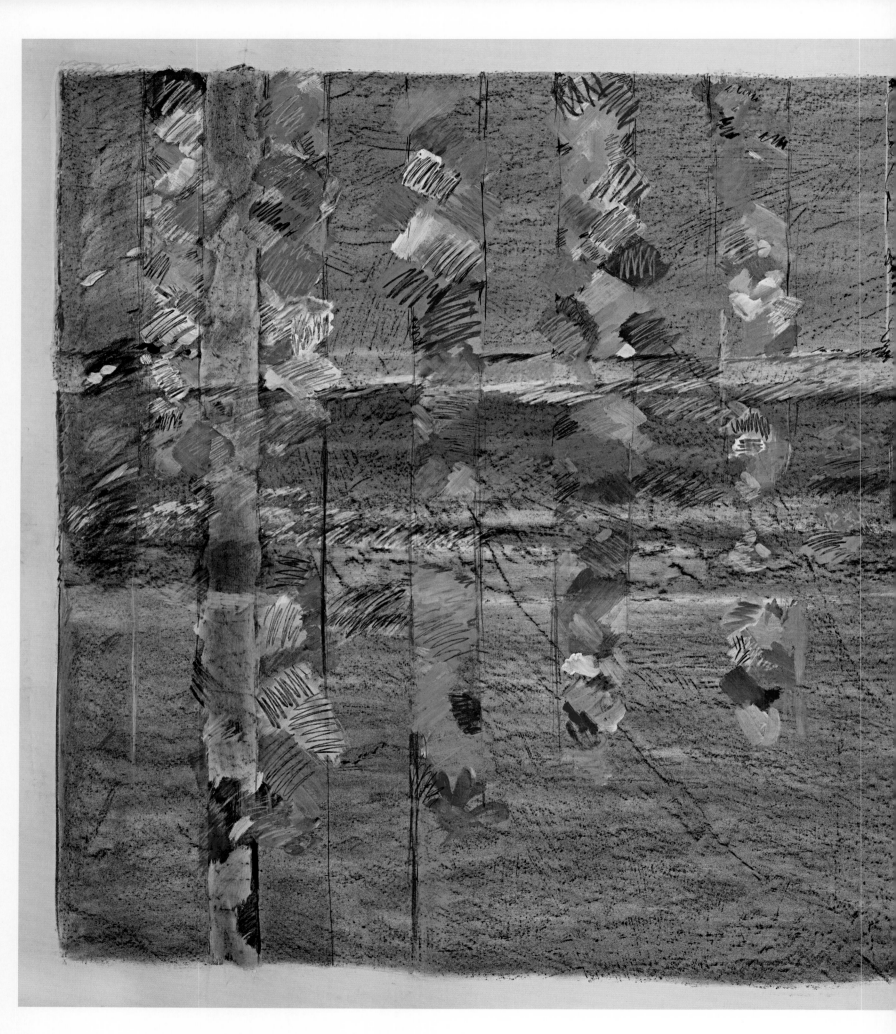

Previous spread: Sybil Yurman in her painting studio,
New York, 2023. Photographed by Norman Jean Roy.

Sybil Yurman
Fragments of Light, 1972–75
Pastel, graphite, and acrylic on paper

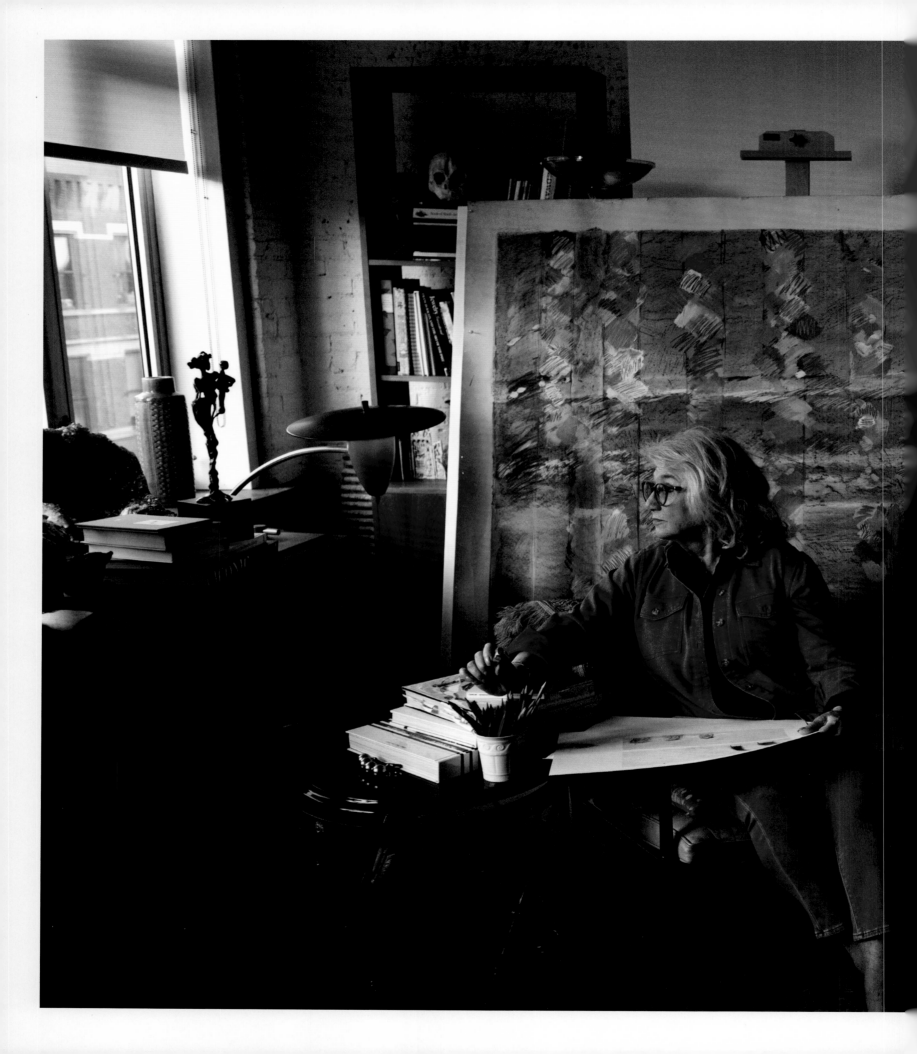

"I had a life before David Yurman," Sybil says as she receives the Honorary Mayor Award in San Antonio, Texas. This ironic remark is the introduction to something with a deeper meaning. Sybil is, through her own merit, an artist, creator, and businesswoman, yet always is surprised by the admiration and curiosity people have about her career, and the path to her success. "It was not paved with diamonds," she laughs, and clarifies for her audience, "but with hard work and an unwavering belief in myself."

When you first meet Sybil, you quickly understand that beyond her irreverent sense of humor, she can be counted on for sage advice. A sensitive and fearless woman, she sees everything, listens to everything, and analyzes everything, while taking an empathetic and humanist approach to life, art, and business.

Beyond the glamor of the jewelry world, you quickly understand Sybil's rebellious childhood in the Bronx propelled her as a teenage runaway to California, where she began to grow as an artist, shaping the woman she is today. "As a child I lived in the Bronx, in a small apartment, where I shared a bedroom with my two brothers, and our parents slept in the living room. Murray and Rose, my father and mother, were formidable characters. Murray worked designing and making furniture, working on celebrities, home decor and furnishings and most notably the drapery for the Radio City Music Hall. As a poet and a historian, he was by nature a creative force, who worked long hours, as did my mother, who left school at eleven years old to help at a nursery school that she later became the manager of in the 1930s. She was a consummate organizer and went on to operate the family business.

"Our family was the epitome of the New York melting pot, and what I learned from a very young age was to be independent and self-sufficient, most importantly, as an independent thinker. In our home, the Greek philosophers, poets, and Shakespeare were required reading, often to teach me a life lesson.

"My younger brother fell ill and died when I was ten. I struggled, but there was no time for attention or tutors. I was always precocious," she recalls. "I couldn't sit still; I was interested in everything. I wanted to talk with everybody. I was thrown out of school at fifteen. The principal told my father that I would never graduate or ever accomplish much of anything, and he would make an exception for me to drop out without them contacting the truant officers. I would now be able to spend my days painting and reading.

"I discovered Monet's *Water Lilies* at the Museum of Modern Art, a curved triptych that covered the gallery walls and surrounded me with sky, water, and flowers. I was struck by the wonder of it and was inspired to paint from a feeling and from the aura of a place. I recognized Monet was not just painting water lilies; he was painting a moment in time, capturing the essence of something—its beauty and simplicity. I understood that a painting could elicit an emotion and convey a feeling, to me the most important, and what other people considered my weaknesses could become my greatest strengths.

"I created these beautiful colored fields in the style of Monet and sold them to whoever came to the house. It was a way for me to paint and to make money. Whether painting or jewelry, it must express emotion. It was important to me to not approach art from a technical point of view. Painting for me has a rhythm like dance.

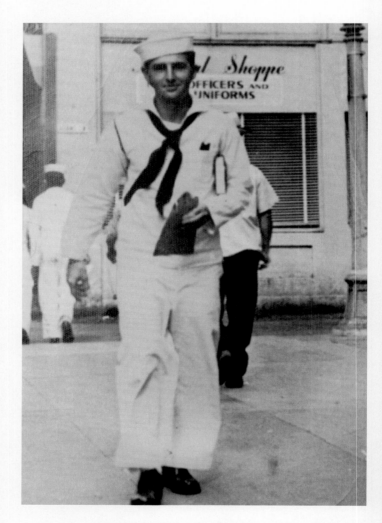

Daily make believe calls to Dad in Tokyo 1944-45

Previous spread: Sybil Yurman in her painting studio, New York, 2023. Photographed by Norman Jean Roy.

Sybil's father, Murray Kleinrock, Japan, 1945.

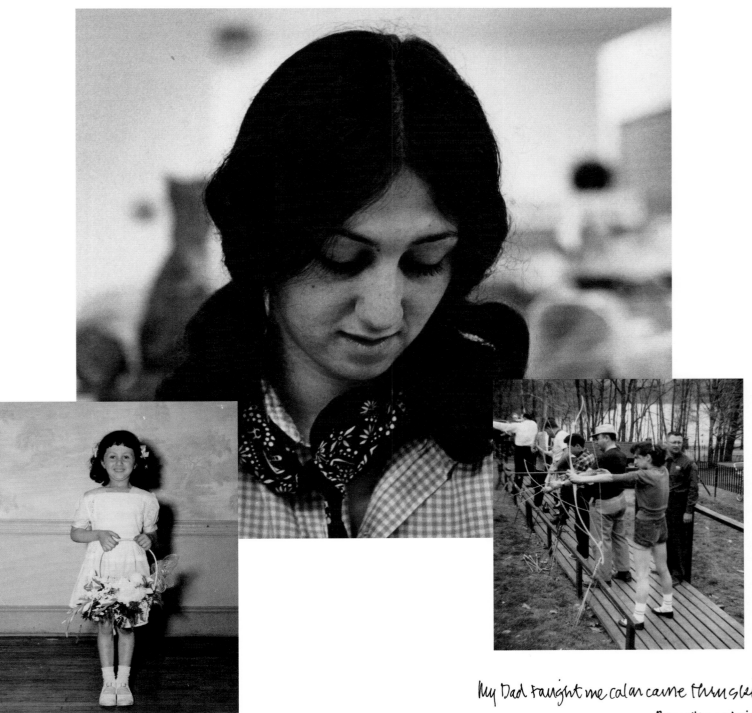

Fired from my first job as flowergirl notice The dirty shoes. :)

My Dad taught me color came thru skill Bear Mountain N.Y

Clockwise from top:
Sybil Yurman in her painting studio, Berkeley, California, 1965.
Sybil Yurman, Bear Mountain State Park, New York, 1957.
Sybil Yurman as a flower girl photographed by her mother, Rose, New York, 1949.

"At sixteen, I got a job in Greenwich Village at a café called The Commons. It was my introduction to the Beat Generation, but above all, to another lifestyle. I dreamed of a life on the West Coast and began selling my work to save money for the journey."

In 1958, Sybil left New York with a coworker from The Commons to start her new life. "We were hired to take a 'drive-away' Mercedes with German plates across the country, getting paid seventy-five dollars when we delivered the car. Arriving in San Francisco, I found a haven for artists, writers, poets, and musicians—we were all looking for an escape from the suffocating conformity of the 1950s by exploring Eastern culture and spirituality. The freewheeling expression of the Beat poets and jazz musicians and my first encounters with Zen and Eastern philosophies became the foundation of my education as a young woman and an artist. I ended up living at Hyphen House—a big, communal Victorian house in Japantown where I met the poets, artists, and writers of the day.

"It all happened without any real plan. I lied about my age and got a job waitressing at Jimbo's Bop City, a jazz club around the corner. Every night you could hear great musicians—Miles Davis, Dizzy Gillespie, Charlie Parker, Hendricks and Ross, or Art Blakey. Music became a point of freedom for me, and a kind of meditation—I couldn't sing or play an instrument, but I was always surrounded by it, and it provided an incredible sense of euphoria and community.

"The Hyphen House neighborhood was changing so fast. All the old buildings were being razed. I watched as everything around me was being bulldozed. Known as Japantown, the area had been emptied out during World War II when the Japanese residents were sent to internment camps. The empty blocks were now filled with artists, beatniks, musicians, and other so-called riffraff. Urban renewal and tearing everything down was the city's misguided solution to the problem. Late at night my friends and I would go out to save these beautiful architectural and ornamental artifacts before they were gone. I had a very strong feeling about them—they were endangered and needed to be rescued. These elements of beauty were being destroyed, but the experience of salvaging some of them helped develop my aesthetic.

"Those early years in California were the first time I felt like I belonged somewhere. People approached life with tremendous curiosity, and a sense of acceptance and inclusion—it was all about being open to new experiences and being connected to nature and to your body, about finding out what was true for you. It was about having an authentic reason for doing the things you did."

California expanded Sybil's mind, as she explains: "We were all seeking an alternative to the mainstream. Seeing artists who thought differently, and being exposed to the Eastern cultures and Zen Buddhism, I was able to free myself."

Later, when Sybil moved to Berkeley, she created raku pottery and monitored the ceramic studio at the Berkeley Student Union. In 1966, moving back to the East Coast, she worked at the Corcoran Gallery of Art in Washington, DC, where she studied with master Japanese potter Shōji Hamada. A half a century later, she would return to the Corcoran as a guest speaker to discuss her life and career.

With her tremendous sensibilities for art and communication, she could have chosen any single path—photographer, teacher, child psychologist,

raku potter, painter, creative director, CEO—and over the course of her life she took them all on. "I am a visual thinker," she explains. "I categorize in my mind. I have to take ideas and translate them into a visual presentation in order to make them resonate." Her ability to visualize and communicate a concept, combined with her creativity and tenacity, paved the way for the extraordinary and unstoppable force she is today. "When David and I design, it's important that we see all the ideas, all the concepts, on paper in a very rough sketch. It doesn't need to be refined—I'm looking to see how an idea could work. I often flip through David's design notebooks and search his sketches for something that inspires me, asking, 'Could we develop this?'

"If you go for perfection, it's not going to have a sense of the human hand or the heart. I consider jewelry to be an expression of emotion, imbued with feelings of affection, love, warmth, and caring. That emotion is what comes through our jewelry: it has a purpose beyond the object."

When you see Sybil and David, you are reminded that these two individuals, both prolific artists and innovators, are part of a family of co-creators. To this day, the most important meeting place in their house is the ten-foot kitchen table. This is where everything happens. Scattered across the table are loose drawings and colored pencils. David sketches an idea. Sybil adds to it. Or vice versa. This same table is where Evan uttered his first words, and fourteen years later designed his first pair of cuff links. Today, at the table, David and Sybil listen to their three grandchildren's dreams and ambitions. They affectionately discuss their potential roles in the family company. The kitchen table is where the family celebrates life's successes, discusses challenges, and hosts board meetings and interviews. Most importantly, it is where David still leaves his notebook close to Sybil's place mat every night before going to bed, for her to flip through first thing in the morning and discover if he sketched something that she will love. This is their lifelong art project.

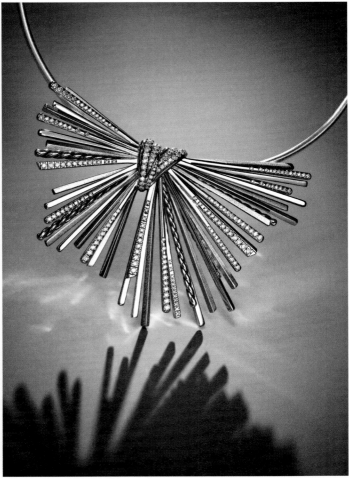

Top: Fukurokuju statue in the Yurmans' loft, New York, 2023.
Bottom: Angelika silver and diamonds necklace, 2020.
Both photographed by Emil Larsson.

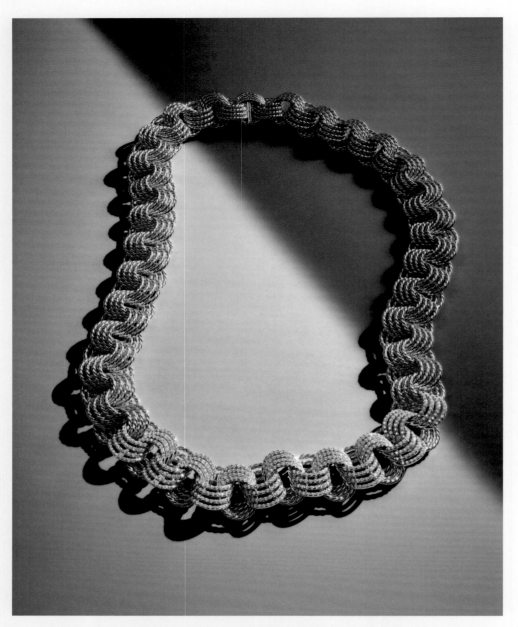

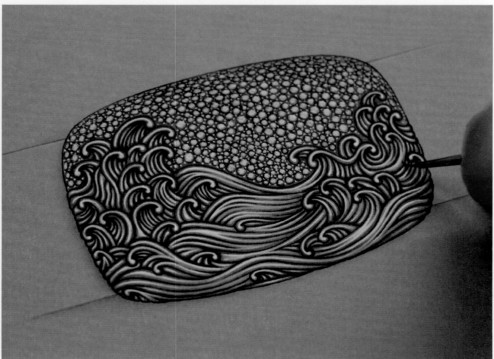

Top: Origami Collection necklace, 2019. Photographed by Emil Larsson.

Bottom: Illustration of Waves belt buckle, New York, 2014. Photographed by Nathan Copan.

Opposite, top: Katsushika Hokusai, *Under the Wave off Kanagawa* (or *The Great Wave*), from the series *Thirty-Six Views of Mount Fuji*, c. 1830–32; Polychrome woodblock print, ink and color on paper; 10⅛ × 15 in. (25.7 × 37.9 cm); Metropolitan Museum of Art, New York.

Opposite, bottom: Ancient Japanese *tsuba* (sword guard), New York, 2011. Photographed by Anthony Costifas.

SYBIL ON JAPAN

It was the end of the summer of 1945. My father returned from the war in the Pacific and brought back gifts from his time in Japan: traditional wooden sandals, a kimono, some origami pieces, and a small wooden sculpture of Fukurokuju, one of the Seven Lucky Gods in Japanese mythology. My father was a sophisticated poet and an erudite philosopher. I remember how important it was to him, even though I was only three years old, that I knew the meaning behind these beautiful objects. He captivated me with stories about Japanese mythology and culture. It was my earliest experience with art and aesthetics. I remember the story of Fukurokuju like a childhood fairy tale. These early memories took root and stayed with me. My brother was ill, and my parents were overwhelmed and unable to deal with me and found my curiosity disruptive. I often felt like an outsider, like I didn't belong. I wasn't celebrated in any way. I knew there was another world, and it wasn't in the Bronx. So I saved my money, planning and imagining a better place. My dream was to swim in the Pacific Ocean at sunset.

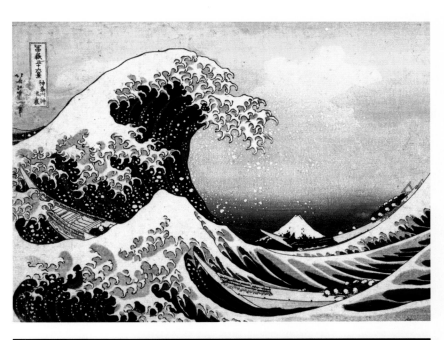

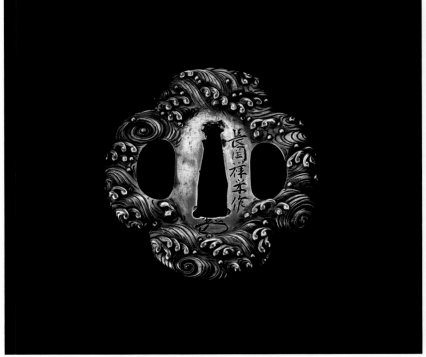

I made it to San Francisco in 1959 and settled at Hyphen House, on the corner of Post and Buchannan in Japantown, a communal residence for artists and poets interested in East Asian art and philosophy. I immediately felt like I belonged and found myself again immersed in Japanese culture. Jay Blaise, another resident, invited me to visit his friend Albert Saijo, who was hospitalized and convalescing with tuberculosis at the Veterans Hospital in Oakland. Albert was a poet revered by the Beats and instructed them in Zen Buddhism. Years later, I read his poetry, including his haikus written with Jack Kerouac and Lew Welch, and realized he was a central figure in the movement. We had a picnic on the lawn of the hospital with Albert's sister, Hisayo. She brought a bento box, elegantly wrapped, and tied with patterned traditional Japanese cloth called *furoshiki*. The ceremony of unwrapping the bento box, revealing elegantly arranged food offered in little compartments, taught me about the importance and beauty of presentation. I had never seen anything like it.

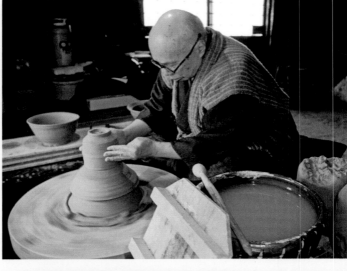

I always painted and drew and had an interest in photography. When I arrived in Berkeley in 1964, I first got a job in the photo studio, which led me to ceramics and raku pottery. Raku bowls used in traditional Japanese tea ceremonies are formed by hand, rather than thrown using a potter's wheel. I was fascinated by the meditative process and the subtle fluctuations in colors, textures, and the crackled glazes created by the low firing process. Each piece is meant to reflect an intimate expression of its creator. The results are unpredictable, underscoring the idea of *wabi-sabi*, the beauty of imperfection and impermanence. In 1966, back on the East Coast, I was working at the Corcoran Gallery of Art in Washington, DC, and was very fortunate to study with Shōji Hamada, one of the most celebrated Japanese potters of the twentieth century.

Today, the beauty of these traditions informs our lives and company. I'm still drawn to Japanese art, especially my collection of woodblock prints by Katsushika Hokusai and Utagawa Hiroshige. I am moved by the importance the Japanese give to all forms of presentation, using furoshiki to wrap gifts, the elegance of bento boxes, the ritual of the tea ceremony, and the symbolism behind it all.

Top to bottom:
Japanese potter Shōji Hamada, 1960s.

David and Sybil Yurman's home, New York, 2023. Photographed by Emil Larsson.

Kikukawa Eizan, *Woman and Children by a Snowball, Winter*, from the series *Elegant Beauties and Precious Children*, 1800–20; Woodblock print, ink and color on paper; 13½ × 10⅛ in. (34.5 × 25.8 cm).

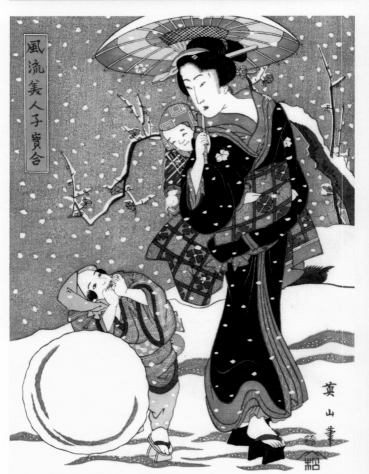

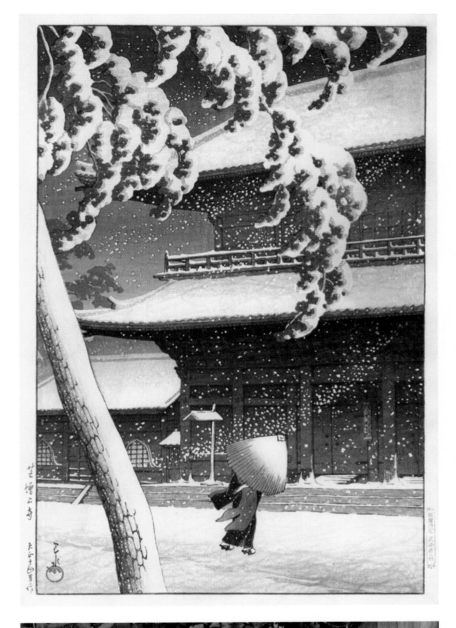

Top: Kawase Hasui, *The Temple Zōjōji in Shiba*, from the series
Twenty Views of Tokyo, 1925; Woodblock print, ink and color
on paper; 14¼ × 9½ in. (36.2 × 24.1 cm); Metropolitan Museum
of Art, New York.

Bottom: David and Sybil Yurman's New York garden, 2023.
Photographed by Emil Larsson.

Sybil Yurman's untitled mixed-media painting
that inspired the Angelika Collection, 2019.

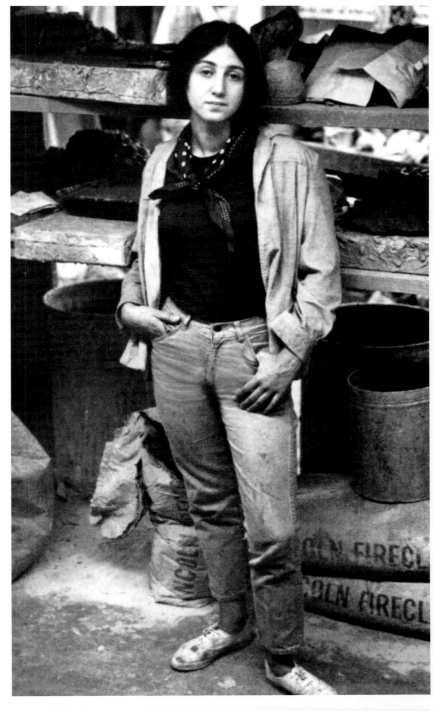

Top: Sybil Yurman at the ceramic studio,
Berkeley University, California, 1964.

Bottom: Raku pottery by Sybil Yurman, 1960s.

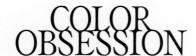

Sybil was always intuitively a colorist. "Painting is the place that gave me peace. I loved exploring, and I loved being seduced by color," she explains. "I could say my home was my first playground to explore art. My father had a library with many books. At a young age, I just thought these were pages that I could, and should, draw on. It was easily accessible to me until I found out I had done something terrible. I thought his library was my canvas."

From her first encounter with Claude Monet's *Water Lilies* at the Museum of Modern Art (MoMA) to her discovery of the Abstract Expressionism scene in New York, she used color to generate a range of emotions. Much like key Abstract Expressionists, Sybil's approach was never purely "abstract" or "nonobjective" in the sense of having no subject matter. Rather, there is a quiet symbolism in her work—often referencing nature and home—that ties it to the reality we all experience.

Not long after Sybil and David met at Hans Van de Bovenkamp's studio, they moved in together, sharing a studio and collaborating on artworks and jewelry. David describes the scene: "I'm welding, and Sybil's painting, and we're having a good time—life is art." Sharing common artistic views, they soon began creating together. Among their first substantial products were necklaces made from Egyptian paste, metal, and beads that Sybil had concocted herself from ancient recipes. These early times of their relationship dictated what each of them brought to the table: Sybil's sense of color and David's innate ability with three-dimensional form. Their willingness to collaborate pushed the boundaries of creativity and redefined the rules of crafting jewelry.

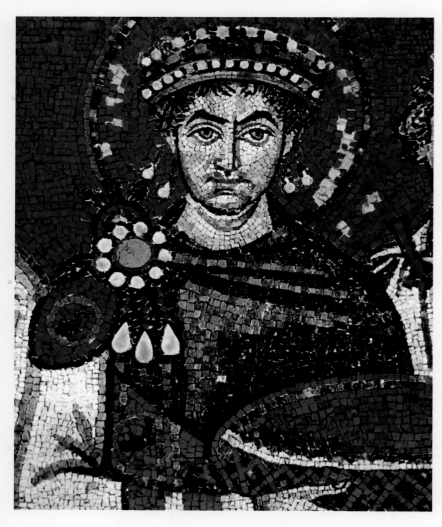

Mosaic of Byzantine Emperor Justinian I (detail), c. 547 CE; Basilica of San Vitale, Ravenna, Italy.

Opposite: Byzantine Mosaic Tesserae, 6th–15th century; Glass, gold, and silver leaf; Dimensions variable; Metropolitan Museum of Art, New York.

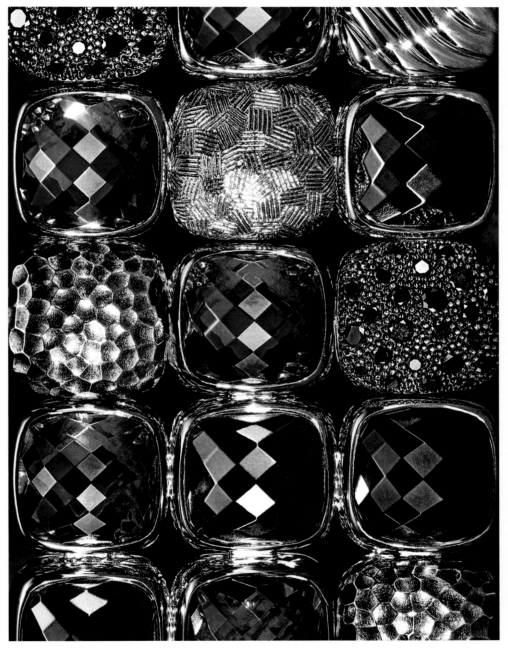

Mosaic of light. 1984

Silver and gold, garnet, black onyx, and pavé-set black diamonds Chiclet bracelet, 2011. Left photographed by Raymond Meier, right by Emil Larsson (detail).

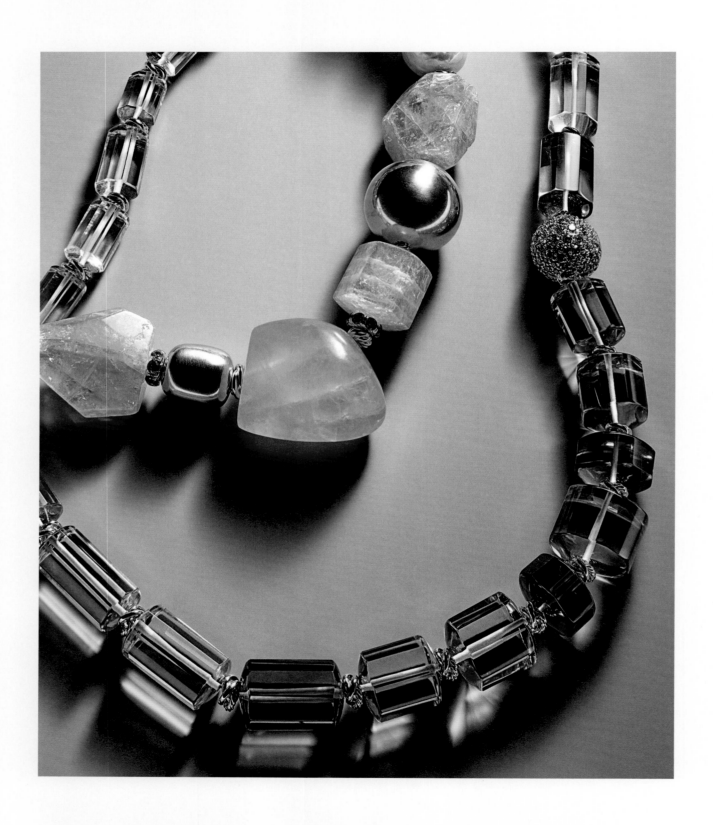

DY Signature necklaces with amethyst, lemon citrine, and praisiolite, 2023.
Photographed by Emil Larsson.

Opposite: 25th Anniversary Mosaic cuff with garnet, pink tourmaline,
peridot, and pavé-set diamonds, 2011. Photographed by Raymond Meier.

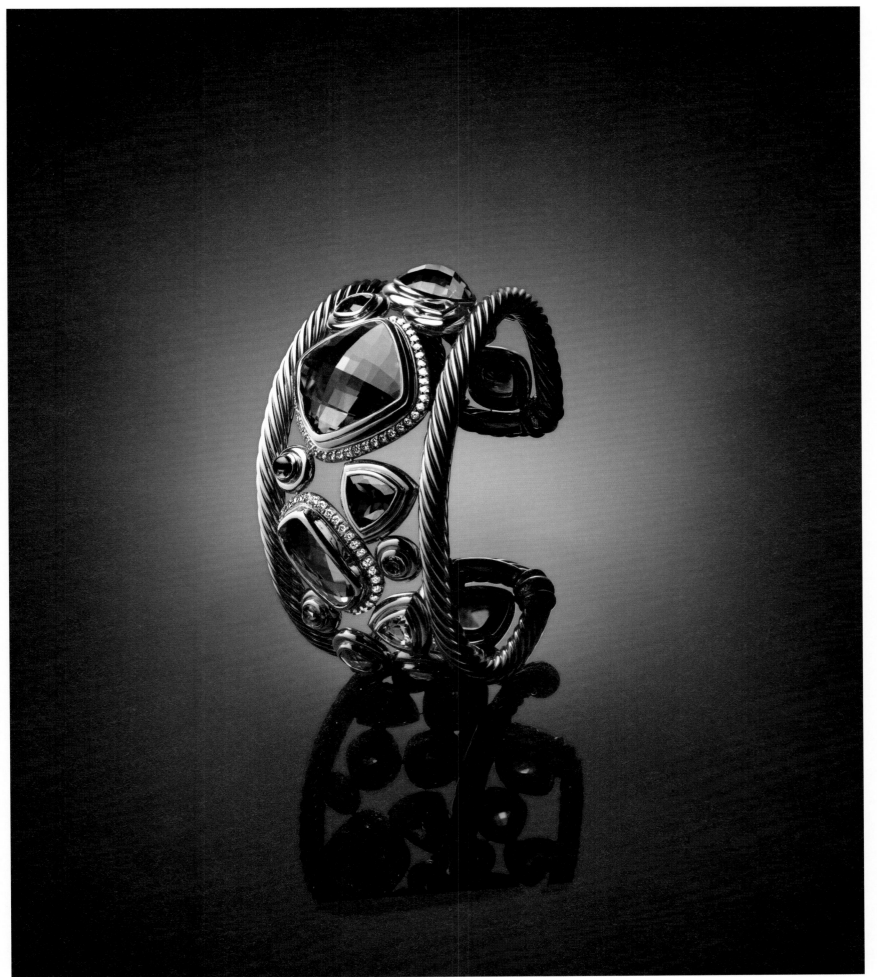

Sybil Yurman
Strata Series VIII, 1990s
Pastel and graphite on handmade paper

Opposite:
Sybil Yurman
Strata Series, 1990s
Pastel and graphite on handmade paper

Made of particles, shards, fragments, and tatters.
Like memory . . .
History scratched, etched, and rubbed.

Sybil Yurman

Museum

Here death proves itself with beauty
And the ancient consent of form
Disguised, the imperceptible drifts
And the return to the pack of disillusion

Murray Kleinrock

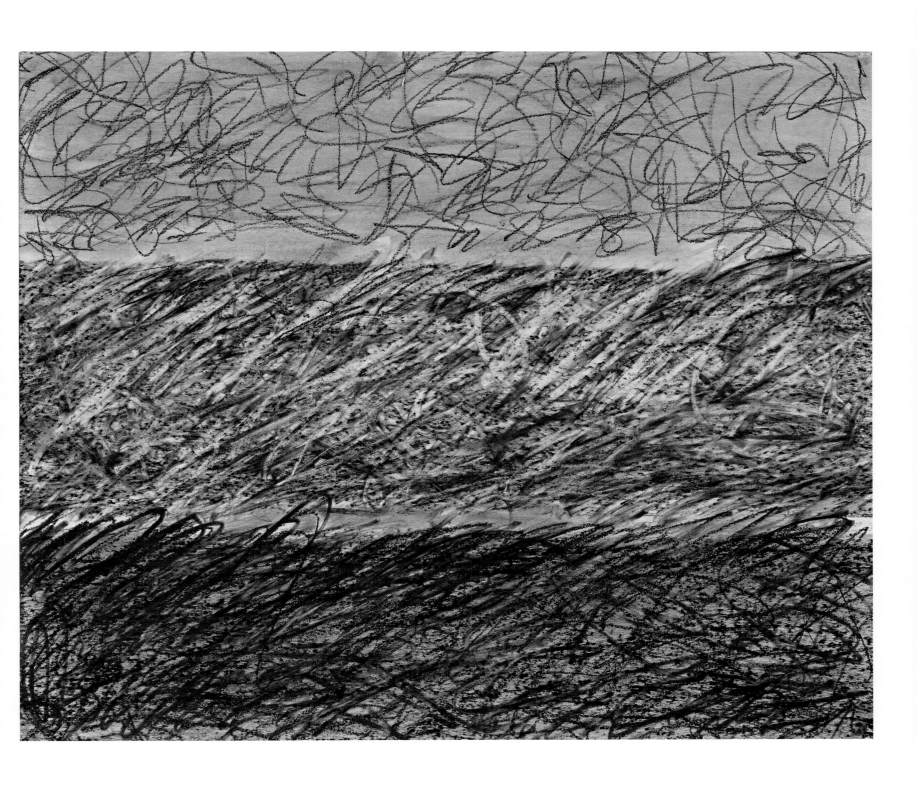

Sybil Yurman
Scribbles, 1976
Graphite rubbing, pastel, and erasers on paper

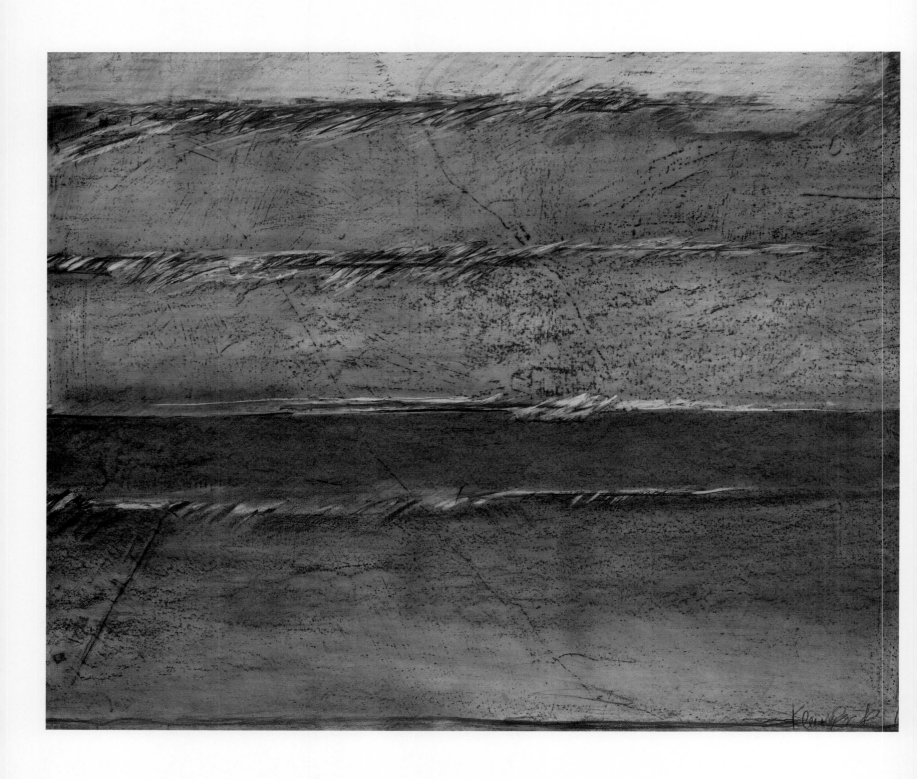

Sybil Yurman
Untitled, 1980
Graphite rubbing, pastel, and erasers on paper

I don't know if I walked on or awoke drifting in the sea
But dark clarities of oceanic light
Fire voyages in my somnolent dreams
Oh desolate surge
Oh shoreward love
Oh single territ isle
Oh destiny

Murray Kleinrock, 1934

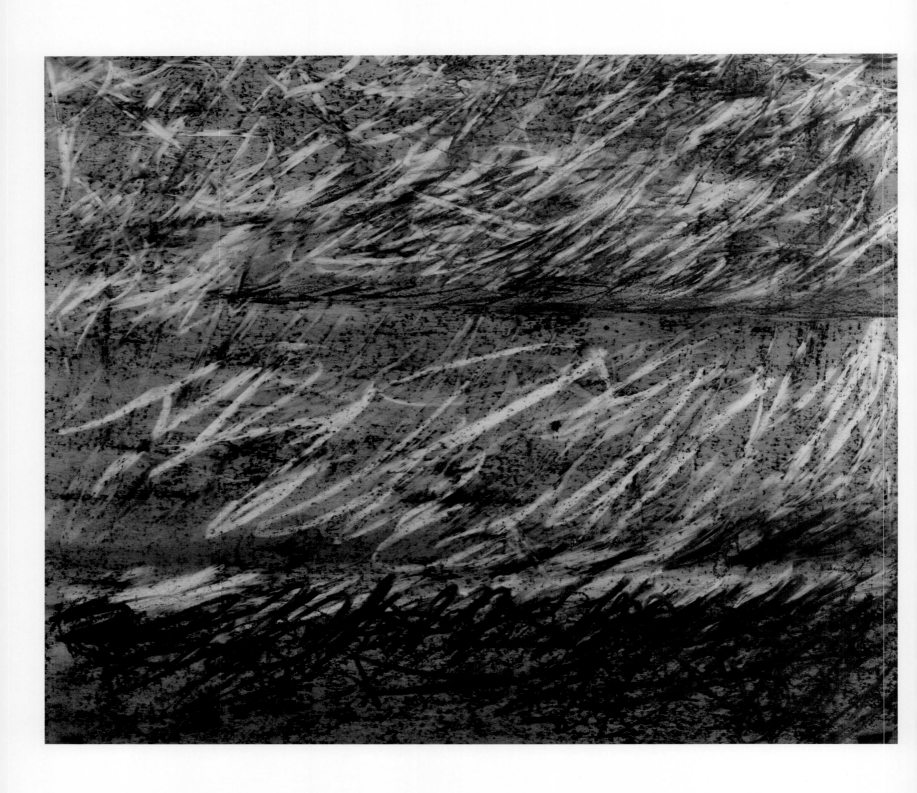

Sybil Yurman
Storm Sky, 1976
Graphite rubbing, pastel, and erasers on paper

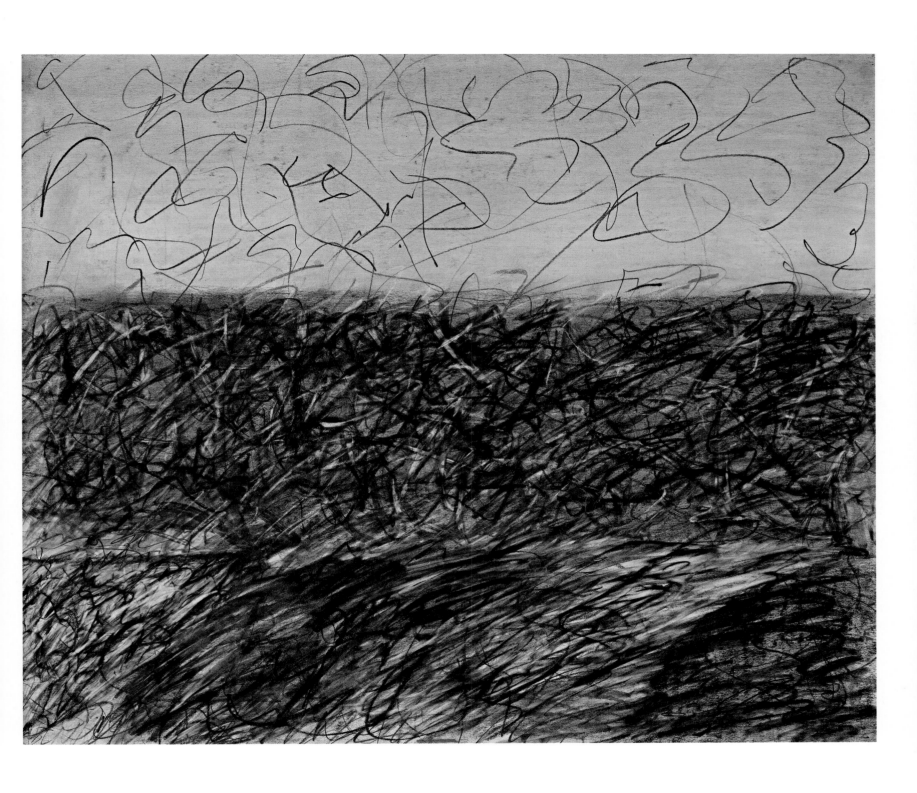

Sybil Yurman
Scribbles II, 1976
Graphite rubbing, pastel, and erasers on paper

Sybil Yurman
Untitled, 1980
Graphite rubbing, pastel, and erasers on paper

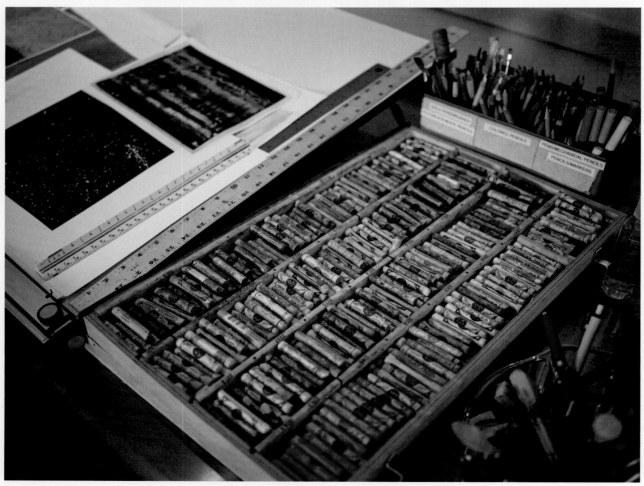

MAKING CHOICES

We spend our whole lives
experiencing our
safety instead of our feelings.

James Joyce

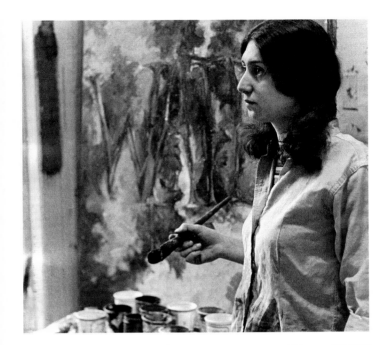

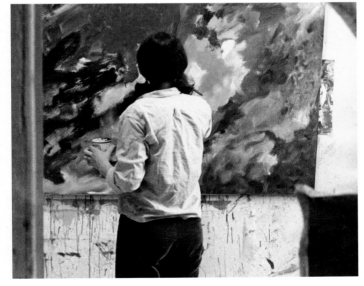

Sybil: I am often asked why the company is named David Yurman and not in both of our names. When we were starting out, the income from my paintings was supporting our fledgling business, and I was selling my art in galleries. The galleries representing me in New York advised not to put my name on a jewelry label, thinking I would appear less serious as an artist. It quickly made me understand that buyers were making calculated investments rather than connecting emotionally with my work, and I was not prepared to make the compromises required.

For many years, David had been making sculptural jewelry, and when the work increasingly consumed him, we started making jewelry together. I was faced with a choice; at the time, women were coming into the art world breaking down barriers, but I questioned whether this was the world in which I wanted to solely pursue my creativity. The success conflicted me. I was exhibiting at the Barbara Gladstone Gallery and in curated shows at the Touchstone Gallery and was doing extremely well, selling all that I showed. But like many artists, I was very attached to my work and hated to see it being treated as a commodity.

A pivotal realization that helped me make my decision to focus on the company: I loved working with David. It was another creative outlet, and I was able to merge our life and work and didn't have to separate those two worlds.

David: For the first five years I was making jewelry, and Sybil was painting and working toward her degree in sociology. When she graduated from the State University of New York (SUNY) at Purchase, she got her BFA, and Roy Neuberger personally invited her to exhibit her paintings in a one-woman show at the Neuberger Museum in Purchase. Sybil was that good. But she was also playing an important role in the business and jewelry design. She was always a wonderful critic and an editor. She didn't want her name attached to jewelry. Having said that, from very early on in *WWD* magazine, we were featured as the new wave of craft, the new wave of young artist jewelers who were a creative duo, and they listed us as Sybil and David Yurman. I guess they knew something long before we did!

Opposite: Sybil Yurman's art studio, New York, 2023.
Photographed by Emil Larsson.

Sybil Yurman in her 25th Street painting studio, New York, 1962.

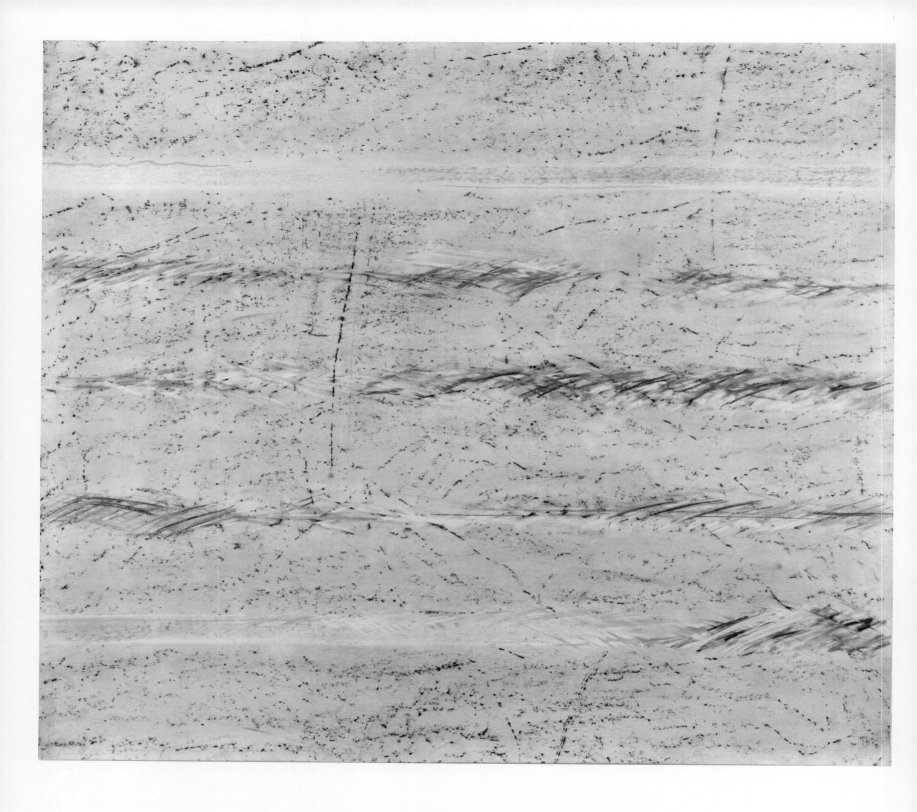

Sybil Yurman
Landscape series, 1979
Pastel, graphite, and erasers on paper
Shown at Touchstone Gallery

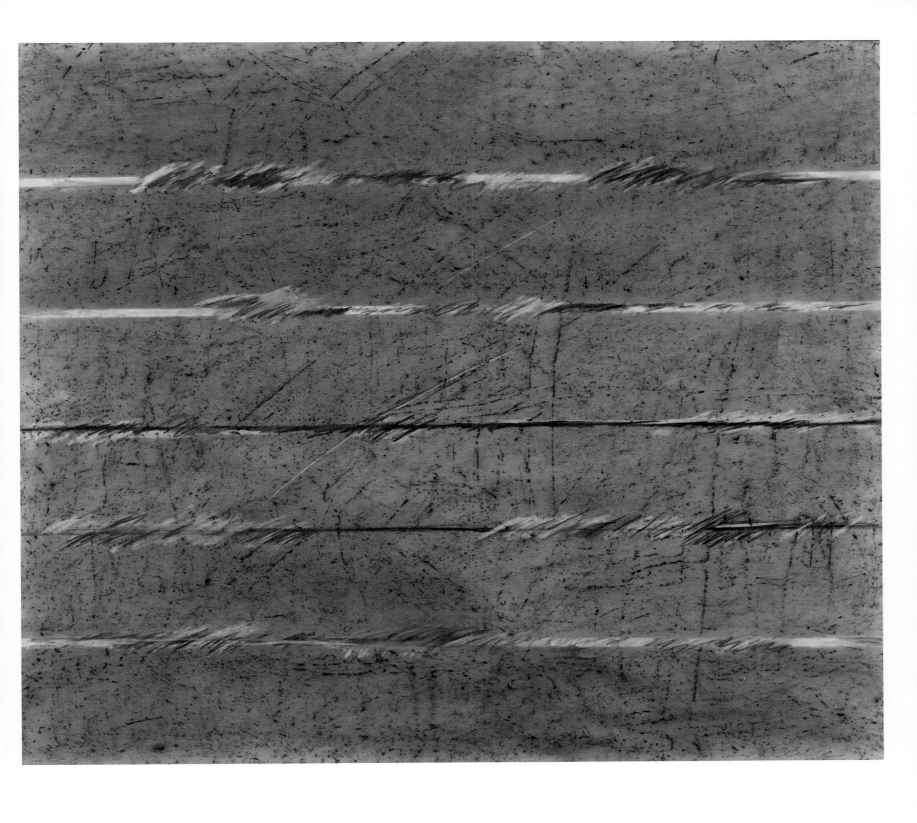

Sybil Yurman
Landscape series, 1979
Pastel, graphite, and erasers on paper
Shown at Touchstone Gallery

Sybil Yurman
Sunlit IV, 2003
Acrylic and graphite on paper

Great plow in the air
I knew the demand
That it could set me against this brave and silent wall
And risk nothing for itself
Except an endless march to the horizon
A dream stamping in the throat

Murray Kleinrock

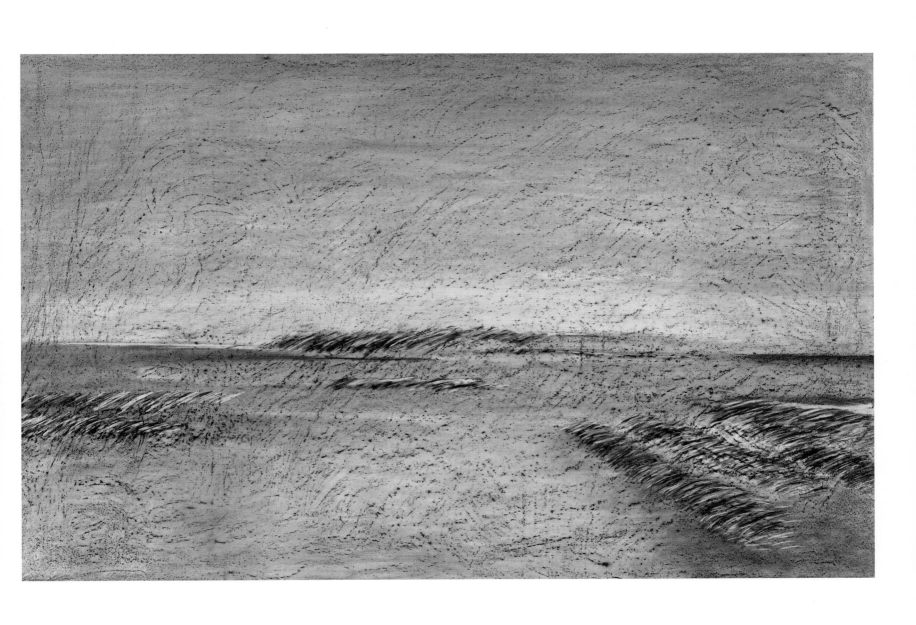

Sybil Yurman
Landscape, 1977
Pastel, graphite, and erasers on paper

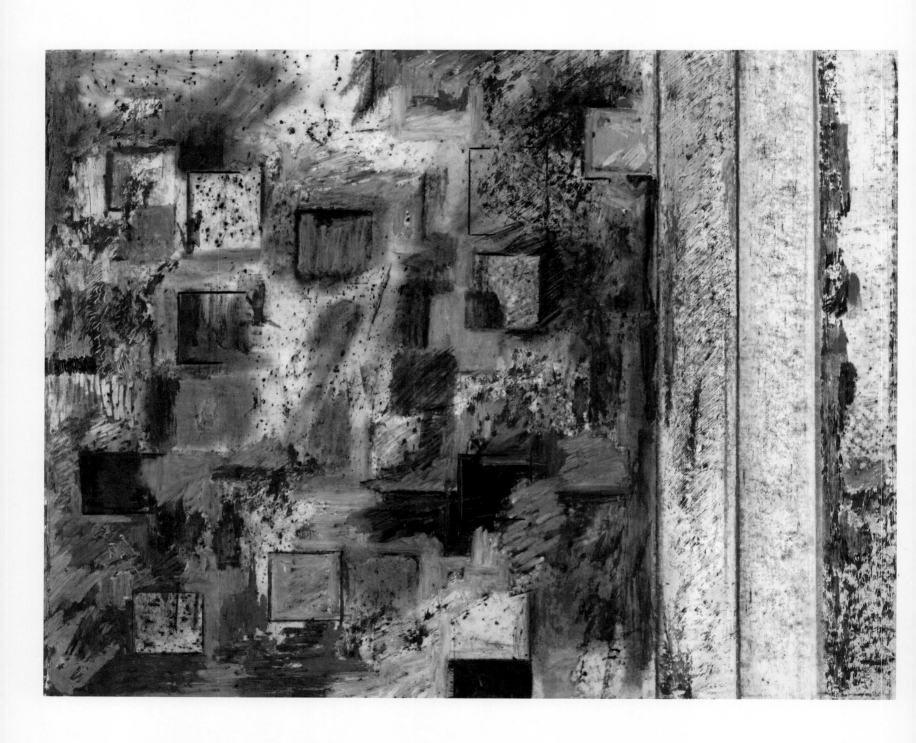

Sybil Yurman
Untitled, 1972
Graphite rubbing and pastel on paper

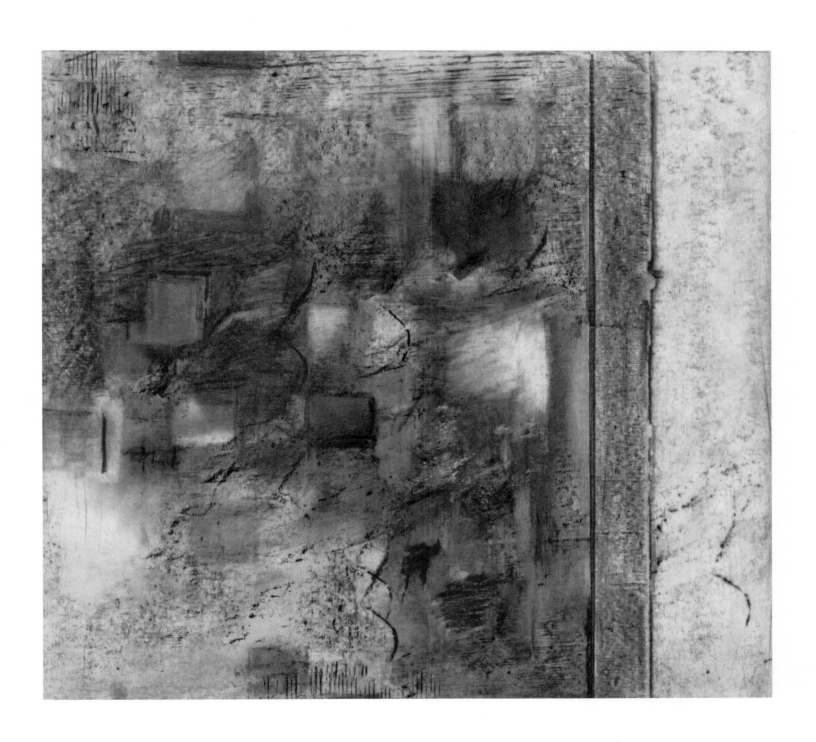

Sybil Yurman
Untitled, 1972
Graphite rubbing and pastel on paper

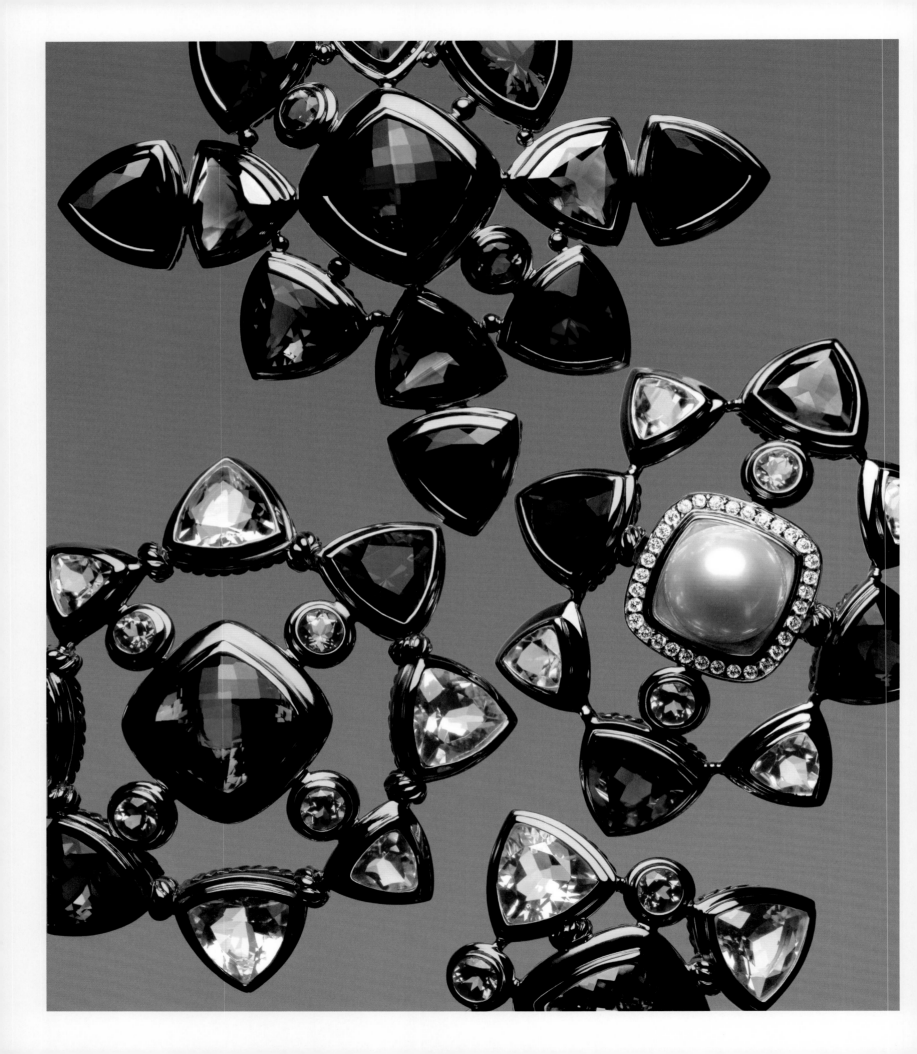

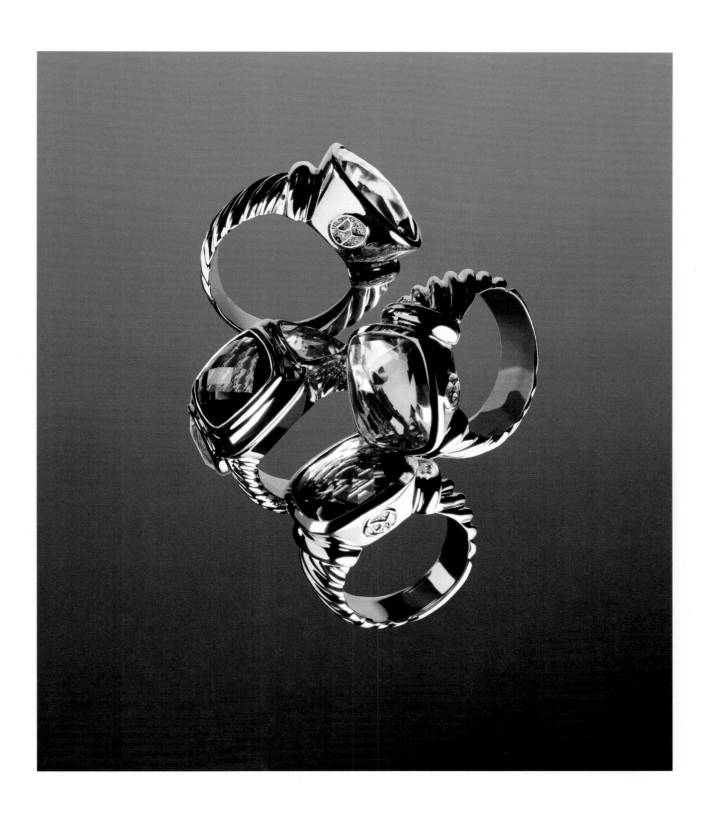

Opposite: Renaissance brooches with gemstones and pavé-set diamonds, 2004.

Clockwise from top: Silver and gold lemon citrine ring; gold citrine Noblesse ring; gold amethyst Noblesse ring; gold with smoky quartz and citrine Renaissance ring, 2005. Both photographed by Richard Burbridge.

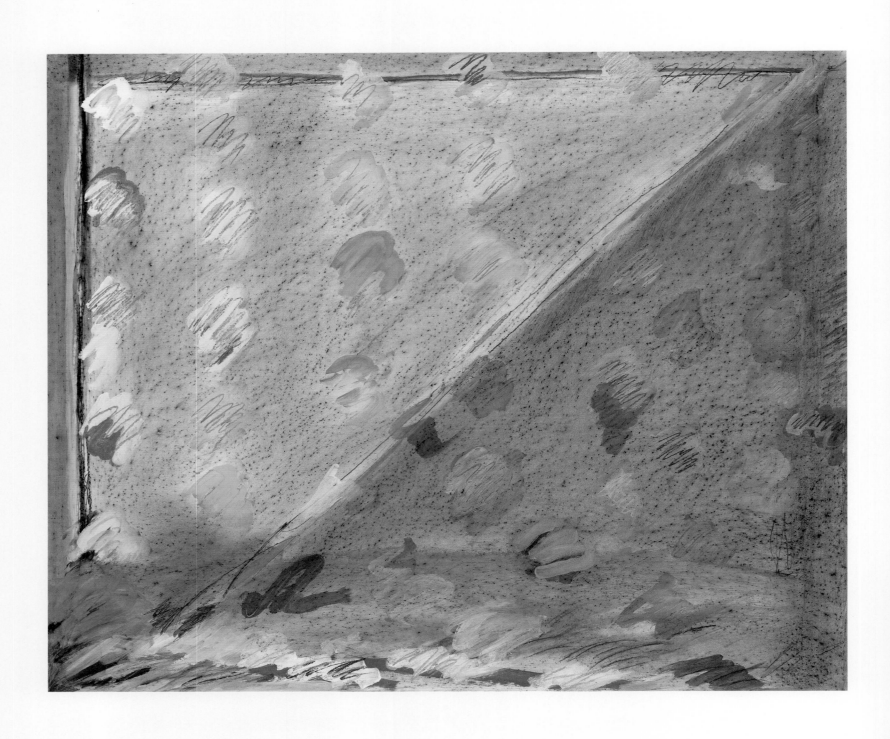

Sybil Yurman
Diagonal in Darkness, 1984
Pastel, graphite, and acrylic on paper
Amagansett, New York

Sybil Yurman
Sunlit Series, 2023
Oil on canvas

A word does not exist that expresses feelings.

Murray Kleinrock

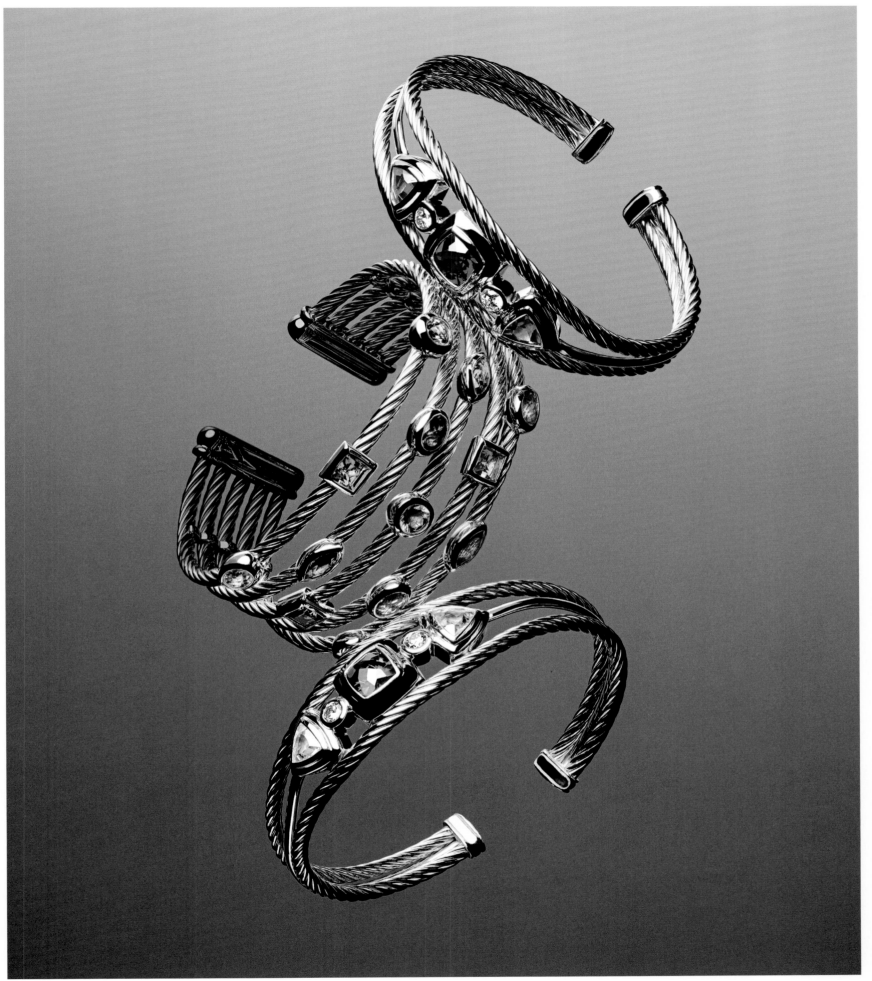

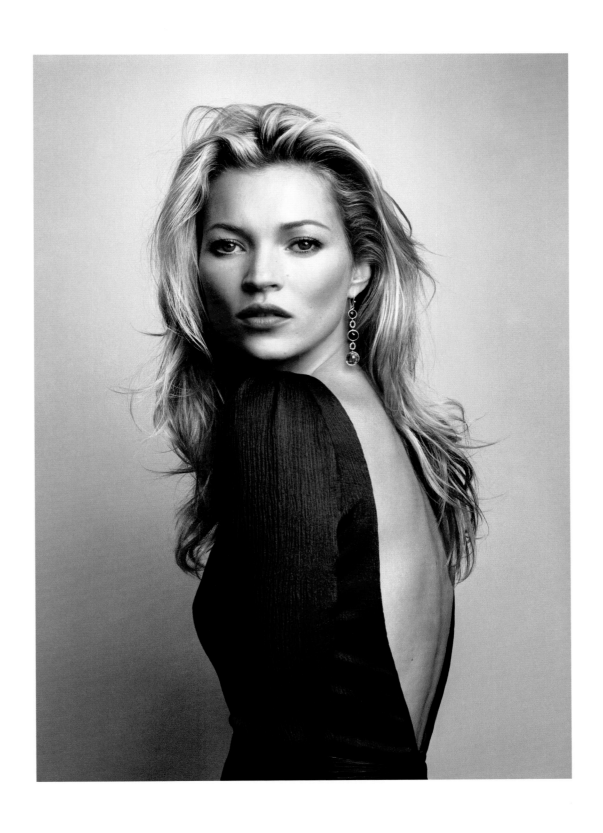

Opposite: Renaissance chandelier earrings in garnet, 2015.
Photographed by Nathan Copan.

Kate Moss wearing gold Chatelaine linear earrings with
gemstones, unique piece, W magazine cover, March 2006.
Photographed by Craig McDean.

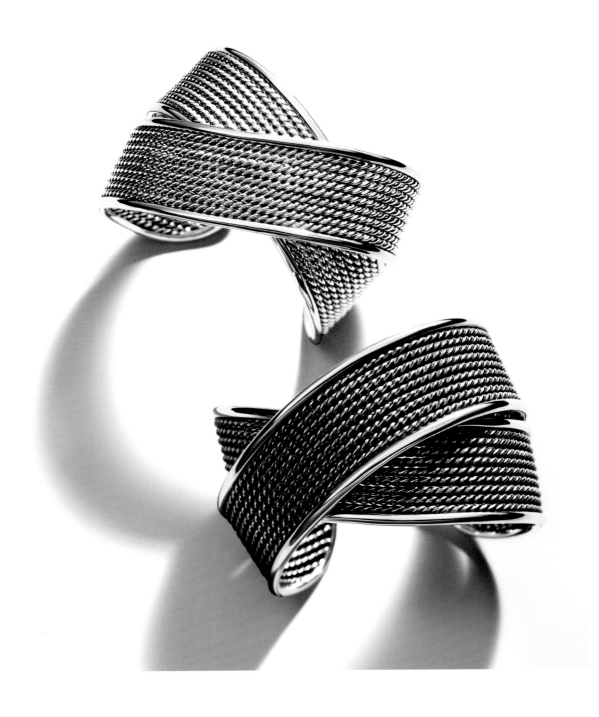

Opposite:
Sybil Yurman
X *Series*, 1981
Rubbings, graphite, erasers, and oil on paper

Origami cuff bracelets, in silver and yellow
gold, 2019. Photographed by Emil Larsson.

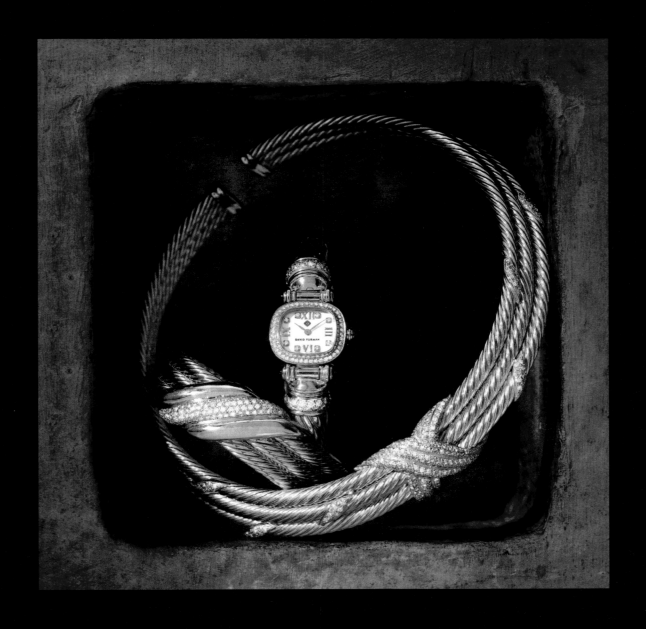

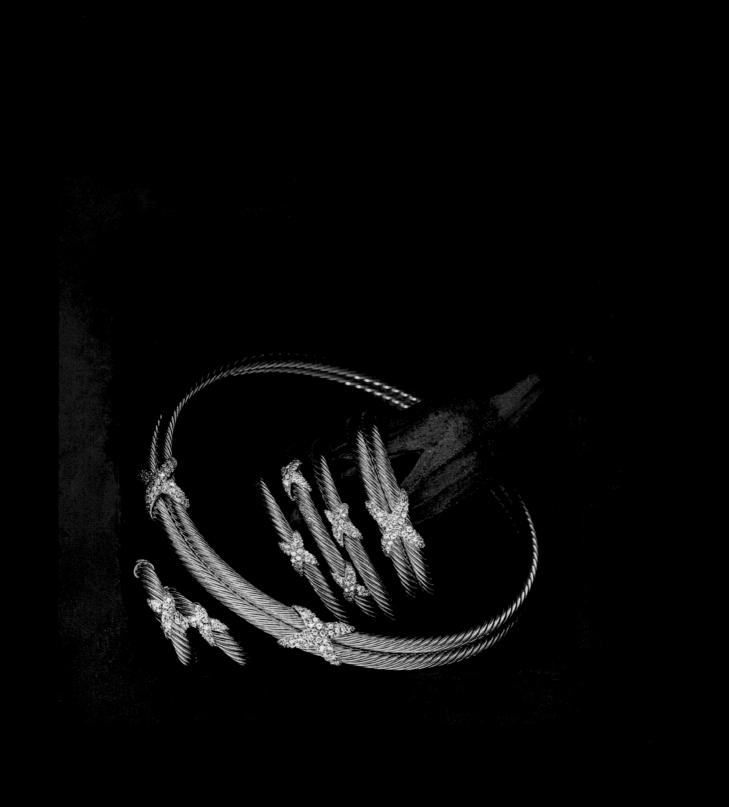

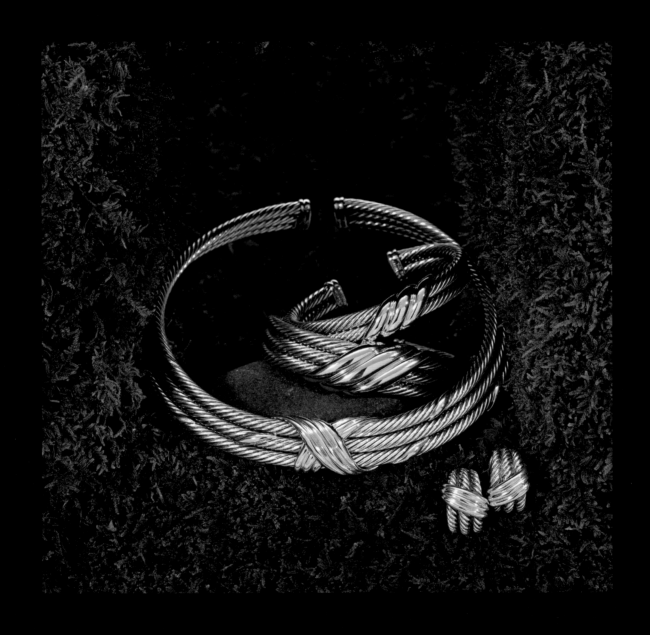

Page 108: Still Life advertising campaign hand-painted shadowbox with silver and gold cuff bracelet, color necklace, drop earrings, and ring from the X Collection, 1996.

Page 109: Still Life advertising campaign, hand-painted shadowbox with gold Cable timepiece with pavé-set diamonds, Cable watch, collar necklace, and cuff bracelet from the X and Waves Collections, 1996.

Page 110: Still Life advertising campaign, hand-painted shadowbox with the X Collection, 1998.

Page 111: Still Life advertising campaign, hand-painted shadowbox with the X and Waves Collections, 1996. All photographed by Lisa Charles Watson.

Opposite: Sybil Yurman, X Series, 1993, Oil on canvas.

SKY MARKINGS

Sybil calls a collection of her paintings *Sky Markings*. "I did most of these in Amagansett and Martha's Vineyard, where I would spend afternoons in open fields, or at the beach just looking at the sky and painting little clouds and sky markings. I used graphite rubbings layered with soft-colored pastels and acrylics."

When asked about her use of color, Sybil explains, "It's just how you feel, the tone of what you relate to emotionally. Everything in the *Sky Markings* series is about softness and sensuality—about notation. There was nothing harsh about that environment, no bright reds or blacks. It was very calming and melodic and brought me back to that moment at the MoMA surrounded by the sky and water of Monet's *Water Lilies*. I am touched by colors in the world, and the palette depends on how I feel emotionally.

"Early on, a pivotal moment for me in combining art and commerce came when a buyer visited our tiny little office to purchase jewelry for her shop. She saw a painting on the wall and asked me if it was for sale and how much. I explained it was mine. She said, 'If I could wear it and add luster to my star, I would spend that kind of money!' I realized she wasn't an art collector but loved the colors in the painting. I wanted to see if I could embody those same colors and mood in a piece of jewelry. David and I worked on a necklace together and thought we made a piece that reflected what I did as an artist in my studio. When she came in next, I slipped the new necklace in with the other jewelry, and she said, 'Oh my God! What's that?' I told her it was a 'crossover' piece because it was about crossing over from art. She paid twice as much as the price I quoted for the painting. It was an 'aha moment' for me when I realized I could express myself by bringing the feeling and vibrancy of a painting into jewelry."

Sybil Yurman
Sky Markings, 1978
Oil and oil sticks on canvas
Amagansett, New York

Sybil Yurman in her studio wearing David Yurman's belt
and buckle, Purchase, New York, December 1975.

Sybil Yurman
Cantata, 1978
Oil and oil sticks on canvas

On the fiftieth anniversary of Jack Kerouac's *On the Road*, Sybil Yurman—megajeweler David Yurman's other half—recalls her beatnik days with rebel writers Allen Ginsberg, Lawrence Ferlinghetti, and Jack Kerouac.

Before Sybil Yurman became the queen of a jewelry company that is beloved by everyone from Gwyneth Paltrow to Barbra Streisand, she was a teenage runaway. In 1957, the Bronx-born fifteen-year-old Sybil Kleinrock—then a fierce-hearted rebel with a forest of long, curly black hair, a passion for Rimbaud, and a hatred of tyranny—got in trouble for fighting with a bully who'd been "terrorizing" her friends and decided she'd had enough of school and her parents. She packed a bag and ran off in search of a better life in Greenwich Village.

In the Village, the teenaged Sybil went to work in a coffee shop, fell in with a French woman named Joelle, who introduced her to the music of Edith Piaf, and soon enough found herself hanging out with Allen Ginsberg, Peter Orlovsky, and other members of the burgeoning Beat movement on the Lower East Side. "Everyone knew Ginsberg was a genius, but nobody talked about it," says the now soft-spoken, butterscotch-blonde sixty-five-year-old who lives in a palatial Zen-style loft in Tribeca with her husband, jewelry-designing mogul David Yurman. "You have to remember, everything was about 'being cool,'" she adds, raising a manicured finger, "and that meant not acting impressed by fame or success."

Instead, Yurman says, the Beats sought their own "inner visions." This meant two things: 1) reading William Blake and 2) taking large quantities of drugs. "The idea was to use drugs as a way of getting in touch with yourself. You were genuinely trying to find out more about who you were," says Yurman, who likes to talk earnestly about inner voices and visions but whose eyes gleam with a shrewd, sober intelligence as she does so. If one can still call her a bohemian, it is of the Donna Karan–esque, enlightenment-in-East-Hampton variety. Her days of psychedelic exploration have long since given way to private yoga and walks on Georgica Beach. "I realized that I really needed to do things my own way," she says, "according to my own instincts." Camped out in an apartment on Bleecker Street full of jazz musicians and marijuana smoke, she wore black turtlenecks and refused to straighten her hair in the fashion of the era. "You could buy mescaline capsules for thirty-five cents in a coffee shop in the East Village," says Yurman, who stayed up drawing late into the night and soon was dancing with Ginsberg and company at nightclubs on St. Mark's Place. Yurman says wryly, "Ginsberg was more about the celebration of dance than the actual skill."

In 1958, Sybil headed west. She had had an inner vision of swimming in the ocean in California at sunset (accompanied by a dream of finding "kind, gentle, accepting people" with whom she could live) and—in the way that people did back then—decided to follow it. "Also," she adds with a good-natured frown, "there was a man named Gerry I had a crush on who'd moved there." In San Francisco, her first stop was the unofficial Beat headquarters: the City Lights bookstore founded by poet Lawrence Ferlinghetti, who had published Ginsberg's Beat masterpiece "Howl" in 1956. "Gerry had said, 'Just go to City Lights and leave a message with Ferlinghetti that you're looking for me. So I went, and sure enough, a few days later, Gerry got in touch with me and said he'd found a place for me to live." The "place" was one of the key Beat clubhouses in

BY KIMBERLY CUTTER
HARPER'S BAZAAR, NOVEMBER 2007

Days of dancing are good days. why not live for fun + joy 1968

This page and opposite: Sybil Yurman, New York, 1968.

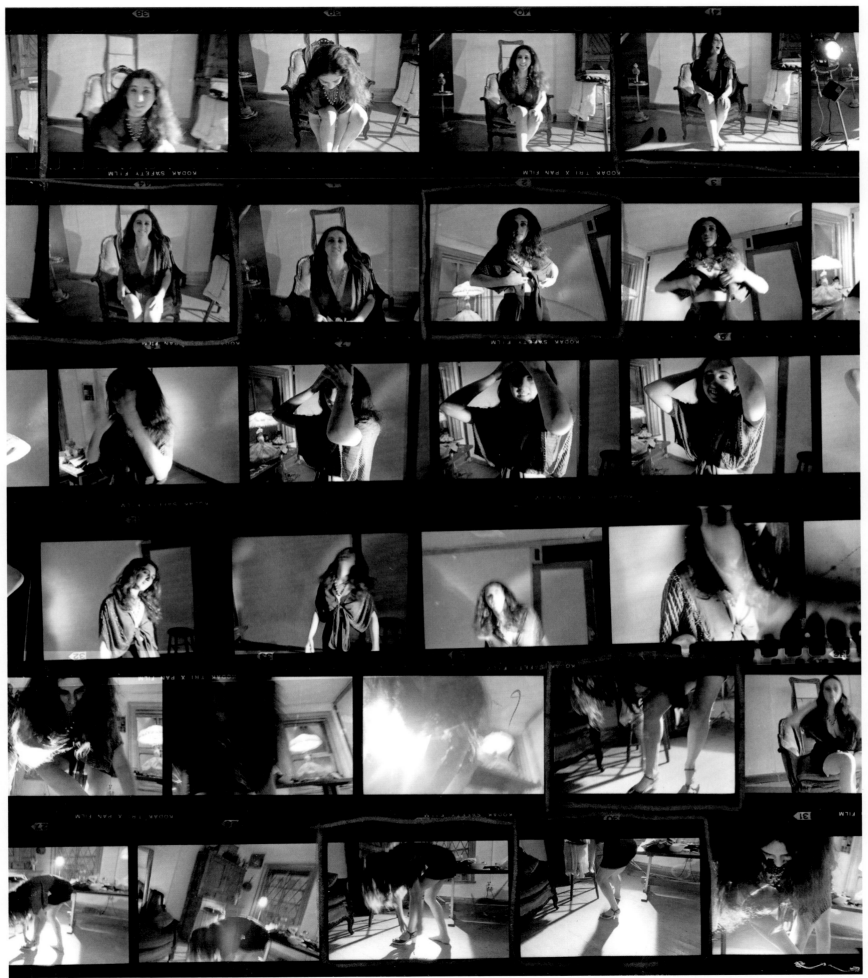

San Francisco—a big old Victorian communal home in Japantown known as the Hyphen House, where a motley crew of artists, Zen students, and poets such as Lew Welch, Philip Whalen, and Lenore Kandel lived. Kandel (who later turned up as the sexy Romana Swartz in Kerouac's novel *Big Sur*) was the resident nudist. "She was always walking around the house in little purple lace underwear and nothing else," says Yurman. "That was just her. She loved life."

Unbeknownst to Sybil, Kerouac was also staying there at the time. "I'll never forget, on my first day there, they were showing me around the house and there was a man lying on the floor, face down," says Yurman. "I said, 'Who's that?' and the man who was showing me around said, 'That's Jack Kerouac. Whatever you do, don't wake him up.'" *On the Road*, Kerouac's ecstatic cross-country journey of self-discovery (now known as the Beat Bible), had come out a year earlier, and Yurman describes him as the writer "everyone read." But she found him to be a "sad presence." "Success hadn't been good for him," she says. "He drank a lot and often seemed unhappy, but at the same time, there was an openness to him. Whenever people were talking, he listened really intently, and sometimes, when he'd been drinking, he'd become very animated and funny."

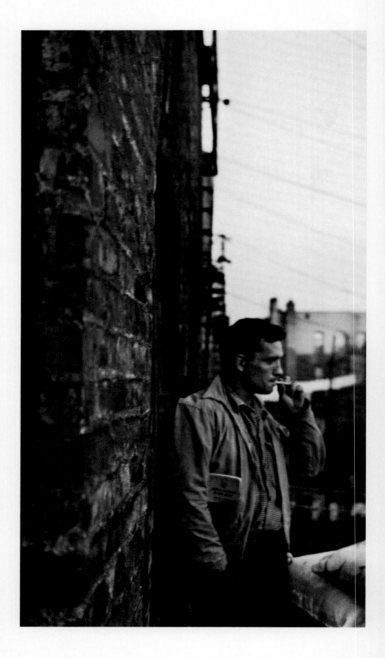

> Ah, life is a gate, a way, a path
> to Paradise anyway, why
> not live for fun and joy and love
> or some sort of girl by a
> fireside, why not go to your
> desire and laugh.
>
> Jack Kerouac

Eventually, Kerouac and crew inspired Sybil to try her hand at drinking too. "Everyone drank when Kerouac was there," she says. "They sat around the kitchen table, drinking and taking Dexedrine and talking about Rimbaud and Blake, so one day, I thought, okay, I want to see what this is all about." Kerouac handed Sybil a glass of vodka. Three glasses later, she was doubled over in the bathroom. "That was it," says Yurman. "I never really drank again."

Consciousness-raising excursions, however, were a favorite activity of hers. "People would drop in and drink and talk and then decide that we all had to go somewhere. We all had to get outside. So we'd get in the car and go to Stinson Beach or Half Moon Bay or Lake Mead and watch the sunset or go swimming. It was a lot about being connected to nature and connected to your body, about finding out what was true for you and saying things that were true and having an authentic reason for doing the things you did. Buddhism was just starting to catch on then, and there were lots of trips to the Zen temple on Bush Street. There were never any plans," says Yurman, who honed her painting skills during this time. "Things just happened."

Jack Kerouac photographed by Allen Ginsberg, Lower East Side, New York, 1953.

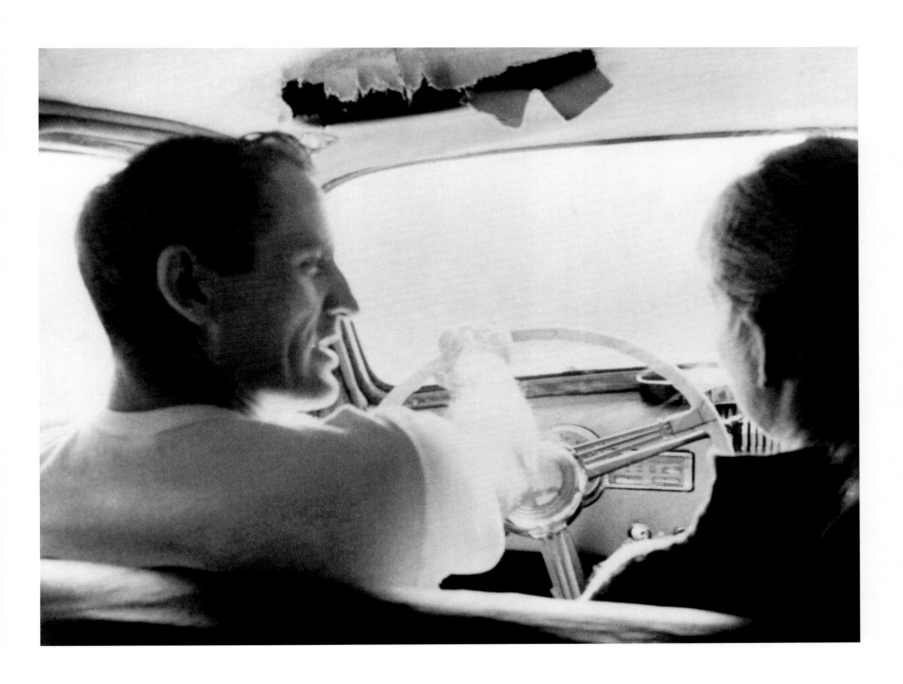

Neal Cassady, the inspiration for Dean Moriarty in Jack Kerouac's
novel *On the Road*, photographed by Allen Ginsberg, c. 1963.

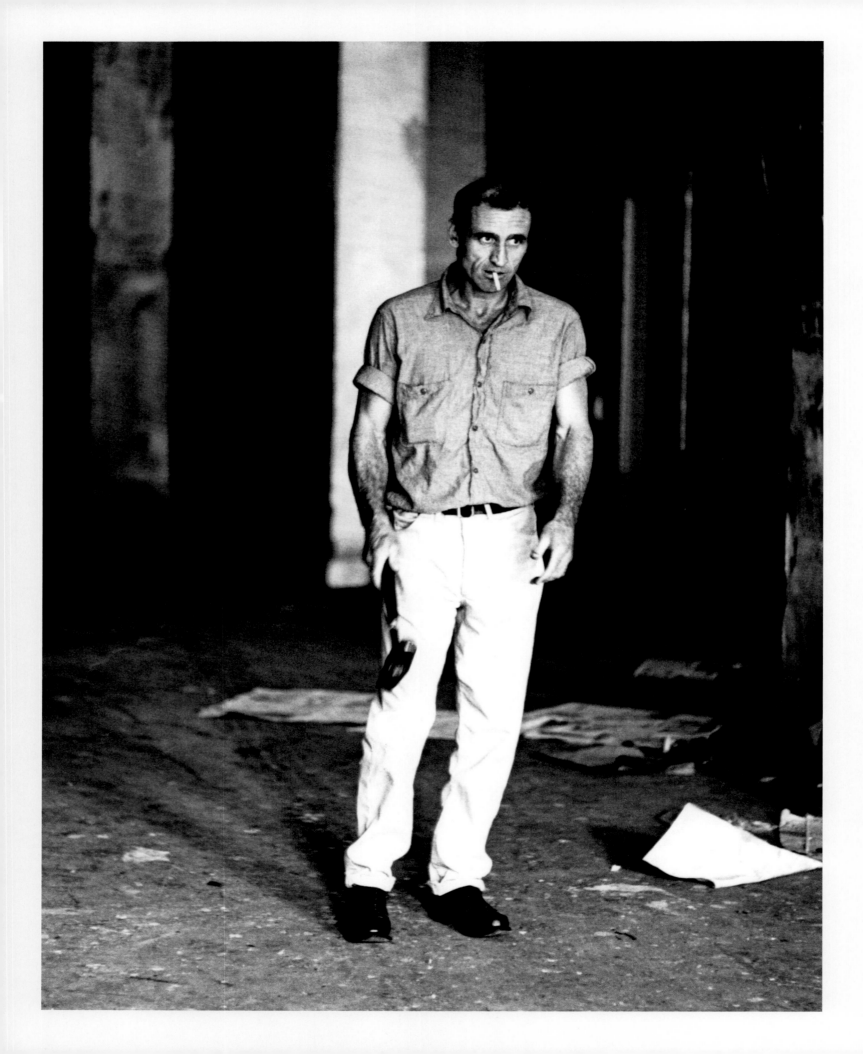

One happening Yurman hasn't forgotten: the day Neal Cassady, the manic wild man whose romantic adventures, petty thievery, and passion for life Kerouac immortalized in *On the Road*, dropped in, looking for pots. "He was very intense, full of energy, a really sensual kind of guy," says Yurman. "One day he came into the house and said he needed some big cooking pots. When he was done collecting them, he asked me if we needed anything in the house. I said we could use some chairs, and a couple of hours later, he came back with chairs. To be honest, I was a little wary of him," says Yurman. "Then one day he was gone, and the talk was that he'd been taken off to jail on a marijuana charge."

> Great things are not
> accomplished by those who
> yield to trends and fads
> and popular opinion.
>
> Jack Kerouac

Sybil was headed in a different direction. She continued painting, but while many of her companions' lives unraveled, hers became increasingly stable. Several years later in New York, she met David, and a few years after that, a gallery owner admired a necklace David had made for her and asked if he could make more. "David said, 'No,' and I said, 'Yes!' and the rest is history." But it's the time she spent with the Beats that Yurman holds responsible for her success. "That time was about learning to rely on my instincts," says Yurman. "We did everything for the love of doing it. We never strategized about how to be successful. We just did what we loved, and the rest came to us."

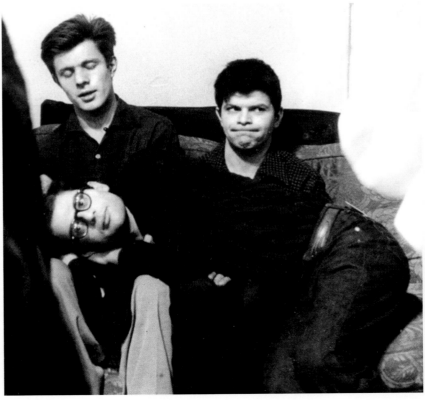

Opposite: Neal Cassady, San Francisco, 1966.

American Beat poet Allen Ginsberg rests across the laps of poets Peter Orlovsky and Gregory Corso, 1959.

The last road went through me long ago
A sea bird went down for an upward look
And took the pains I always took
For passing light

Murray Kleinrock

Opposite:
Sybil Yurman
Untitled, 2023
Gold leaf and oils on grit paper

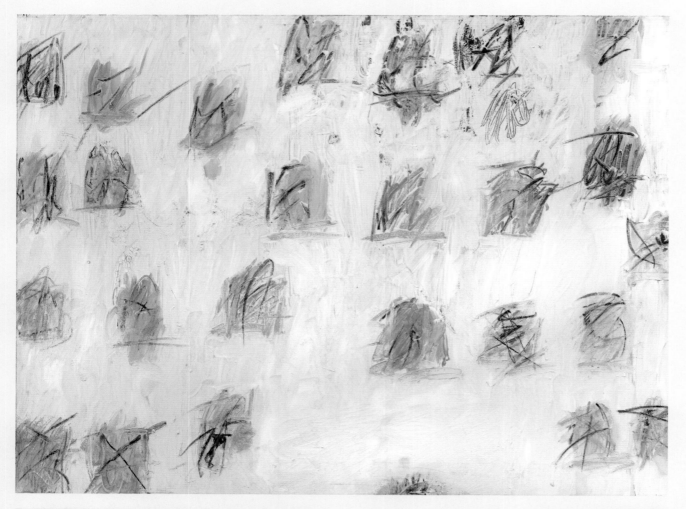

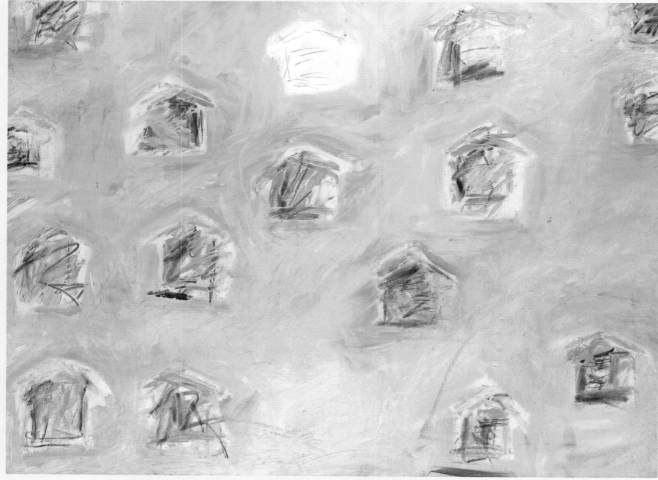

Top:
Sybil Yurman
White Houses, 1992
Oil on canvas

Bottom:
Sybil Yurman
Yellow Houses, 1992
Oil on canvas

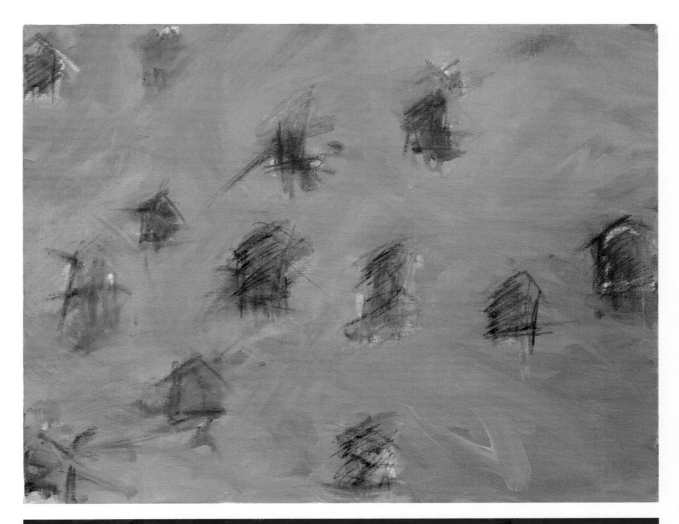

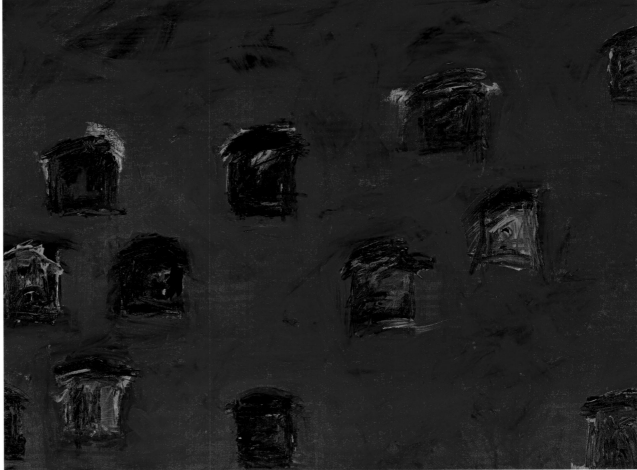

Top:
Sybil Yurman
Blue Houses, 1992
Oil on canvas

Bottom:
Sybil Yurman
Red Houses, 1992
Oil on canvas

Sybil's — intelligence, her intuitions,
her spontaneity, her being in the moment....
creating for herself through every line
and shape and shade of color.. defines
the moment ... a surprise even to herself.
Reveals its beauty and joy... Needless
to say she paints for her self. for her own
Discovery ...that now we can all share in

David

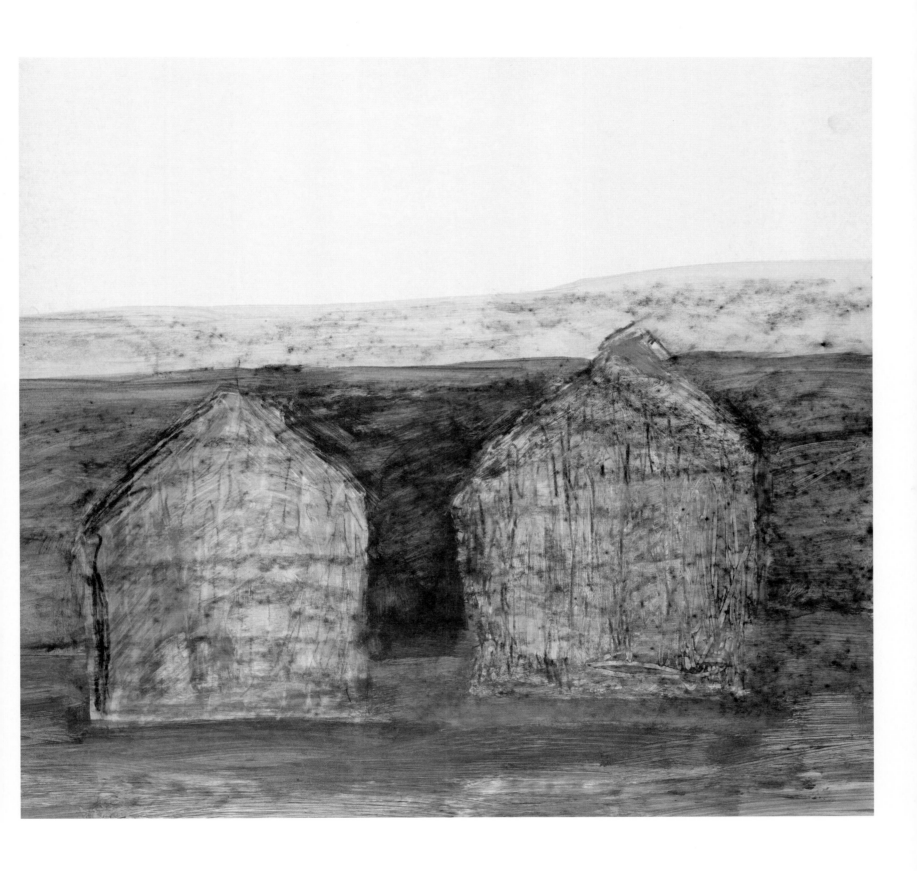

Sybil Yurman
House Series, 2024
Graphite on paper

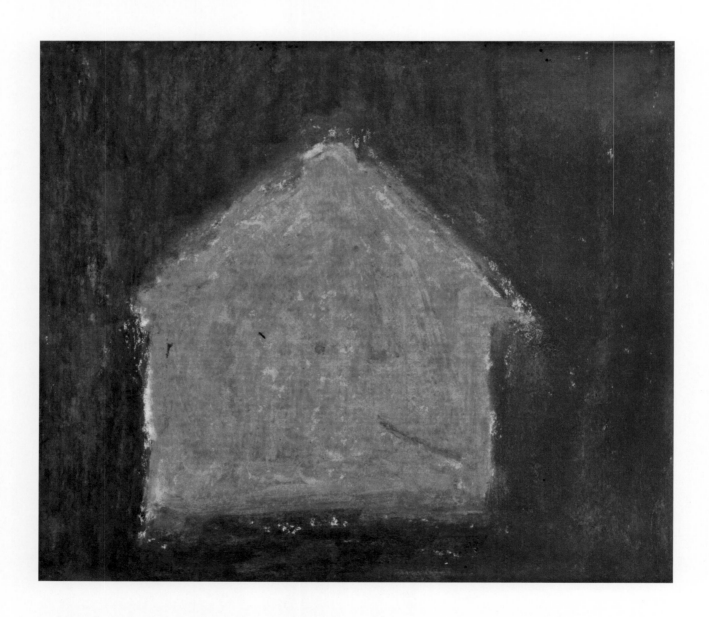

Sybil Yurman
House Series, 2019
Oil on paper

Opposite:
Sybil Yurman
House Series, 2023
Oil on paper

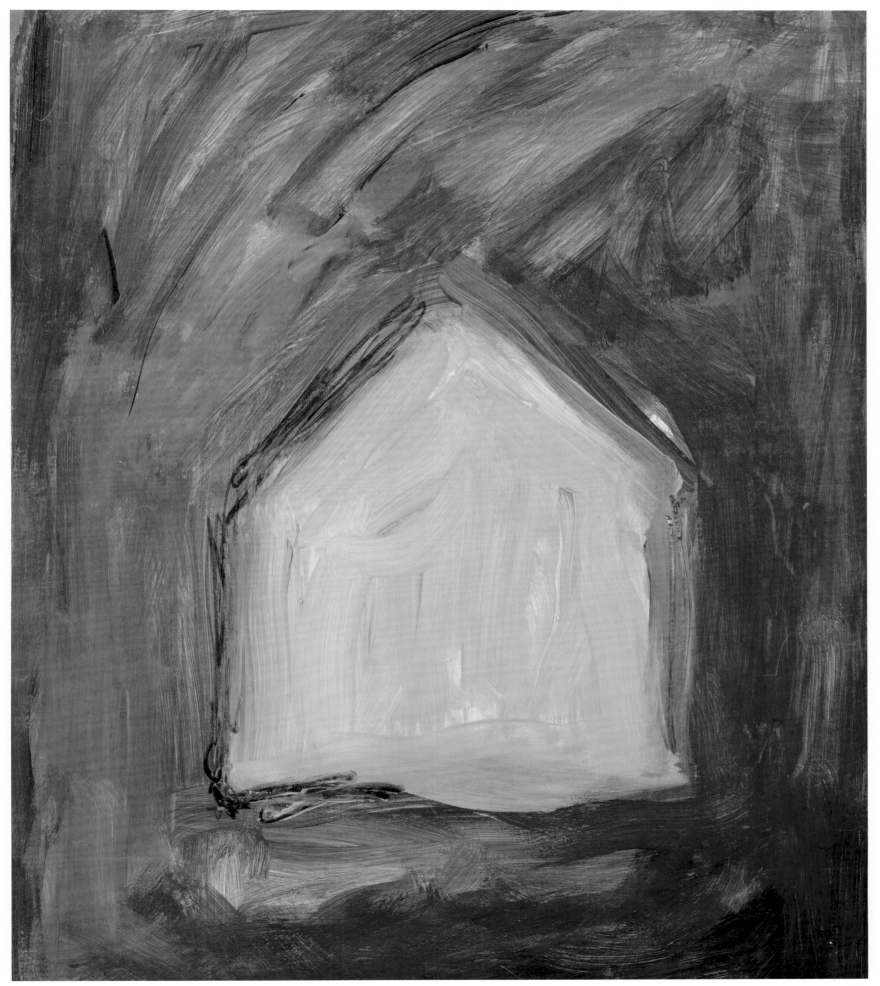

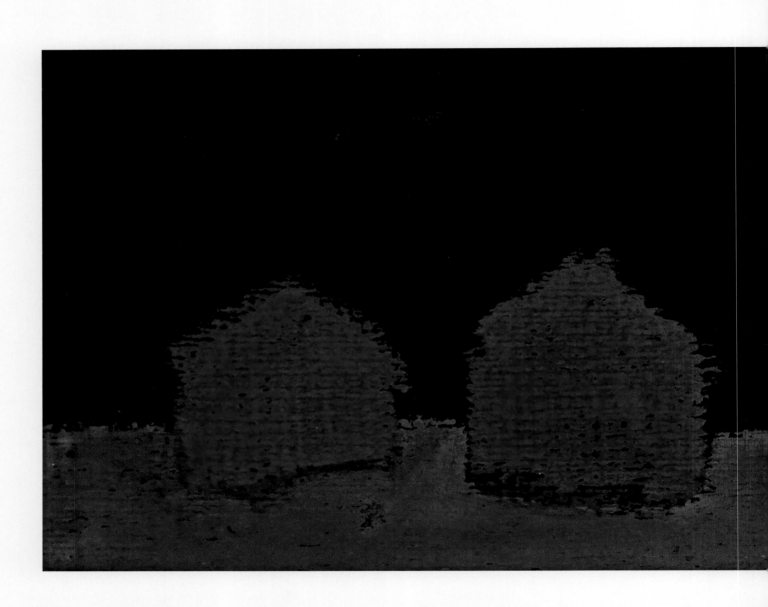

Sybil Yurman
Red Houses in a Row, 2011
Pastel on black paper

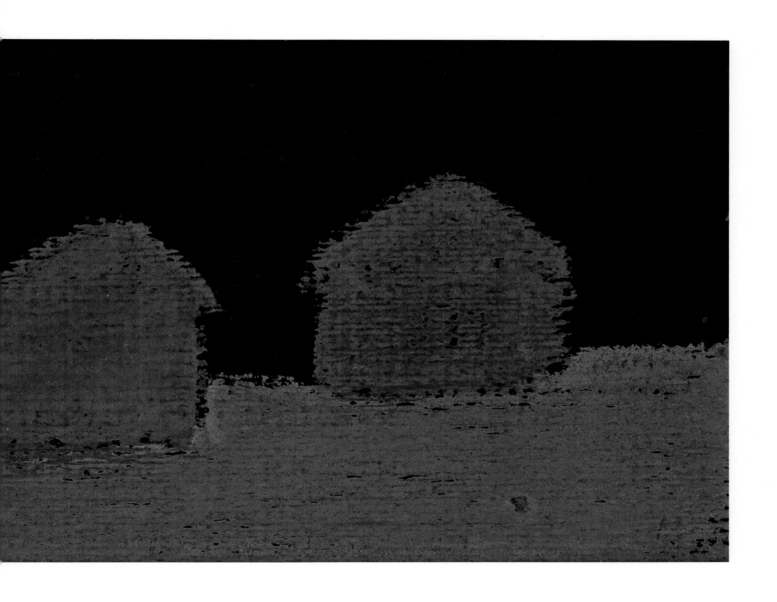

Sybil Yurman
Night Series I, 1991
Pastel and graphite on pumice paper
St. Barts

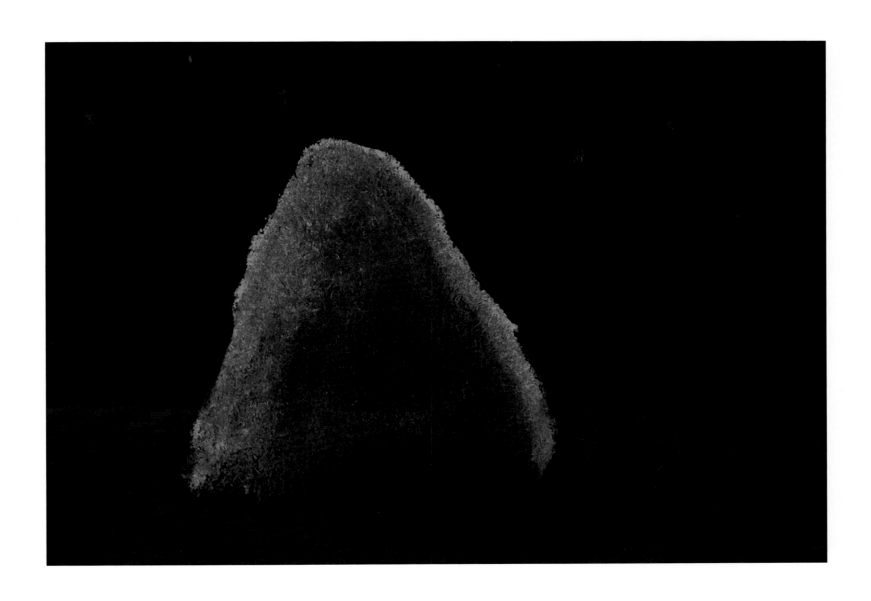

Sybil Yurman
Night Series 23, 2023
Pastel and graphite on pumice paper

At my desk with my Dad watching

Sybil Yurman in her New York office with
a photograph of her father looking over her,
2023. Photographed by Norman Jean Roy.

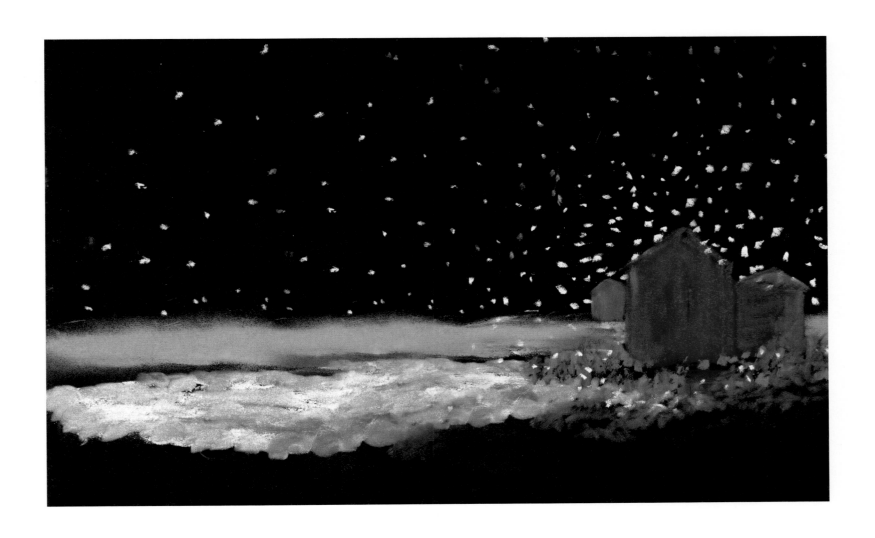

Sybil Yurman
Houses in Snow, 2012
Pastel on pumice paper

Sybil Yurman
Evergreens in Desert, 2018
Pastel and graphite on paper

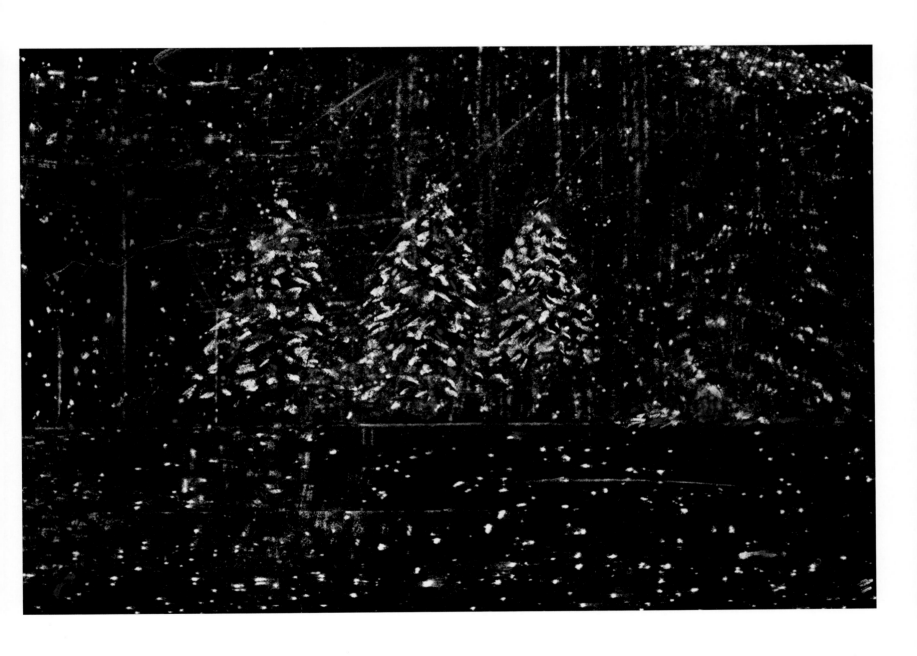

Sybil Yurman
Night Snow, 2023
Pastels on pumice paper

Many ideas are rooted in passion, emotion, and sometimes romance. The place was Paris, the City of Light, and the event was the opening of David Yurman's first Parisian store. "Paris during the day is beautiful, but Paris at night is spectacular. . . . It's about dreams. It's about contrast: blacks and whites, darks and lights," David muses as he remembers the first moments of inspiration for the Starburst Collection. "Sybil and I are intimately touched by the night sky and the constellations. She always gets teary when she watches fireworks or hears bagpipes playing! Our hotel room faced the Tuileries Garden, and from the balcony we could see spectacular fireworks over the Eiffel Tower. Starburst captures those exciting bursts of golden and white light, making this collection a magical moment in time and a celebration of light."

Sybil further explains, "Sculpture is about a transformation of materials as they are worked." In 1982, the thin rods David melted for his sculptures inspired him to bundle strands of gold, accented with diamonds, creating the first Celestial Collection—Starlight. The random pavé settings transformed the diamonds into a constellation of stars. Princess Diana owned a Starlight necklace.

Always seen from a different perspective, the mysteries and drama of the night sky are an ever-evolving theme in Yurman designs that became the inspiration for Moonlight, Midnight Mélange, and Midnight Ice, all Parisian Collections.

David Yurman sketches of the Starburst Collection, 2010.

Opposite: Alexandra Agoston wearing Starburst earrings, 2020. Photographed by Chris Colls.

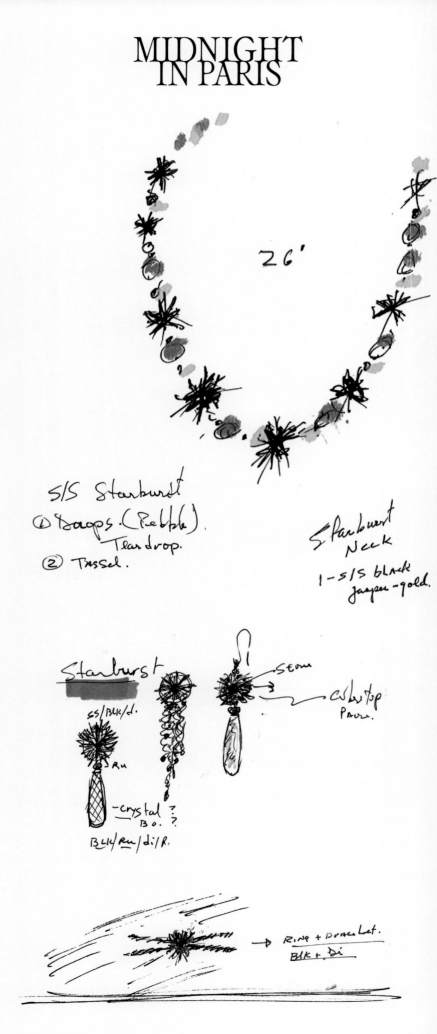

MIDNIGHT IN PARIS

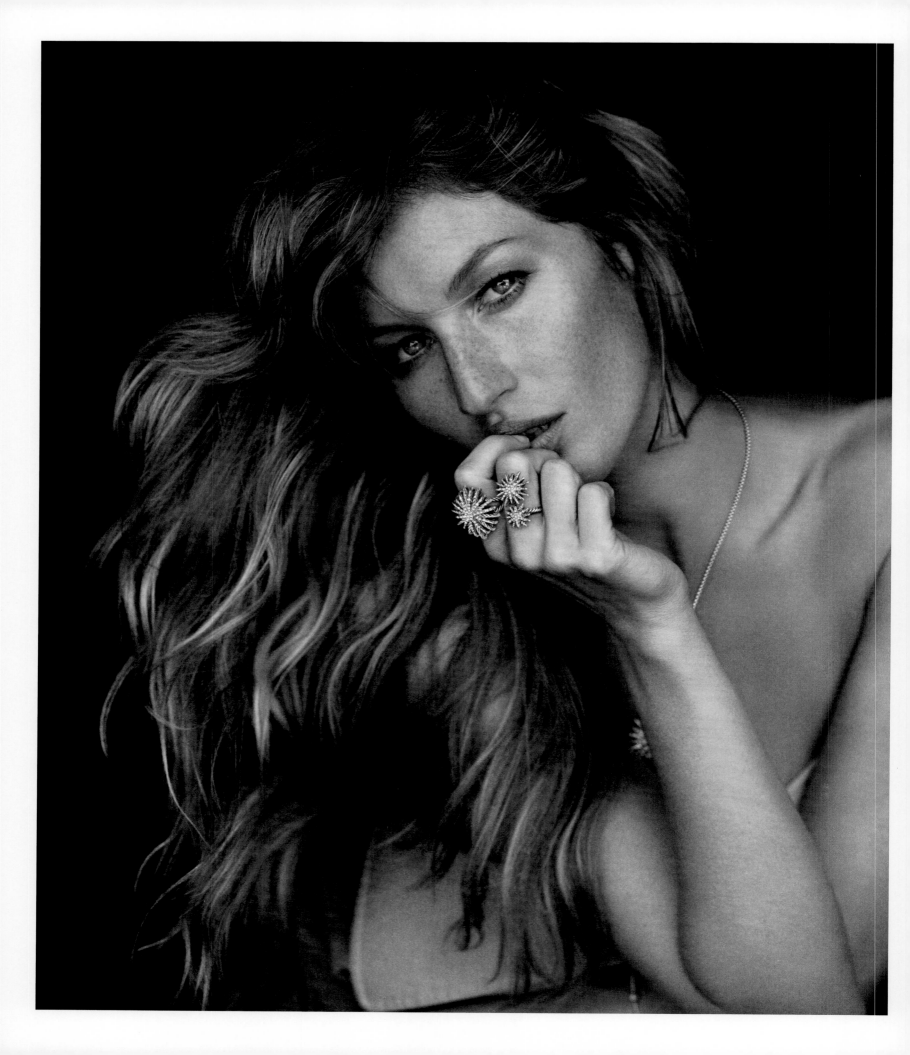

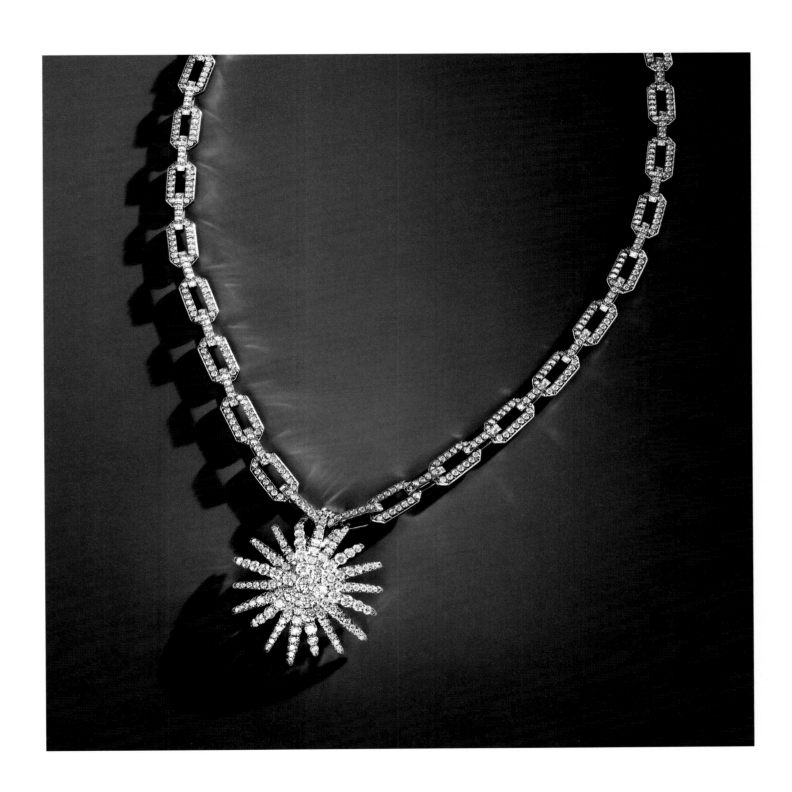

Opposite: Gisele Bündchen wearing gold pavé-set diamond
Starburst necklace and diamond rings, Malibu, California,
2012. Photographed by Peter Lindbergh.

Starburst pavé-set diamond link necklace with pendant, 2023.
Photographed by Emil Larsson.

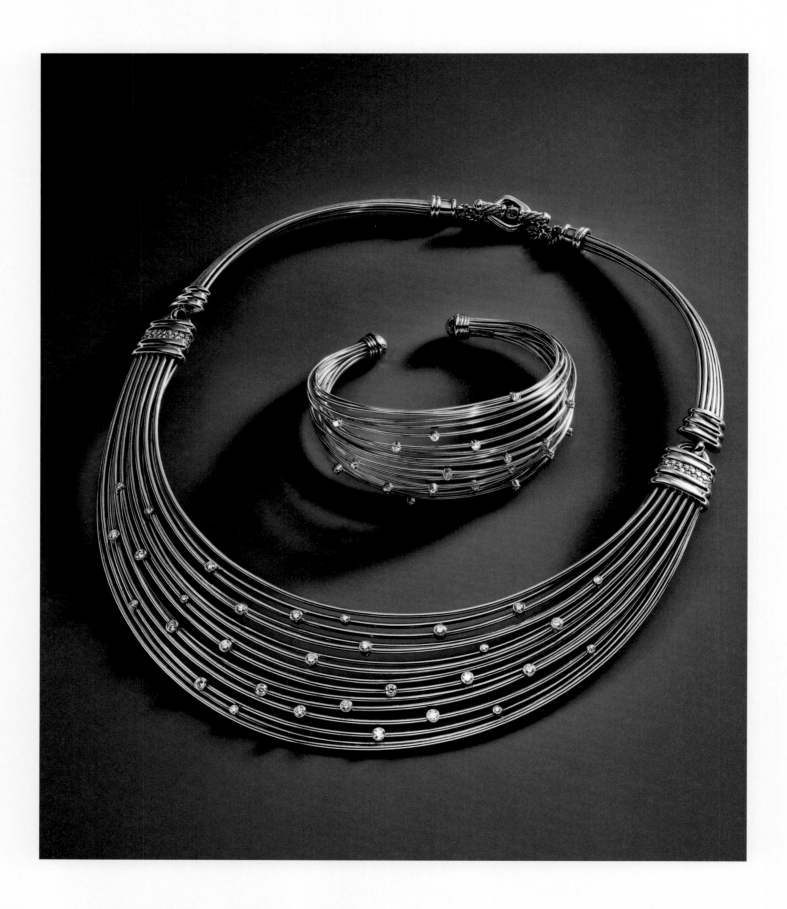

Starlight necklace and cuff bracelet with bezel-set
diamonds, 1983. Photographed by Emil Larsson.

10 years of Collaboration
with Peter Lindbergh & Kate Moss

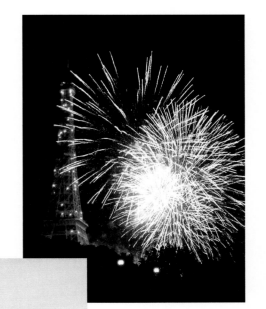

in Printemps and spent many
days and night in the City of Lights
Sybil was look out of our hotel window
one evening and was tearing up
Viewing Fire works..... for Sybil

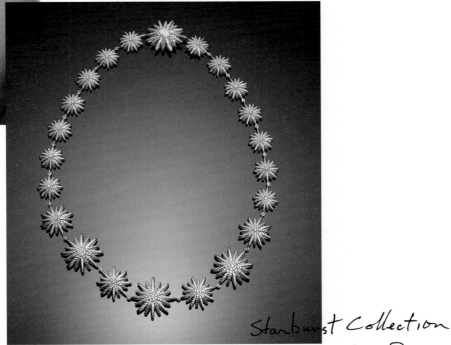

bag pipe and fire works are very
emotional.. I told her.. "I'll make
you a fire work collection and we
did for our opening. we called it

Starburst Collection
inspired by Paris.
We were opening a Shop

From top to bottom: Fireworks at the Eiffel Tower, Paris.

Kate Moss wearing gold and pavé-set diamond
Starburst ring and large Starburst statement ring, 2014.
Photographed by Peter Lindbergh.

Gold pavé-set diamond Starburst linked necklace,
2011. Photographed by Raymond Meier.

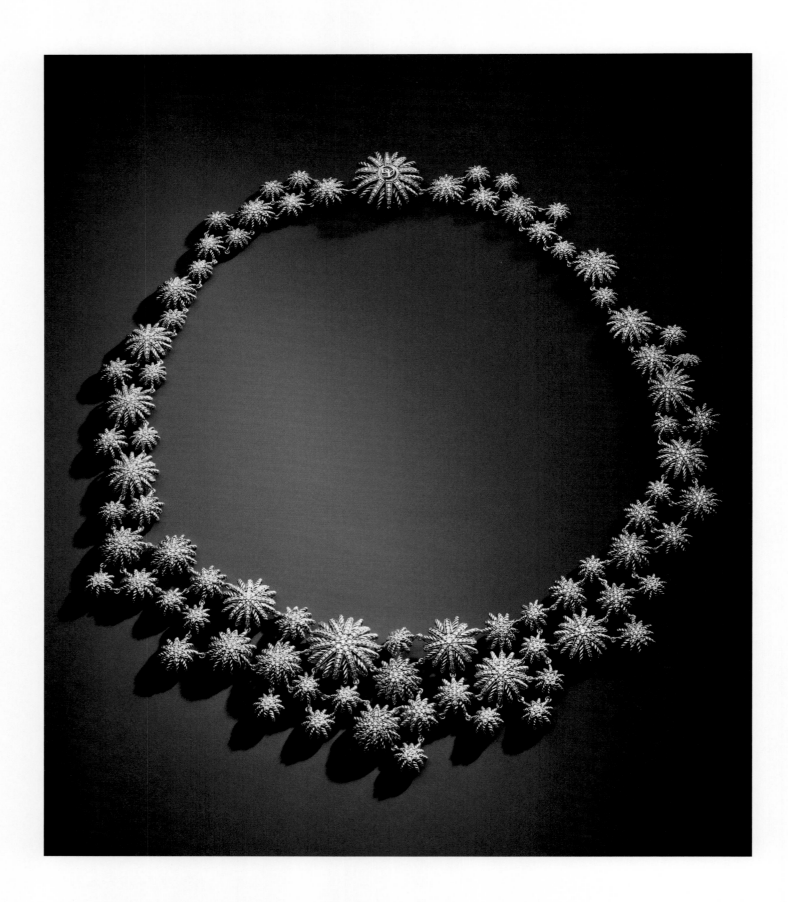

Starburst gold and pavé-set diamond bib
necklace, 2014. Photographed by Emil Larsson.

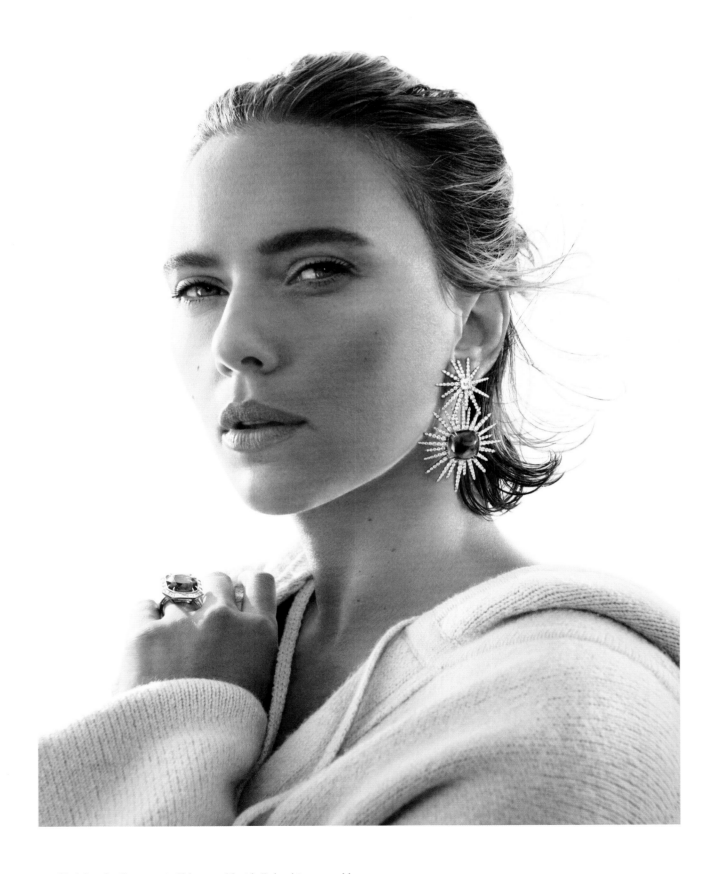

Scarlett Johansson wearing High Jewelry Stax ring in 18-karat gold with Colombian emerald and diamonds, Starburst pavé-set drop earrings in 18-karat white gold with 13.42 carats of Colombian emeralds and 4.44 carats of diamonds, 2023. Photographed by Glenn Luchford.

DAVID THE HITCHHIKER

David's story is rather remarkable, even in an age of remarkable stories. It has the sense of a novel, as does the age as a whole. In 1957, the seminal writer Jack Kerouac published *On the Road*, an iconic novel whose title alone captured the spirit of a new generation of American artists and poets who had set out to discover the United States as a means of discovering themselves. The novel couldn't have been written anywhere else; it is a profoundly American story from a moment when American culture shook the world. Sybil later said of the early 1960s that "to be an American artist was something that had never been done before," and the road—both as a metaphor and a physical reality—was a vital part of that experience.

For David, traversing the country was a search, a way of embracing new terrains and people while exploring and discovering himself. Being on the road wasn't so much a way of inspiring art; it was part of the art process itself. In the early 1960s, he hitchhiked and drove from coast to coast at least eight times, later saying of his and Sybil's lives before they met: "We each went on the road. We were a runaway and a hitchhiker. We had whatever money we had earned waiting tables or selling art and the few tools we needed to create art." David spent several years in California—as did Sybil—as the Beat Generation reshaped American literature. He moved up and across the country, where the leading American artists of the day were transforming the international scene, gathering vital experiences as he went.

As important as this time was, a lot had happened to David before then that shaped his outlook on life. He grew up in New Hyde Park on Long Island, New York, the middle child between two sisters. The family was prosperous enough in his youth: his father had a successful company producing belts and trimmings for the New York fashion and garment trades. He set an early example for David as to how a company should be run by being involved with everything: he was the designer, a colorist, and the main salesman. While David's mother mostly stayed at home caring for the family, she was a talented creative spirit who loved music, dance, and collecting antique jewelry.

Despite this seemingly nurturing environment, David says that his childhood was not easy. He had learning issues driven by dyslexia and an attention deficit disorder in an age when neither was recognized nor understood: "In school, I was just basically screwing up. I hated it. It was like living through the most embarrassing nightmare you could imagine. That was my everyday reality. Pushing away from school and 'normal' education was something I had to do."

He struggled with his academic work, but as with so many who suffer from dyslexia and ADD, he showed heightened physical coordination and visual perception from an early age. He excelled in a number of sports and competed nationally in athletics: "I could dance, I was a runner, and I played most sports—I was the star pitcher of the baseball team, on the track team, and also loved to play soccer. During my senior year, in 1960, I ran a mile in 4:20, breaking the high school record from 1938. I also held the two-mile record." While injuries brought his athletic career to an early close, it had impressed on him the importance of dedication and discipline, and it bestowed him with a sense of pride in what he could achieve.

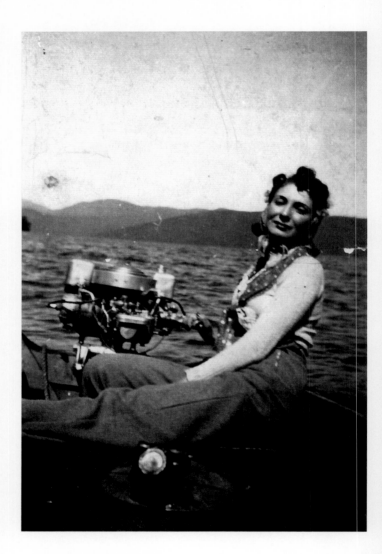

Previous spread: David Yurman, 2004. Photographed by Peter Lindbergh.

David's mother, Annie, 1940s.

Opposite, clockwise from top left: David Yurman with his father, Leo, Parkchester, the Bronx, 1951.

David Yurman, Parkchester, the Bronx, 1952.

David Yurman in a close mile finish for the county qualifiers race, Great Neck High School, New York, c. 1959–60.

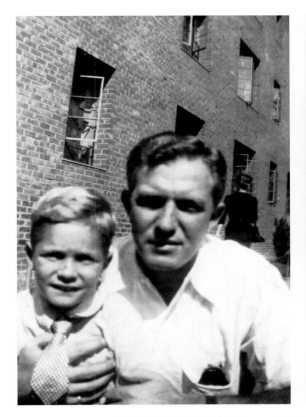

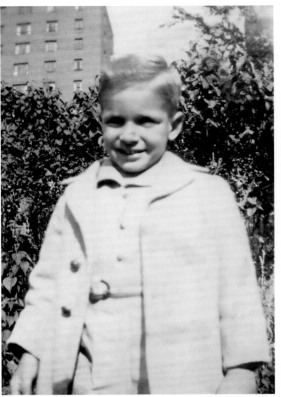

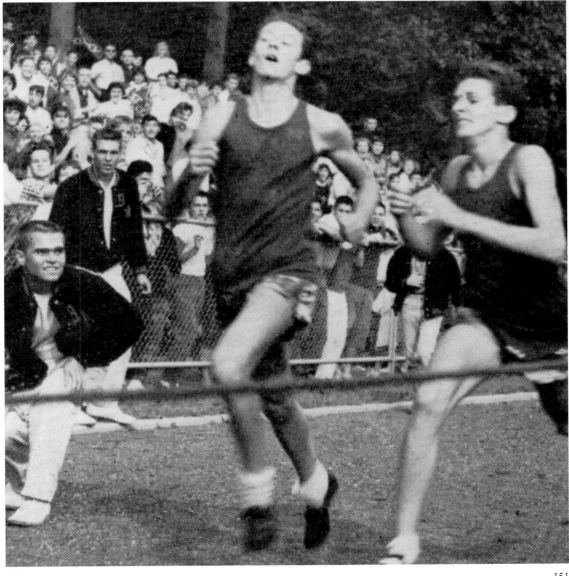

David Yurman
Bronze sculpture, 1960s. Photographed by Emil Larsson.

FERNAND WINDELS

LASCAUX

" CHAPELLE SIXTINE " DE LA PRÉHISTOIRE

Lascaux: Chapelle sixtine de la préhistoire (Lascaux: The Sistine Chapel of Prehistory) by Fernand Windels, 1948.

Most of all, David showed a pronounced ability in art. He could make things; people noticed, and in this way he could move on from what he couldn't do by searching out and perfecting his talents: "I was dyslexic. I had ADD. I was driven and focused by what I couldn't do. It took me down a specific path, showing me what it was that I could do." He discovered a world in which he could excel: "I'm visual and very manual. I was a craftsman. When you're crafting and you're working on something intently, you're not distracted because every moment is new. You're in it. You're like a dancer or an athlete—totally in the present. I came to this through natural inclination."

David had found his creative obsession and realized that his future would be in making art.

He moved in and out of formal education in the early 1960s in search of a program that matched his abilities and ambitions. He attended New York University (NYU) for a year, and he took classes at the Art Students League and the School of Visual Arts (SVA) in New York City. He was then accepted into Santa Monica College. It was there that he befriended his art teacher, who liked his work and thought it was advanced. Interestingly, that teacher assisted David in getting permission to bring his welding equipment into the studio. But as later chapters will show, most of his education was completed through his successive apprenticeships over nine years with leading sculptors Jacques Lipchitz, Theodore Roszak, and Hans Van de Bovenkamp.

Another aspect of David's early life impacted his outlook going forward. Tragedy struck his family when he was thirteen: his father had a major heart attack and could no longer work. This event put at risk the relative prosperity the family had enjoyed and forced David and his sister Sheila to pursue a working life earlier than most: "I delivered two different newspapers after school, the *Long Island Press* and *Newsday*, which you were not supposed to do because they were competitors. . . . I had both routes. . . . At the end of the week, I had to collect the money. I learned about collection and about how people hide. I also had a lawn-mowing service for two full summers growing up, and then I hired three or four of my friends to take over some of the jobs that I couldn't do. I never went to camp like a lot of my friends. I worked. . . . I probably made fifty to a hundred dollars a week. And then I had more jobs."

Tellingly, in a later comment about those years, David said that he became an entrepreneur by necessity early on. The two underlying components of his outlook were in place by the time he embarked on the road: his commitment to art and an intrinsic understanding that economics are important in making a life in art possible. As Sybil once said when giving a lecture at the Smithsonian: "You have to sell more to make more."

David had no idea, of course, that this existence was mirrored in the person who would soon to become his partner in life. By 1973, when he and Sybil moved to Putnam Valley, New York, and established their first company, "the road" had been for both of them a physical fact: they had traversed the continent in pursuit of their dreams. And the road was also the perfect metaphor for their extraordinary journeys through life.

153

David: I took my bar mitzvah money, or actually what was left of it, because my father had lost his business. Out of three or four thousand dollars, there was only about six or seven hundred left, but I had enough to buy a motorcycle. I bought a Honda Dream 305—it's a collectible now, but it wasn't sought-after back then. It was not the hot bike, more of a businessman's bike, a bit goofy. It was white. I lived in the mountains and rode it back and forth from Venice Beach to Big Sur, in California.

I had long hair, no job, and was living in the Venice Beach beatnik community. I ended up in Monterey fishing for abalone, digging up ferns and selling them in markets. I was a conscientious objector, just living the life. I was in nature, thinking of nothing more than just exploring. I wanted to live closer to this girl I was dating, so that was the first time I drove my motorcycle to Big Sur.

After riding to Big Sur, I lived on and off with a beatnik community in Limekiln Creek, with Price Dunn and his family, for about a year. Price became famous for being the inspiration behind Lee Mellon, the fictional protagonist of Richard Brautigan's first novel, published in 1964, *A Confederate General from Big Sur*. I was around twenty-two years old; Price kind of adopted me. He was living in the burnt-out remains of the Jordan mansion; when the roof fell off, he went to the salvage store and brought corrugated metal sheets. He lived there for more than a year. When you live in Big Sur, you live in nature, unless you're very wealthy. I was making sculptures. I was reading *The Journal of Albion Moonlight* by Kenneth Patchen, published in 1941. You didn't have to smoke anything to get stoned if you read Patchen.

That time was about existential moments for me. Nothing is better than the present moment; it is real. The future is what you plan for, and so I started thinking: I'm reading existentialism. I'm so involved in it. I'm developing my own personal mission statement. I'm evolving my own philosophy. I've become an existentialist, perfect. But I have ADD; I can't remember this or that. I have to live in the moment! I have no choice! It's perfect for me, and designing is great because you design this, you design that. You have a lot of things to do, and you're jumping around from one to the next. You're wearing so many hats, doing so many things. I couldn't be happier. This artist, designer, jeweler thing: it was just perfect for me.

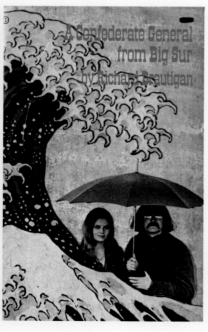

On the Road by Jack Kerouac, 1957.

A Confederate General from Big Sur by Richard Brautigan, 1964.

Honda "Dream" 305 cc. first Motorcycle

Freedom to travel up + down the California
Coast. Living in Venice Beach and
Big Sur — Lime Kiln Creek in Price Duma
and formaly. "Livin' the Life"

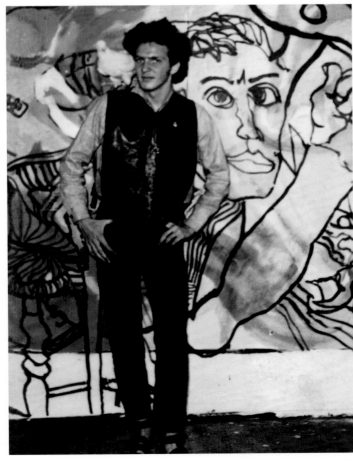

Top to bottom: Honda Dream 305 motorcycle, 1950s.

Limekiln State Park, Big Sur, California.

David Yurman with his rescue bird, Wilbur, wearing his own
custom-made jewelry and leather vest, in front of a mural by
actor Lance Henriksen, San Francisco, 1963.

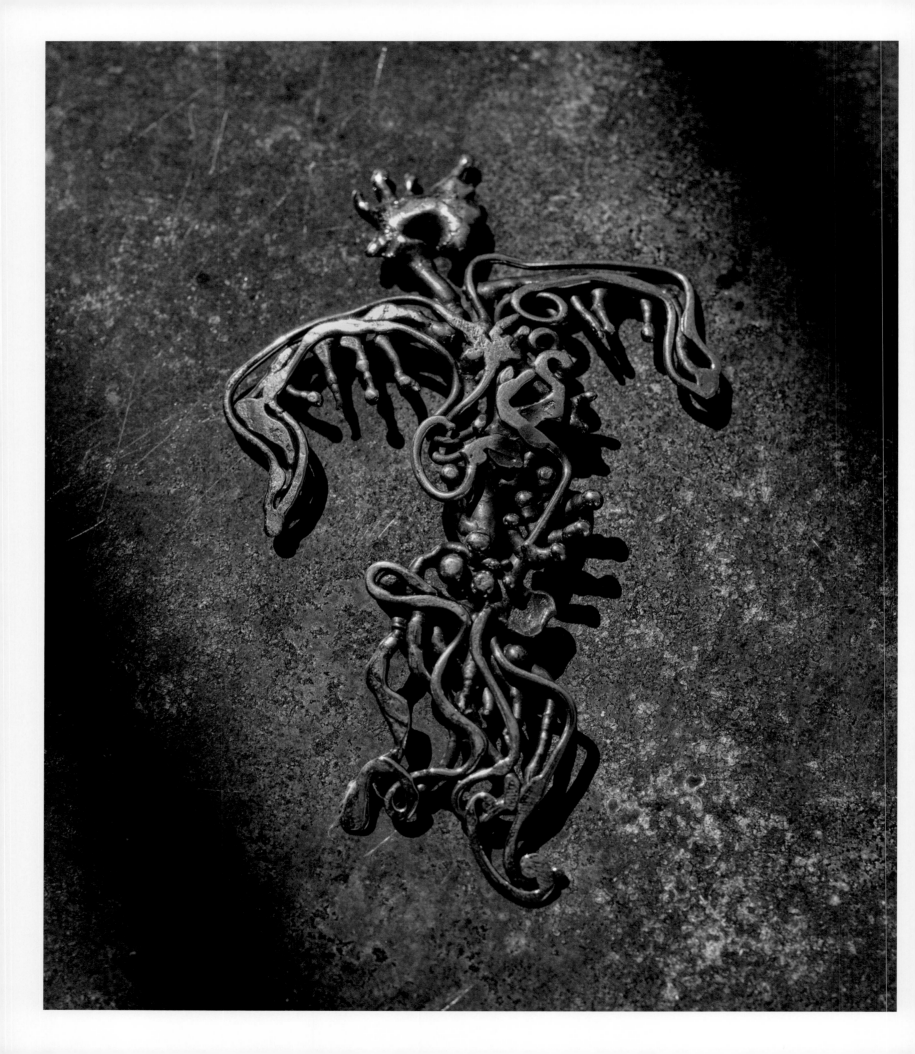

WELDING MY WORLD

BY PAUL GREENHALGH

David's full arrival as a sculptor was largely due to his discovery of welding as a vehicle of expression. He had experimented with various media during the course of his frenetic early years—in the early 1960s, he hitch-hiked from coast to coast eight times—but it was the discovery of welding sculptures that settled him and led to his first consolidated body of work.

As with so much in life, serendipity played a part. David made his discovery during a visit to his sister Sheila in Provincetown, Massachusetts. Sheila was in a relationship with Ernesto Gonzalez, a prominent expatriate Cuban sculptor; Gonzalez's main technique was direct welding. The classic media for sculpture had always been casting, carving, and modeling—welding had emerged in the interwar period as a serious alternative to those traditions, mainly as a way of constructing abstract forms. It was closely associated with Modernism and became the main vehicle for major figures like Julio González, Alexander Calder, and David Smith. Pablo Picasso also famously had a period during which he used welding to create his sculptures. Gonzalez was welding in this spirit.

Gonzalez was a prominent figure on the American scene, but it would be an exaggeration to say he was a teacher by any means. As David recalls, "Ernesto showed me how to turn the torch on and off and how to be safe, and he taught me a little bit of technique." For David, that was enough: he was hooked.

Very quickly, direct welding became much more than a mere technology for fabricating objects. The unmediated immediacy of the process allowed David to use it as though he were drawing. It could be moved, changed, or built up without pause or interruption. More than this, for him it was a way of thinking, a way of losing oneself in the "poetry of the possible": "Direct welding was like dreaming with my hands. . . . Making sculptures is not an intellectual process. You don't want your brain to get in the way—at least not the critical side. You have to shut down that part of your brain, the one that thinks too much. You need the part that dreams. You're wearing goggles, so it's dark. It puts you in something of a dreamlike state."

Bending, joining, and twisting rods of metal to create three-dimensional forms became central to his sculptural sensibility, and it would later translate directly into his jewelry. Crucially, this allowed him to move elegantly from two- to three-dimensional forms without any additional adjustments. Lines melted into each other and took form: "The technique is interesting because you are literally melting bronze rods that are molten metal slowly dripping. You're controlling the metal and improvising at the same time. It's fluid." This fluidity made the fusion of line and mass into a single process. Direct welding opened the door to David's full realization of his artistic capabilities. He had found a way of depicting his world.

Opposite: David Yurman, Direct-welded bronze sculpture, 1970s. Photographed by Emil Larsson.

David Yurman with his rescue bird, Wilbur, wearing his own jewelry and leather vest, San Francisco, 1963.

Top: David Yurman's home studio, New York, 2016.
Photographed by Evan Hunter McKnight.

Bottom: 19th-century engraved illustration of fingerspelling
the manual alphabet of American Sign Language, used as a
reference to weld sculptures of hands.

Opposite: David Yurman, *Sundancer*, 1973, Bronze.
Photographed by Emil Larsson.

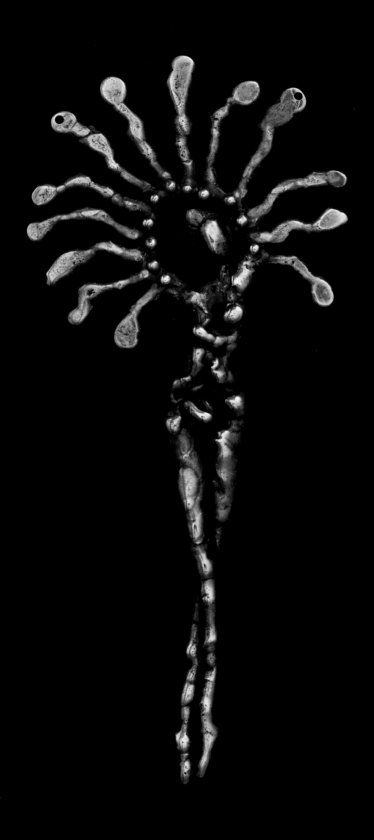

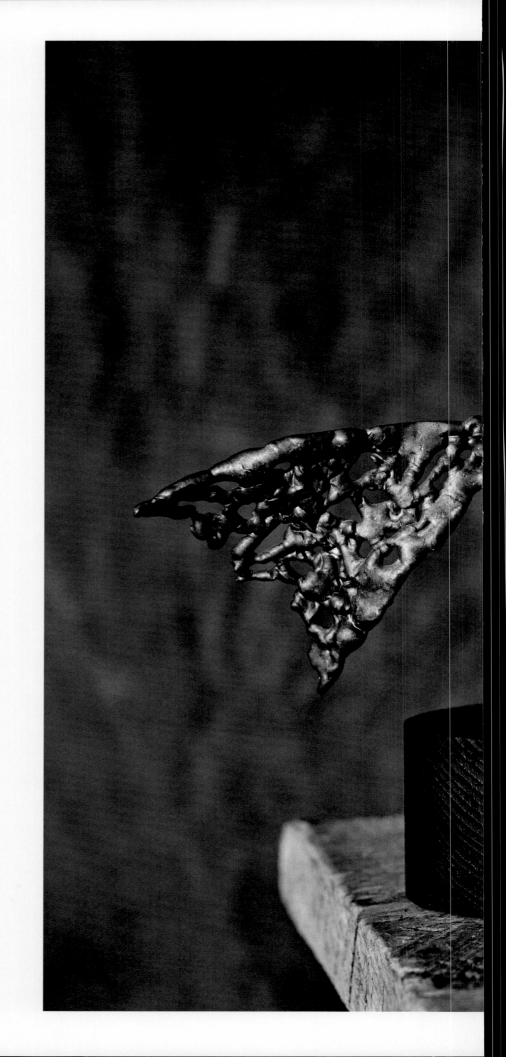

David Yurman
Bronze fish sculpture, 1960s.
Photographed by Emil Larsson.

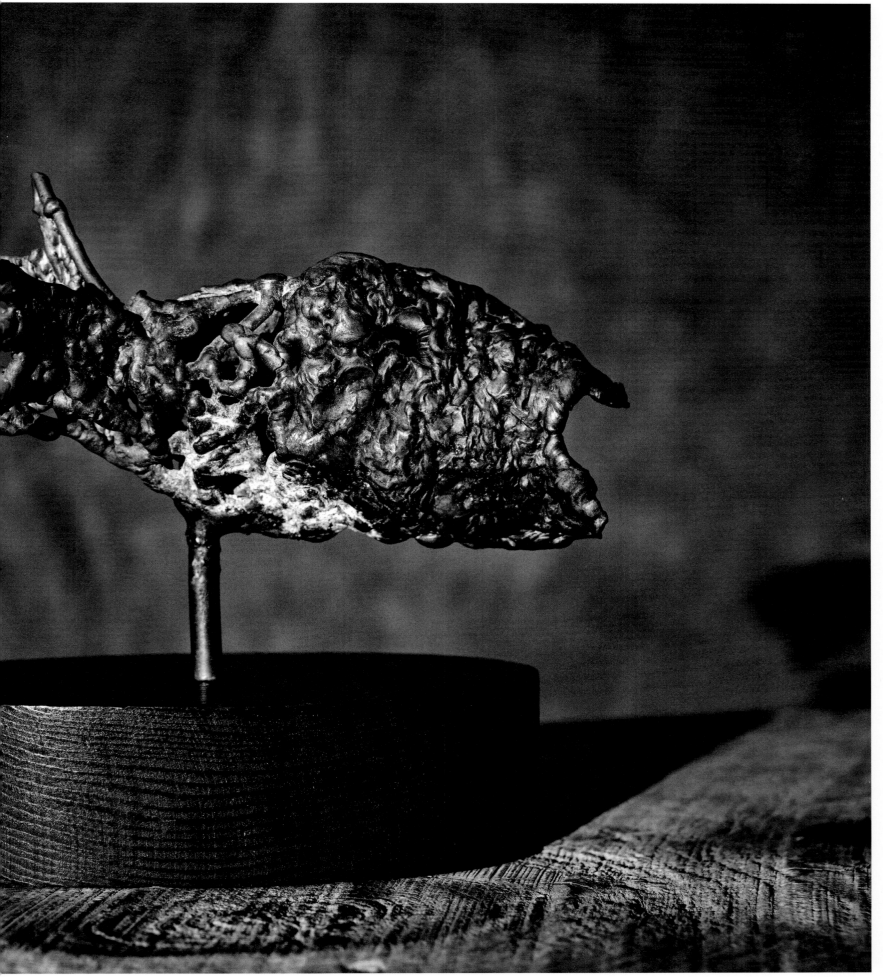

My Sister Sheila was essential ister
in bringing me into the world of art and music.
2 years older obviously she was my "older sister".

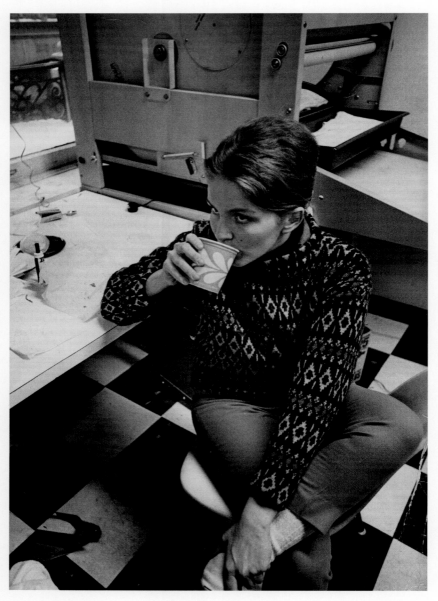

her photographer processed.
the image of me to the (right) was a
double exposure she took ... actually
a big surprise to her.

Sheila Yurman, New York, 1960s.

My sister Sheila was Miss North Shore. She looked
like a good-looking Kim Novak. She was a beauty.
She was a wonderful photographer; she had a great eye.
She taught me a lot and introduced me to Latin
music and jazz, but most importantly to her boyfriend
Ernesto Gonzalez, who was my first mentor.
He taught me how to sculpt by direct welding.

David Yurman

David Yurman photographed by Sheila Yurman, 1969.

ERNESTO GONZALEZ

Ernesto gift to me.
oval buckle

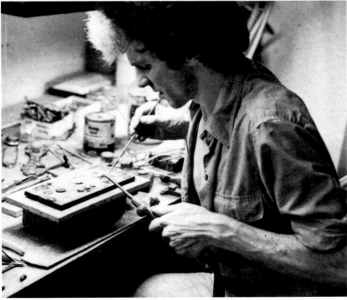

Ernesto .. My introduction
. To Direct Welding and Sculpture,
. I'm the Apprentice for 2 years.

The summer of 1958 was life-changing for David Yurman. At the age of sixteen, he had dreams of becoming an Olympic track star, while his father planned for him to find a stable job. His father's partner in a new lumber business acquired Shamrock Lumber Mills in Eugene, Oregon, and David's father thought it would be a good idea to send him to Eugene to learn the business. "I only agreed to go because Dyrol Burleson—the second man to break the four-minute mile—was being coached by Bill Bowerman, who would become the cofounder of Nike. I wrote a letter to him asking if I could come and use the facilities. I told him my mile time was 4:18, and he simply wrote back, 'Any day after 3:00 p.m. Bring your spikes to Hayward Field!'

"This was my first time traveling to the West Coast, and on my return flight, I realized I had four weeks left in the summer and decided I would stop in Provincetown, Massachusetts, to visit my older sister, Sheila. She was living with her boyfriend, Cuban sculptor Ernesto Gonzalez. It was there that I first experienced what it was like to live as an artist. When Ernesto arrived in the United States, the prestigious *Art in America* magazine gave him five pages of coverage. He was part of a gallery cooperative called the Woodshed, and his studio was at the far end of an alleyway. At night, people would walk along the street window-shopping, but they weren't able to see down the alley. Once, when my sister and Ernesto went to dinner, he told me, 'Take the torch and a steel coat hanger and make some sparks. Bronze doesn't make sparks, so use steel.' The sparks in the dark alley attracted customers to the gallery; a clever bit of showmanship."

Ernesto taught David technique and discipline, emphasizing the idea that you should always practice your craft. David recalls the first time Ernesto put a torch in his hand: "He gave me one of his torches and showed me the technique for direct welding. It felt like dreaming with my hands. I was immediately hooked. Welding and brazing are like drawing with metal—the result is always a surprise. The metal rods melt slowly; you are creating on the spot. This was my aha! moment: I could focus for hours.

"This was Provincetown in the late 1950s, an art colony and a beatnik enclave with galleries, craft cooperatives, painters, poets, writers, musicians, artists, and artisans. There was, of course, Jack Kerouac, Allen Ginsberg, Gregory Corso, and other Beat authors, as well as Mark Rothko, Franz Kline, and Norman Mailer. I met a Frenchman named Roger Rilleau. Roger was a master sandal maker. I learned from him the craft of working with leather, which gave me a foundation for the belt and buckle business I later established. I enjoyed listening to him talk about art. He was a person that everyone respected." At the end of the summer, when David returned home to New Hyde Park on Long Island, New York, he was committed to becoming an artist, and he knew that he could make a living with the new skills he had acquired.

Opposite: Belt buckle by Ernesto Gonzalez given to David Yurman, late 1950s. Photographed by Emil Larsson.

Top: Ernesto Gonzalez, 1960.

Bottom: David Yurman direct welding, New York, late 1960s.

David: In 1964, a few years into my beatnik experience that took me to Provincetown, Massachusetts, and the West Coast, I was forced to return to New York City with a case of mononucleosis. I moved back to my parents' home on Long Island to recover. I set up my welding equipment in their garage and began working on small sculptures. Needing to work, which was a rule in my family home, I got a job delivering dry-cleaning to some of the wealthiest households on the North Shore of Long Island.

The stars unexpectedly aligned for me during a routine stop. I was making deliveries to beautiful homes with amazing art collections. It was during this time that I met Joan Avnet—the Avnet collection was world-famous for its pieces spanning from the old masters to modern art. One day, I made a delivery to the Avnets' residence when no one was home. I found myself surrounded by all these amazing museum-worthy art pieces: I was in awe as I saw a Rodin and a Giacomo Manzù, one of my favorite Italian sculptors. When Joan returned home, she found me in the middle of her living room. "What are you doing here?" she asked. Slightly embarrassed, I told her I was looking at their incredible art pieces. After she scolded me for walking on her white carpet, I told her I was a sculptor, and she asked to see my work. I happened to have a few pieces in the back of my truck. I brought them in and put them on the kitchen table. She said, "These are wonderful!" Besides being a major collector, Joan was opening a gallery and she invited me to exhibit. All I had was four pieces—I had four months to complete new ones. I went to work and produced ten more sculptures.

Joan encouraged me, suggesting, "Why don't you make multiples of these? You just have to make a mold for some of them, and we can sell editions." I ended up having a one-man show at the Avnet Gallery. It was very successful. It was the first year of the gallery, and I sold a lot. I was ecstatic. At some point, Joan asked, "By the way, do you really want to be delivering dry-cleaning?" This was clearly not my future. Her husband had recently bought a fine art foundry, renaming it the Avnet Shaw Art Foundry. Through the Avnets, I met Joel Meizner, the director of the foundry. The Avnets collected works from many famous sculptors: Henry Moore, Louise Nevelson, as well as Jacques Lipchitz. At the time, Lester began casting for Lipchitz, and Joel said, "David we can cast for you. It's amazing what we can do." He added, "By the way, Lipchitz is looking for an apprentice. Would you be interested?" I said, "Absolutely."

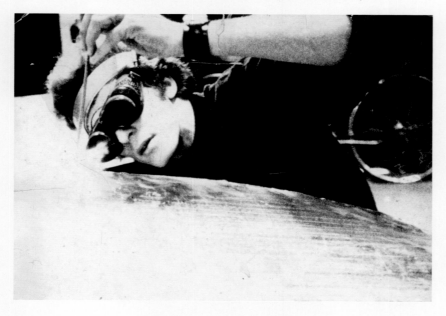

David Yurman brazing in Hans Van de Bovenkamp's studio on West 10th Street, New York, 1968.

PHOEBE

I direct welded a copy
of Jacques "Sword of Death"
in his Studio."
He said if I Sold it he
Wanted of <u>Percentage</u>.

David: In the back of Jacques Lipchitz's studio, I set up my equipment, so I could work on my sculptures and weld metal mountings for his collection of artifacts. I once copied one of his pieces in a direct-welded bronze and called it *Phoebe*. Jacques was a very playful and curious person, and he would experiment with elements of his existing sculptures. Jacques had a particular way of working. He would cast his sculptures in multiple parts, which, on occasion, he would reuse to create new works, essentially giving a second life to parts of his sculptures. After he cast all the elements, he would rework them, and, finally, he would start making them into figures.

Once, while working on a sword about four feet high, he decided to add an embellishment. Casting it separately, he made the handguard look like a little girl with a hand on her hip. I liked these spontaneous bursts of creation and the playfulness of Jacques—he was open to these fun moments. In art, unexpected things happen all the time. You must be aware of them, have fun with them, and stay open-minded because things don't always go as planned. When Jacques saw my *Phoebe* sculpture, he said, "If you sell it, I want twenty percent!"

He was also a businessman!

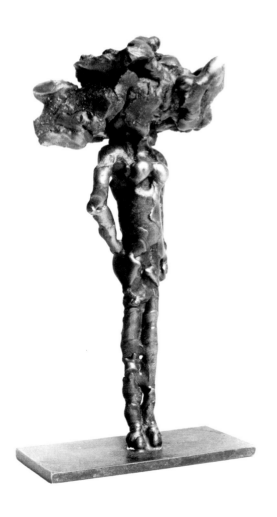

David Yurman
Phoebe, 1965
Direct-welded bronze

David: As a teenager in the mid-1950s, I was left alone on most Saturdays with a glass of milk and a piece of my grandmother's apple pie. I would regularly watch my favorite Saturday morning television show called *What in the World?*. This was heaven. It was a quiz show; a piece of art or a historical object would be presented on a turntable in a cloud of smoke in front of museum scholars, who would try to identify it as the smoke dissipated. In one episode, two of the scholars were a curator from the New York Metropolitan Museum of Art and Jacques Lipchitz. Jacques always guessed the object correctly. He was a true luminary in the art world. I learned a lot about art from this program, and from Jacques. In 1964, I was lucky enough to meet Jacques in person when I was recommended by Joan and Lester Avnet for an apprenticeship as a studio assistant.

On the first day of my apprenticeship, when I asked Jacques what he wanted me to do for him, he answered, "Basically, you come at eight in the morning, and you leave when I tell you it's okay to leave." He said it with a chuckle. Jacques would later encourage me to get my own studio, so I found a studio in Greenwich Village on Thompson Street. From then on, I always had my own studio. He also encouraged me to go to art school, so I attended night classes at the Art Students League, on the Upper West Side, and the School of Visual Arts. He said to me: "You're talented. You're one of only two people I've ever let work directly on my sculptures."

For over a year, I took care of his studio, drove him around, but mostly, I worked building armatures, sculpting, welding, and working in the foundry. It was an honor that he would allow me to touch his sculptures. I learned about patinas, coloring metals. I also did a lot of restoration, repairs, and mounting work in his huge collection of antiquities, which had over ten thousand pieces, from amulets to ancient African sculptures.

After a while, the apprenticeship was a bit of a routine for me, and when Jacques realized I was getting bored, he lectured me: "David, this is life. This is how you make art. You're disciplined. You do art every day. This is how you focus, and you get freedom. You don't do that? You have nothing." Jacques also taught me that you must have a point of view for your work, for everything. And that takes time.

JACQUES LIPCHITZ

Jacques, taught me about consistency, Focus, and being Humble. and not knowing was part of the experience of thinking.

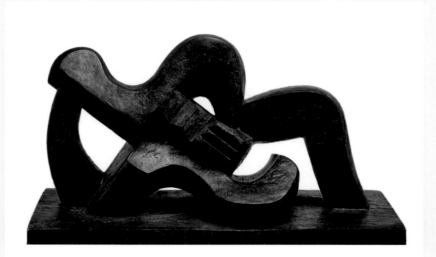

Jacques Lipchitz, *Reclining Nude with Guitar,* 1928; Black marble; 16⅜ × 27⅝ × 13½ in. (41.6 × 70.2 × 34.3 cm), including base; Museum of Modern Art, New York.

Opposite: Jacques Lipchitz and David Yurman in Lipchitz's studio, Hastings-on-Hudson, New York, October 1965. Photographed by David Gahr.

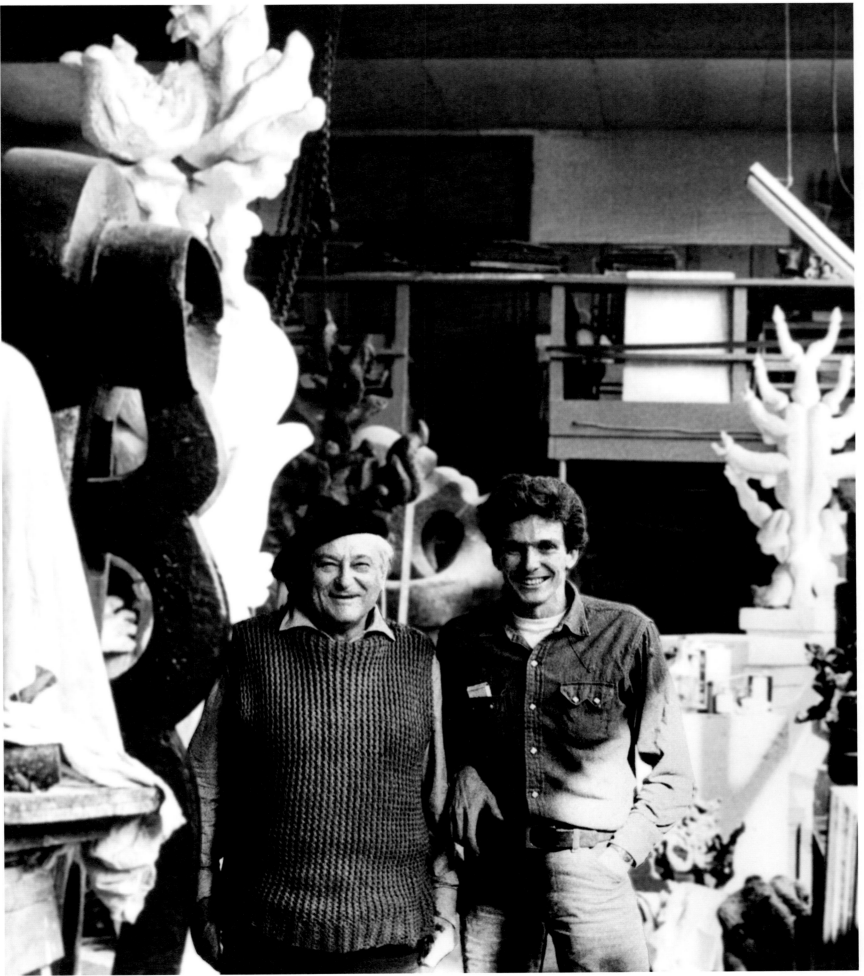

Dutch artist and entrepreneur Hans Van de Bovenkamp moved from the Netherlands to Canada in the 1950s and then to New York in the 1960s to continue working on his monumental sculptures, mainly with architects and city entities on commissioned fountains, gates, and other large structures. At Hans's Tenth Street studio, he created a working community for young artists and developed what would become a lifelong friendship with David. It was also at Hans's studio that Sybil and David met and fell in love.

As part of the New York City avant-garde scene of the 1960s, Hans was instrumental in forming the Tenth Street galleries, a consortium created to promote the growing art scene in Manhattan's East Village. David worked as his foreman for six years, while Sybil served as a studio assistant for three years. Hans remembers that, "David was always playing music. He was on his feet moving; he had this joie de vivre. He welded a variety of interior decorative fountains and offered constructive feedback on reengineering possibilities; he was like the orchestra leader, directing the assistants! Sybil was like a flower. She wore clothes with lots of colors, and even had little bells on her shoes. It was fun—those were the sixties; we were all crazed!"

What did David learn from Hans? "Hans is the living example that you could make art and also run an art-related business—in his case, interior water fountains—to support yourself. Most importantly, you could do it all and keep your integrity as an artist."

HANS VAN DE BOVENKAMP

Small sculpture of Hans' in our House Embracing Forms.

Hans Van de Bovenkamp sculpture in the Yurmans' New York residence, 2023. Photographed by Emil Larsson.

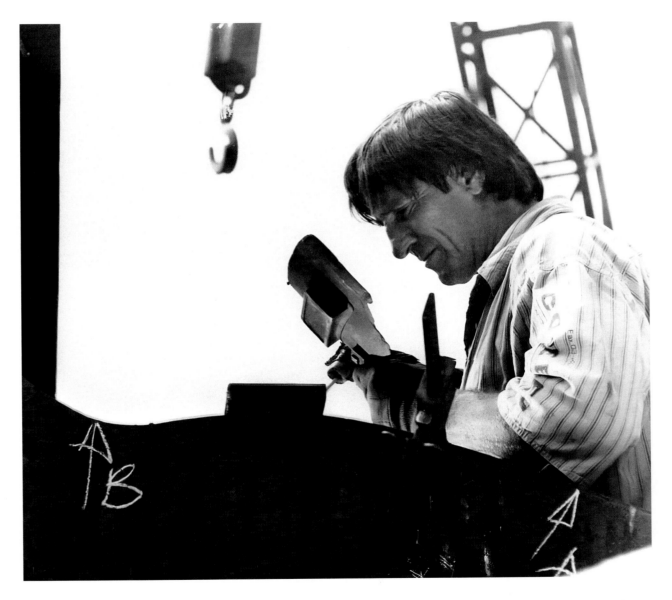

Hans taught me that being
a sculptor in modern times
required great skills in business
as well as the Making off
Which he was a Master

Hans Van de Bovenkamp, late 1960s.

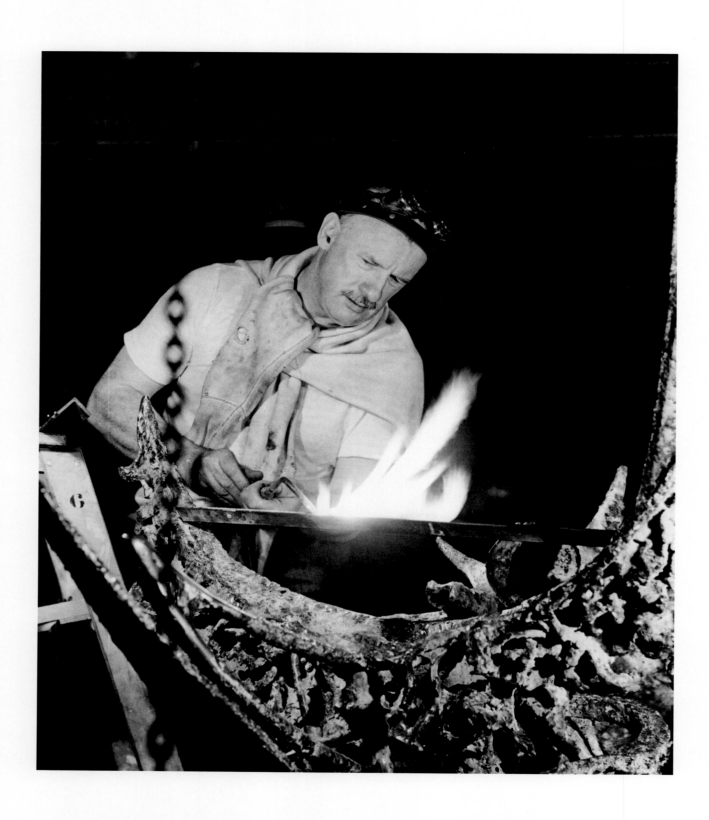

Sculptor Theodore J. Roszak, in his workshop at 1 St. Luke's Place,
New York, fires a garland for the eagle that is to adorn the
facade of the US Embassy in London, 1960.

THEODORE ROSZAK

Roszak ... unbelievably INtense
and a Ironic mind.

Very desaphial

Tought me to simplify
my life

David: It was the 1960s, and I was part of the counterculture. I had a small basement studio in Greenwich Village. I hung out with a group of artists and sculptors. We were a fellowship, and we would help each other out. I would call them on occasion to get together to work on large installations. It was during this time that I met Theodore Roszak. One of the most memorable jobs I worked on with Roszak was mounting his thirty-five-foot eagle at 1 Federal Plaza, in downtown New York, where it still hangs above the US Court of International Trade today.

Roszak was an incredible sculptor. He made unbelievably fierce sculptures on a monumental scale. I apprenticed with him, working in his studio on Leroy Street in the West Village. It was a two-person studio—Roszak and me. I was taking care of his tools and equipment, building his sculptures, and handling installations of his work, all the while doing my own work. He would work late into the night after his family was asleep. I called him the night owl. From Roszak, I learned the work ethic needed to be an artist. Roszak was impassioned about his work—he was pure energy and emotion, and he was incredibly dedicated. He started working around 11:30 a.m., and we would always work late into the night, until about 2:00 or 3:00 a.m. I would arrive at the studio at 9:30 a.m. and have about an hour and a half for cleaning up, organizing, and consolidating. His mantra was "Consolidate, consolidate, consolidate." Consolidating was anticipating what he would work on that day. His advice for me was to consolidate my life. When he met Sybil he said, "Hold tight to her, and steer clear of politics."

Roszak was a professor of art, and he was very precise. He was very sardonic. At one point, he was the New York City Commissioner of Fine Arts. In 1960, he was commissioned to create a piece for the American Embassy in London, another giant eagle. The sculpture made the front page of the *New York Times*. It became a subject of controversy as people debated whether or not it was art, but Roszak staunchly defended the process.

I met Sybil then and
she would come to visit
the Leroy Studio in Greenwich Village ...
he approved of her..
The rest is history

Top: The Eero Saarinen–designed US Embassy building with Roszak's American Eagle on the facade, London, September 1960.

Bottom: Theodore Roszak, *Eagle/Justice Above All Else*, 1970, US Court of International Trade, New York.

173

SKILL
THE 10,000-HOUR RULE

A few years ago, in a discussion about how companies involved in quality production should be led, David said that "a chef that's not in the kitchen, for me, is not a chef." That is, executives of businesses should know how the things they are selling are made. More importantly, they should know how to make them. This comment underscored one of the most complex and controversial concepts of our times: skill.

Skill has always been important to the Yurmans. When we look at their lives and the company they have built, we understand that they recognize intuitively that skill is about more than just making. Like many of their artistic forebears through time, they understand it to be the means of creative control and a fundamental way of interacting with the world. Leonardo da Vinci understood drawing to be a tool for communication, a skill that allowed him to promote ideas in his own society. He wasn't unique in this outlook. When we step into the Metropolitan Museum of Art, as Sybil and David have frequently done, the thousands of works on display allow us to commune with the people who made them, and through this we can relate with the civilizations in which they lived. When he was still a boy, David marveled at the Lascaux cave paintings he saw in a library book and thought about the artists who made them. From his earliest days, he understood skill to be a vital component of the artist's toolbox: beyond capturing an image, it sheds light on the world around the artist, revealing what it is to be a human being.

No one is born with skill. Many are blessed with a talent of one kind or another, genetically endowed in ways that are still not fully understood. Skill is acquired through work, ongoing training, and a great deal of practice. It is talent transformed through training. As such, it is not a gift but something that is fought hard for over a long period of time. Ten thousand hours has often been referred to as the time any artist has to put in to learn and master their trade. It implies years of training and learning.

For Sybil and David, ten thousand hours is far too small a number. While crisscrossing the nation to sell their work at craft fairs—a learning experience in itself—they sought to develop their skills through training. David apprenticed successively with Jacques Lipchitz, Hans Van de Bovenkamp, and Theodore Roszak, all leading sculptors in the American scene. Sybil enrolled in a succession of programs up and down the East Coast. She attended Hunter College in Manhattan; she took classes at the Corcoran College of Art in Washington, DC; she studied calligraphy at Columbia University and medieval literature under Alain Renoir at the University of California, Berkeley; and she went to Purchase, a college in the State University of New York system. Once there, she moved into Purchase's newly developed art department, which had embraced a radical agenda based on Bauhaus principles. She graduated in 1978.

By the time Sybil and David founded the David Yurman company in 1980, ten thousand hours was a mere fraction of the time they had spent honing their talents. They were already, perhaps, the most experienced and skilled jewelry team in the United States, ready to inject what they had learned in the worlds of art, craft, and design into their new company.

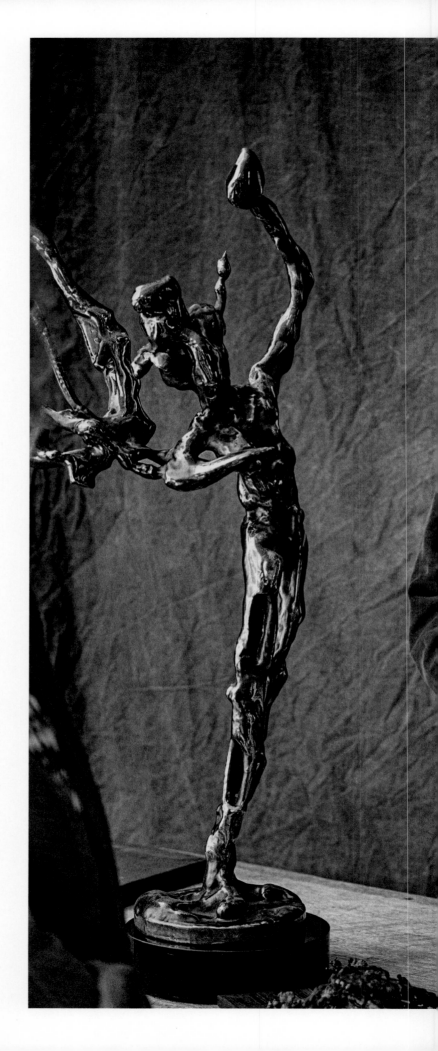

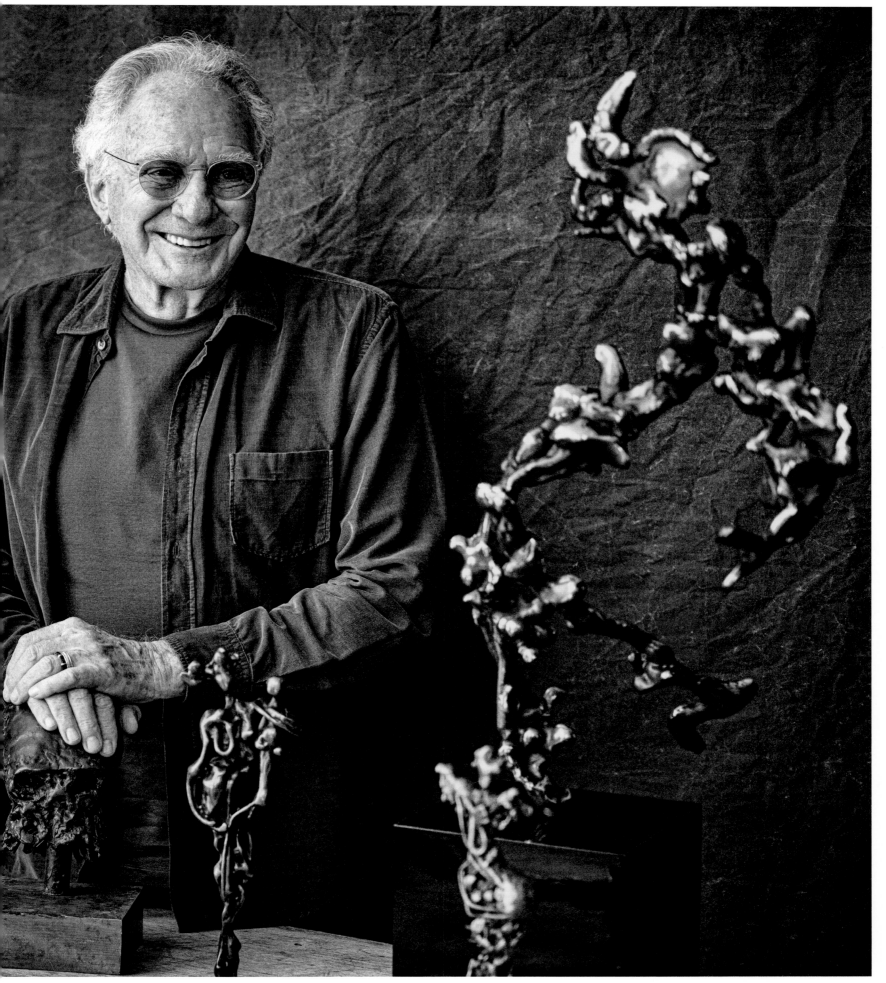

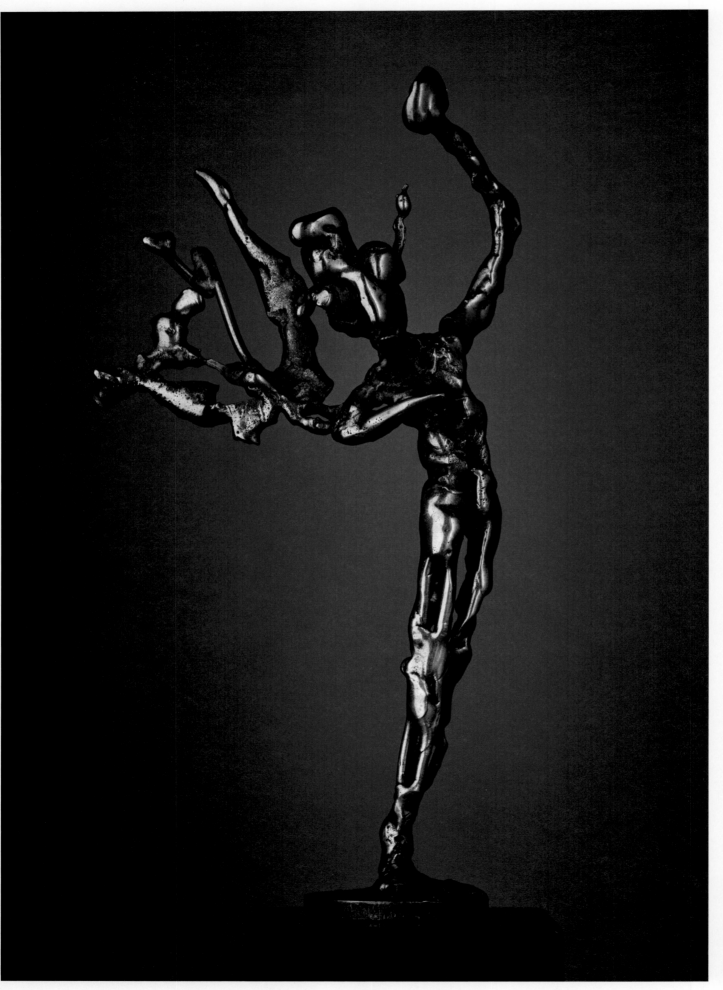

Previous spread: David
Yurman, New York, 2023.

David Yurman
After the Bathers by Degas,
1975, Bronze.

Both photographed by
Emil Larsson.

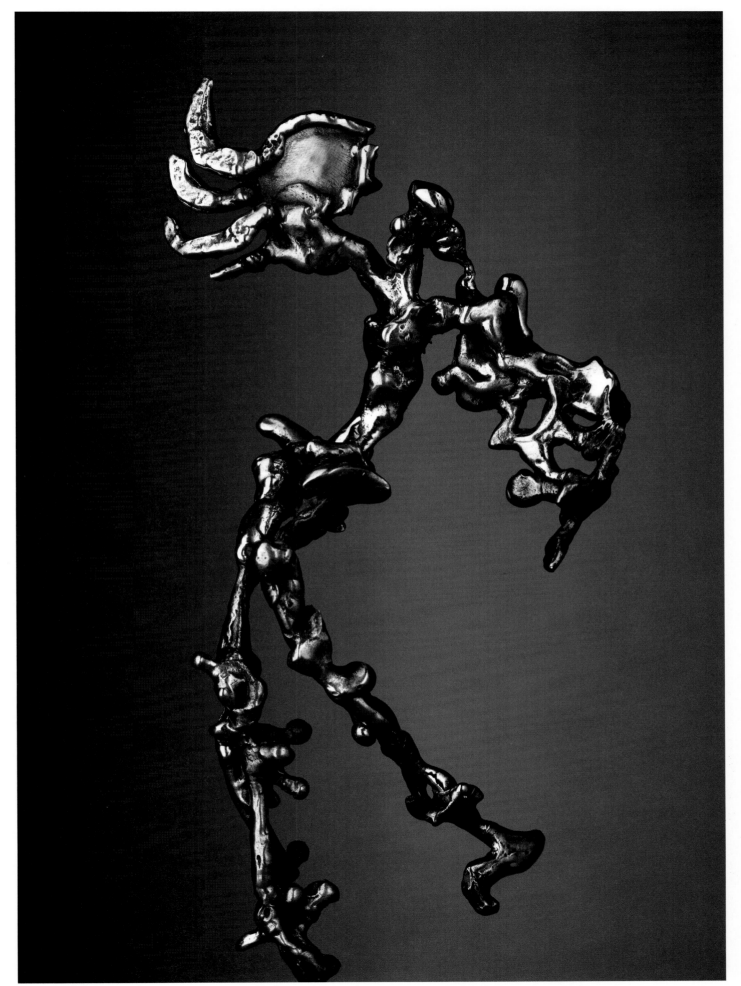

David Yurman
Aging Angel, 1973, Bronze.
Photographed by
Emil Larsson.

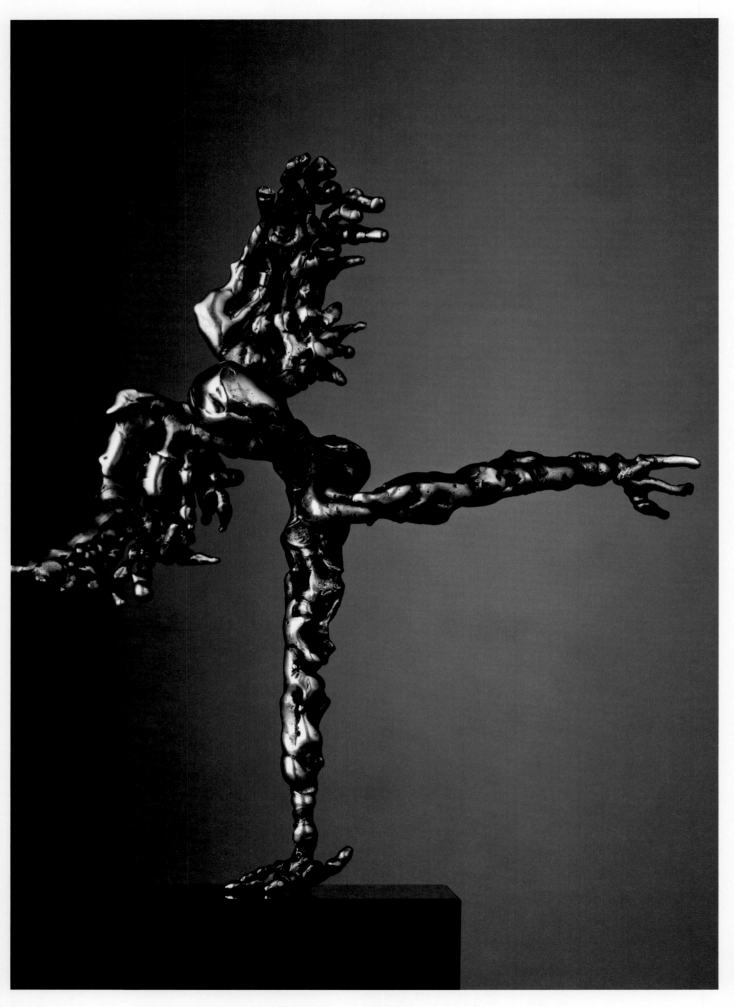

David Yurman
Icarus (Chickenfoot), 1973,
Bronze. Photographed
by Emil Larsson.

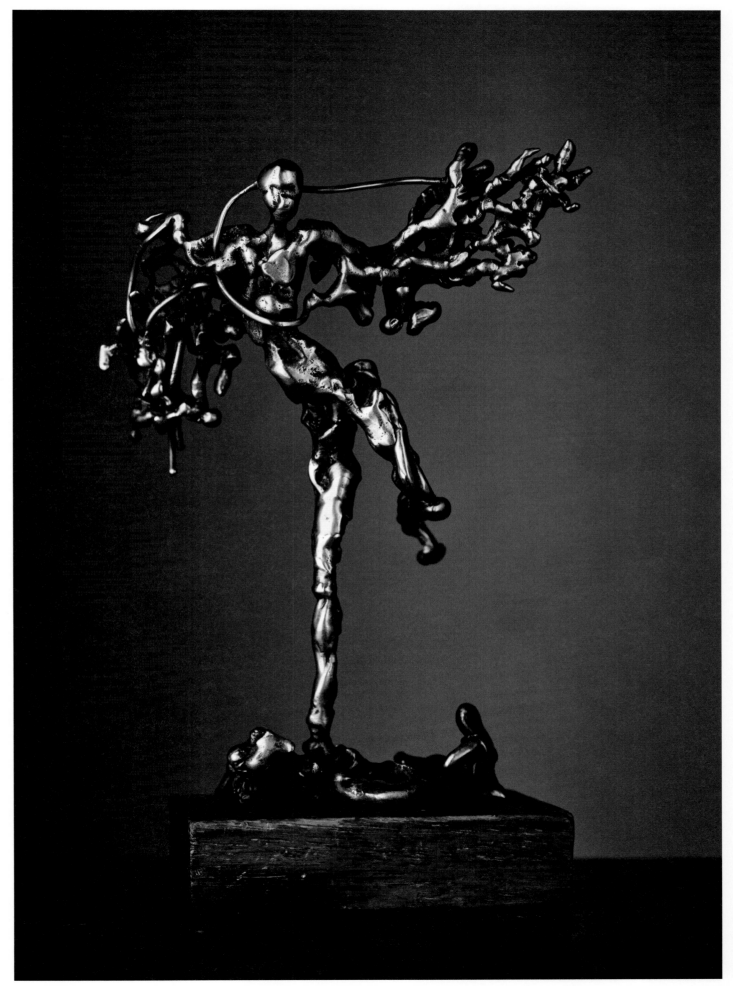

David Yurman
Icarus I, 1974, Bronze.
Photographed by
Emil Larsson.

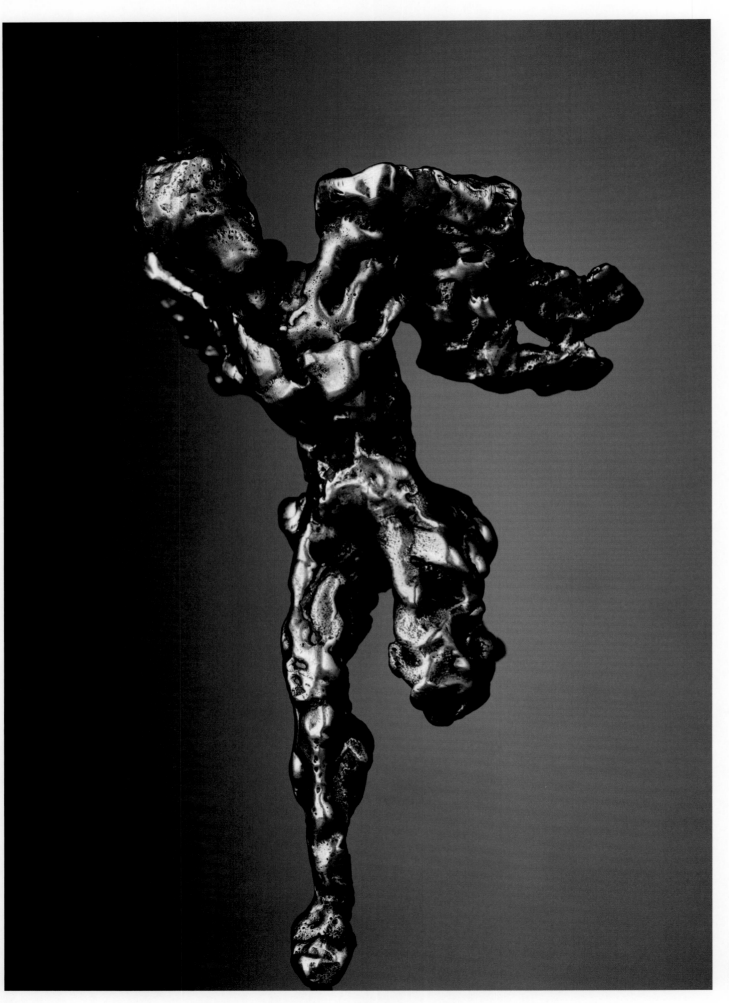

David Yurman
Ascending Angel, 1973,
Bronze. Photographed
by Emil Larsson.

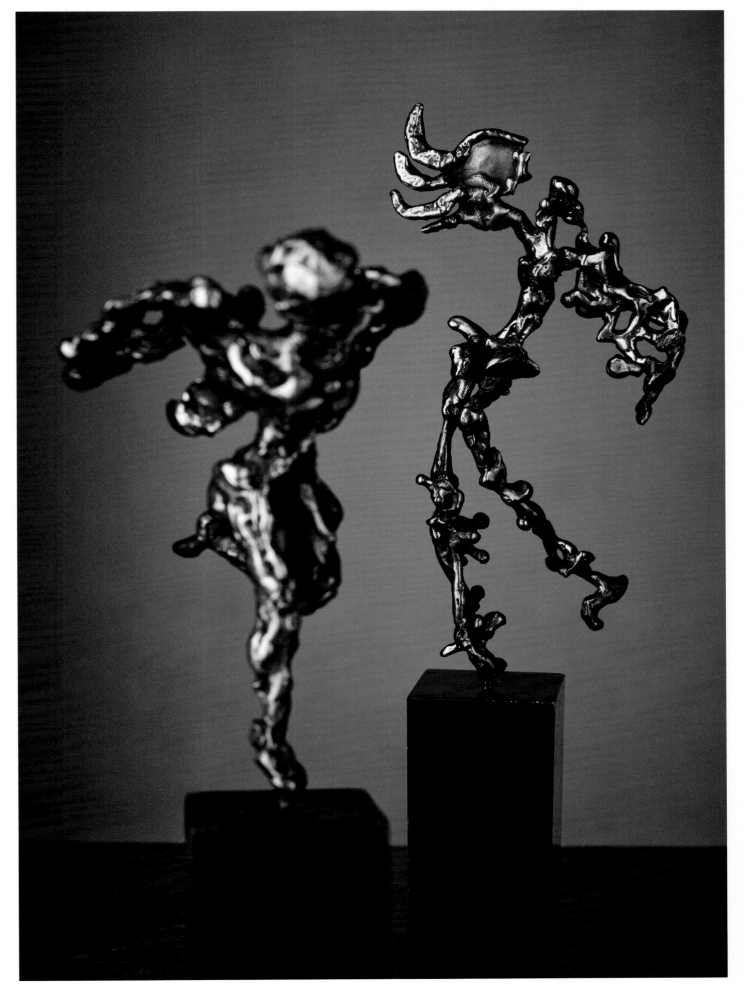

David Yurman
Aging Angel and
Ascending Angel, 1973,
Bronze. Photographed
by Emil Larsson.

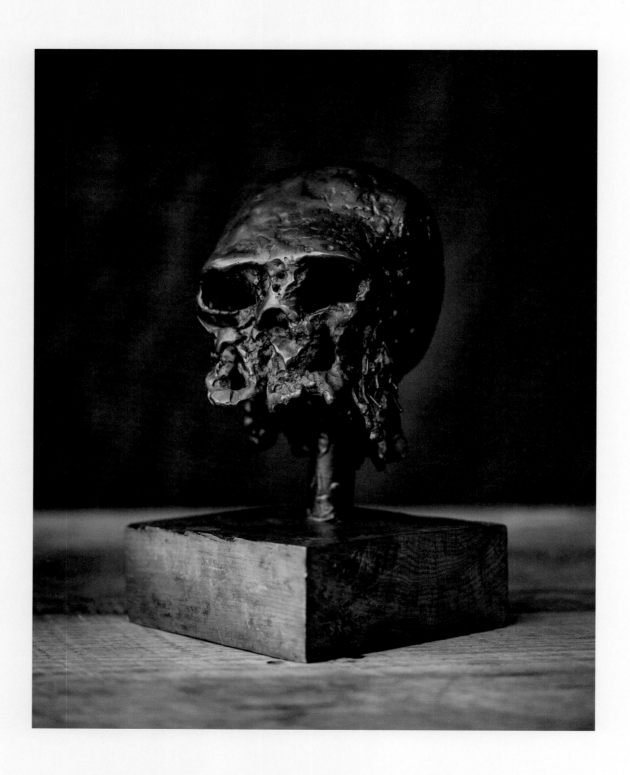

David Yurman, *Skull*, 1960s, Bronze.

Opposite: David Yurman sculptures, 2023.
Both photographed by Emil Larsson.

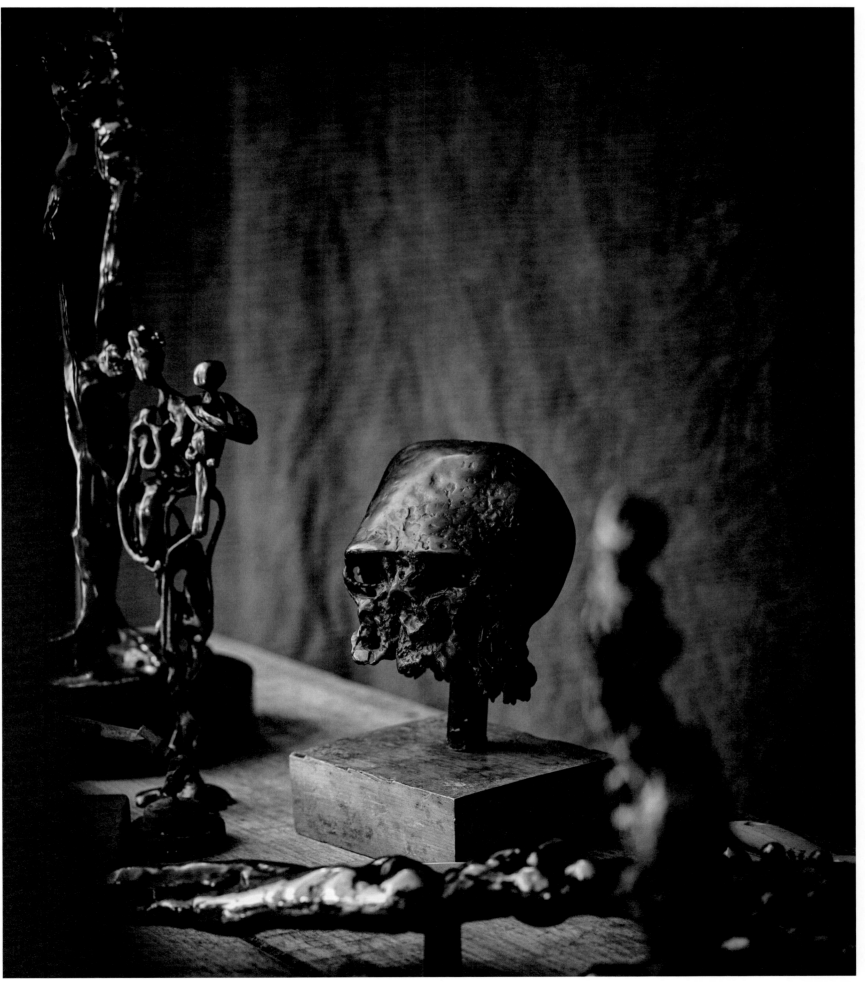

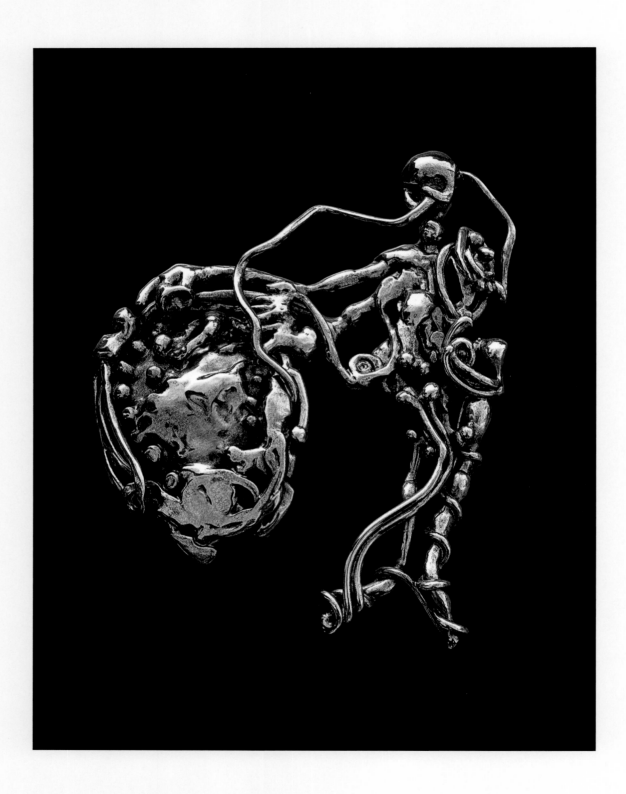

David Yurman
Spaceman, 1970s, Bronze.

Opposite: David Yurman
Venus and Four Babies, 1973, Bronze.
Both photographed by Emil Larsson.

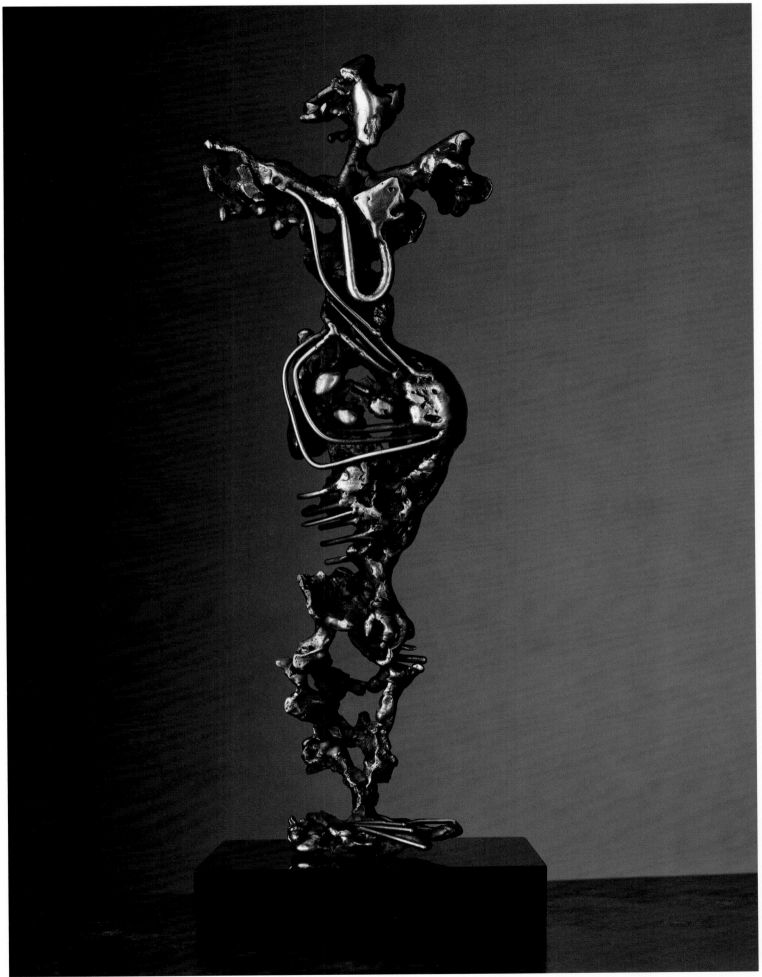

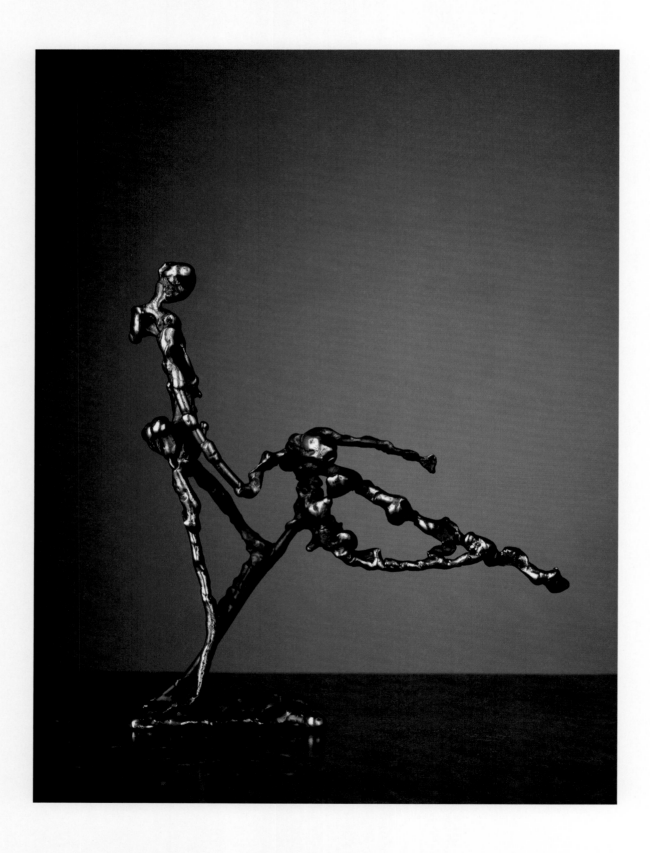

David Yurman
Dancers, 1973, Bronze.

Opposite: David Yurman
Dancers, 1973, Bronze.
Both photographed by Emil Larsson.

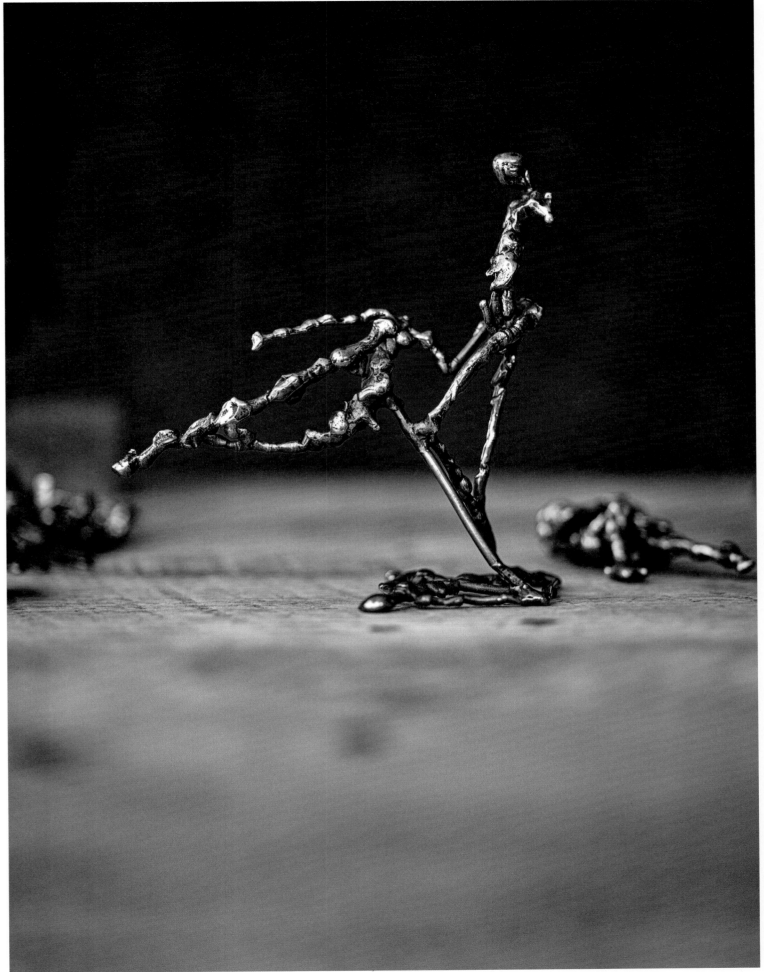

What touches me the most about David's sculptures is the level of intensity and emotion he puts into his work. It comes from the heart, from his unconscious; through his sculptures, he has invented his own language. I had this vision that anything was possible with his creativity and this thought that if only there was a way to transform those sculptures into wearable art. I wanted to see them in the world.

Sybil Yurman

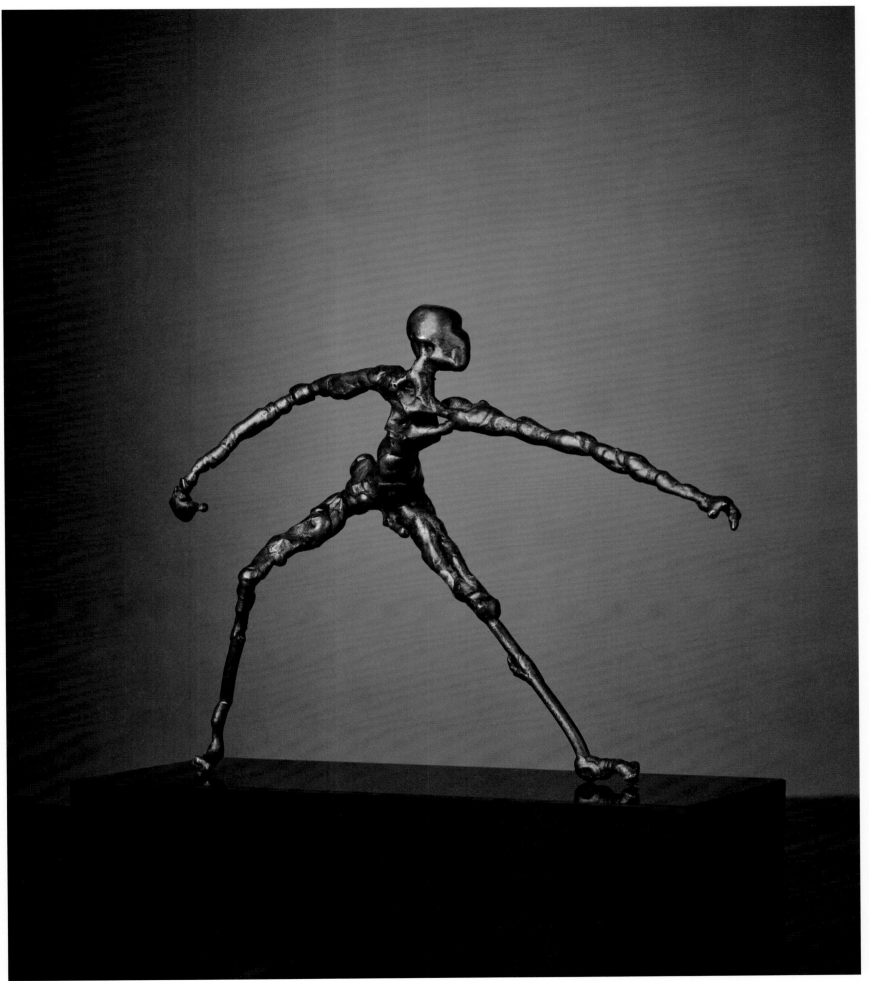

189

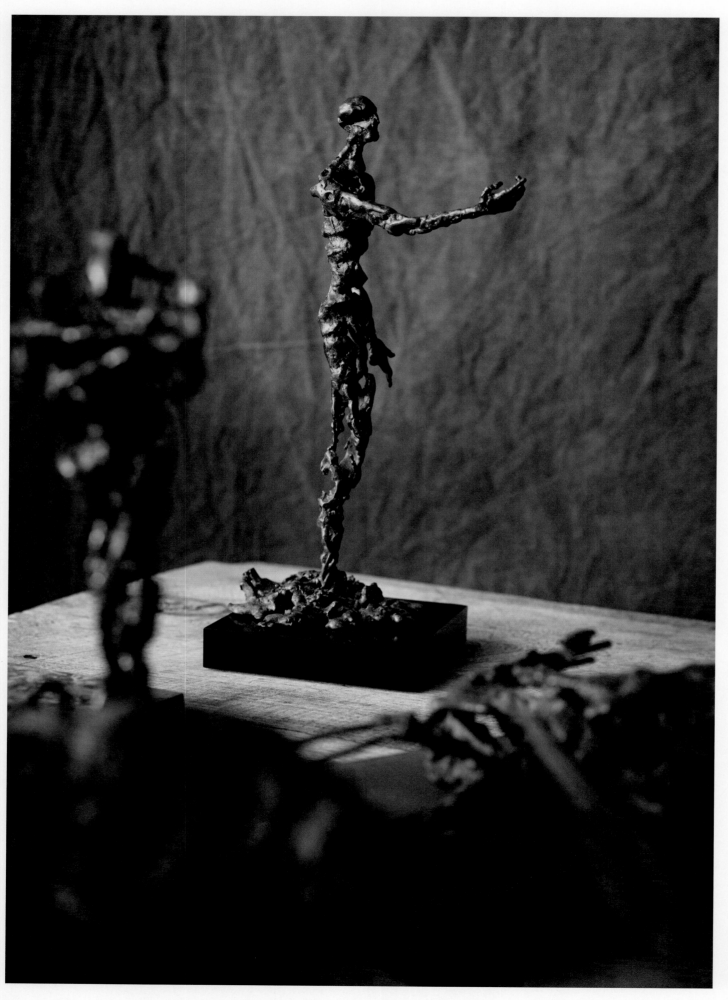

David Yurman
Man with Outstretched Hand, 1972, Direct-welded bronze. Photographed by Emil Larsson.

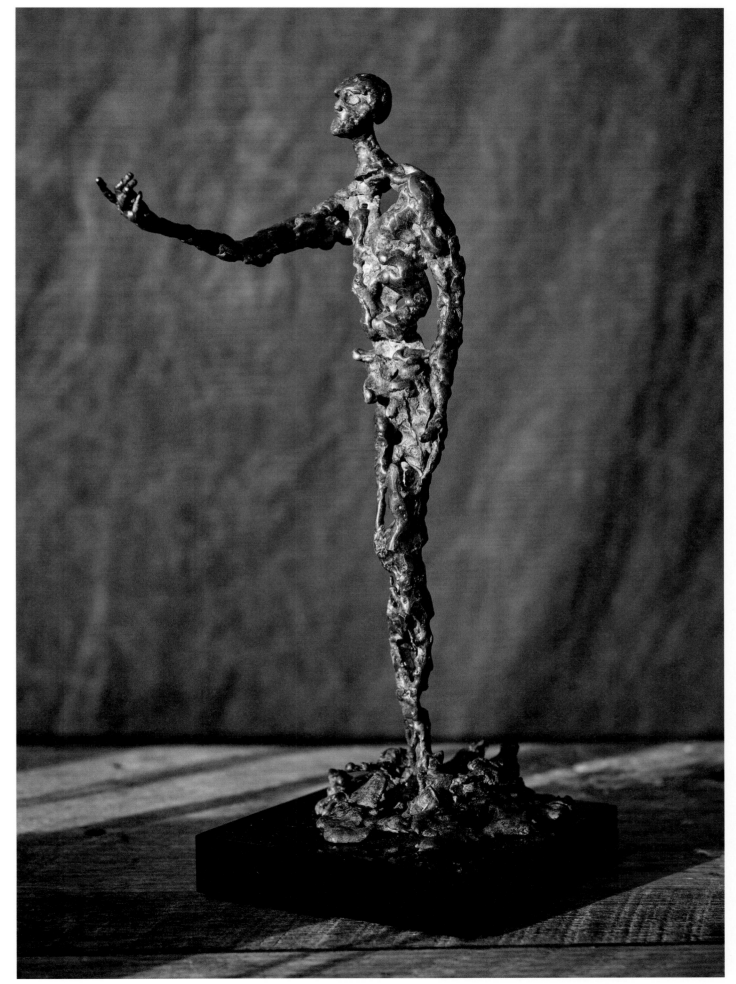

David Yurman
*Man with Outstretched
Hand*, 1972, Direct-welded
bronze. Photographed by
Emil Larsson.

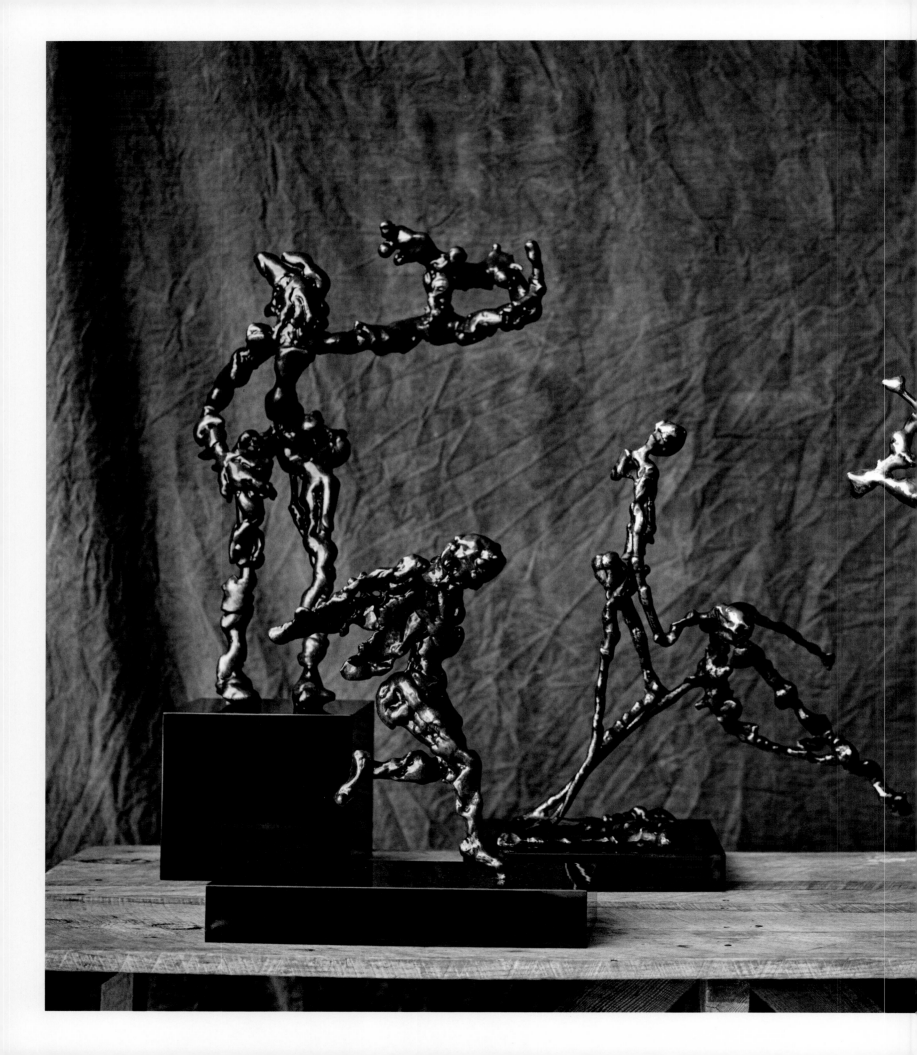

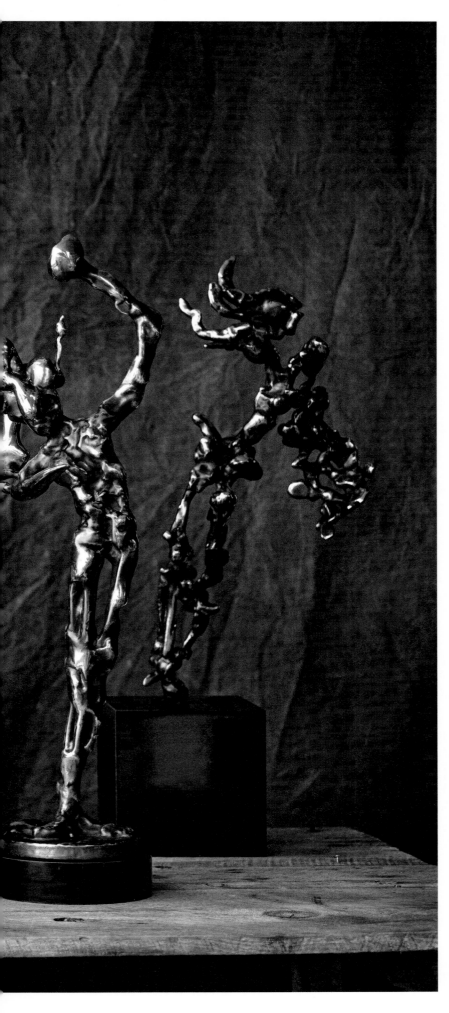

David Yurman sculptures, 2023.
Photographed by Emil Larsson.

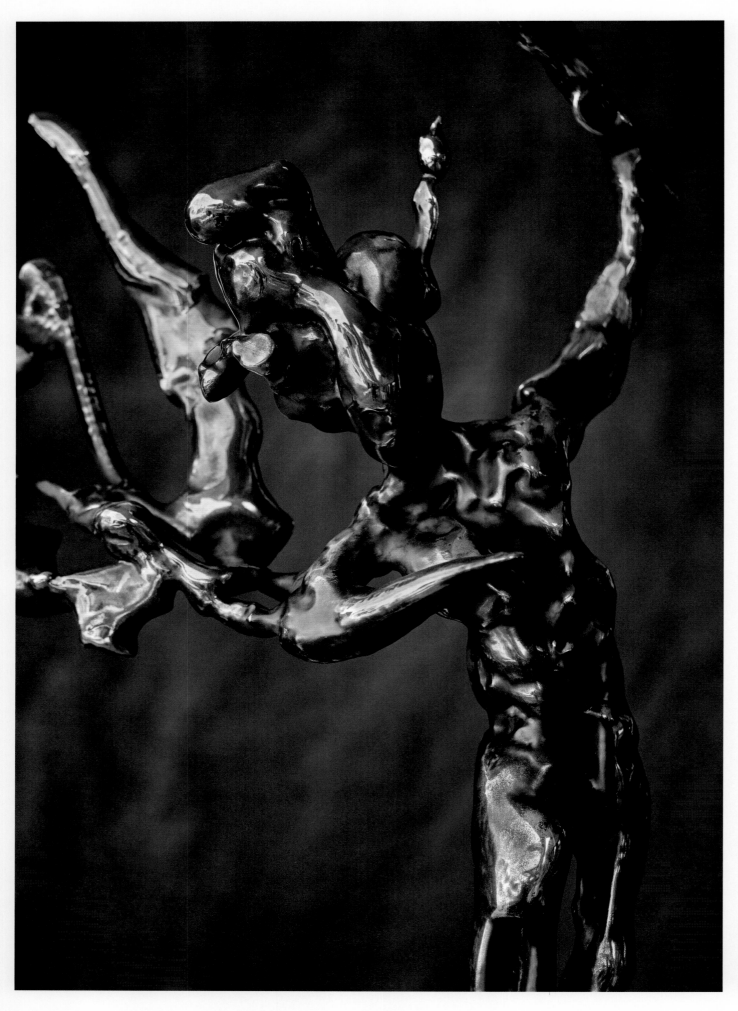

David Yurman
*After the Bathers by
Degas* (detail), 1975,
Direct-welded bronze.
Photographed by
Emil Larsson.

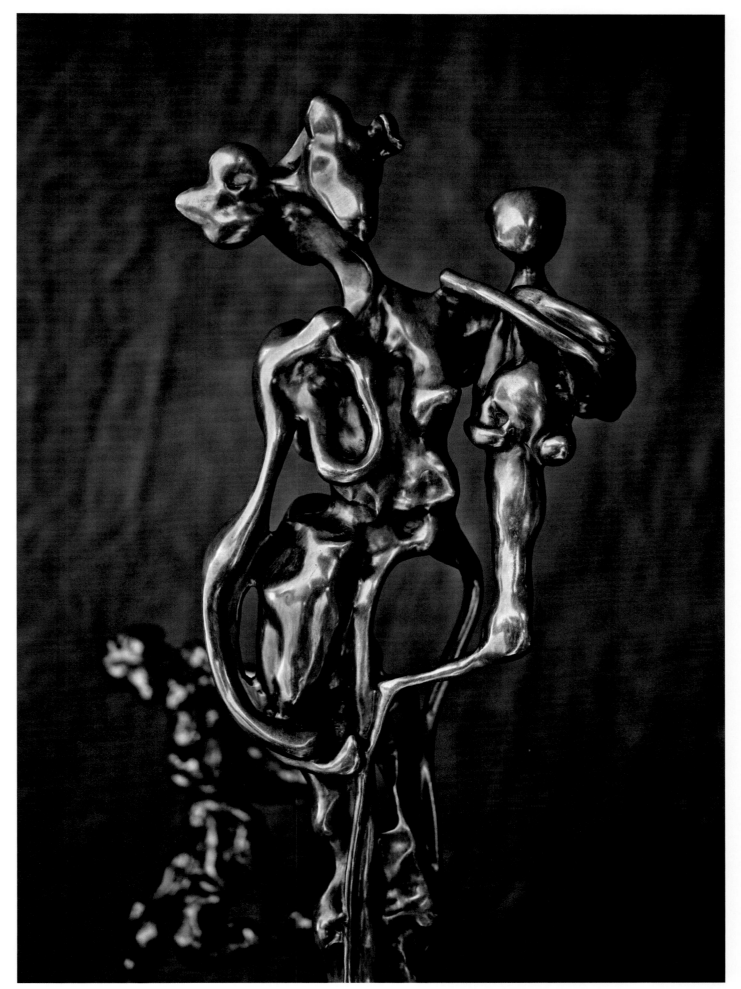

David Yurman
Mother & Child, 1971,
Direct-welded bronze.
Photographed by
Emil Larsson.

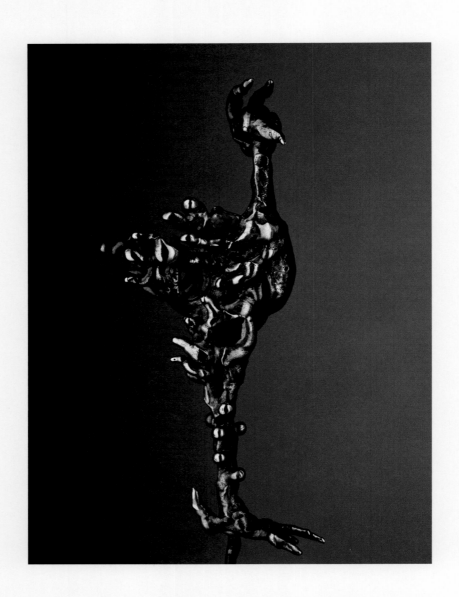

David Yurman
Untitled, 1970s, Direct-welded bronze.
Photographed by Emil Larsson.

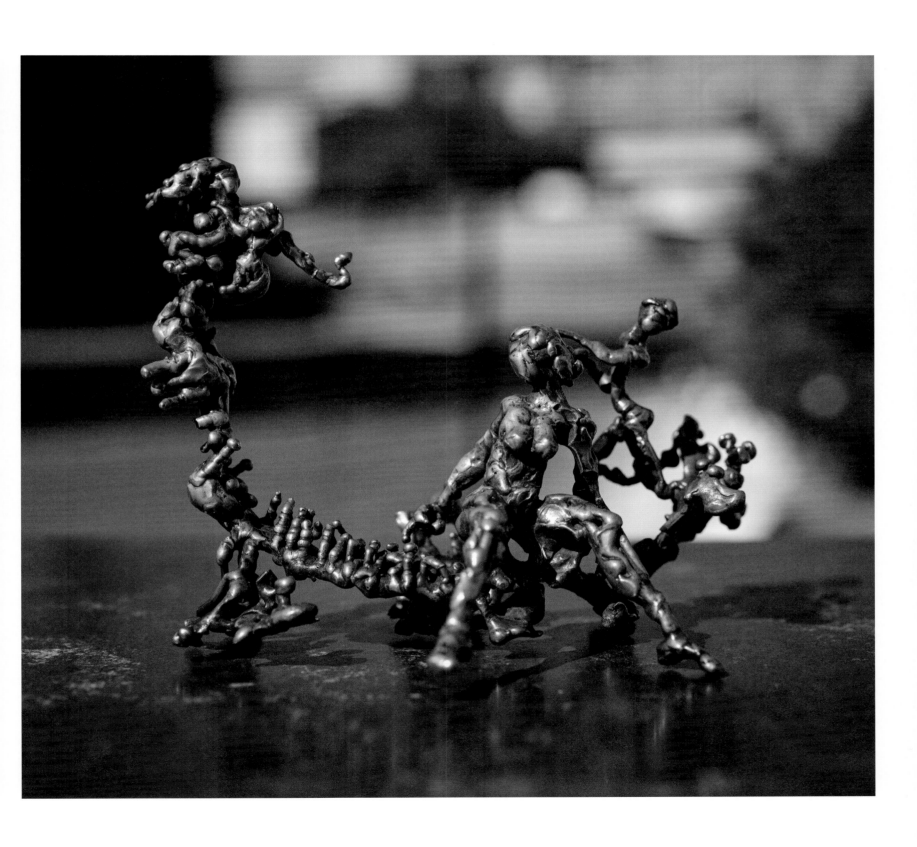

David Yurman
Cavorting Figures, 1970s, Direct-welded bronze.
Photographed by Emil Larsson.

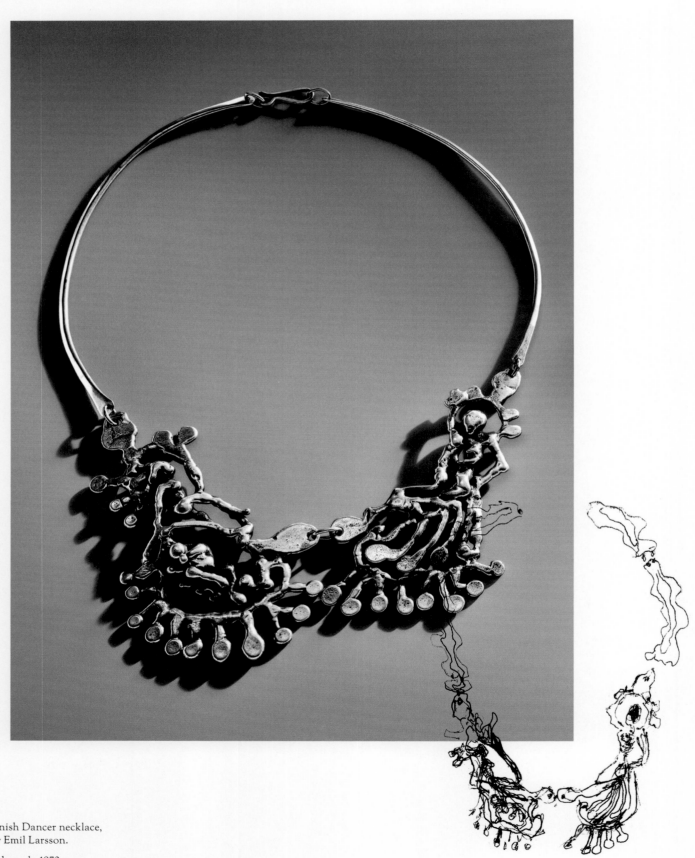

Top: Putnam Art Works Spanish Dancer necklace,
early 1970s. Photographed by Emil Larsson.

Bottom: David Yurman sketch, early 1970s.

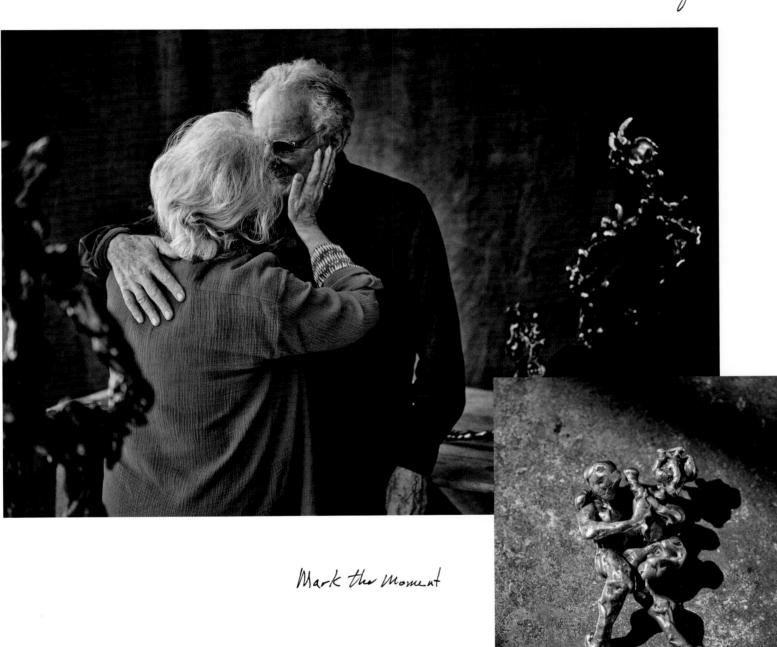

Forever Perfect

Mark the Moment

Top: Sybil and David Yurman, New York, 2023.

Bottom: David Yurman, Untitled, 1970s, Direct-welded
bronze. Both photographed by Emil Larsson.

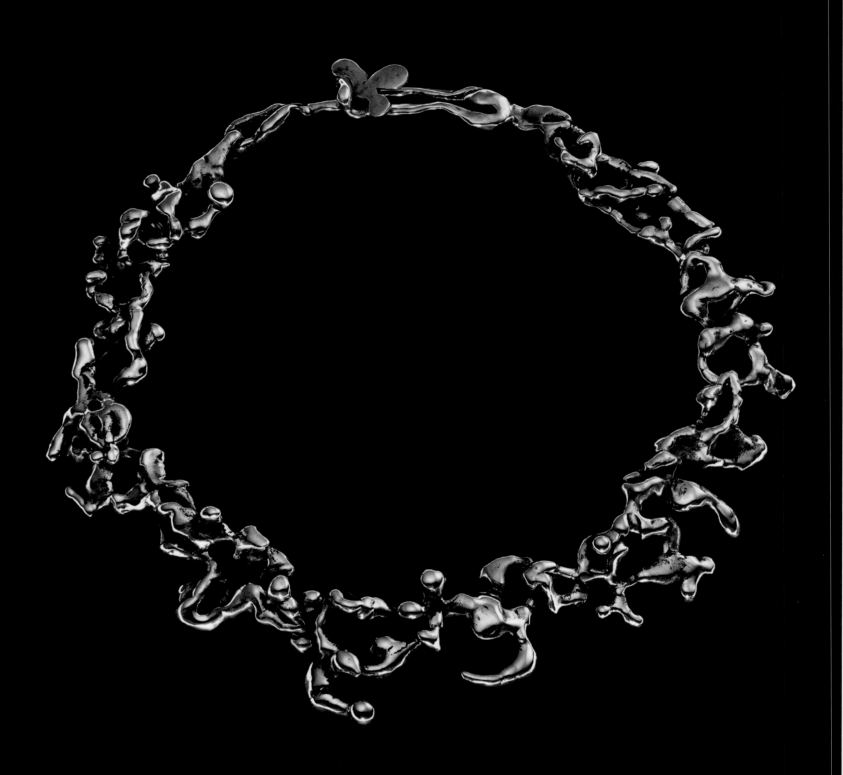

DANTE NECKLACE

"Initially, we had positioned ourselves in the art world, and in art galleries, because that's where we came from. The fashion world began to fall in love with our products only later in the early 1980s." Sybil explains, "David was doing his sculptures, which are beautiful. I loved his work and told him, 'I would love to be able to wear one of your sculptures. Isn't there any way you can make it into a piece of jewelry?'" David proceeded to create for Sybil a piece of sculptural jewelry: a welded bronze necklace with brazed figures that he named Dante. At that time, David was working with Jacques Lipchitz, whom he would often drive to the Forum Gallery on Madison Avenue in New York. Sybil recalls that, one afternoon, when she and David walked into the gallery, founded by Bella Fishko, "She asked me where I got my necklace. I turned around to David, pointed at him, and told her he had made it. She asked if he could make more. We literally—in sync—answered. I said, 'Yes!' and he said, 'No!'"

David had thought she wanted the necklace Sybil was wearing. He did not want to give it away, but Sybil took it off her neck to show Bella. The gallerist asked if they could leave her the necklace for a few days. By the time they returned to their apartment, Fishko had called them back to inquire about the price: she had already sold four pieces, stating it had been created by a collaborator of Cubist master Jacques Lipchitz. Sybil realized immediately that she had to learn quickly about key differences such as wholesale price versus retail price. They had created a distinct and desirable product and found a market where they could sell it. Sybil recalls that, "David worked round the clock filling these orders. I just kept adjusting the prices as it became a business. That's how it began." As David says of Sybil, amused, "It is not difficult to guess who the businessperson is here!"

"This is how it all began," says David. "I had to learn all the steps; we both had to learn everything from polishing and setting stones to building a business." Dante represents the Yurman outlook. It was a crossroads, where the art, craft, and jewelry design worlds met, but perhaps more importantly, it indicated a potential way to make a living.

David Yurman
Dante necklace, 1969, Direct-welded
bronze. Photographed by Emil Larsson.

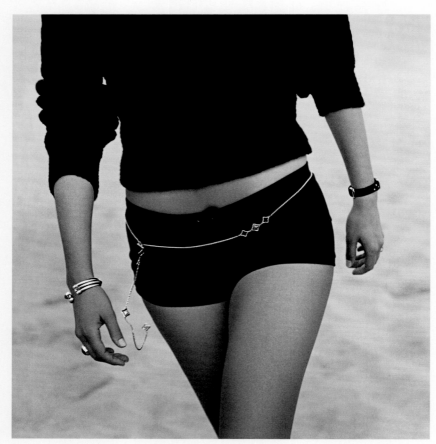

I make this links for practice and later made it for Sybil as a belt.

Amber Valletta wearing Quatrefoil necklace as a belt, St. Barts, 2001. Photographed by Peter Lindbergh.

Opposite: Direct-welded bronze chain made as a belt for Sybil Yurman by David Yurman, 1969. Photographed by Emil Larsson.

Following spread: Direct-welded link chains, 1960s–1970s. Photographed by Emil Larsson.

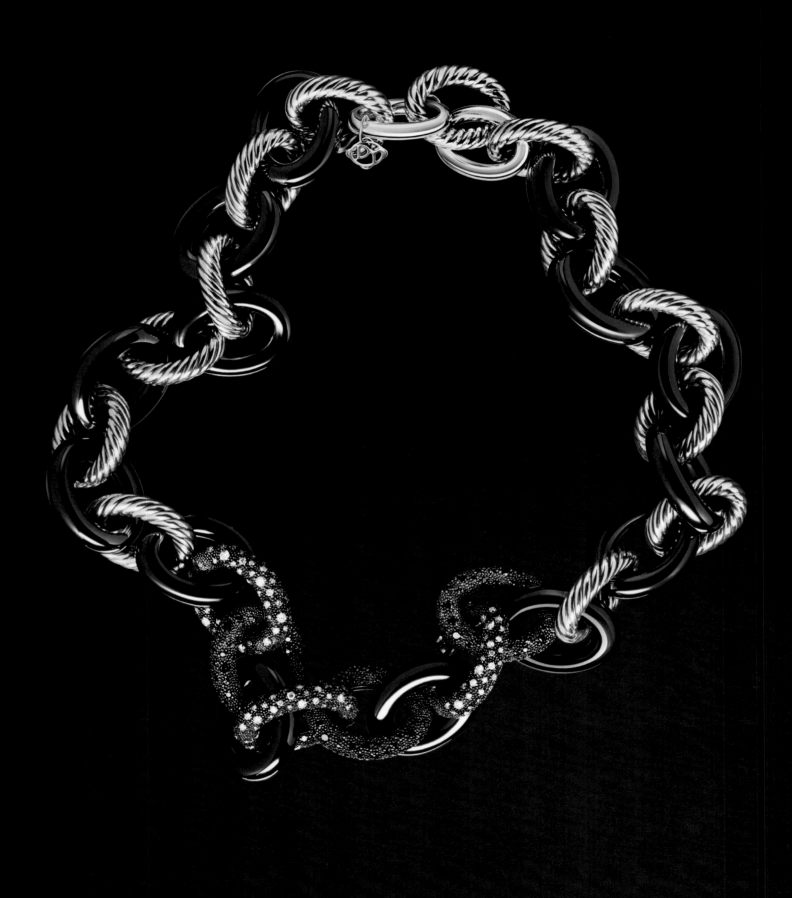

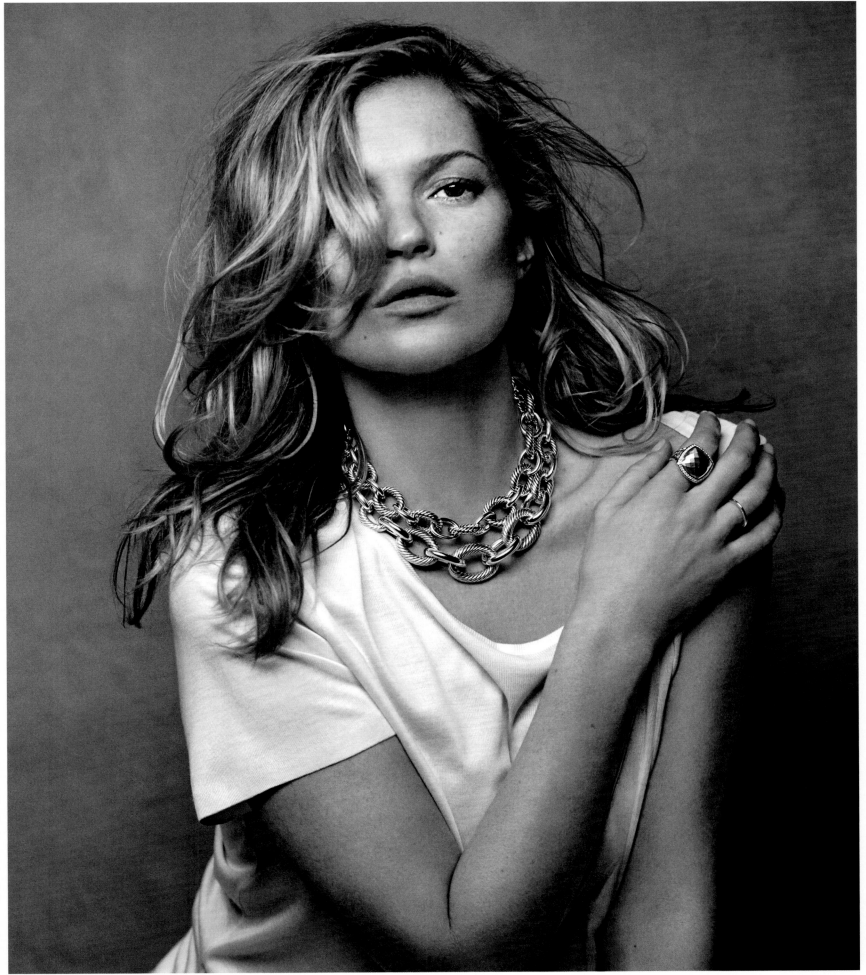

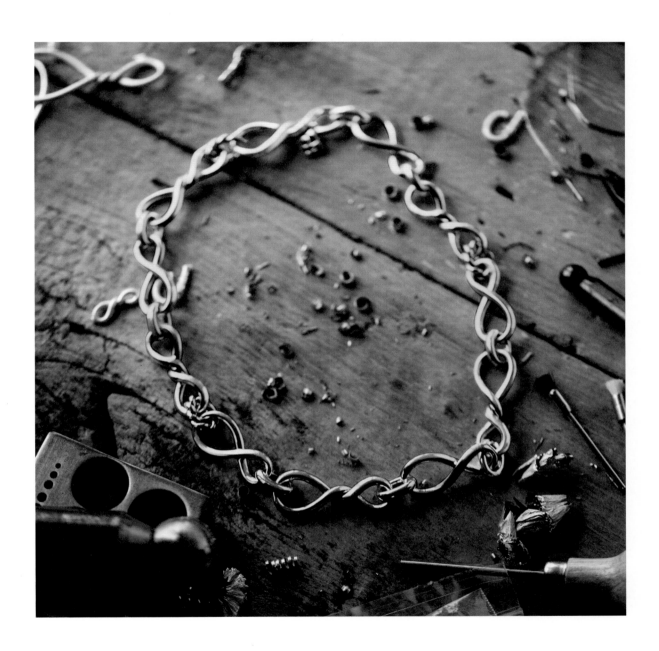

Previous spread, left: Midnight Mélange silver with black and white diamonds, and black ceramic link necklace, 2011. Photographed by Richard Burbridge.

Previous spread, right: Kate Moss wearing silver and gold dome and pavé-set diamond Albion ring with silver X oval link necklace, Paris, 2011. Photographed by Peter Lindbergh.

Opposite: Direct-welded link bracelet, 1970s. Photographed by Daniel Cano.

Yellow gold Continuance link necklace, 2016. Photographed by Kike Besada.

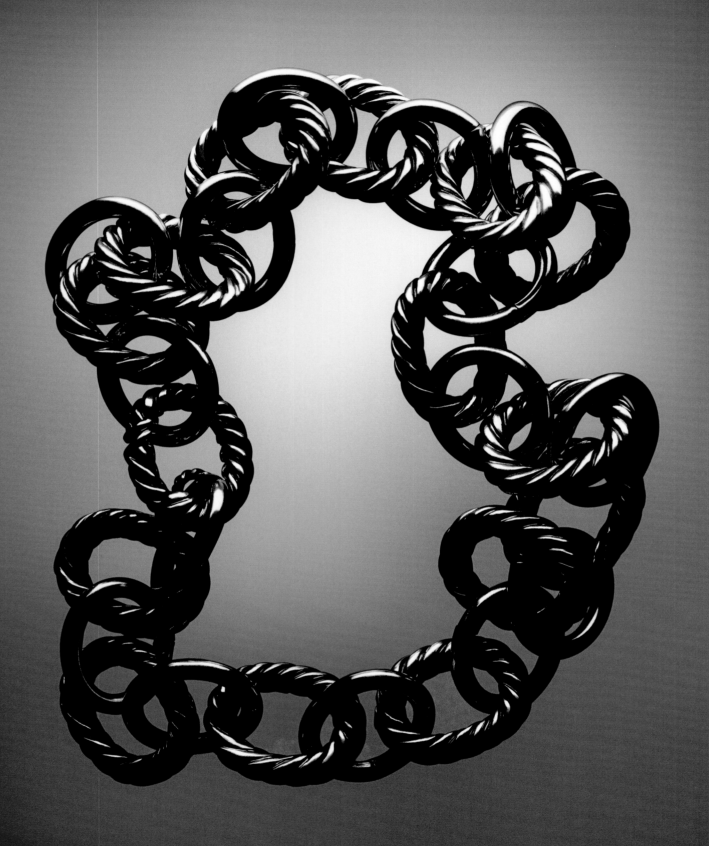

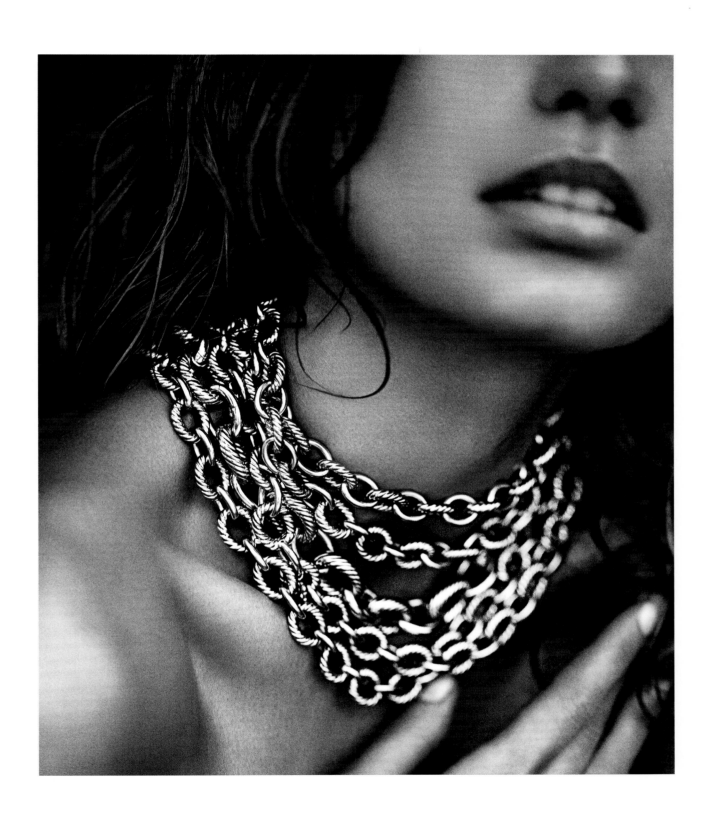

Opposite: Oversized Oval link necklace, 2003. Photographed
by Guido Mocafico.

Andrea Diaconu wearing silver and gold Oval link necklaces,
2014. Photographed by Mario Sorrenti.

David was drawn to the emotional power and grace of angels as exquisite allegorical figures. "How they spoke to me was in their physical form—how beautiful the body was; how beautiful the wings were. It could be Icarus flying too close to the sun or Daedalus holding Icarus's body. These sculptures were powerful in a very organic, understated, human way. They came from my unconscious through these thin metal rods. I held these bronze rods to the flame and I watched the shapes of angels unfold."

For Sybil, David's angel sculptures symbolized freedom: "I viewed David's sculptures differently than most people. Seeing all his works, I began to imagine them as wearable art! So to please me, David made a necklace with these beautiful, classical forms as a gift." These forms represented the heart and soul of what they both wanted to express as artists and the kind of life they wanted to live. "These pieces weren't literal," she adds. "They had feeling and emotion. David's work is about connection and about raw, tender, sensitive feelings. A lot of pieces were in great conflict, turmoil, and pain. Angels were these winged figures that were very powerful." One of her favorite pieces, the Angel belt buckle, was created when they first met: Sybil having forgotten to wear a belt, David made one for her while she was sleeping.

In 2001, David created a new Angel sculpture that became a symbol of the Yurmans' lifelong commitment to charitable causes when they established the David and Sybil Yurman Humanitarian and Arts Foundation. David sculpted the Angel for the foundation's Humanitarian Award, which is presented to individuals who give the gift of time, as well as funding, to charity and the arts. Past recipients include director Steven Spielberg, pop icon Elton John, and conductor Leonard Slatkin. In addition, Sybil and David have used their jewelry facilities to create unique designs to support many charitable causes. Their philanthropic efforts also include dedicating the sales of their Angel pin to Project ALS and the Elton John AIDS Foundation and creating a pin for the Silver Shield Foundation to benefit the families of New York City's firefighters and police officers.

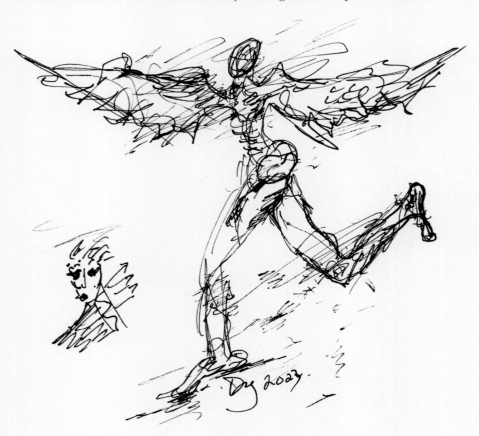

David Yurman, Gestural drawings, 2023.

Opposite: Angel and Mermaid & Fisherman direct-welded pendants, early 1970s. Photographed by Emil Larsson.

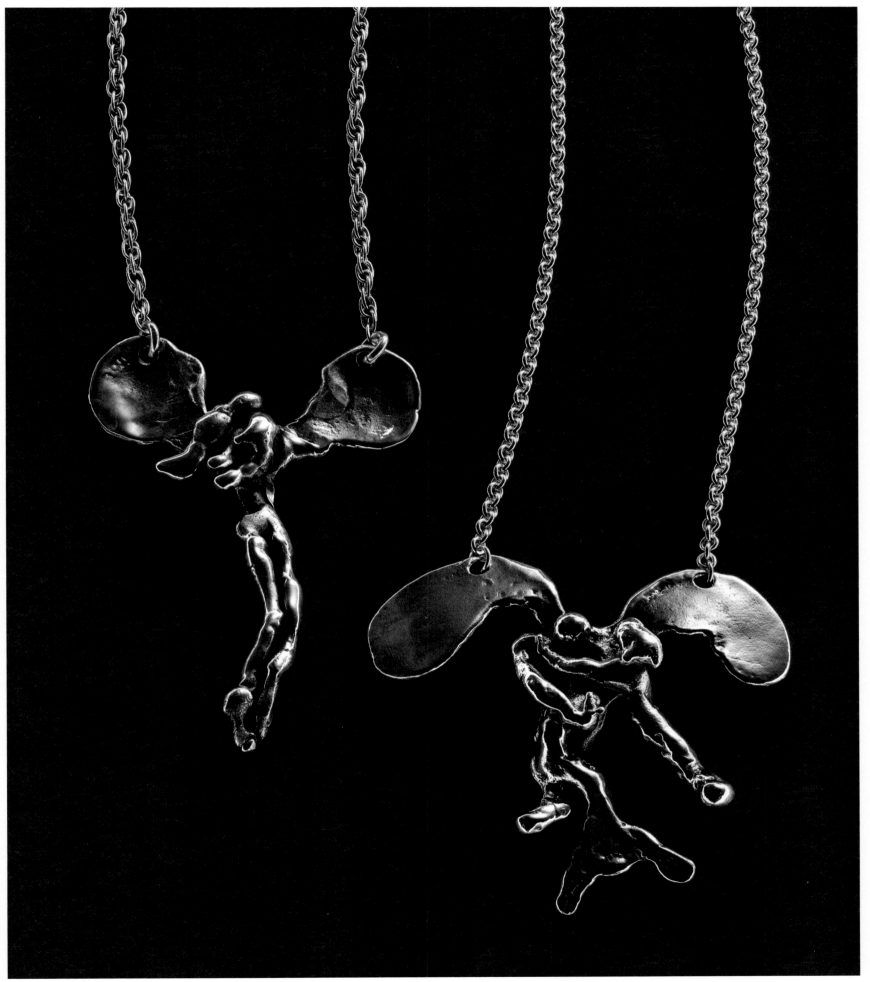

Icarus. Casting of direct weld. 1971

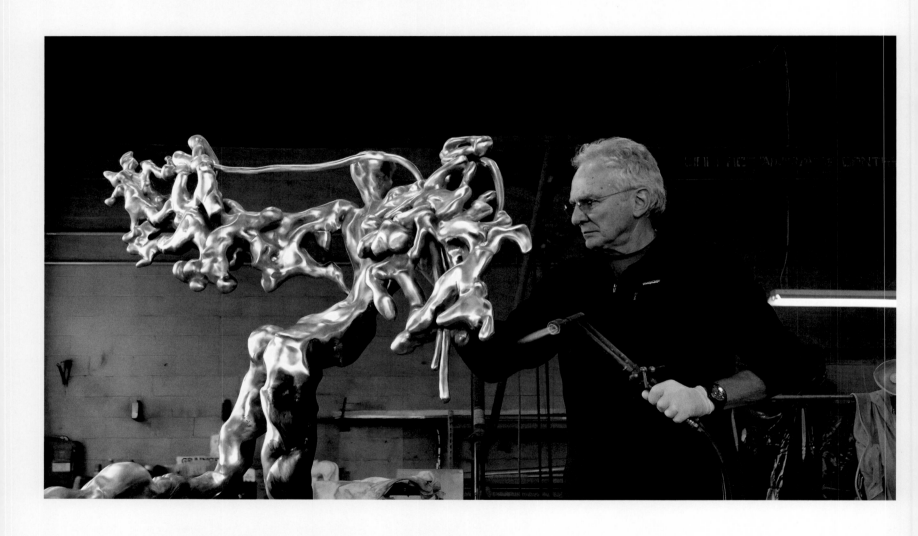

Previous spread: David Yurman
Icarus Angel, early 1970s, Bronze.

David Yurman sculpting, New York, 2014.

Opposite: David Yurman sculpting Angel at Talex Foundry,
Newburgh, New York, 2003. Photographed by Sybil Yurman.

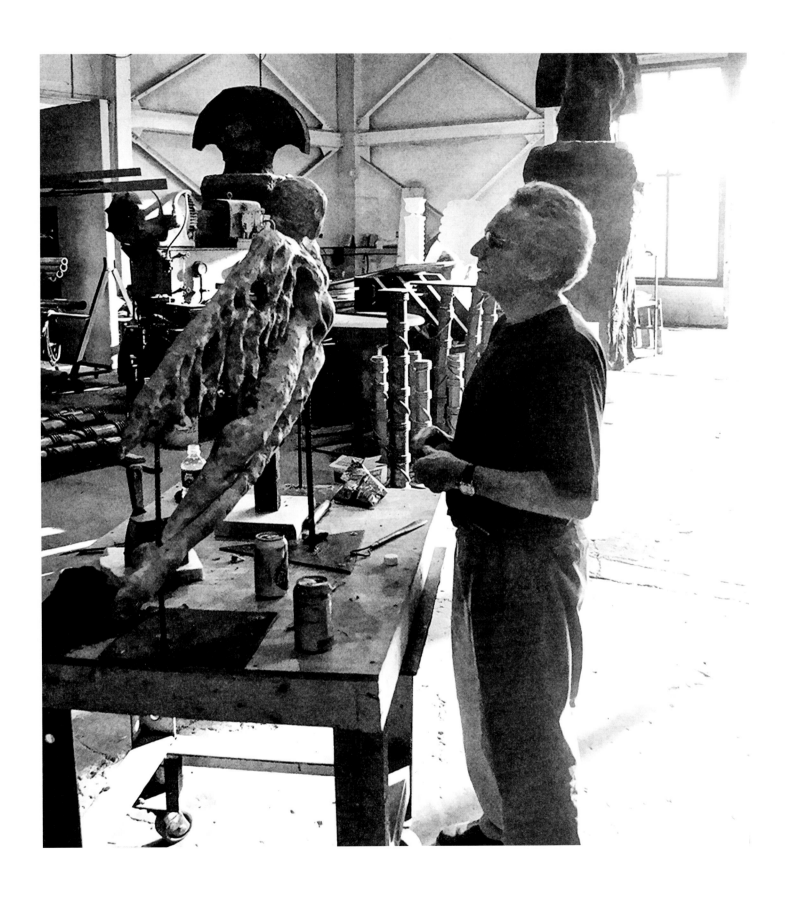

Trade shows have always played a pivotal role in the designer jewelry marketplace. In August 1969, David filled his 1962 Cadillac with his own craft jewelry and belts and drove to the famous Woodstock festival in Upstate New York. As it was advertised as a music and craft fair, David thought he could do some business at the festival, but things did not go as planned. He remembers, "People were interested in the bands and the music, not in our crafted pieces! It taught me it is important to scope your market before leaping into it. We packed quickly and left!" Around the same time, the Bennington craft fair was growing exponentially, morphing into the famed Rhinebeck fair in 1973. The outdoor craft fair became the benchmark for fine handcrafts, especially jewelry. Many designers got their start at this show, including David, who was creating small-scale wearable sculptures, belts, belt buckles, and beaded necklaces. "He certainly wasn't aware of it, but there was a place for his creations. Every time I wore one of his jewelry pieces, people would respond to it. When we went to the Bennington craft fair, the response from the buyers and the members of the American Craft Council was great. We were extremely stimulated to keep doing what we were working on," recalls Sybil. Ultimately, they received two awards: one for the Dante necklace, the other for the Icarus belt buckle. But how do you start your own brand when you don't have any savings?

In 1973, the young Yurmans moved to Putnam Valley, an hour's drive north of New York City, to create Putnam Art Works. Every week, they would travel to a different city or state, participating in some fifty craft shows a year to sell their jewelry, among them the juried craft fair in Rhinebeck. It was a unique opportunity for them not only to meet their customers but also to get exposure and build camaraderie with fellow artisans. It was a vibrant time. At the same time, Sybil was graduating SUNY Purchase with honors. Her thesis at Purchase, titled "Taking Your Pigs to Market: An Alternate Lifestyle," described the dysfunction of the craft fair model. David recalls, "It was a good apprenticeship for me because I was not only creating but selling and connecting with the customer. I learned how to display, how to pack."

"We did not have money to fill the orders," Sybil explains. "No bank was willing to lend us money. A Lower East Side immigrant loan association gave us a five-hundred-dollar loan. We could now afford the molds, which were ten dollars each." In their first year at the Rhinebeck craft fair, they presented their pieces on a card table topped with a blue blanket and built a display from the edges of tree-bark planks to hang their belts and belt buckles. David recalls, "We were in a terrible position, against the back wall, hidden by spruce trees, and on one side there was a dumpster. You really couldn't see our booth. Sybil managed to scout a second location in the air-conditioned building."

They presented in craft fairs over a period of about seven years. The time they refer to as their "craft period" lasted nine years. "It got old after a while because you have to pack up your stuff over and over again, go to Stowe, Vermont, or wherever the next fair was and set it up. Sometimes it would be raining, cold, and windy; it was outside. It was challenging, but in the end, I made most of my contacts at Rhinebeck," explains David. Around the same time, they met Peter Roth, a young student who was still in high school. He became their jeweler in Putnam Valley and still works with them to this day. David recalls their first encounter: "I shook his hand; I said, 'You're hired.' He replied, 'Well, you didn't even interview me.' I said, 'You have a great handshake, and you showed up!'"

FROM CRAFT TO COMMERCE

Top to bottom: First designer jewelry room at Retail Jewelers of America Show built during the New York City blackout of 1977, Americana Hotel, New York, 1977.

Retail Jewelers of America (RJA) show booth, New York, 1980s.

Premier Hall of Baselworld, Basel, Switzerland, 2006.

Opposite: David and Sybil Yurman, Clio necklaces made with hand-forged petals and Czechoslovakian glass beads, early 1970s. Photographed by Emil Larsson.

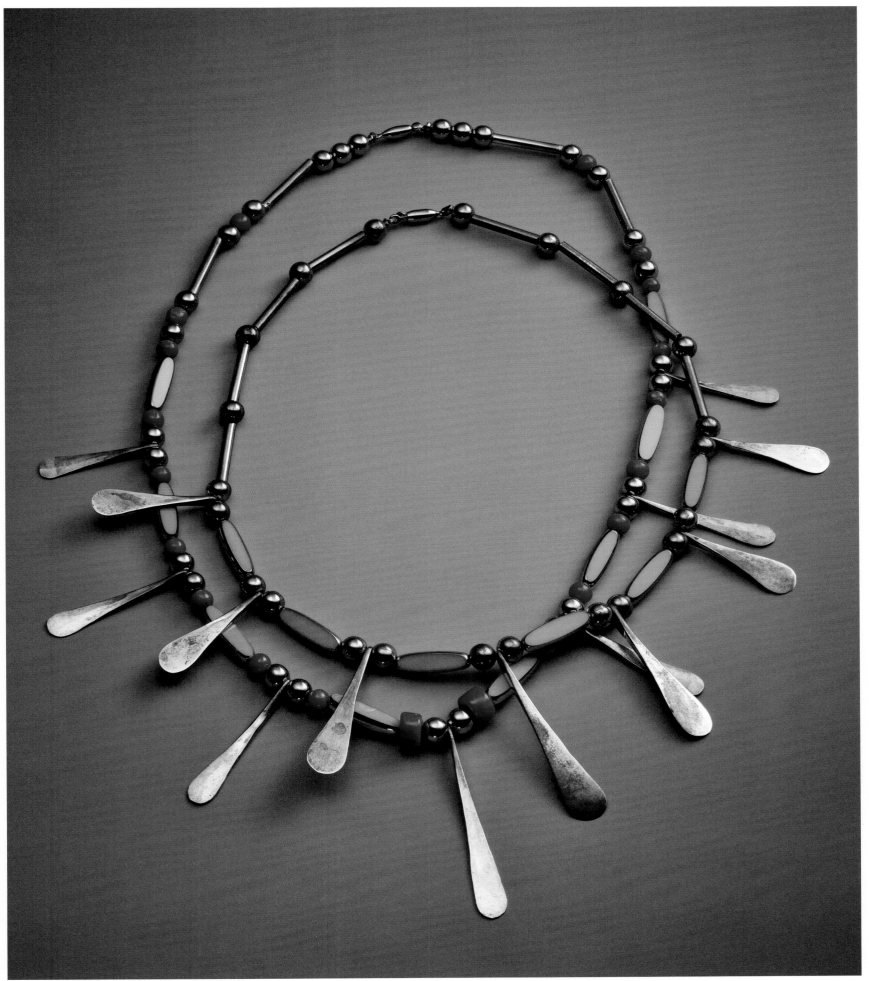

It was in many ways an existential existence: they were following their feelings at all times. In the 1970s, people questioned how they wanted to live their life, who they wanted to be, did they work to live or live to work? Sybil and David knew from the start that they were not going to work for someone else: the times were conducive to independence in so many ways. They were in the eye of the storm of the American craft movement. While the women's movement was making powerful inroads in the workplace, the New York art scene was booming and abundant, and to be an American artist was something groundbreaking. In those years, the development of a business was also a personal statement, as there was only fashion or fine jewelry in the marketplace. Early on, Sybil and David had a clear vision of how to fill that gap and how the brand should be marketed and presented in stores. They were requiring the retailers to display the Yurman collections together, with their logo, but beyond this, to embrace their philosophy and vision.

"The business was done very strategically from day one," explains Amy Rossi, former VP of commerce at David Yurman. "We treated the business as a brand, so it became something from the beginning. When we sold in department stores, it had to fulfill very specific requirements; it had to have a certain type of counter, special displays, co-op advertising; there was a certificate of authenticity and custom packaging. We wanted to convey this feeling that you were getting something of value, something to treasure. This was the core of our merchandising and our cohesive message, the way we sold the product. Also important was how we made business plans for each market and account—it was a serious business. To have an opening order, you had to order a minimum amount, and cohesive collections that represented the breadth of our products. I mean, we were a bit too ambitious, but it worked; we presented ourselves like we were Rolex!"

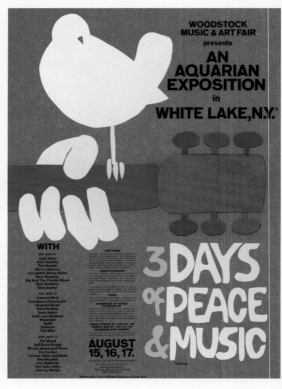

This page and opposite: A collection of early art and craft fair posters from the 1960s and '70s that Sybil and David Yurman attended.

Center: Outdoor craft displays at the Northeast Craft Fair 12, Rhinebeck, New York, June 23–25, 1977.

Opposite, top: "Crafts and Commerce: Bridging the Gap" by Ettagale Laure, *Jewelers Circular-Keystone*, March 1982.

Opposite, bottom left: Directory from the 1976 Northeast Craft Fair 11 held by the American Craft Council in Rhinebeck, New York.

Crafts and commerce: Bridging the gap

by Ettagale Lauré
JC-K New York editor

It's only a hundred miles or so from New York to Rhinebeck but it's another world as far as commerce is concerned. Rhinebeck is the craft world, peopled by young artists; New York is the home of nuts-and-bolts businesspeople, making a living. What then of those mavericks who have one foot in both worlds? More than a dozen young jewelry designers have bridged the gap by selling at both the Rhinebeck Craft Fair and the Jewelers of America show. How do these two worlds of craft and commerce co-exist?

There's no doubt about one thing— Rhinebeck is fun. It's a show that still houses some of its exhibitors in big yellow and white striped tents. The most permanent spaces are in buildings with corrugated tin roofs. When the sun beats down, they heat up; when the rain hits, it's like listening to thousands of tiny hooves. One is never far from the elements at Rhinebeck. In between bouts of buying, customers can pick up a delicious,

healthy lunch and a fresh-squeezed lemonade and relax in the shade of a big tree on the vast lawns that surround the exhibit areas.

Because Rhinebeck is a crafts show, it's not all jewelry. Shoppers can browse past exquisite pottery, art glass, woodwork, leather, tapestries and other hand-made goods. These refresh the eye and enable the buyer to view the next jewelry exhibit with renewed enthusiasm.

For the exhibitors, Rhinebeck offers a place to share and exchange information. The value of such shop talk is called the key to Rhinebeck by jewelry designer David Yurman. Yurman's experiences at Rhinebeck go so far back that the show wasn't even *in* Rhinebeck yet—it was still a wild and woolly event held in Bennington, Vt., with not even a tent overhead.

Yurman, who was showing a line of belt buckles under the company name of Fatty R. Buckle Co., describes his show space as "up against a brick wall behind a spruce tree." It was 1970, and he stayed with the show through the move to Rhinebeck a few years later. Each year he submitted

slides of his work and each year he was accepted. In July 1977, he did his first JA show, appearing in the first New Designer Room. Although it was

Yurman

a big move for Yurman, who says, "I really felt I was turning a corner when I did it," in fact he did more

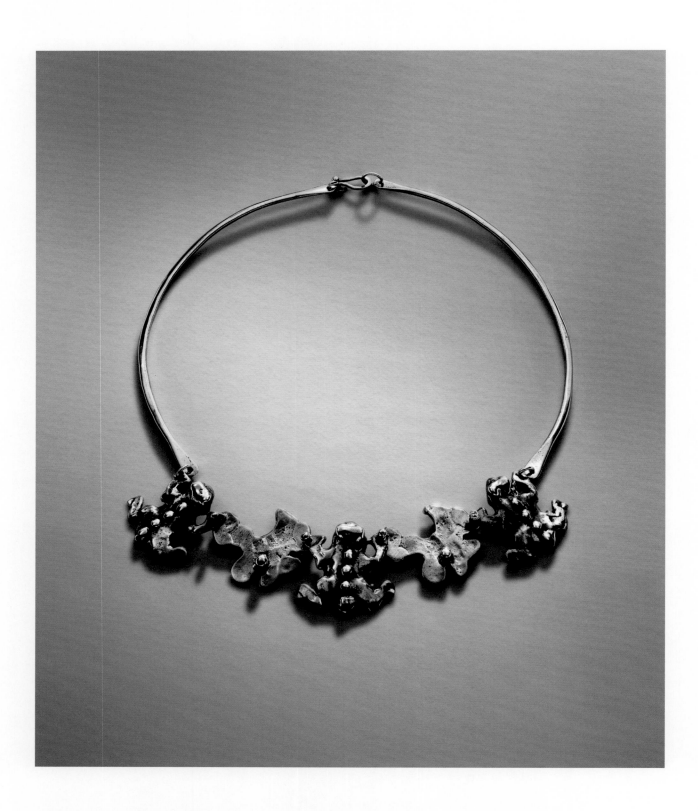

Putnam Art Works Frog and Petals necklace, bronze and silver early 1970s.

Opposite: Putnam Art Works Baroque mirror necklace, direct-welded bronze, early 1970s. Both photographed by Emil Larsson.

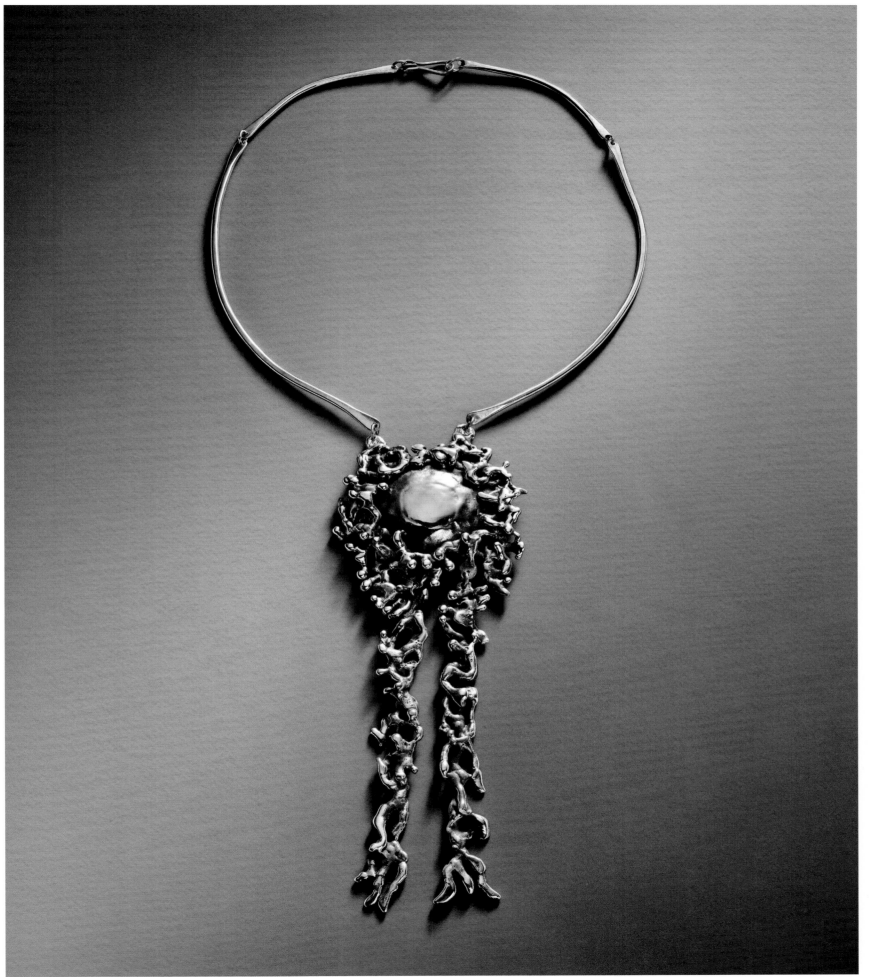

THE BUCKLES BUSINESS

BY PAUL GREENHALGH

One of the first major product lines that David developed was belt buckles. As a vehicle of expression, these had considerable advantages for the young artist. Most directly, the buckles allowed him to use his sculptural sensibilities. They often have the feeling of sculptural figure groups, twisting and dancing around a framework, akin to a miniature version of Rodin's *Gates of Hell*. In some respects, they also facilitated David's transition from being a sculptor making jewelry to a jeweler who had sculptural abilities. The use of stones eventually made the transition complete. David's experience with leatherwork also drove the aesthetic success of the buckles. They had a powerful ambiance of wearable art and sat perfectly in the fashion world of the late 1960s and 1970s.

More than this, the buckles facilitated Sybil and David's wider vision of practice. They were committed to the view that to live and work consistently at the highest level, artists have to engage meaningfully with commerce. For them, this is true of all the arts but especially so with jewelry. It is not simply expensive to buy, it is expensive to make; therefore, a relationship between maker and consumer has to exist in order to achieve the best quality. The two of them understood this from the earliest days. In her thesis at SUNY Purchase, titled "Taking your Pigs to Market," Sybil had articulated the need for the crafts to engage with economics. The thesis provocatively addressed a major feature of the crafts scene, that craftsmen tend to dislike commerce rather than seeing it as part of the process.

Sybil explains, "When I wrote my paper on "Taking your Pigs to Market," I watched people in the crafts movement do everything to get in their own way of selling their product. . . . Because of their need to maintain their individuality, they maintained their integrity, and they went down with the ship, as it were. Wearing earphones while they were at a craft fair, so they didn't have to be bothered by people . . . maintaining an indifferent distance from people who were interested in their work. They shied away from any praise of their work. It was the craziest thing. Here were these people who could barely pay for their gas to get there. For the people who I liked . . . I would feel bad for them or have sympathy for them, and I would go and sell for them during the day."

The logic is clear. The right environment for viewing a painting is a gallery; the right environment for viewing a piece of jewelry is the human body. Once this truth is embraced, it is clear that the jeweler must have an understanding of the people who will wear their work. In short, the audience is part of the process, and there is no significant space between creativity and commerce—the two are interdependent. The buckles proved an excellent vehicle for David to fuse art and commerce, a way of sharing his artistic vision with his audience.

Sleepless nights caused by a persistent chorus of frogs from a small pond in the Putnam Valley inspired these frog belt buckles.

Opposite: David Yurman belt buckles, late 1960s–early 1970s. Photographed by Emil Larsson.

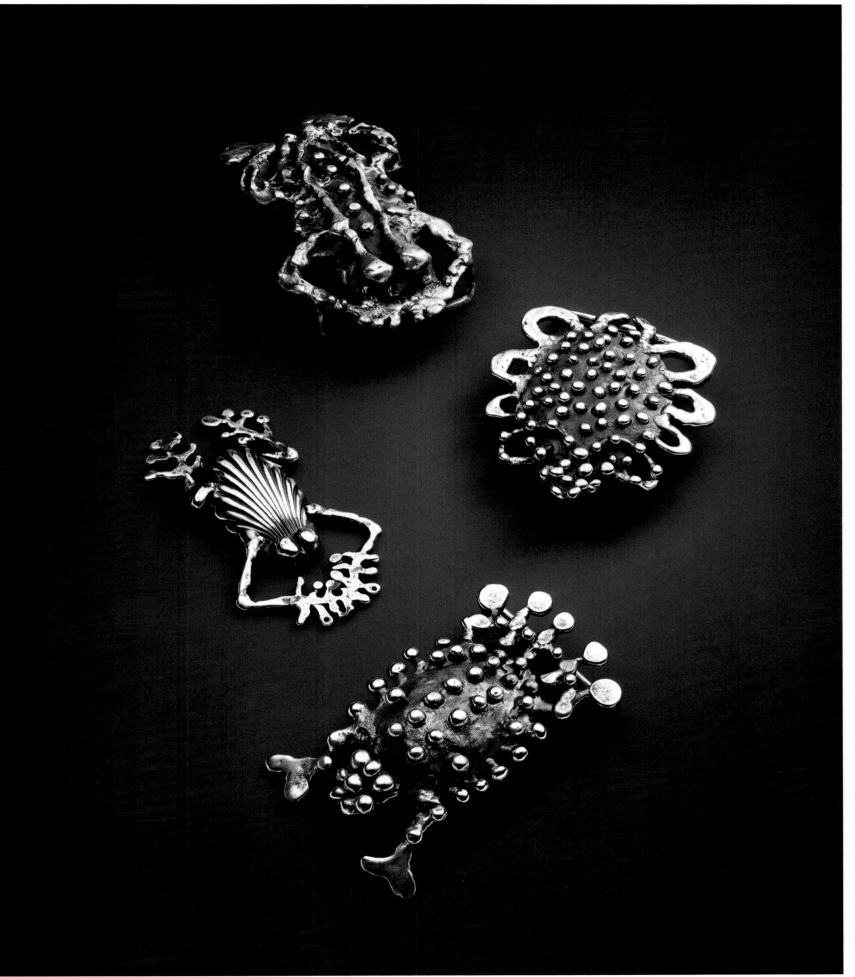

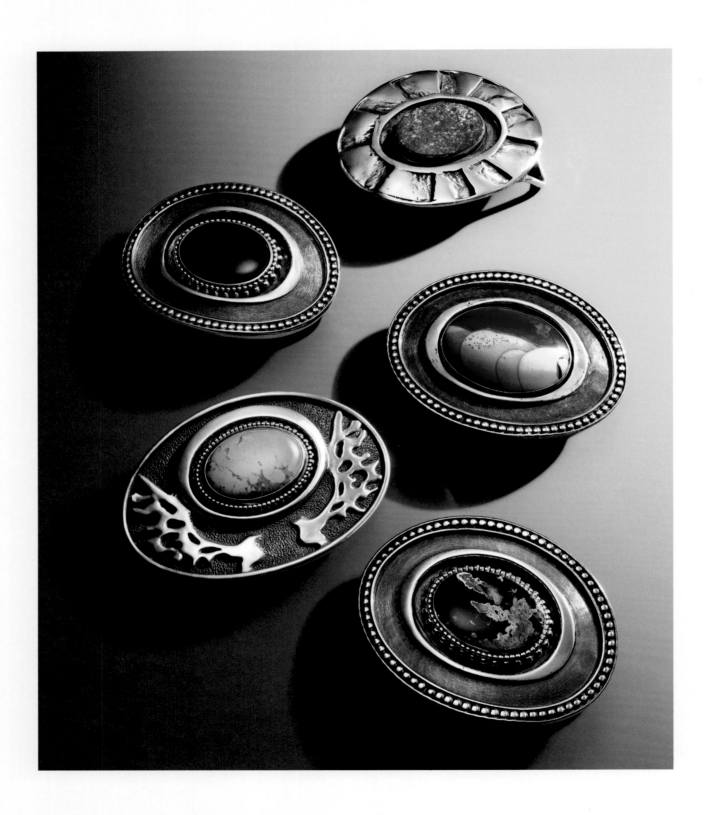

David Yurman belt buckles, silver with exotic stones (top to bottom): lapis, black onyx, turquoise, agate, and tiger's eye, late 1960s.

Opposite: David Yurman hand-carved buckle, jasper concho with wings, with hand-patinaed belt, late 1960s–early 1970s. Both photographed by Emil Larsson.

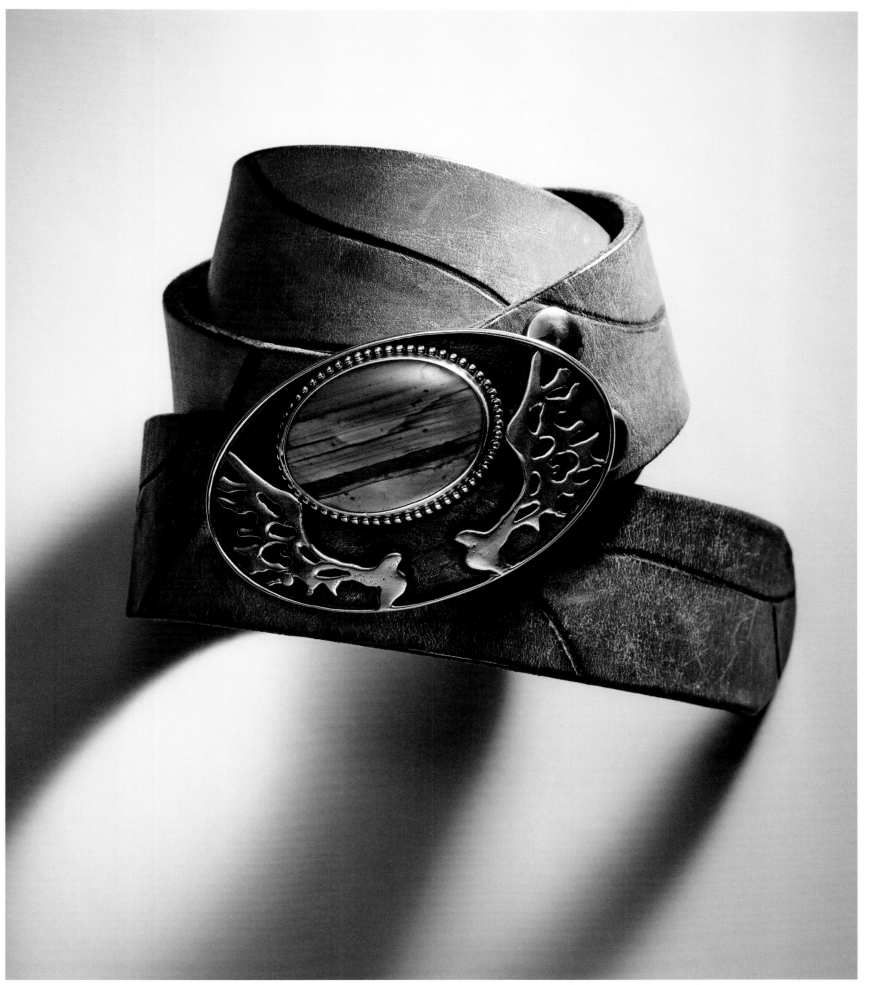

David and Sybil Yurman

Sybil Yurman

Yurman's 12-strand collar of blue onyx, turquoise and yellow pearls

David Yurman

"**W**hen someone chooses to wear a particular piece of jewelry, it's often connected with something unconscious and in some way related to history," says David Yurman, who, with his wife, Sybil, owns Yurman Designs, a business they started with $500.

The team has been selling its fine-jewelry collection for 1½ years. David has been a sculptor; Sybil is a painter. Both design the collection — now 168 new pieces, ($120 to $3,500, retail). "This collection," says David, "is a classic revival using contemporary materials, like apricot color fresh water pearls with amethysts set in gold."

Whether the designs are single or multistrand necklaces, incorporate a few, or many, different stones — there is an understated mood. The showiest piece is the necklace of dyed blue onyx, turquoise, and yellow pearls with an 18-karat gold flower clasp which detaches to be worn as a pin. "I find that most jewelry with an over encrustation of stones leaves me cold," emphasizes David. "Bulgari's pieces are an inspiration — the work is so fine."

Both Yurmans agree the fluctuation of gold prices is a big challenge because, "We will have to come up with a new approach to jewelry — setting stones in stones, for instance. It's a way of avoiding gold for the middle market. Another approach is using gold so the value is visible."

The couple lived in Putnam Valley, N.Y., where they had a workshop and sold their sculpture jewelry to galleries.

"We came to New York just to get more exposure for our artwork," explains David. "I had a whole sense that my jewelry was right here; that the city is a lot about how you look and what you wear.

"I want to use fine materials in beautiful arrangements of color — for day . . . pieces that look expensive but are not outrageous in price.

"We feel connected with a tradition in jewelry — from the Greek Minoan period and the Renaissance — when materials incorporated sunlight, creamy buildings and a simulation of nature. Egyptian pieces are perfect examples."

"David and Sybil Yurman" by Bobbi Queen,
W magazine, May 1980.

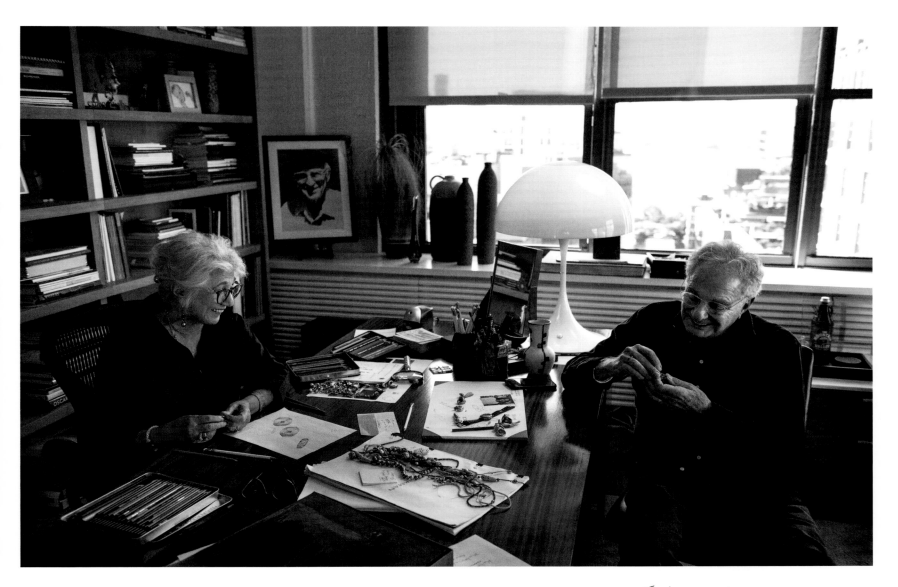

Sybils office in Tribecca Studio "Headquarters"

Sybil and David Yurman in Sybil's office at the Vestry Street
headquarters, New York, 2023. Photographed by Norman Jean Roy.

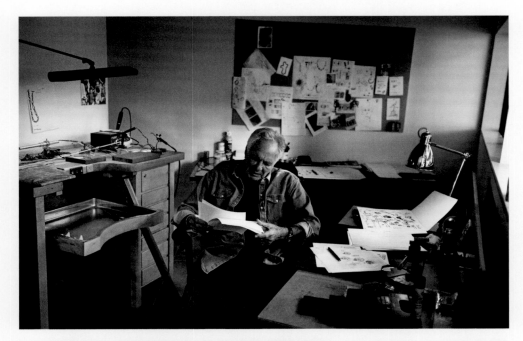

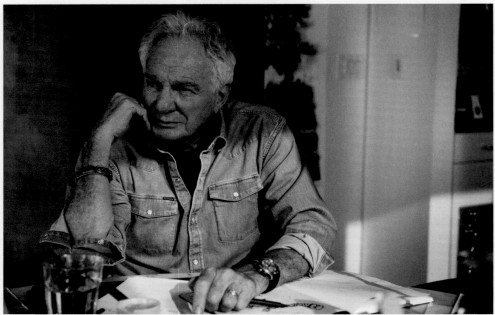

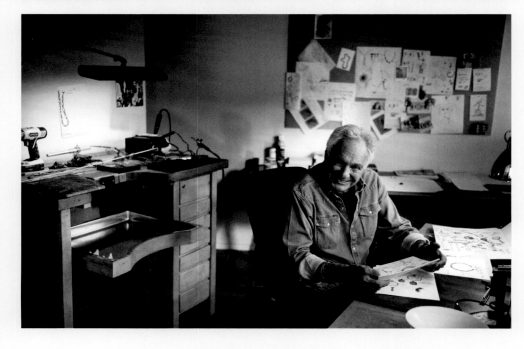

David Yurman at his home studio, New York, 2023.
Photographed by Norman Jean Roy.

David Yurman in his office at the Vestry Street headquarters,
New York, 2023. Photographed by Norman Jean Roy.

In 1981, David was approached by the prestigious Cartier jewelry house to design a collection for the coming year. The approach made to David was seminal not only in the recognition of the young American's unique talents and growing influence but also in the acknowledgment of two worlds coming together. David and Sybil had become a significant force in the American craft movement. The established and traditional jewelry houses had always lived in a different universe. Cartier was acknowledging that David had broken through the barriers that had separated these worlds of advanced modern craft and high jewelry design.

For the young designer, having a dedicated window to display his creations on Fifth Avenue at Cartier was important. David developed a collection using black onyx beads, replacing his customary red coral with red garnets, framed by his now-signature mix of silver and gold.

The Cartier commission gave David and Sybil a greater sense of creating work in collections, rather than one-off pieces. A collection allowed themes to be fully explored and ideas to be carried to new levels. The Yurmans later built signature collections and sold them to major stores, with the agreement that they would buy whole collections and identify them directly with David's name.

Opposite: Jewelry designed for Cartier, 1985.
Photographed by Emil Larsson.

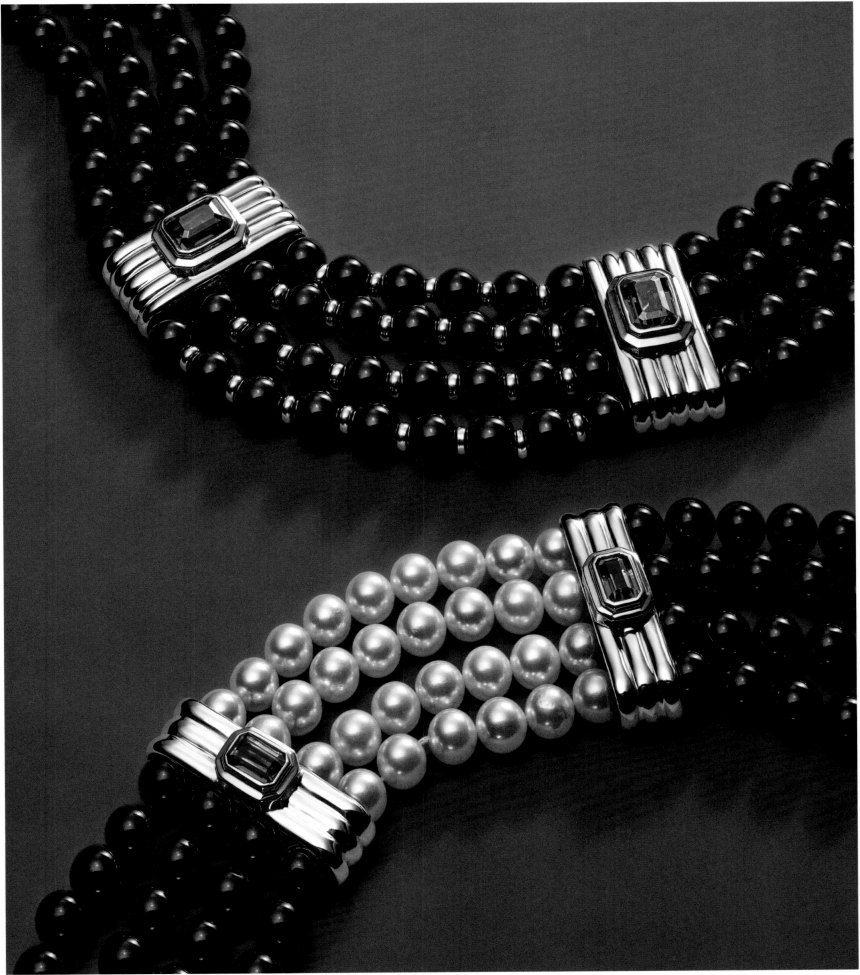

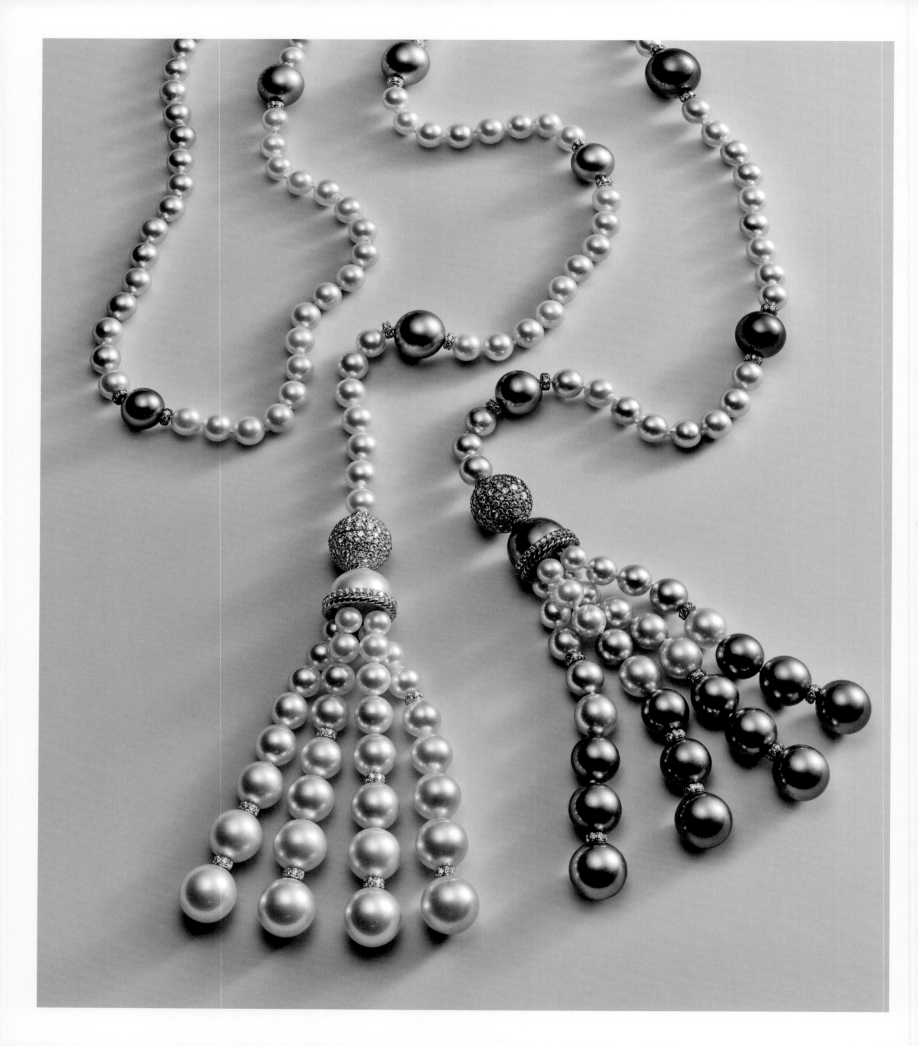

PEARLS

David's love of pearls began at the age of eleven when he purchased a turn-of-the-century gold lavalier pendant with a single Mississippi wing pearl for his mother from an antiques dealer who knew her. She generously allowed David to pay what he could afford.

In 1981, David was named Designer of the Year by the Cultured Pearl Associations of America and Japan for his artistic use of pearls. To create his award-winning mabé pearl and amethyst necklace, David combined blister pearls with cabochon amethysts and handcrafted eighteen-karat bezels. The inspiration for this innovative pearl necklace began with a visit to a pearl dealer, Assael, and finding a bag of blister pearls. Sybil and David saw something very organic and beautiful in these blister pearls, which were not normally used for jewelry. They bought every single one the dealer had in stock.

This one-of-a-kind pearl necklace was chosen by the editors at *Harper's Bazaar* to appear on the magazine's front cover. It was also featured on the front cover of *Jewelers' Circular Keystone*, a jewelry industry publication. The Yurmans recall, "A few months later, these blister pearls became much more expensive. We also started selling rice pearl necklaces, and as soon as we started advertising them, everybody wanted them. Major American department stores were buying more than we could possibly supply; the pearl boom of the 1980s had begun." In 1982, David was named Designer of the Year for a second time for his body of work using pearls.

Opposite: Tie necklace with detachable tassels made with South Sea and Tahitian pearls and pavé-set diamonds in white gold. Photographed by Emil Larsson.

Naomi Watts wearing one-of-a-kind South Sea cultured pearl necklace with jewel bead clasp, 2006. Photographed by Peter Lindbergh.

David Yurman watercolor of the Mabé pearl necklace, early 1980s.

Opposite: Mabé pearl necklace in 14-karat gold with amethyst and large gray Mabé pearls, 1980. Photographed by Emil Larsson.

Following spread: Kate Moss wearing Tweejoux necklaces with silver box chain necklace, 2007. Photographed by Peter Lindbergh.

Mabé & Blister Pearls

a Love Affair with Mabé Pearl

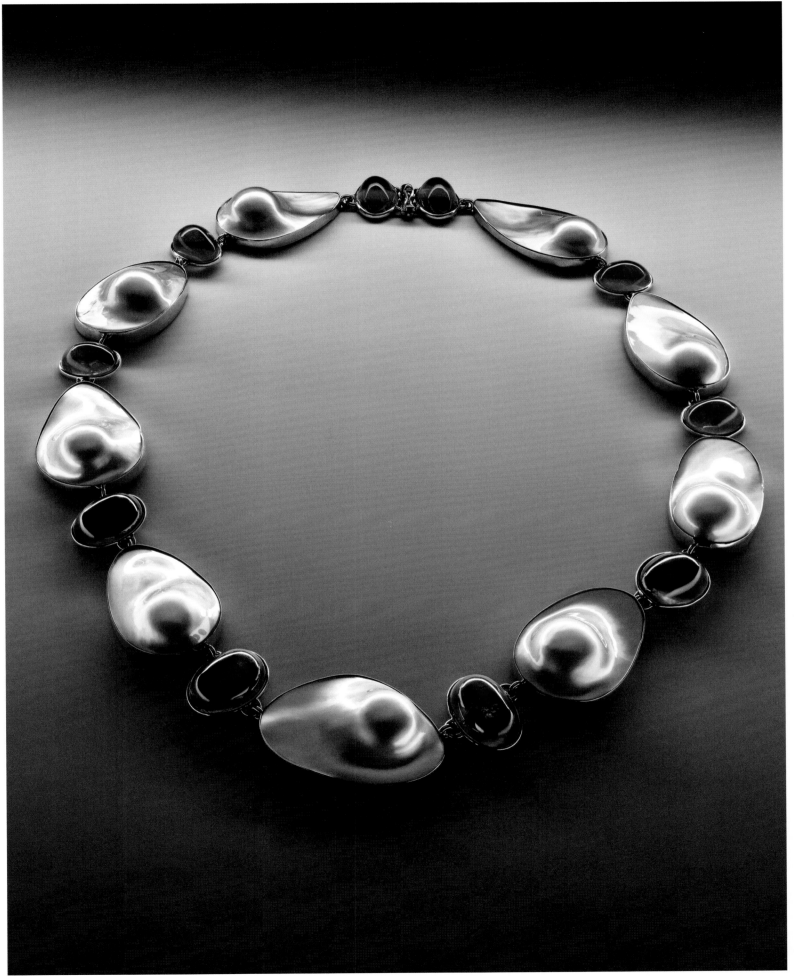

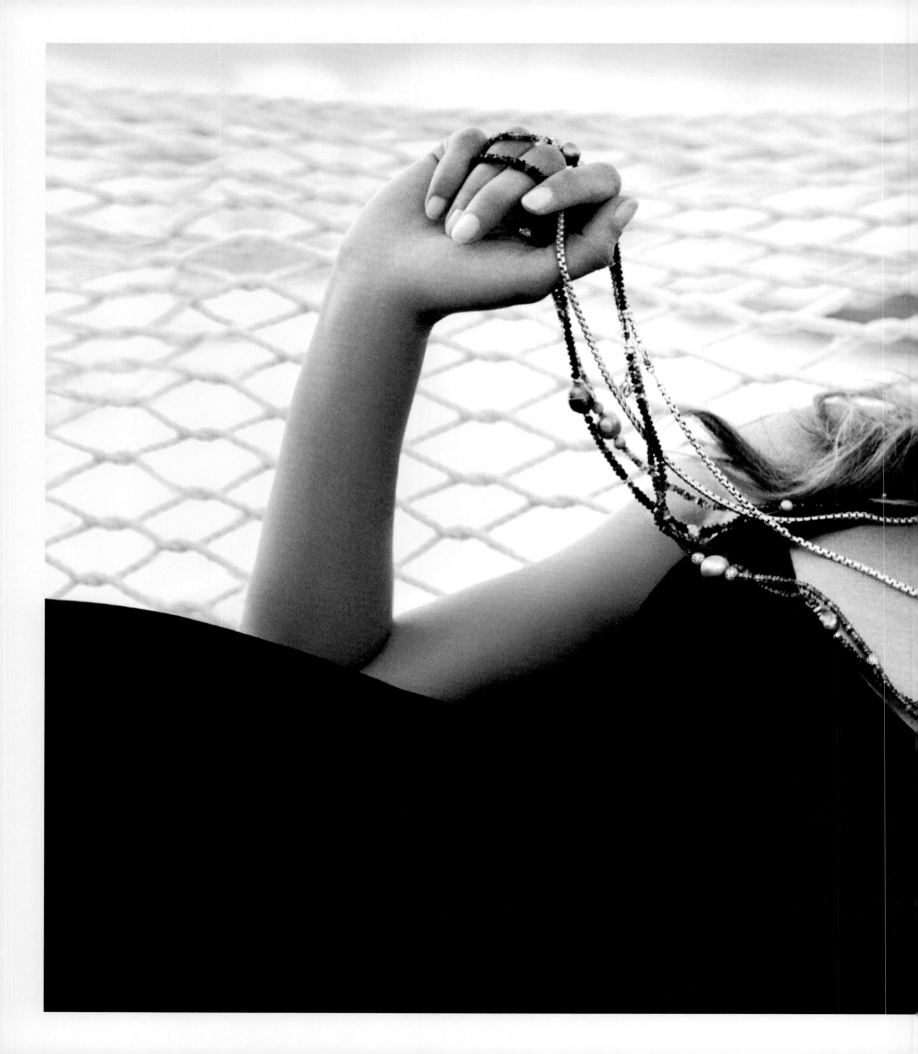

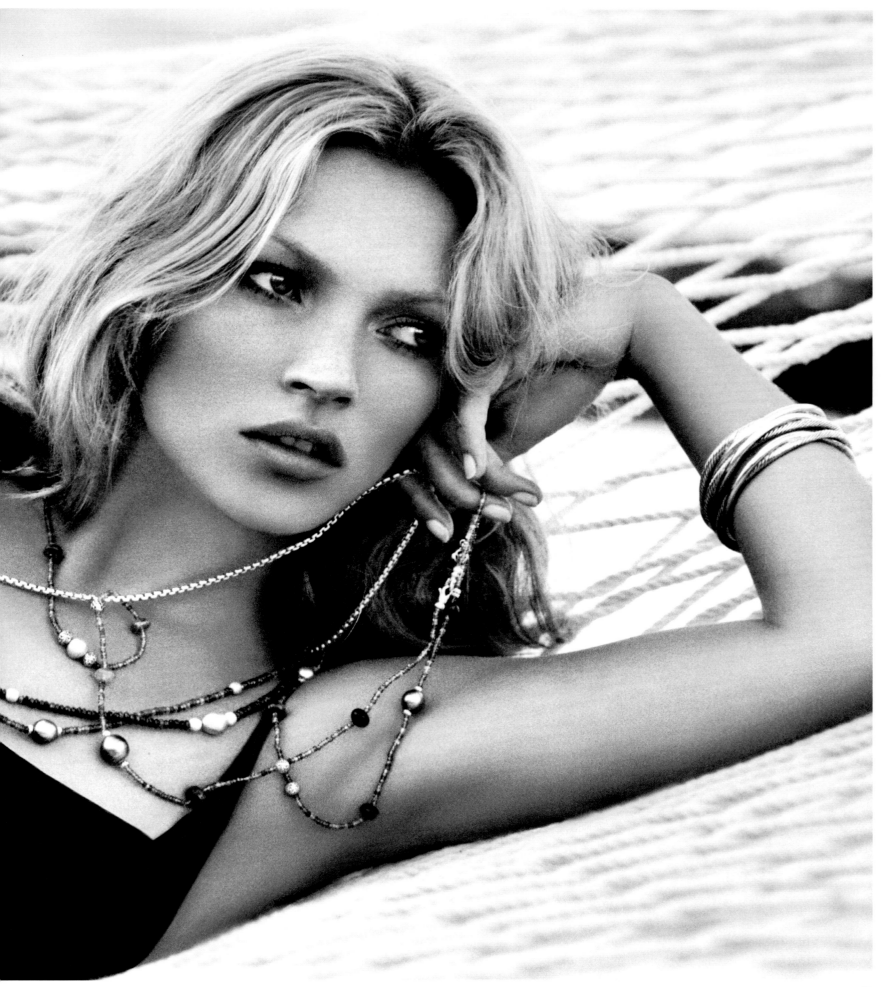

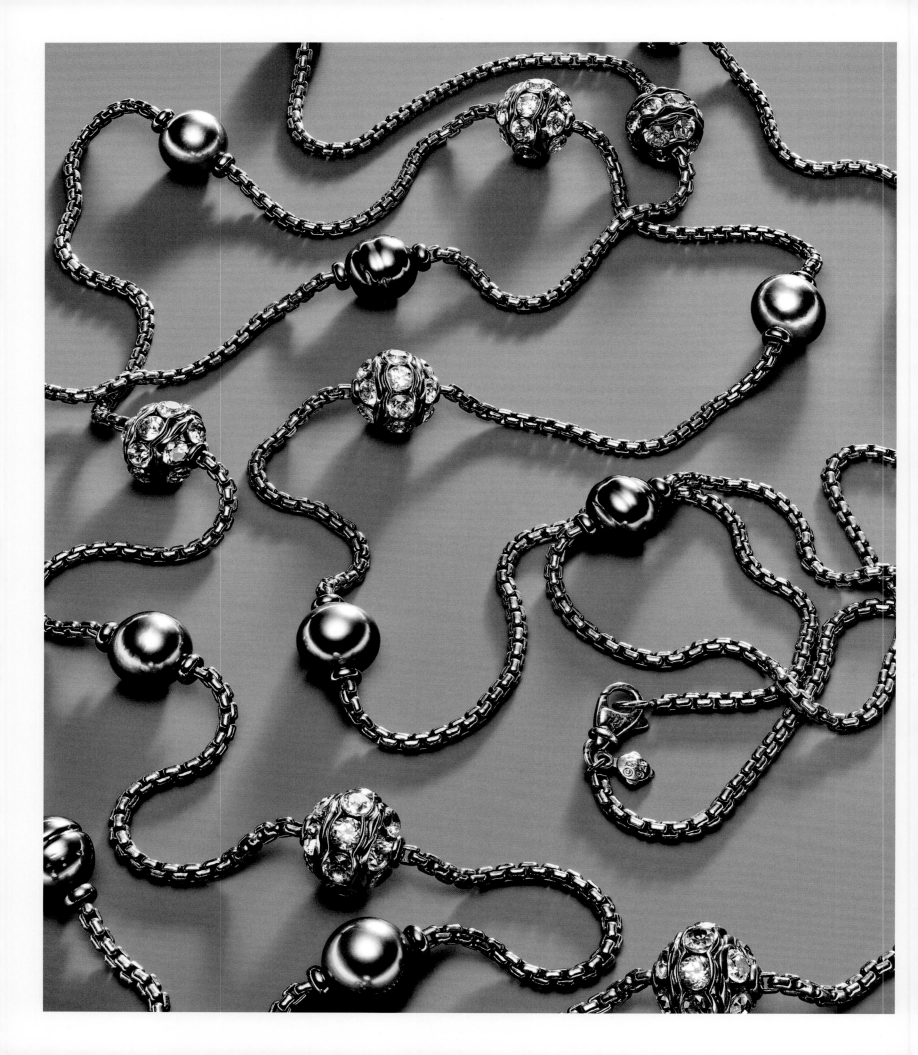

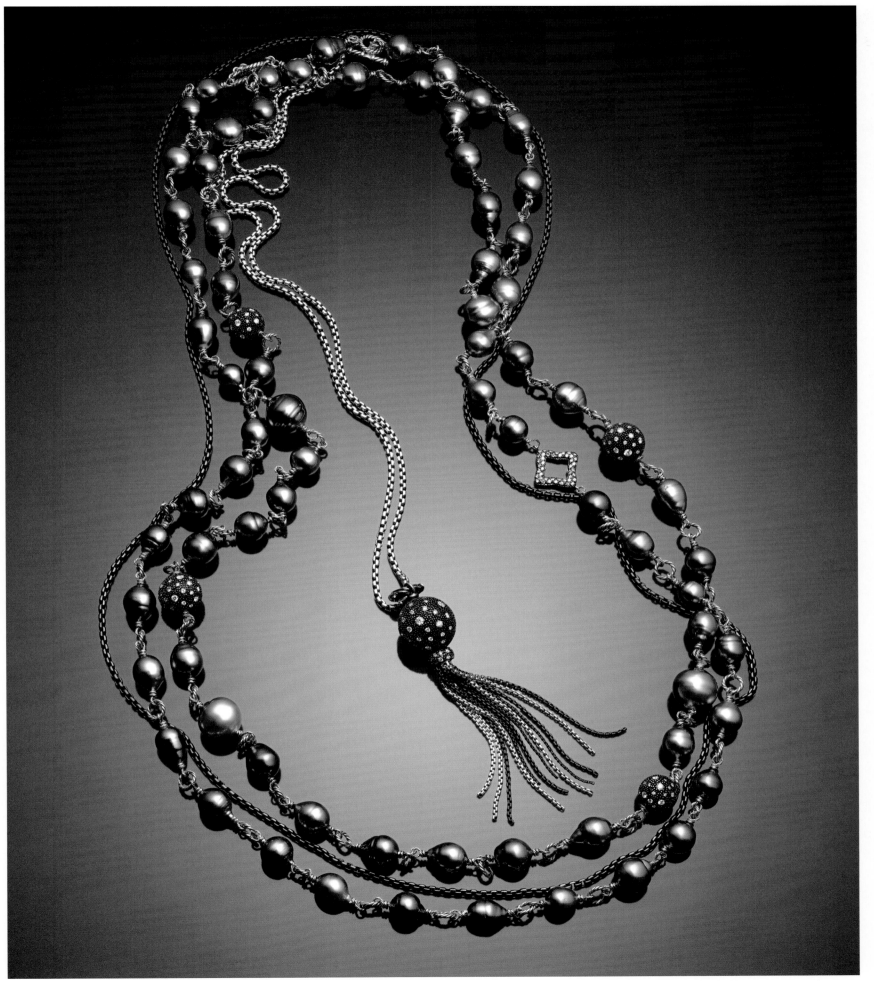

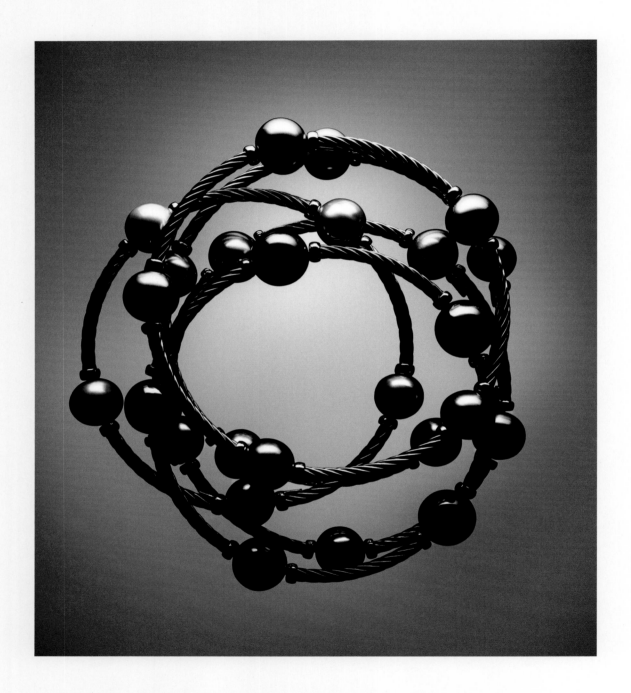

Previous spread, left: Silver and blackened silver with blue topaz jewel beads on box chain necklace. Photographed by Emil Larsson.

Previous spread, right: Silver and blackened silver with Tahitian pearl necklace, and tassel necklace on a box chain. Photographed by Emil Larsson.

Orbit bangle bracelets with Tahitian pearls, 2003. Photographed by Guido Mocafico.

Opposite: Du Juan wearing High Jewelry Pearls, 2008. Photographed by Peter Lindbergh.

Following spread, left: Lantana necklace with South Sea pearls in gold cable baskets, 2004. Photographed by Richard Burbridge.

Following spread, right: Solari bib necklace with Tahitian pearls, 2016. Photographed by Geoff Kern.

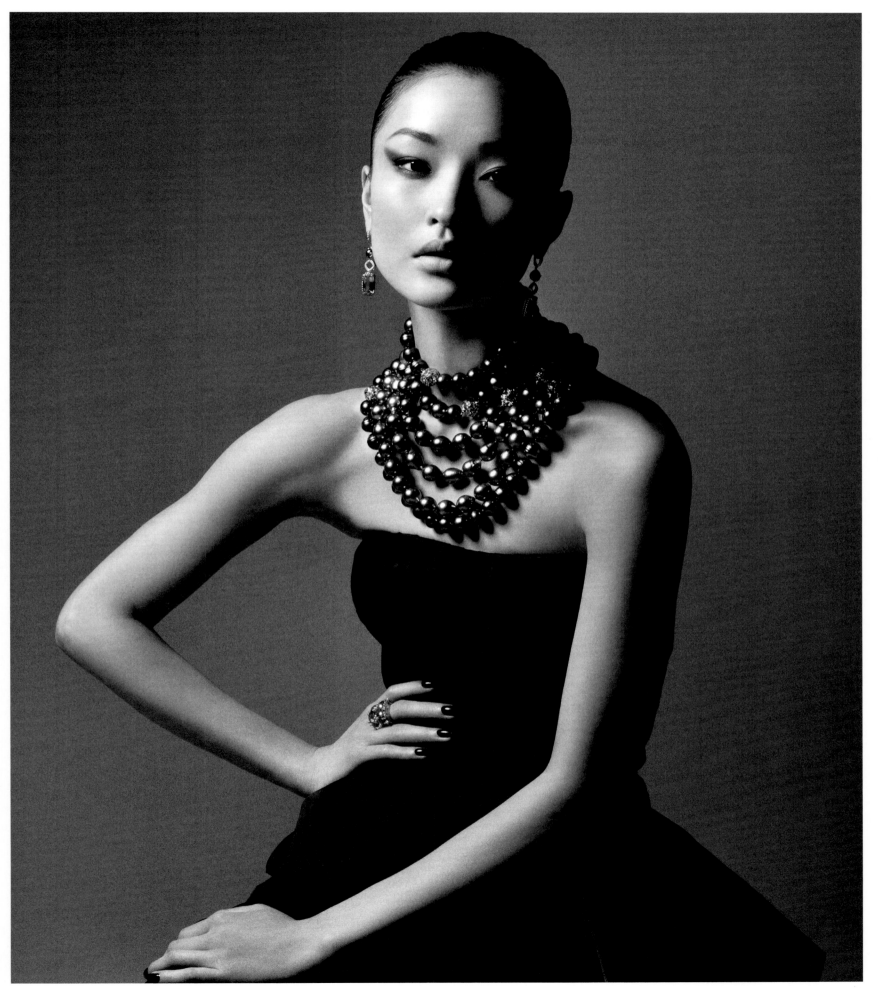

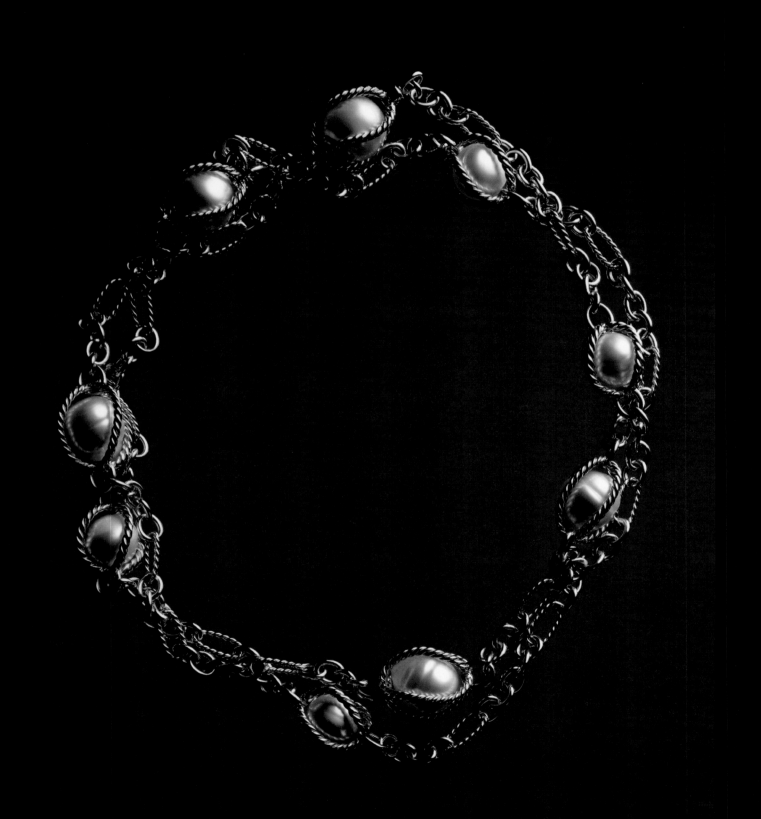

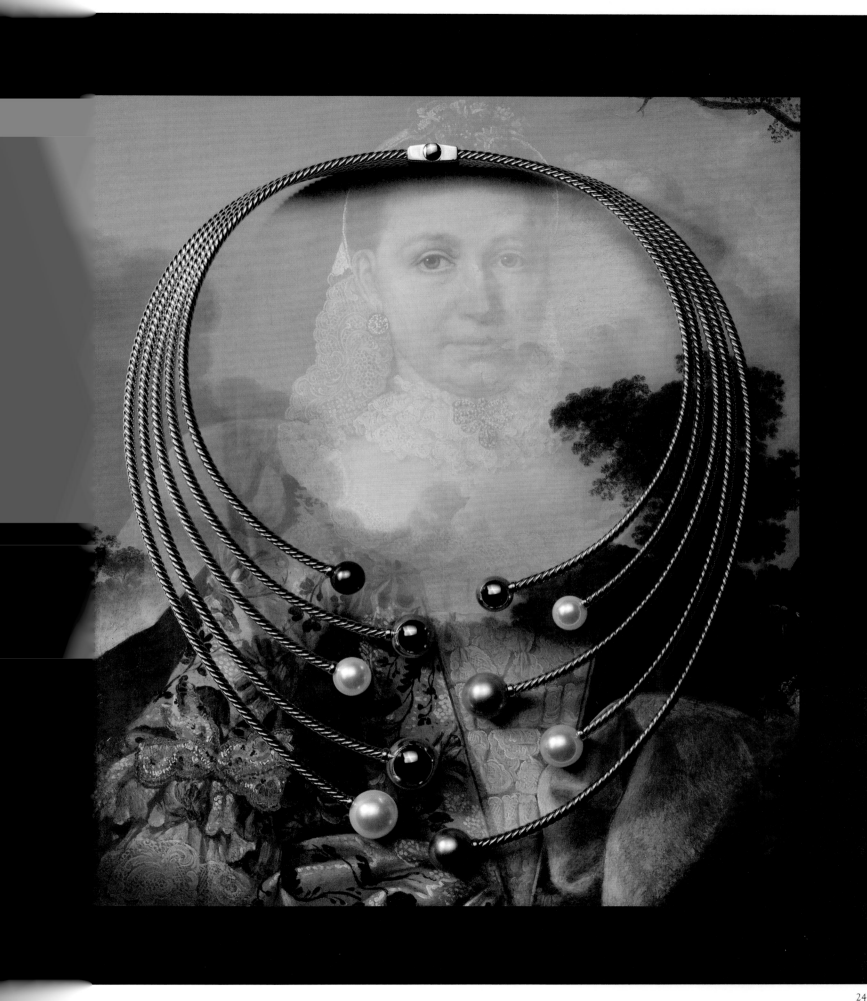

Love is
the delighting
in the
well-being
of the others.

Murray Kleinrock

Sybil and David Yurman in the atelier at the
Vestry Street headquarters, New York, 2023.
Photographed by Norman Jean Roy.

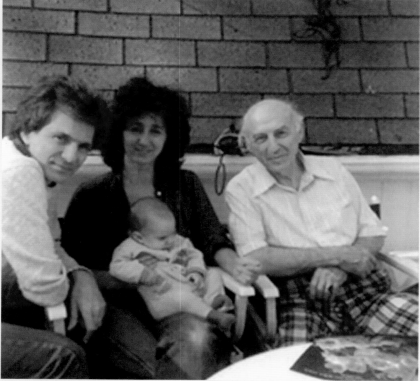

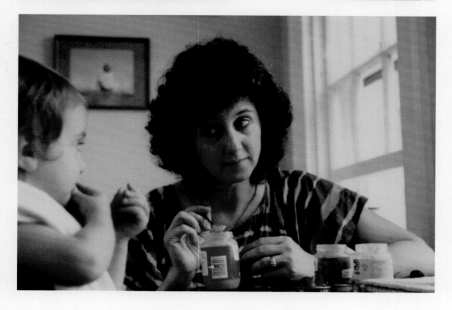

Top to bottom: Sybil Yurman's mother and father, Rose and Murray Kleinrock (lower right), with extended family at a New Year's celebration, 1940s.

David, Sybil, and Evan Yurman, with Sybil's father, Murray Kleinrock, Nyack, New York, 1982.

Sybil and Evan Yurman, New York, 1983.

Opposite: David Yurman
Mother and Child, 1971, Bronze, Edition of 10; 6 × 1 × 2¼ in. (15.2 × 2.5 × 5.7 cm).
Photographed by Emil Larsson.

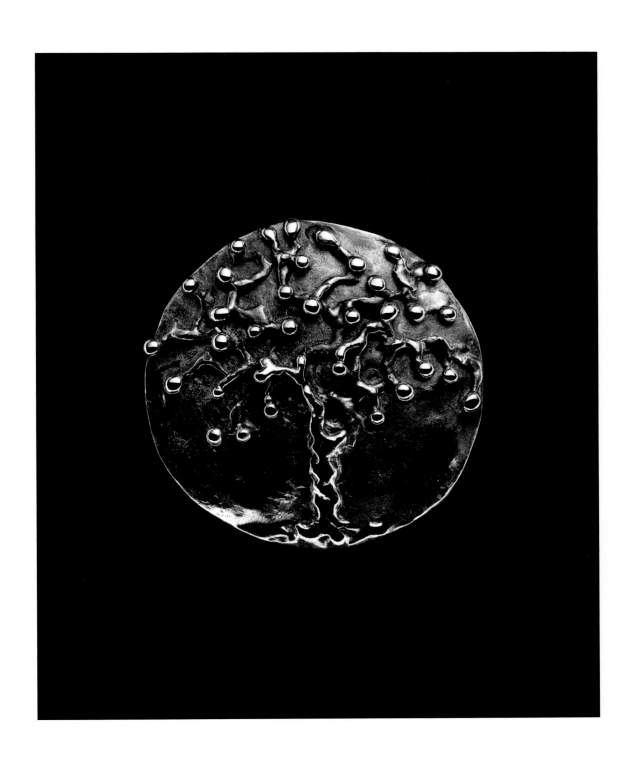

Opposite: Putnam Art Works Adam and Eve
direct-welded pendant, c. 1973–74.

Putnam Art Works Tree of Life belt buckle, 1973.
Both photographed by Emil Larsson.

Two can be better than one

BEING THERE FOR EACH OTHER

It all happened very fast. "We found each other as guides," Sybil and David recall, which says much about their partnership and about the give-and-take that has always been in their vision of art and life. They often finish each other's sentences, adding colorful insights and comments to help visualize the narrative. In many ways they have become their own art project. The combination of their artistic and intellectual outlooks and their interdependence is what has made them such a formidable force. Every day feels like the day they met: they are ready to change the world one day at the time. Advertising guru David Lipman points out that Sybil became David's muse the day they met and, later, his editor and model. His most symbolic pieces were created for her, pivotal moments of creation and collaboration, from the Dante necklace and the Icarus belt buckle to the famous chain links she wore as a belt, inspiring Lipman for numerous quintessential campaigns.

Sybil and David explained the mechanics of their collaboration in creating jewelry as a harmonious fusion: "When we started making sculptural jewelry, and more mainline jewelry, we probably started doing more collaboration. We would ask ourselves, 'What's going on in the world? What do we feel that we can bring into the world? We are going to draw on David's sculptures, Sybil's sense of color.' Sybil did a series of paintings where there is this big X. So I said, 'Why don't we run with this?' Emotion is essential. We've never done our jewelry from a place of 'Let's make a living' or 'Let's make money.' We never set out to make a business. It was always done from a similar place as the way we painted or did sculpture."[1]

Sybil remembers that the process of creating a business in the late 1960s was rather unique for many reasons. The social and economic context played a part, but there was also the fact neither of them were business-people. She recalls, "Serendipity is important in life and is an enormous factor in business. People noticed the pieces created by David, especially collectors and art-world enthusiasts. We began to wonder how we could sell what we made. The basis was established: a collaboration to produce and sell jewelry, but the central part of our relationship was looking for a way to live as artists. It started totally organically. We set our own rules and made a space for ourselves outside the academy, and we have stayed there."

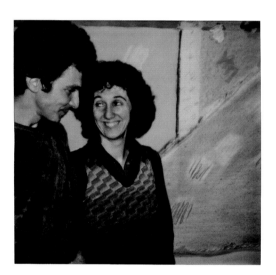

Previous spread: Sybil and David Yurman, Angel collaboration, 1978, Mixed media.

Opposite, top: Sybil Yurman, *Sky Markings*, 1980, Graphite and pastels on paper, Amagansett, New York.

Opposite, bottom: Sybil Yurman, *Diagonal in Darkness II*, 1984, Pastel, graphite, and acrylic on paper.

David and Sybil Yurman in Sybil's studio, New York, 1976.

David considers Cable to be "the river that runs through everything we do," describing its immediately identifiable signature as "a principle of classicism in purity of form." Cable is the DNA that unifies his designs; it is a helix—rhythmic, strong, and flexible. Its beauty and endless possibilities lie in its simplicity. "The cable bracelet didn't really look like anything else," wrote Virginia Smith, fashion market and accessories director at *Vogue*. "It was unique, and that has been one of the reasons they've been successful for so long—this unwavering point of view. To have that sort of clarity is very powerful."[2]

In 1978, David made the first bracelet in the Cable family—the original of which he still wears daily—now called the Trail bracelet. A year later, he created the original Renaissance Cable bracelet with vibrant gemstone-studded finial caps for Sybil. He twisted six feet of wire with pink tourmaline and emerald-green end caps by hand into the first Cable bracelet. Sybil wore it every day, and in the back of David's mind, a dynamic design parameter emerged: Would Sybil wear it? Would Sybil like it? (And later for the company it became: let's just make Sybil happy!)

Although the cable motif is thousands of years old, David proposed an innovative idea using hollow wire tubes as well as solid wires, something he had not seen before. Sybil recalls, "David was welding long bronze rods, grabbing them and binding them together. It happened organically, right in front of us. It was unbelievably simple yet time-consuming to make. We had no time for a normal life. He would be working until the middle of the night. We never saw each other. We understood that this was not what we signed up for!" They had to find a way to use technology. Machine and designer would have to collaborate. As David explains: "Twisting wires by hand without gaps or irregularity is difficult; to run hollow tubes through a machine's spinning arbor without collapsing the tubes would be an engineering challenge. As the tubing is twisted from the front end, it would have to be unwound in the back, turning in the opposite direction. The tubing would have to be perfect, and the machine designed from nothing, just an idea."

In the spring of 1981, Sybil and David went to the international jewelry show in Basel, Switzerland. During the event, in a café, they fortuitously met Bill McTighe, a former Berlin-based artist who was head of product development at Leach & Garner, a century-old American company and the world's largest gold and silver manufacturer for the jewelry industry. Ted Leach, CEO and great-grandson of the founder, understood that American jewelry lacked the identity of the historic European houses. Leach wanted to support American jewelers with distinctive styles: despite his father's reservations, he gave the Yurmans access to technical resources during the night, where the engineers successfully created a machine and process to make the Cable.

For more than four decades, the Yurmans have continued to evolve the Cable motif in their jewelry, reinventing their helix into a myriad of designs, from jewelry to watches, even in their fragrance bottle and eyewear collections. A simple twist transformed wires into a cable; a simple but precise bend transformed that cable into a bracelet. David's approach begins with an exploration of this essential form as a creative challenge and ends with an artistic solution, an innovative variation on the same theme.

David Yurman
Renaissance Cable bracelet sketches, 1985–2014.

Opposite: Renaissance silver and gold bracelet with amethyst and rhodolite garnets, 1979. Photographed by Nicholas Alan Cope.

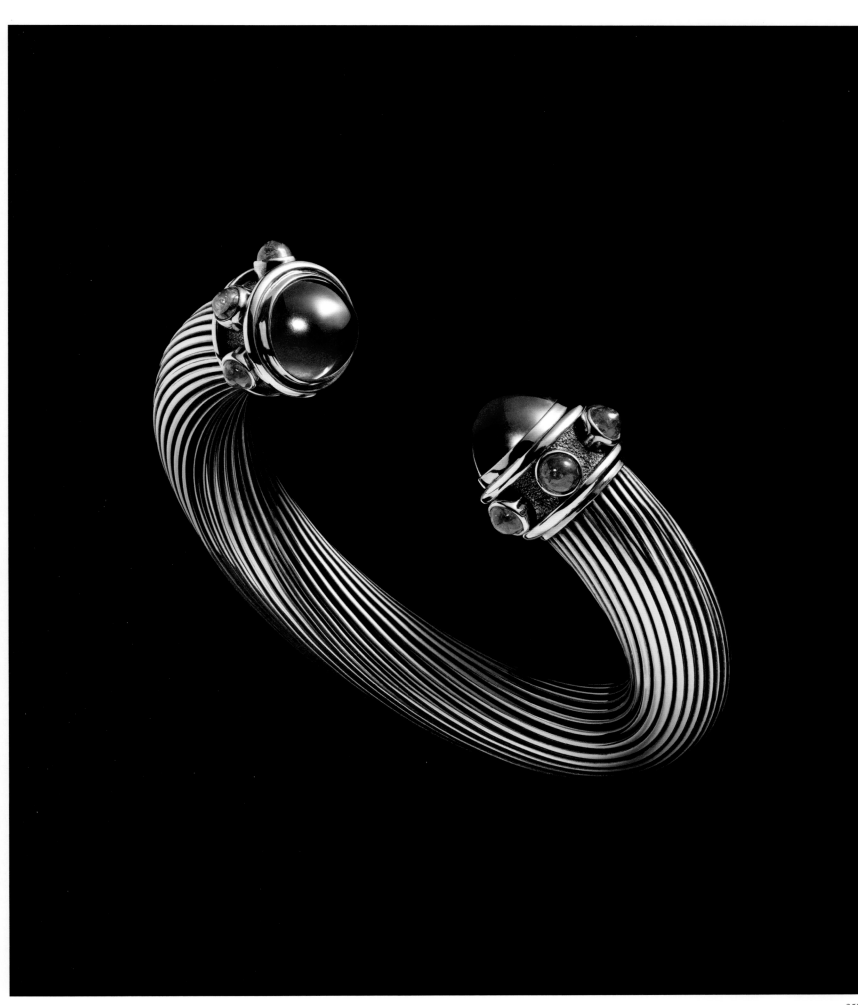

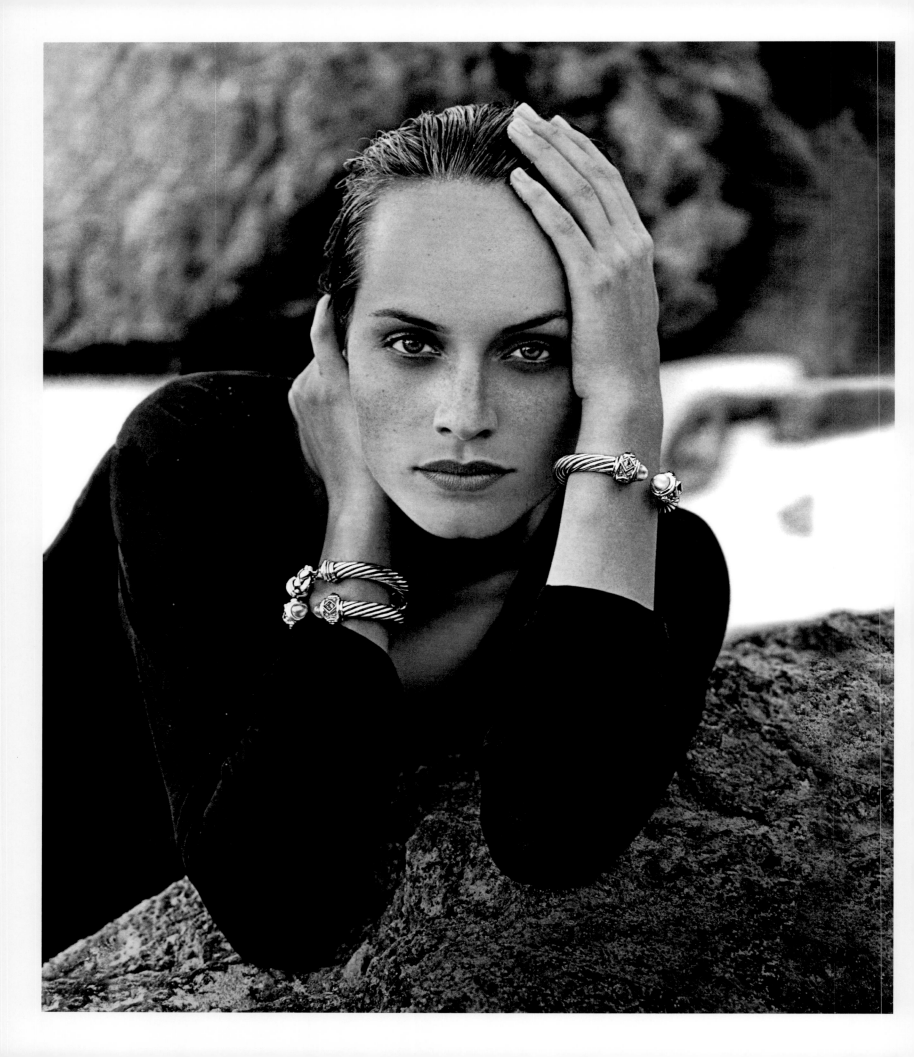

The process is both limiting and liberating. David says Cable is both a point of departure and the edge of the page.

American retail jeweler Mark Fink recounts, "They brilliantly touched a chord of the casualization of our lifestyles when it was starting to change in North America. Their jewelry matched our lifestyles. They saw it coming way before most people did. The Yurman jewelry could be dressed up: it could look phenomenal with blue jeans, but it also could go out at night. It was affordable, and it had a unique design. They brought color into the spectrum with their love of gemstones."

The popularity of the bracelet took everyone by surprise. Having witnessed the Cable frenzy, Fink adds, "The Cable bracelet became iconic very quickly, and customers wanted to buy it because other women were wearing it. In US cities, from Kansas City to Charlotte, there were these Cable Clubs, where the women would get together and talk and show off their Cable bracelets."

Since its launch in the early 1980s, the Cable bracelet has gone through around two thousand iterations, metamorphoses, reinventions, and innovations. Sybil and David's son, Evan, continues to explore the boundaries of Cable, which can now be seen in bright aluminum pop colors, rubber, and, in its highest version, full diamond pavé. Cable is at the heart of the company, representing the core humanist values of the jewelry house. It is not only linked to supporting charitable causes but also to sharing moments of joy and marking countless multigenerational milestone moments.

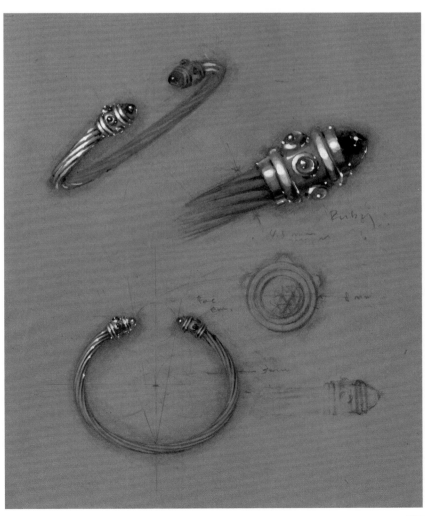

Opposite: Amber Valletta wearing pavé-set diamond Buckle bracelet and Renaissance bracelets with gemstones, St. Barts, 2001. Photographed by Peter Lindbergh.

Renaissance Cable bracelet sketches, 2013.

When I was around eleven years old, I started riding horses with my father on Saturdays. It was English riding, with tweed jackets and jodhpurs. He gave me a good foundation of horsemanship and the courage to keep up or fall off. I have continued horseback riding all my life, and I noticed parallels with the discipline of technique and the relationship with animals. With horses, you cannot force things. Part of yourself needs to be in their world.

At the end of the 1970s, Sybil and our friend Ed Segal set up a meeting with Arnold Duke and Myron-Bubba, jewelers from Hudson, New York, at the Retail Jewelers of America (RJA) show in New York City. They all were dressed in cowboy style, selling their accessories: bolo ties, boot tips, collar tips, etc. When I met them, they told me they did these trail rides with a group called the Kosmic Kowboys. The next thing I knew, I was on one of the rides. We went to a place called Cold River, which is up on the Rockefeller Estate in the Adirondacks. You pack in all your grain, your food, and your camping stuff. I didn't have a horse at the time, so I borrowed one from John Rossi (JR). That was the beginning of an amazing ride that has lasted over forty years now, bonding with horses and friends, still going strong today.

With two exceptions, we've gone riding as the Kosmic Kowboys once a year—sometimes twice. I've never missed a ride. Throughout the last fifteen years or so, we've been riding out West, in Arizona, Montana, Utah, and Wyoming. It's pretty much the same group of guys. We ride easy and drink a bit of tequila along the way. Horses are like perfect beings. They smell fear. They sense and hear your heartbeat. They know a lot more than you think they do. It's always nice to be welcomed by them. They make a choice whether they want to join up with you or not. You just have to lower your body temperature and get into a good state of mind. A large part of riding is about just letting go and trusting the horse.[3]

DAVID ON THE KOSMIC KOWBOYS

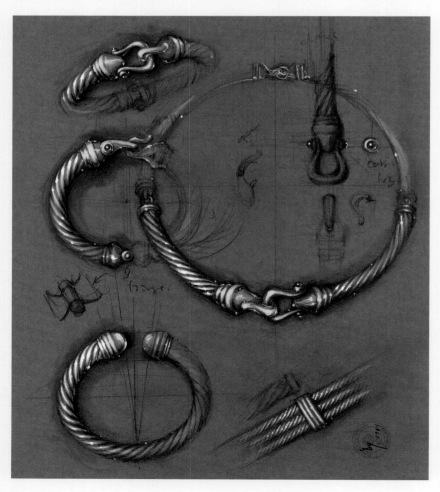

Buckle Collection sketches, 2017.

Opposite: Hand-painted shadowbox with Buckle and Renaissance Collections (top to bottom): gold and pavé-set diamond Buckle bracelet; Renaissance bracelet with gold cabochons with pink and green tourmalines, and iolite; Renaissance gold cabochon ring with amethyst and green tourmaline, 1993. Photographed by Lisa Charles Watson.

Following spread: Gisele Bündchen wearing gold wide Crossover cuff bracelet, Noblesse pavé-set diamond ring, Cable Classic gold dome and pavé-set diamond bracelet, Wheat chain, and Waverly bracelet, Malibu, 2012. Photographed by Peter Lindbergh.

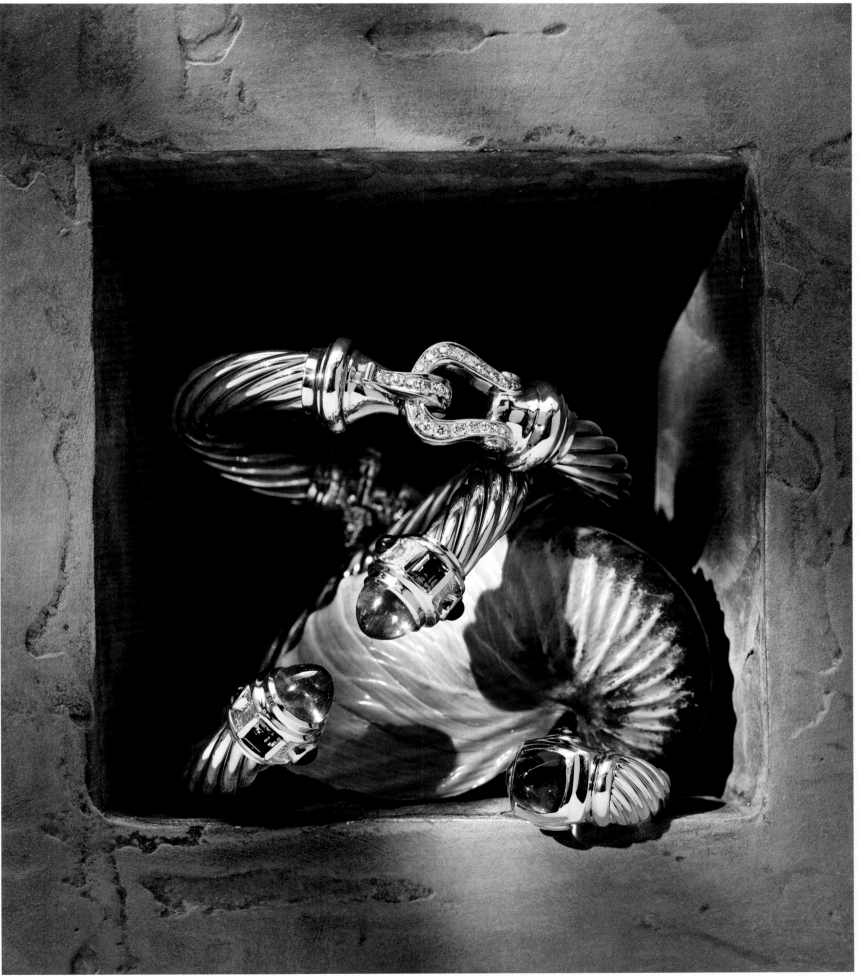

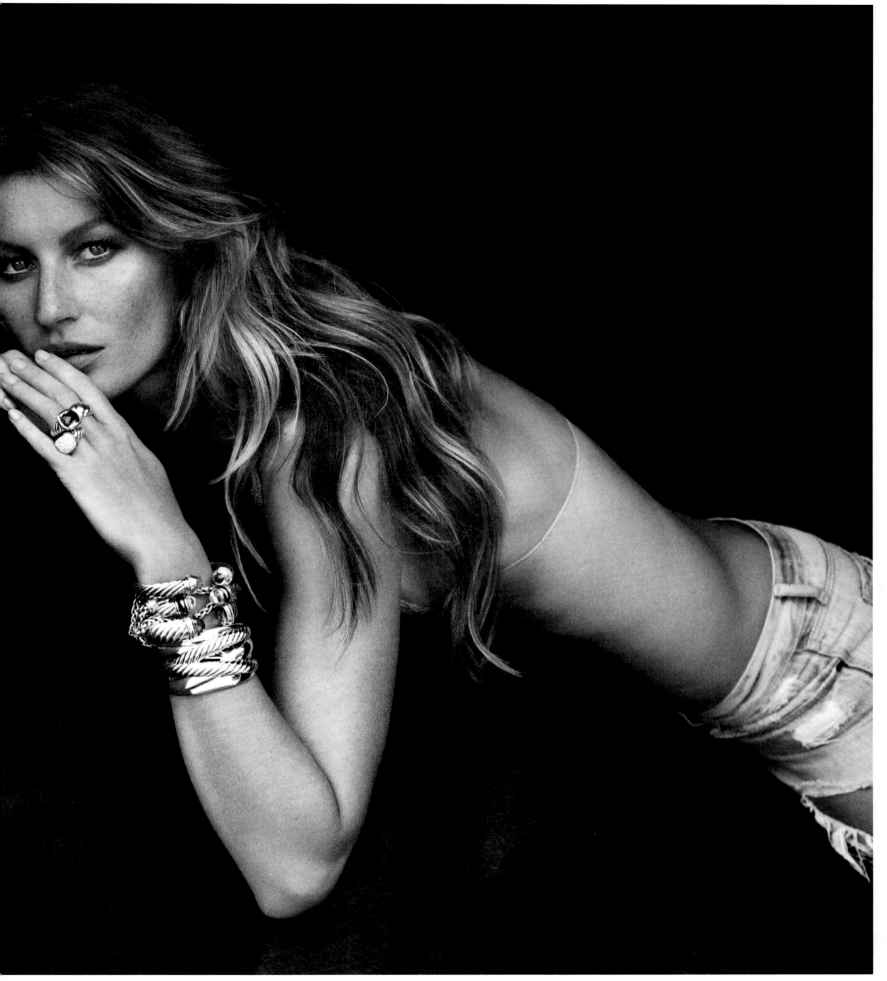

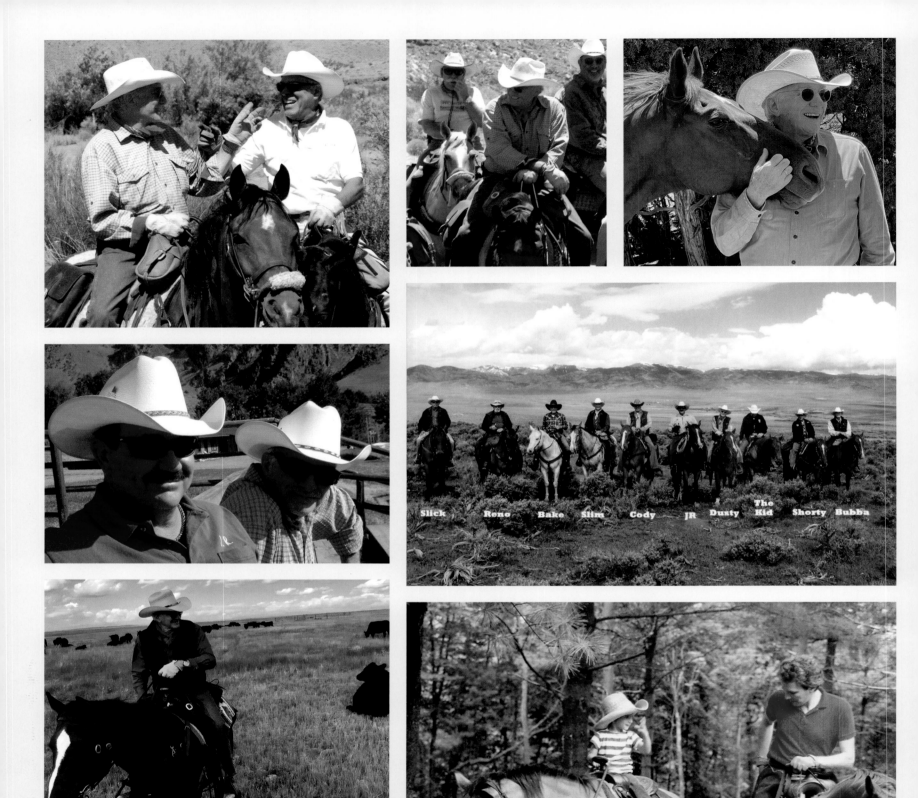

Slick Reno Bake Slim Cody JR Dusty The Kid Shorty Bubba

David Yurman and the Kosmic Kowboys' Annual Trail
Rides, Wyoming, Utah, and Arizona, 1987–2022.

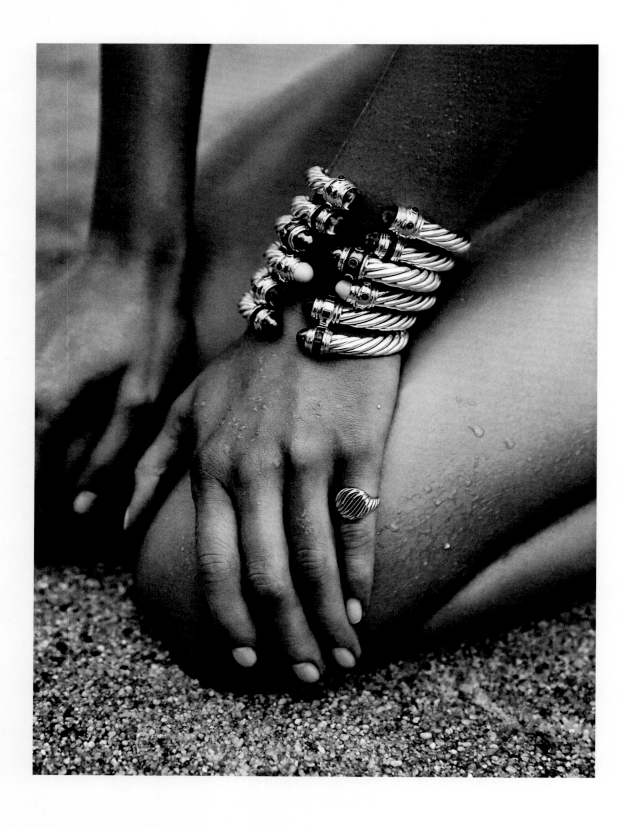

Renaissance Collection bracelets in assorted stones, 2014.
Photographed by Mario Sorrenti.

Opposite: Moonlight Ice bracelets with pavé-set diamonds, 2011.
Photographed by Raymond Meier.

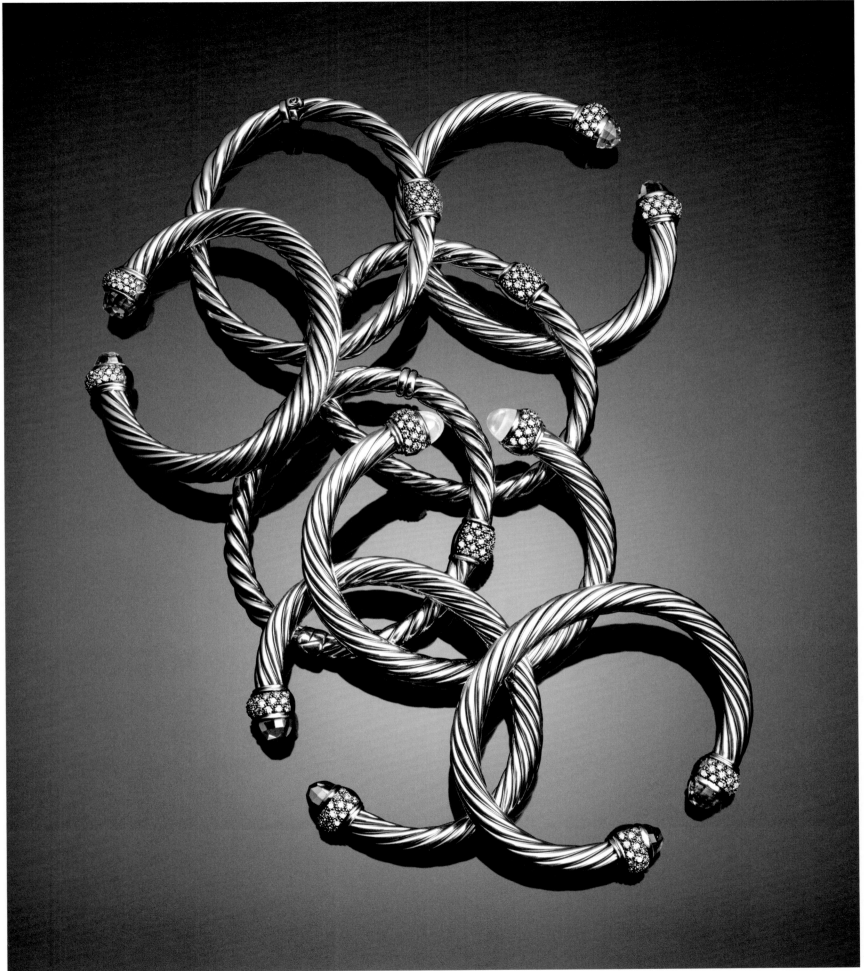

The Art of Layering

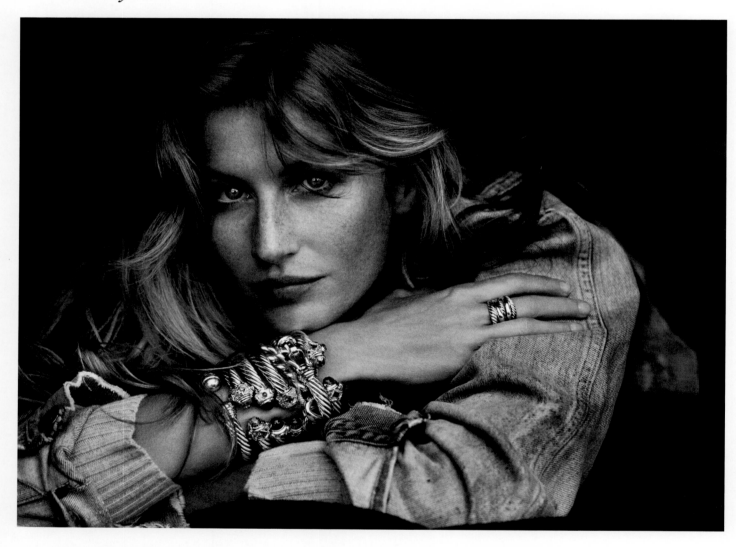

Gisele Bündchen wearing Renaissance, Buckle, Curb Chain, and Gold Dome bracelets, with X ring, Malibu, California, 2012. Photographed by Peter Lindbergh.

Opposite: Renaissance gold hinge bracelets with peridot, iolite, and pink tourmaline (left) and citrine, iolite, and rhodolite garnet (right), 2014. Photographed by Raymond Meier.

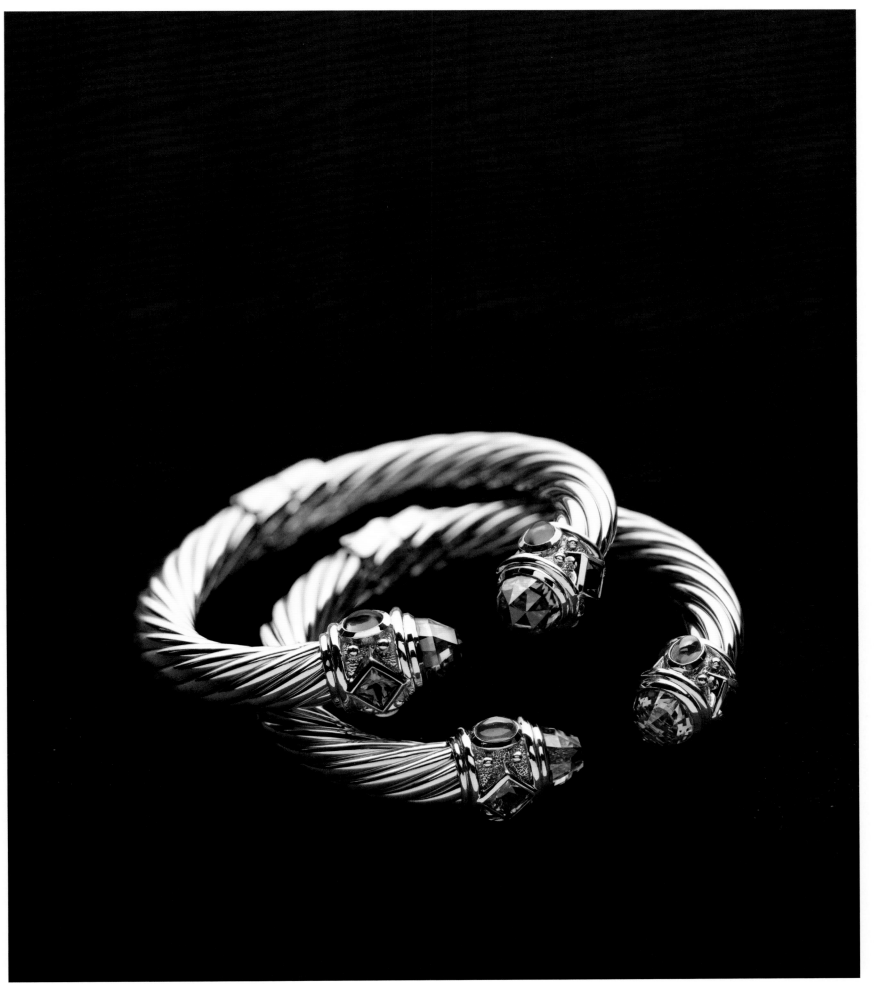

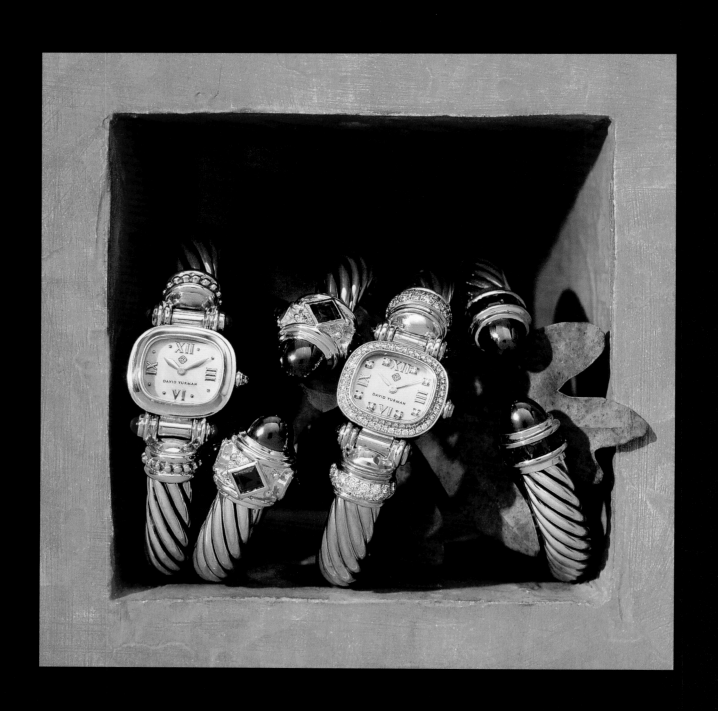

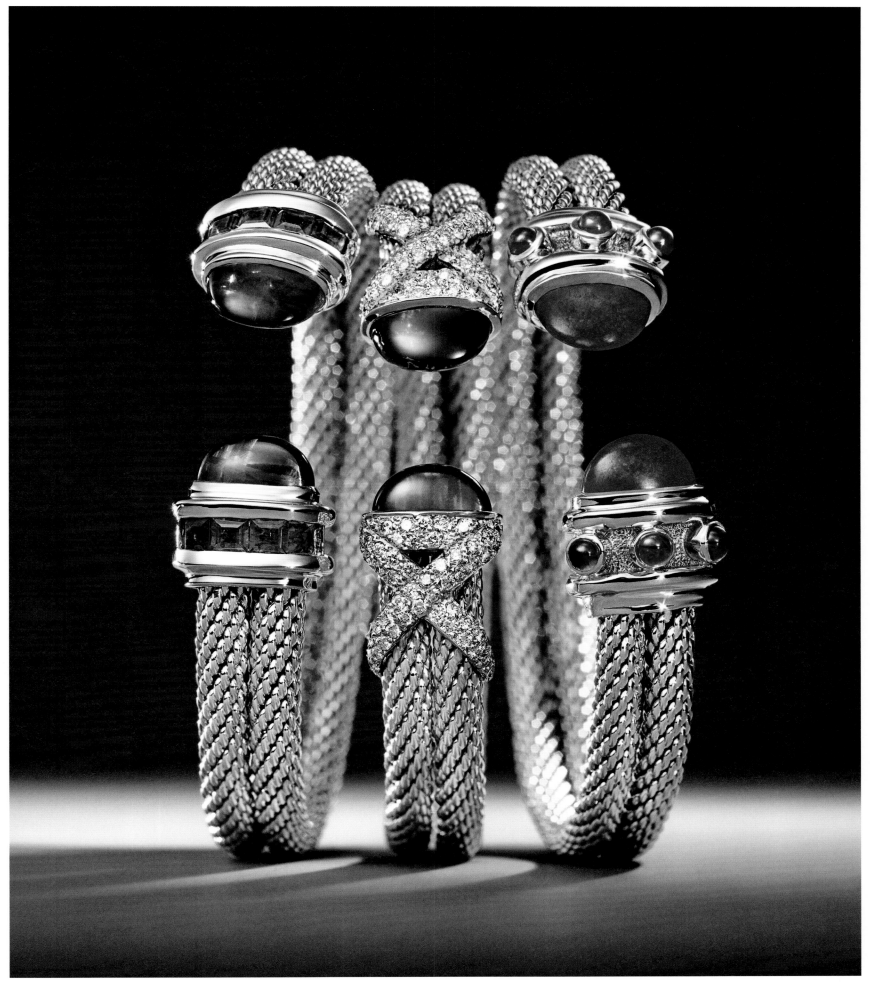

"Are you crazy?" This is what buyers asked David when they discovered his first collection that set diamonds into silver. "No one is going to buy it," they added. David loved the soft sensuousness of silver and wanted to develop a way to set diamonds into it. People thought he was crazy and that the diamonds would fall out. David recalls, "We made a collection called Silver Ice, which later became half of our entire business. It's this concept of setting diamonds into silver. In the 1970s, jewelry was categorized and sold by group: gold, gold with diamonds, gold with precious gemstones. Of course, the buyers were confused: they had structured their buying by commodity, and now they were taken out of their comfort zone!"

"We were mixing metals—silver and gold jewelry—and they didn't know how to value it. It was difficult in the beginning to make sales," Sybil explains. Buyers would come together, puzzled and confused, pointing at each other and telling her: "I buy silver. She buys gold. He buys diamonds." Silver pieces tended to end up at the back of the store with the silverware, as silver was basically a category that was reserved for tea sets and silverware. With a variety of mixed-metal pieces, Sybil and David were trying to make the point that they were not just selling silver; they were selling a design. Breaking down the boundaries of traditional jewelry buying, a new category emerged: designer jewelry. A buyer had to be found for this new category. The combination of silver and diamonds became a signature design motif for Yurman, which can now be found in many of his collections.

In 1984, a decade after securing a place for combinations of silver, gold, and gemstones in the jewelry market, the Yurmans introduced the groundbreaking Silver Ice Collection, mixing silver with diamonds, with the clear intention of making people understand that they had elevated silver to its rightful place as a noble metal by adorning it with diamonds. "We wanted to make fine jewelry that had a sense of design, that was attainable both by someone like Elizabeth Taylor and by someone who is not a movie star. When we accomplish this, we reach a broader span of customers; that is also our goal."

Previous spread, left: (left to right) Swiss-made women's Cable watch in silver with gold accents; Renaissance cabochon hematite garnet bracelet; Swiss-made women's Cable watch in gold and pavé-set diamonds; Renaissance cabochon hematite bracelet with channel-set garnets. Photographed by Lisa Charles Watson.

Previous spread, right: (left to right) Venetian amethyst and green tourmaline bracelet; X pavé-set diamond bracelet with cabochon rhodolite garnet; Venetian cabochon lapis lazuli and garnet bracelet, 2014. Photographed by Raymond Meier.

Sculpted Cable gold sculpted bracelet, white gold and pavé-set diamond bangle, and pavé-set diamond Sculpted Cable ring, 2023.

Opposite: Silver pavé-set diamond Buckle bracelet, Cable Classics silver pavé-set diamond dome bracelet. Advertising for the Buckle Collection, 1997.

DAVID YURMAN

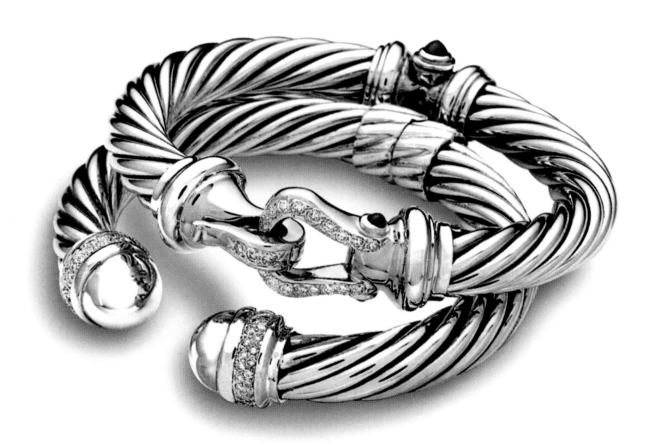

THE SILVER ICE COLLECTION

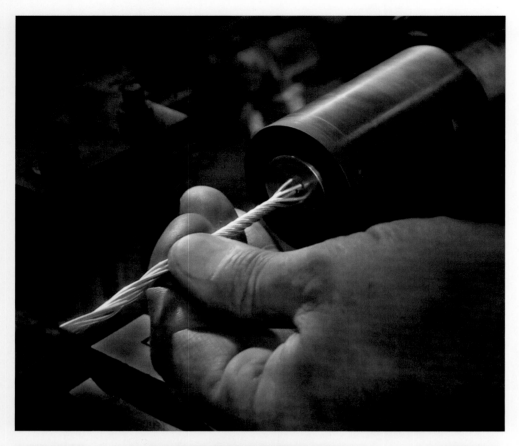

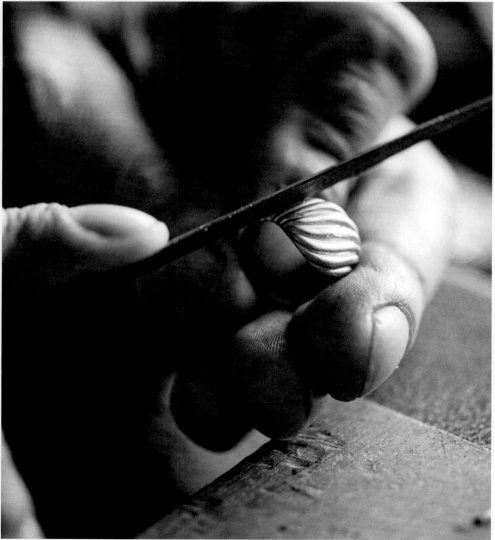

Top: Early Cable machine, Providence Jewelry Museum, Rhode Island, 2013.

Bottom: Wax carving at the David Yurman atelier, New York, 2014. Photographed by Nathan Copan.

Opposite: Silver and blackened silver cuff bracelet with pavé-set diamond swoosh, silver and pavé-set diamond rails on sculpted Cable cuff, 2010. Photographed by Emil Larsson.

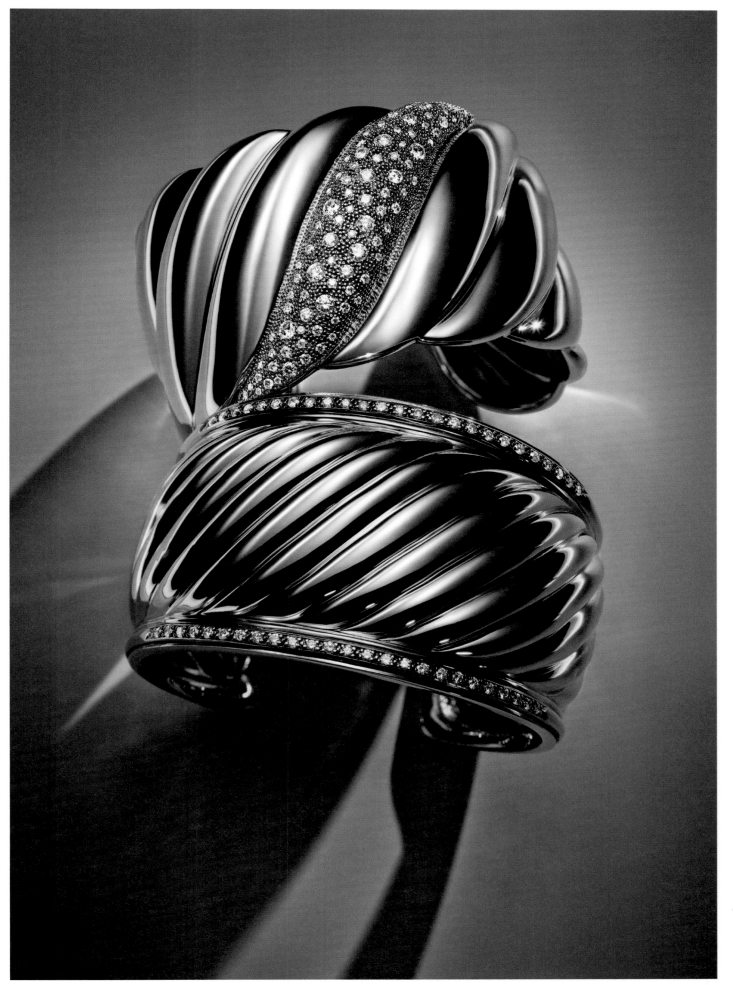

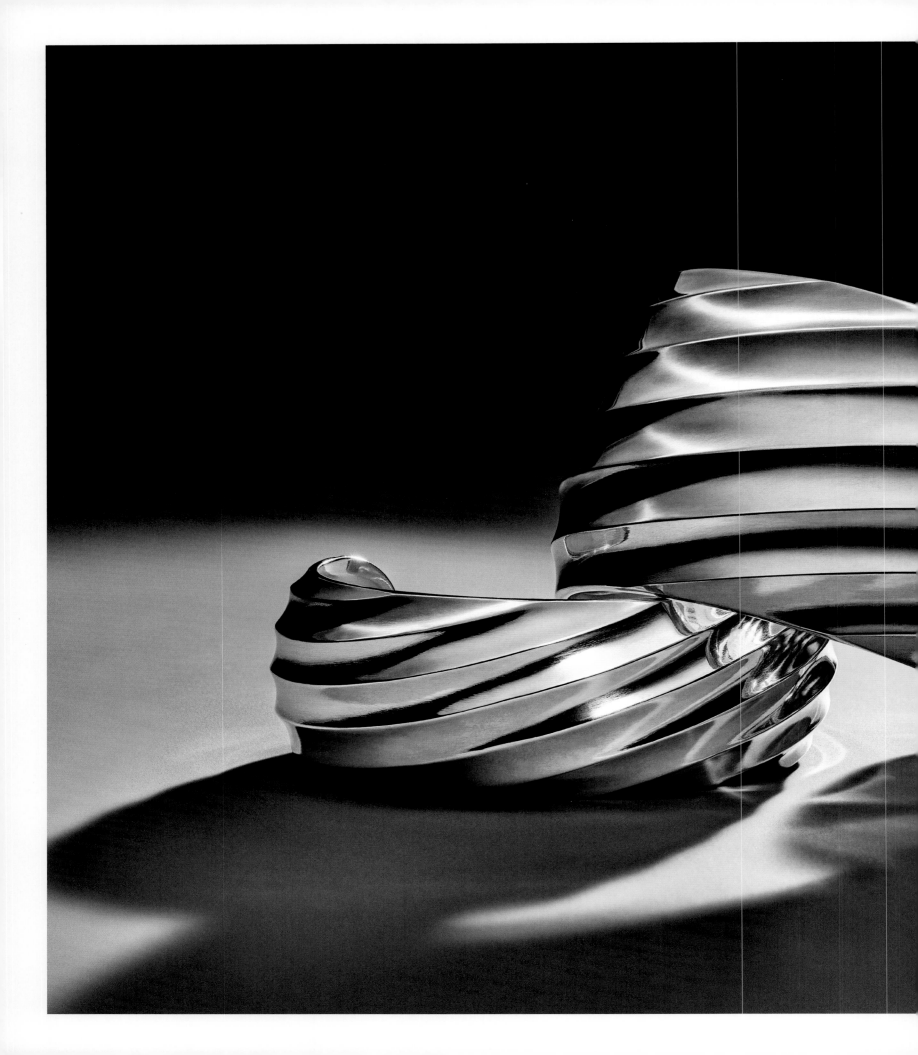

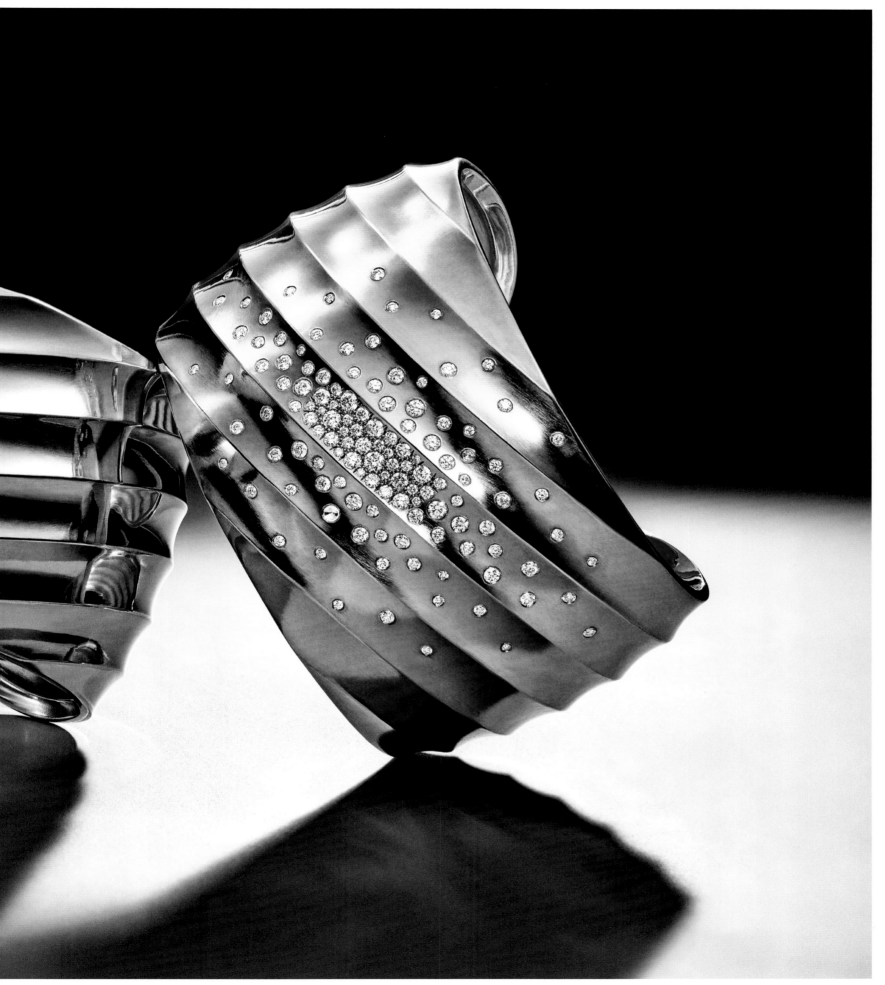

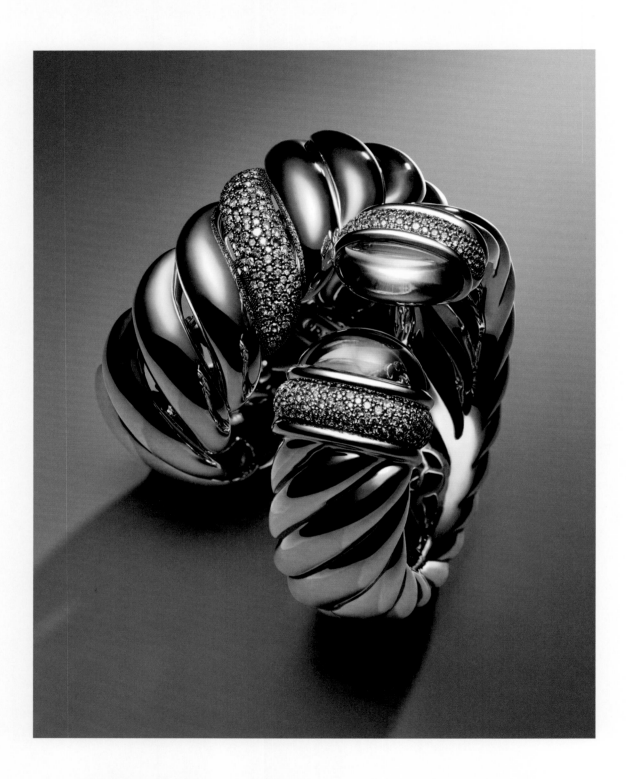

Previous spread: Cable Edge Collection, gold cuff bracelet, silver cuff bracelet, and gold cuff bracelet with scattered diamonds, 2022.

Hampton silver bracelet with pavé-set diamonds, and gray and blue sapphires; silver Waverly cuff with cabochon lemon citrine and pavé-set demantoid garnets. Both photographed by Emil Larsson.

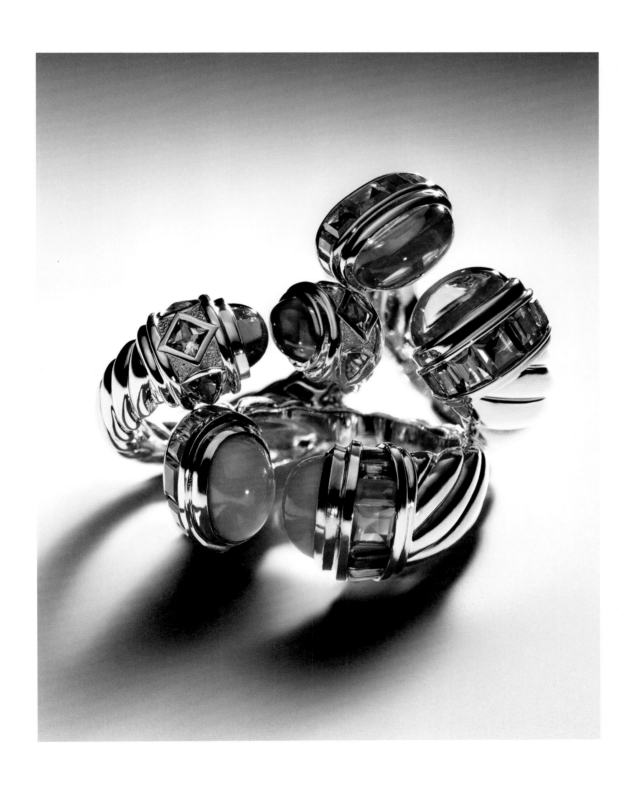

Renaissance gold rings: cabochon rubellite with citrine, cabochon citrine with rhodolite garnets, and a cabochon turquoise ring with tsavorite, 2007. Photographed by Emil Larsson.

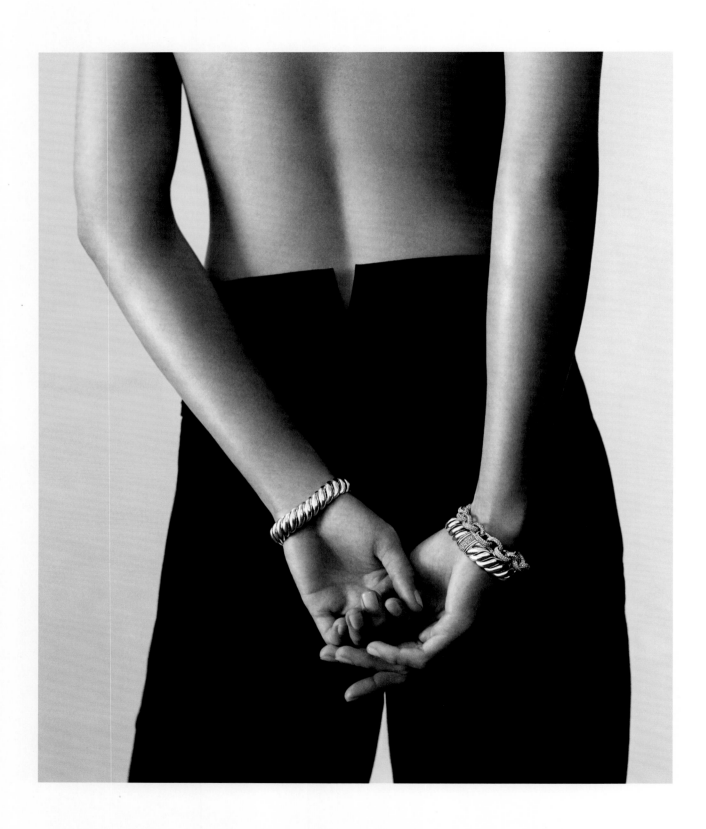

Hana Jirickova wearing High Jewelry Oval Link pavé bracelet worn with two
Hampton bracelets, one with diamond clasp, 2015. Photographed by Josh Olins.

Opposite: Hampton Collection silver bracelet and silver pavé-set black diamond
bracelets, 2023. Photographed by Emil Larsson.

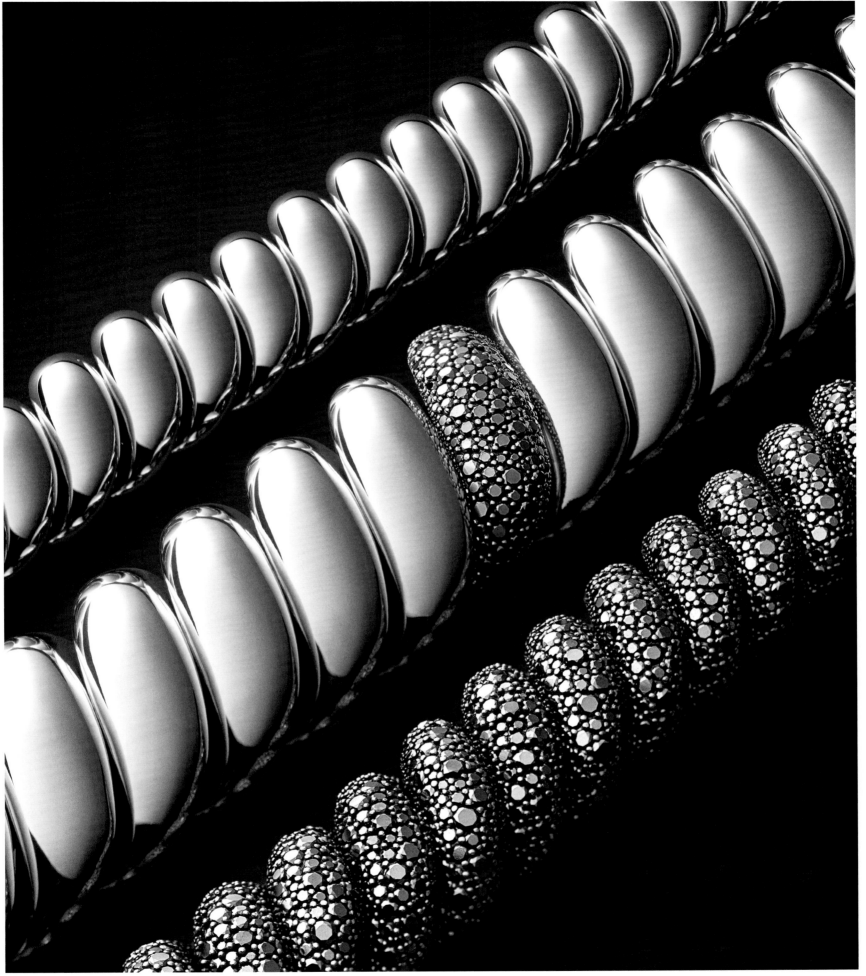

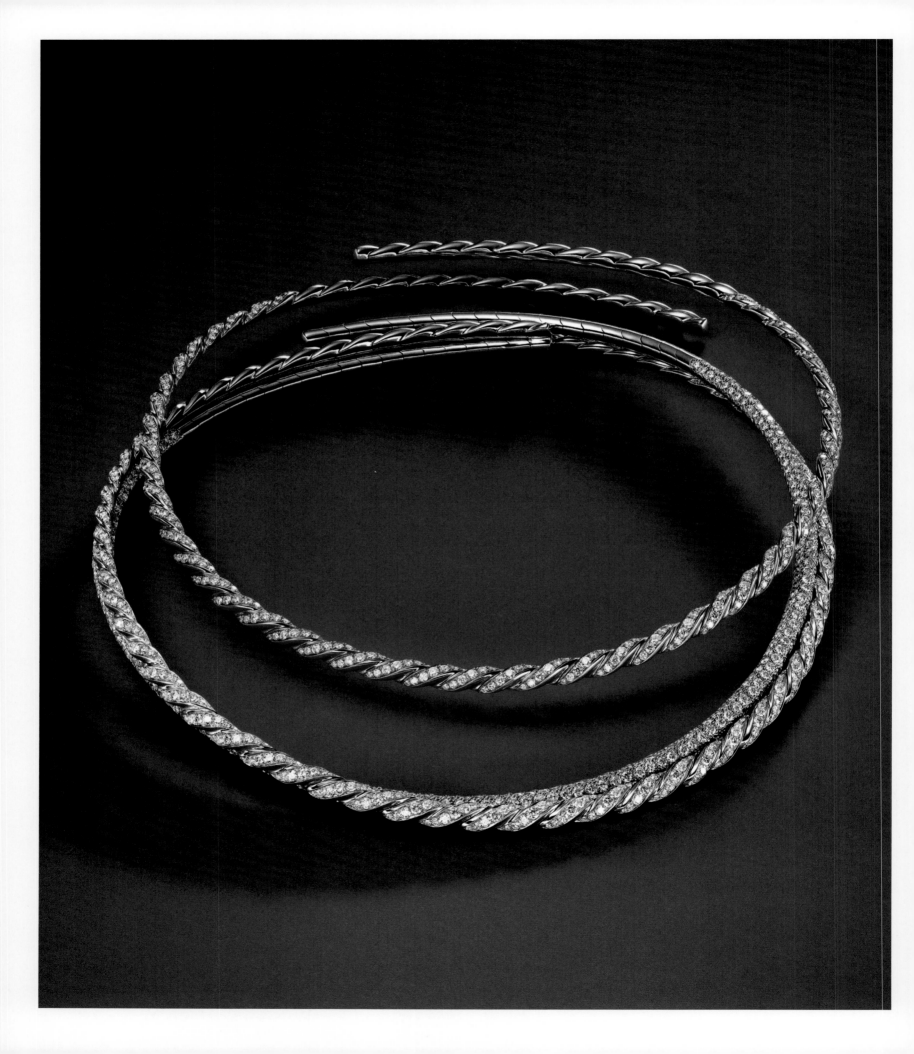

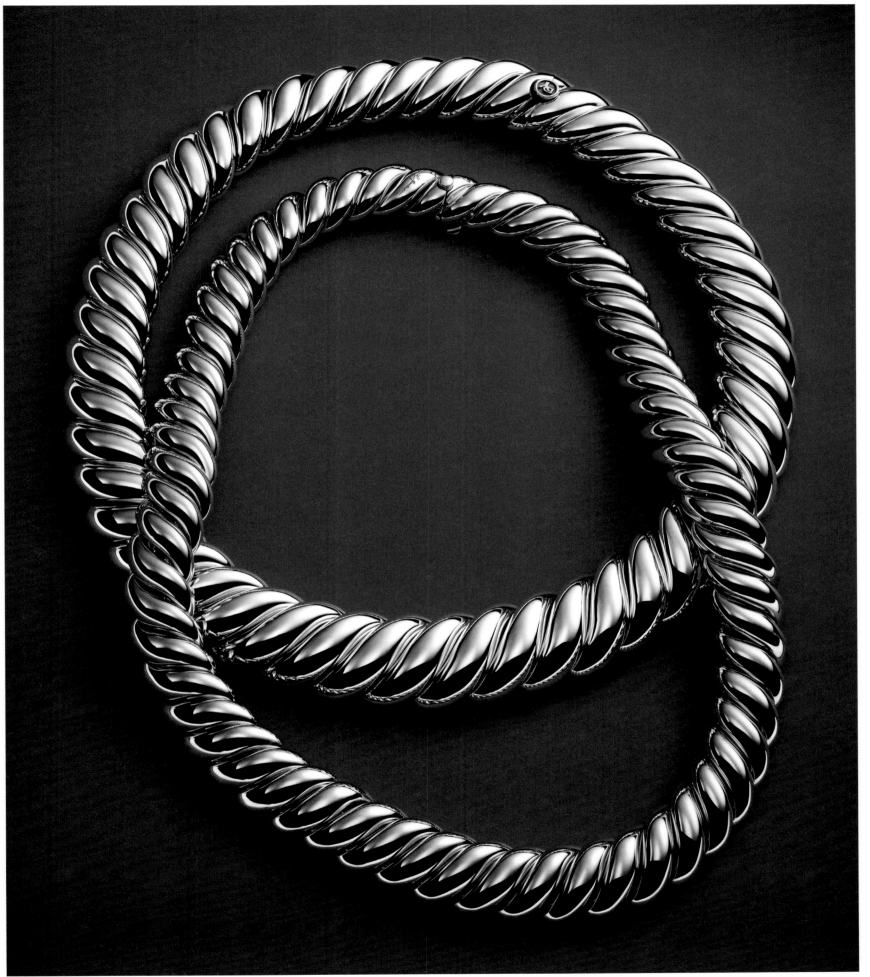

Living their lives and building their business side by side in New York City, Sybil and David kept in mind that they must create products that are affordable and desirable to different economic classes. This singular democratic approach defined their vision of "relaxed American luxury." It was a creative choice that built brand loyalty with younger customers and families, encouraging them to become collectors. In 1989, the Yurmans had their first design atelier on Madison Avenue in Uptown Manhattan, and a decade later, they opened their first retail store. The success of their first retail boutique, followed by others nationwide, inspired them to create their first-ever jewelry-designer shop-in-shops with retail partners in North America and Europe. Today they sell to nearly three hundred independent retail stores. In the early 2000s, Sybil and David expanded the company and consolidated their operations in Tribeca, a neighborhood in downtown New York City. This space became the creative laboratory, the "shop," where all prototypes and products were handmade. Both artist and artisan, the "Made in America" principle has been considered a strength since the early days of craft fairs. The 120,000-square-foot ateliers in Tribeca teeming with skilled artisans, including wax carvers, sculptors, and gemologists, are a firm testament to the value given to the excellence and the craftsmanship that stem from the exceptional savoir faire that exists in the United States.

New York, the city the Yurmans call home, has always served as an inspiration for them, from the bold elegance of Art Deco architecture reminiscent of the Jazz Age to the singular light and energy of the metropolis. For many jewelry pieces, Sybil and David were influenced by landmark buildings, including the details of the Empire State Building, the steel rising lines and circular forms in the roof treatment of the Chrysler Building, and the floor of the mythical Carlyle Hotel. The couple even borrowed the names of roads like Mercer and Lexington for their collections. In 2021, to celebrate the Empire State Building's ninetieth anniversary, they were commissioned to create limited-edition pieces inspired by the architectural icon as well as windows for its ground floor, all of which were proudly designed in New York City.

Previous spread, left: Pavé Flex gold and silver pavé-set diamond necklaces, 2023.

Previous spread, right: Hampton silver and yellow gold necklaces, 2023. Both photographed by Emil Larsson.

David and Sybil Yurman on their Tribeca apartment terrace, New York, 2023. Photographed by Norman Jean Roy.

90th anniversary
new york
always inspired by our city!

Top: Statue of Liberty, New York.

Bottom: King Kong diorama for the Empire State Building's 90th Anniversary, 2021.

Opposite (left to right): Empire Collection blackened silver pavé-set diamond bracelet; yellow gold pavé-set diamond bracelet; silver and copper pavé-set cognac diamond bracelet; blackened silver pavé-set diamond bracelet, 2021.

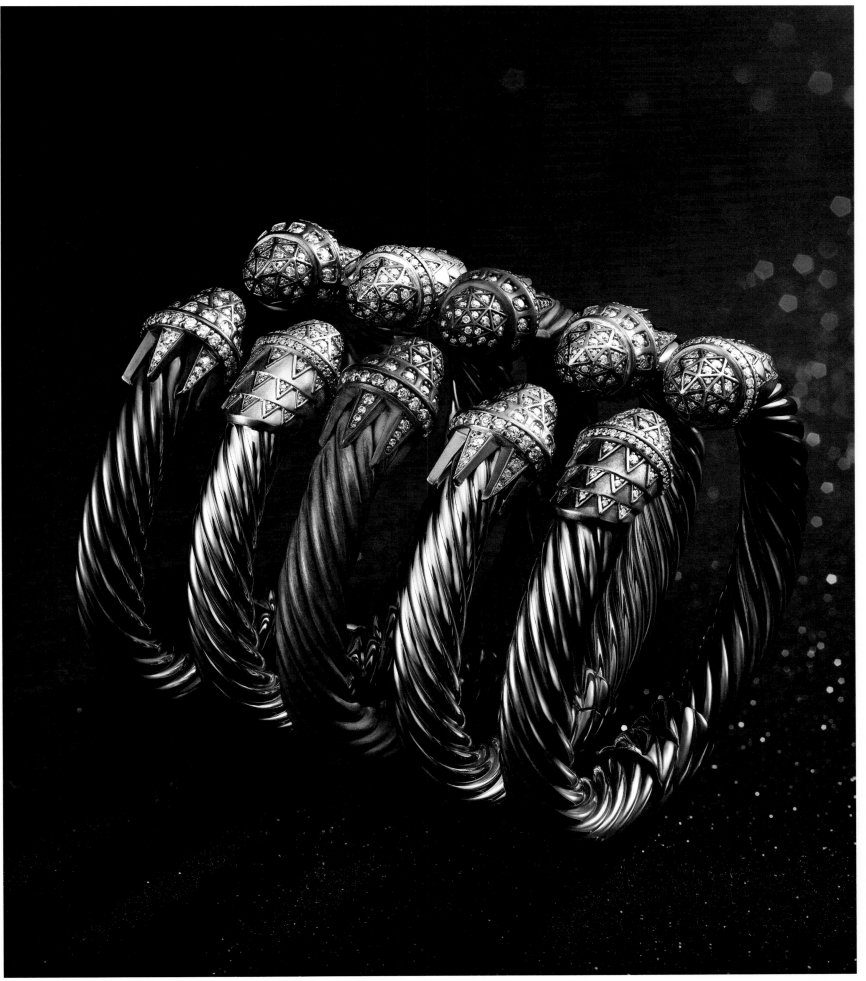

The Corcoran Gallery of Art, perched for 140 years across the lawn from the White House, is one of the oldest public art galleries in the country. On a November evening, it was hosting the final event of the series *An Audience with Art*, in which great American artists were interviewed in public. Previous luminaries included Christo, James Rosenquist, Annie Leibovitz, and the great writer Robert Hughes. Now it was the turn of Sybil and David Yurman to conclude this most prestigious lineup of American culture.

I was the very fortunate interviewer, and like everyone else who was there that evening, I will never forget it. All the artists had attracted a large attendance, but the Yurmans' gathering was beyond all expectations. Well before the doors opened, a queue stretched out toward the White House, and when they did open, the theater was jammed full in minutes, with many people sitting in the aisles. As the lights lowered, the glistening of bracelets, rings, and necklaces gave the effect of a twinkling night sky. This audience knew exactly why they were there, and they had come dressed in their Yurman art. The "democratization of luxury," I thought, as I looked out at the crowd from the side stage, having just learned that phrase from David. When I think back to that moment, it reminds me of something Sybil has often said of the people who buy their jewelry. Rejecting any notion of the "marketplace" as an abstract idea, she insists that the customer is part of the creative process: "We're not there just to sell jewelry to them; we're there to form a relationship with them. When they come into our stores, we want to know about them. What is the occasion they are shopping for?" The idea that the jewelry is completed only when the customer wears it says much about this extraordinary company.

Nomenclature, the science of names, is important for what it can tell us. In this particular case, the name David Yurman immediately puts two concepts into our minds, which in turn suggest the nature of the whole enterprise. Most obviously, it identifies a large-scale company that has changed the shape of postwar American jewelry. More intriguingly, it is the name of a living, breathing person. In the large-scale business world, one doesn't think that a Mr. Nike, a Mr. Levi Strauss, or a Mr. J. P. Morgan is out there personally designing our trainers, sewing our jeans, or counting our money. But in so many ways, David and Sybil have been engaged in doing exactly that. The company name doesn't come from an ancient founding moment sometime after the Civil War or a corporate branding exercise in which a personality is invented. It arrived through decades of the tangible presence of these two people. And they—and now their son, Evan, as it is and will remain a family-owned company—haven't simply run the company in the business sense: they have been central to the design and making of everything it has produced. It is this that makes the David Yurman phenomenon rare, if not unique, in our times: an artist-led company operating on an international scale. To say the least, these two things don't normally go together: that they do in this case is entirely a testament to David and Sybil's journey through life.

The Corcoran soiree was a revelation, not only because we realized the scale of the company and its achievements but also because we all bore witness to the extraordinary historical context it came out of. David has humbly quipped that he and Sybil never consciously thought about themselves as part of a grand cultural history—"We were just making things with our heads down."—but they are so clearly a living manifestation of a powerful thread within the modern American visual arts.

A NIGHT AT THE CORCORAN

BY PAUL GREENHALGH
WASHINGTON, DC, NOVEMBER 18, 2009

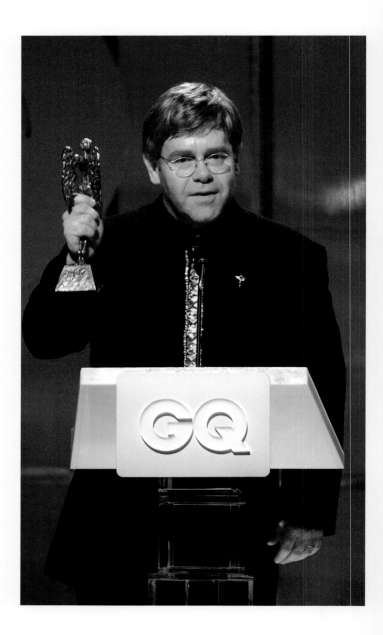

Elton John with the Angel Award designed by David Yurman for the Humanitarian Award at the GQ Men of the Year Awards, New York, 2000.

Top to bottom:
Former Secretary of State Madeleine Albright with Sybil and David Yurman at the GEM Awards, where she presented the couple with the Lifetime Achievement Award from the Jewelry Information Center, Cipriani 42nd Street, New York, 2004.

Kate Moss with David and Sybil Yurman at the *Dazed & Confused* magazine dinner, New York, September 2006.

David and Sybil at the GQ Men of the Year award ceremony at the Beacon Theatre, New York, 1999.

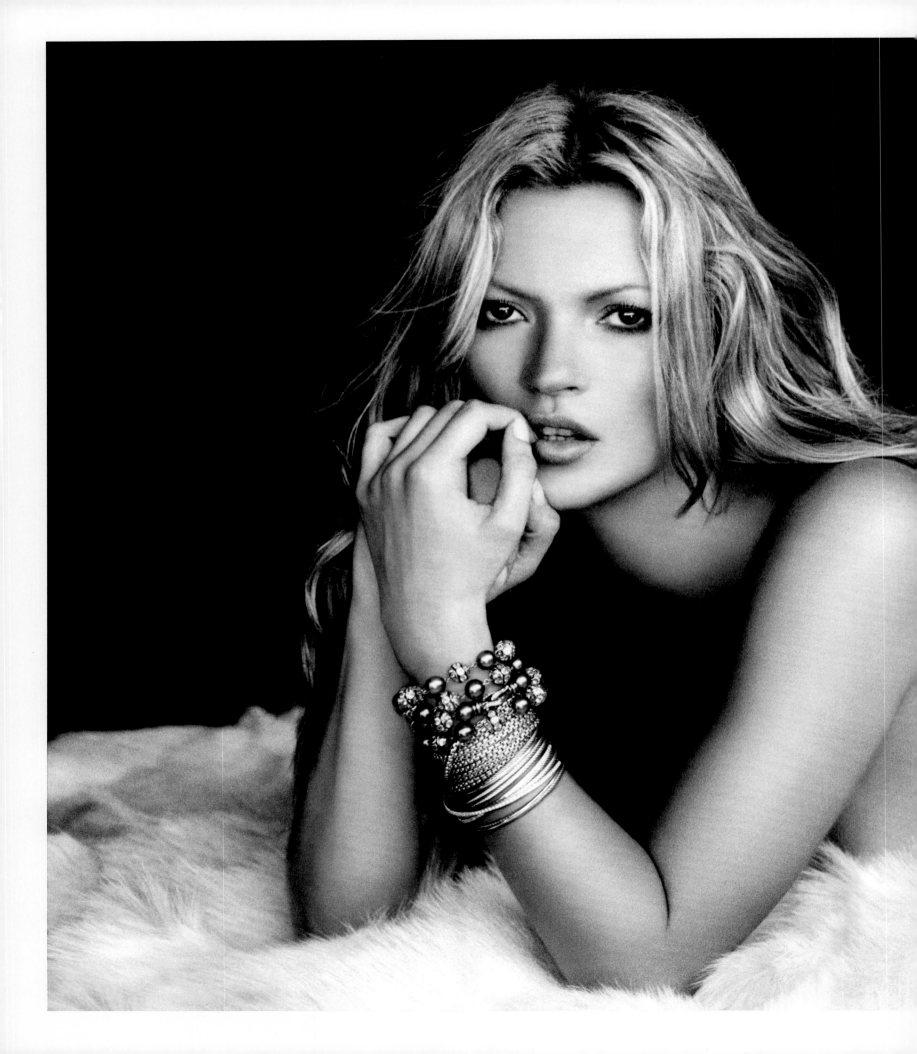

This context they come from—and continue to shape—emanates from two core sources in the history of modern art and design. First, the great age of artist-led companies that emerged in Europe and the United States in the last decades of the nineteenth century. These companies gave us the international Arts and Crafts movement and the Art Nouveau style, for example, which then led to the Art Deco style and established a set of aesthetic and ethical standards for the role that consumer goods should play.

From the 1870s onward, companies run by William Morris, René Lalique, Émile Gallé, Georges Fouquet, and Louis Comfort Tiffany, among others, were sizable enterprises that led taste in their times: more important in this context, they were artistically led from the front. They collectively set the stage for a great era of craft production generally and jewelry specifically. Second, the American craft movement, which blossomed through the 1960s and '70s, was one of the most important developments in postwar American art. It revolutionized the status of craft and impacted the global craft scene. Benefiting from the platform created by its end-of-the-century forebears, the new movement placed value on individual creativity and an idea of craft that wasn't only to do with making but also with lifestyle.

David and Sybil were at the heart of the American craft movement, a vortex of creative activity. They contributed powerfully to the debates on art, craft, and life that formed the outlook of the American scene; they supported fellow craftsmen and took part in the organization of the national crafts infrastructure. And they made a phenomenal number of pieces. In 1973, they moved to Putnam, New York, an hour or so out of Manhattan, and created the Putnam Art Works. Through this craft jewelry operation, they sold their work in hundreds of galleries, crisscrossing the country month after month, year after year, meeting in person with the people who bought their work. It was an important developmental phase for the two of them, a final apprenticeship as it were, like no other. They created a vibrant business in this new craft environment. Vitally, they gained a profound understanding of the relationship between maker and consumer through their face-to-face meetings with their buyers. In 1980, when they founded the David Yurman company, nobody in the United States had a better sense of what jewelry is, how it is made, and why people wear it.

Something else sits at the heart of their outlook. Their love of making—of producing things—led them to defy all the artificial barriers between art, craft, and design. David and Sybil shared this outlook with the Art Nouveau generation: shared, not received, because they didn't learn it from these grand ancestors. It was already inside them from the very start.

Their careers were moving along independently at the time they met. Sybil was becoming an established painter with an interest in ceramics, and David was a sculptor focused on metal who had engaged with other materials. They began a relationship, and the artistic partnership unfolded from there. David puts it succinctly: "I met Sybil. It didn't simplify my life, but it clarified it." Perhaps the most powerful aspect of this clarification was the commitment to art and to finding a way to live as artists. As Sybil has said, "We came to art separately, and when we came together our objective was simply to continue being involved in what we wanted to do with our days: art. . . . David was a sculptor and I was a painter, and in the beginning we didn't have a specific direction.

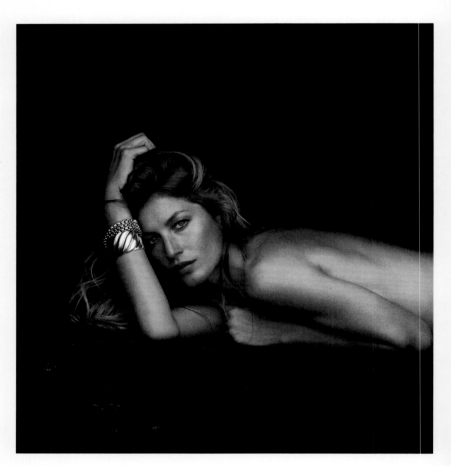

Previous spread: Kate Moss wearing blackened Tahitian pearl and Hampton topaz bead necklace as a bracelet, silver box chain bracelet with multiple silver pavé-set diamond bangle bracelets, 2006.

Gisele Bündchen wearing gold sculpted Cable cuff box chain bracelet, Malibu, California, 2012. Both photographed by Peter Lindbergh.

Opposite (left to right): Renaissance silver and gold bracelet with pearl and pink tourmaline cabochon, silver and gold with iolite and pink tourmaline, and silver and gold with pearl and iolite, early to mid-1980s. Photographed by Emil Larsson.

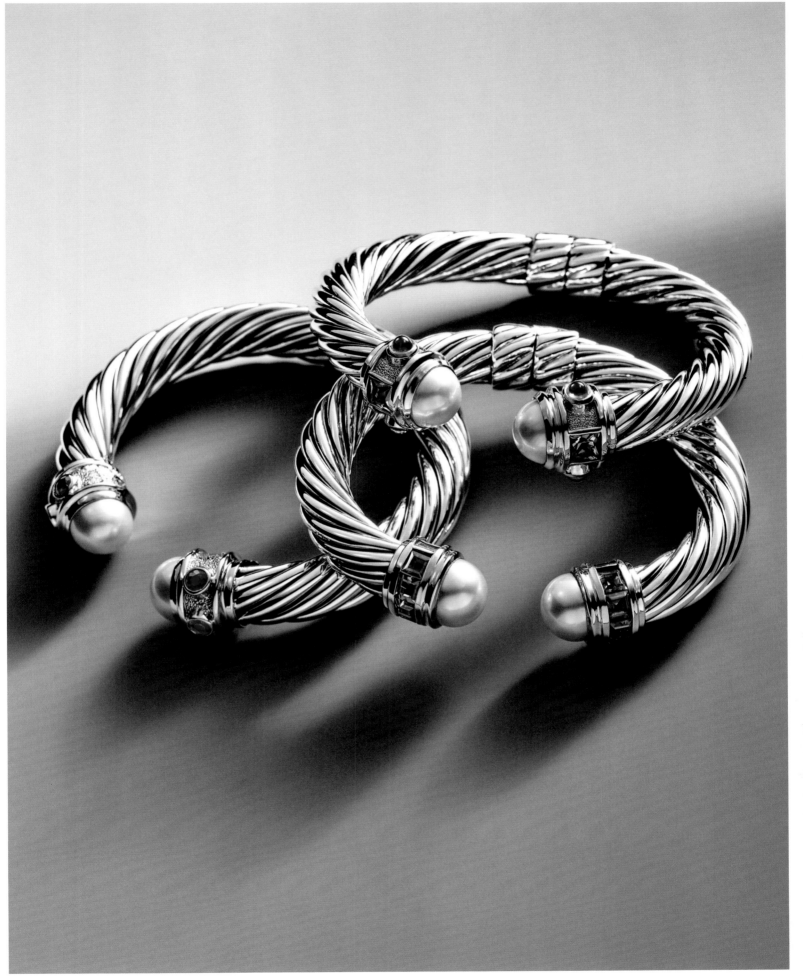

Looking back, it is pretty clear that we were in the process of finding a way to live that was involved in creating art. . . . The central part of our relationship was looking for a way to live as artists."

From their earliest days, their practice was rooted in the physicality of transforming materials into beautiful things. Their ideas didn't so much inform the objects they made; the objects *were* the ideas. Sybil mentions, "We both had the making gene. . . . Our intention was to make things; we liked making things. . . . This is where our sense of satisfaction came from. We had a sensibility driven by craft and our idea of what design was." They set out to fashion a life that would allow them to make art.

The ethos of the American craft movement was very much driven by the individual maker fabricating by hand: one made things as a way of life and worried about how to stay alive as a secondary issue. Among many of these modern craftsmen, there was a deep suspicion of the two things that had made the modern world: commerce and technology. David and Sybil didn't buy into this. They felt that the way forward was to embrace the individuality and integrity of handmaking but also to integrate technology and commerce into the process. In the fashion of some of the influential artist-led Art Nouveau companies, they fused the craft ethos with technology and commerce in a fully integrated approach to design.

The story of one of their most seminal pieces, the Cable bracelet, perhaps best reveals their outlook. David made the first Cable bracelet in 1978. He and Sybil quickly realized the potential of this form, one which simultaneously resonates with ancient symbolism and contemporary life. But it took far too long to make by hand to be commercially viable. After considerable research, they found an engineering solution that enabled them to mechanize the production of the Cable twist to a high standard. Thanks to this specific technology, the bracelet could become far more widely available.

The story brings to mind another seminal moment in American design. At the turn of the twentieth century, C. R. Ashbee, one of the leaders of the British Arts and Crafts movement, was lecturing in the United States, when he met a leader of the Illinois crafts community, the young and then-unknown architect Frank Lloyd Wright. Ashbee was aggressively anti-technology in his vision of design. In a famous altercation, Wright took Ashbee to task over this, asserting that hand skills and technology should be brought together to enable a new harmony to be achieved and that this way more people could be brought into contact with art. A century later, and in a very different world, the spirit that challenged Ashbee is the same one that invented the Cable bracelet.

Back to the evening at the Corcoran. The maxims that the Yurmans live and work by emerged through the easy elegance of their words. Five stood out: the personality and skill of the maker is vital; art, technology, and commerce must work in harmony; the relationship with one's audience is part of the creative process; jewelry is wearable art; and most important perhaps, quality is paramount. As I sat with these two people facing a very contemporary audience, I somehow felt close to the artistic giants of the American past.

Joan Smalls wearing Renaissance aluminum, proceeds of which went to charity, and silver Pure Form bracelets with a sculpted Cable cuff, 2021. Photographed by Lachlan Bailey.

Sybil and David Yurman on set with Peter Lindbergh, Malibu,
California, 2014. Photographed by Darius Khondji.

Sybil and David Yurman in their atelier, New York, 2023.
Photographed by Norman Jean Roy.

EVAN YURMAN THE RISING SON

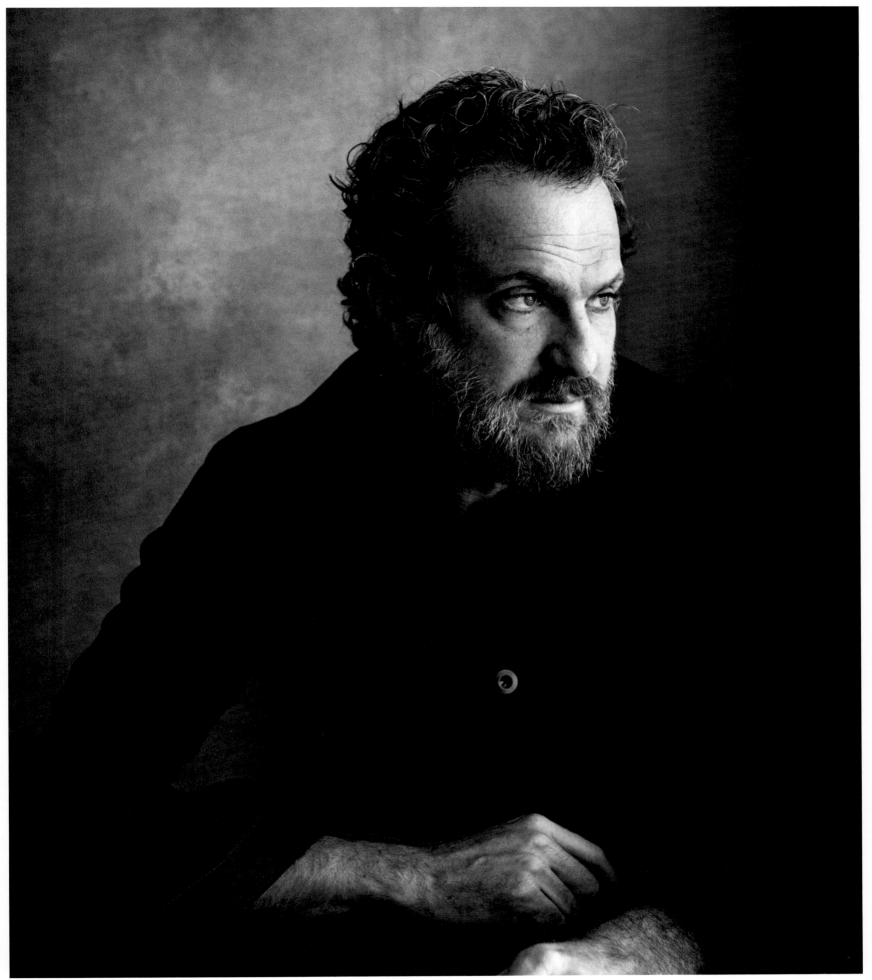

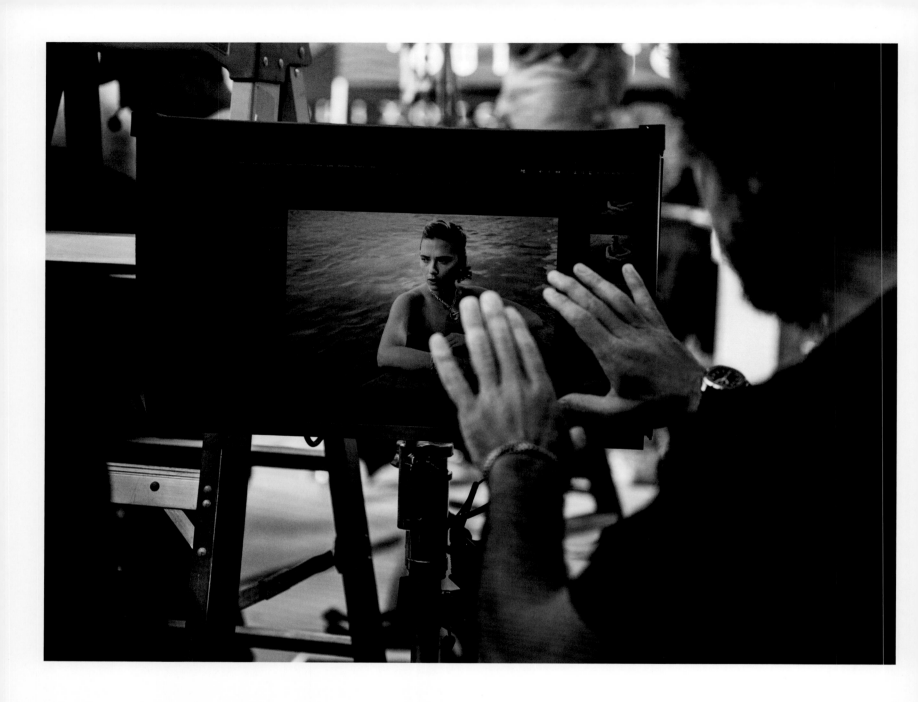

Previous spread: Evan Yurman, New York, 2023. Photographed by Norman Jean Roy.

This page and opposite: Scarlett Johansson and Evan Yurman, Amagansett, New York, 2024. Photographed by Lewis Mirrett.

EVAN YURMAN THE RISING SON

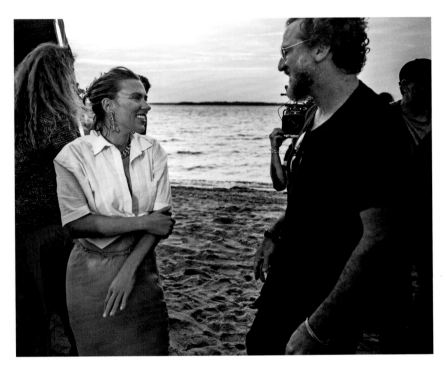

If you are fortunate enough to visit the Yurman family's design atelier, you will find a world of exceptional artists and craftsmen. A haven that lies on the border between calculated order and creative chaos, where the artist is nurtured and given room to explore and grow. It is in this environment that the young Evan first learned to navigate the road between business and art. This was the classroom where he could experiment and eventually carve out a place of his own.

Over the last four decades, Evan has grown up alongside a business that his parents have humorously described as one long art project. Born in 1982, the same year that the company launched its signature Cable bracelet, which he jokingly calls his twin brother, Evan is now the company's president, responsible for all aspects of the business from design and production to sales and marketing. However, his early memories are as a young child eating his lunch or doing his homework under the busy but watchful eyes of a variety of workers, who became his second family, his friends, and his mentors. As he grew older, he had a front seat to the growth and evolution of the business, and these days, he is challenged with setting a path for the company's future.

Away from Evan's executive office in the firm's Tribeca headquarters, where he administers day-to-day operations, there is a quiet studio that he retreats to when he wants to explore an idea or work on a design. When he first created this space, he was twenty-two years old and had just been made head of men's designs. He decided to call his studio Noumenon. The definition of *noumenon* is related to Kantian philosophy: a thing as it is in itself, as distinct from a thing as it is knowable by the senses through phenomenal attributes. Because everything has an essence—even if our senses can't see or feel it, it's there—and Evan saw the creative process as a search for that which is essential. Noumenon is therefore the perfect name for a studio that could be best characterized as an elegant cross between an art gallery, a movie set, and the treasure chest of a bohemian/high-tech character: "It is preorigin—the idea before a reality."

Once you access this exclusive, beautifully curated space, you can see both the taste and the sophistication of the artist behind the broad and varied content of this connoisseur's collection, the large array of remarkable attributes in his passions (muscle cars, modified motorbikes, and records, but also Scandinavian furniture, exquisite design objects, rare coins, and stones) and obsessions (ancient Japanese samurai masks, books, swords, Masonic jewelry, and anything with an extraordinary texture). "My parents taught me what I needed to know. My father said, 'If you have an idea, draw it, then make it, and then you have to sell it.' So I went to the trade shows, created sales and marketing packages, learned sourcing and manufacturing, and all about gross margins and profitability," explained Evan to *Forbes* magazine back in 2022.[4]

When Evan looks back on his childhood with his parents, who at one point had less time to practice their own art as they became more and more successful with their jewelry, he recalls, "Well, they were just extremely passionate about their work. Creativity was paramount. If I wanted to stay up late past my bedtime as a child, I could only do it if I was doing something creative, like drawing or painting. I grew up around a lot of adults, and then I had my friends, but I was never really interested in kids my age." The school bus dropped him off on the corner of the

atelier and store at Madison Avenue and Fifty-Third Street every day at 3:00 p.m. "I did my homework in the office around employees—they were my extended family. As long as I can remember, we've always had a business, and I grew up coming to the office."

This proximity to employees is something the young Yurman certainly tries to recreate: "I wanted to marry my strategic goals with my people goals as well." Referring in retrospect to the five major pillars of his business—finance, operations, design, merchandising, and creative marketing—he realizes now: "My mother was always the merchant and the marketer. My father was the operations, finance, and design. They had this mix and most importantly this great balance of being merchants and pure creatives." Favoring teamwork and collaboration, he acknowledges that he could not achieve his work without the unique savoir faire of his teammates, as he refers to them, adding, "I have visions and goals for the company, but I'm not going to be able to accomplish any of it without our people. I want to marry our people with our organization and our strategy. You can't be a customer-centric business without being employee-centric too."

Vacations with the Yurmans were not to the beach or Disneyland. Early on, David and Sybil made sure their son would have every opportunity to absorb what took them decades to learn, fast-tracking his business education. The so-called vacations would be where there was a store or a wholesale account. "I would sit in the store and watch them merchandise and work with the consumers and develop the relationship with the customer and then come back and talk about the product and what they would make. I would see how the business works—the marketing, the merchandising, the sales. I would see it sort of like all in one," Evan recounts. The unplanned daily masterclass did not go unnoticed; he astutely understood that, being the only child, he would have to decide at a very young age if he wanted to join the business or not.

His school years were certainly not the best memories, as he explains: "School wasn't for me. It was just too structured, and I have a creative mind, kind of all over the place with a touch of ADD. I was dyslexic at the time; it was kind of hard. They didn't really know how to deal with it back in the day. There was one school, two schools in the country that focused on it, one outside of Washington, DC, and another one in Westchester, New York, which we found later, and went there; it helped a lot. But school was not a place where I felt good." He remembers that a small number of teachers guided him through the transformation of what could have been considered a weakness into his strength. "My creative writing teacher in English, she basically made sure that all my English was only creative writing, and I didn't have to do any other type of writing. She was the head of the English department, so she made me focus on what I was good at, creative writing, because she quickly understood that I had an unusual perspective. These teachers are lifesavers; they just change the mold and give confidence to kids."

What does a teenager do when his workaholic parents work around the clock, drawing sketches even on napkins at the twelve-foot kitchen table covered with papers, magazines, drawings, samples, and notebooks? When he knows that every piece of paper in the house could become covered with sketches and end up in the atelier to be prototyped? He does the same. Evan started drawing collections from a young age with his

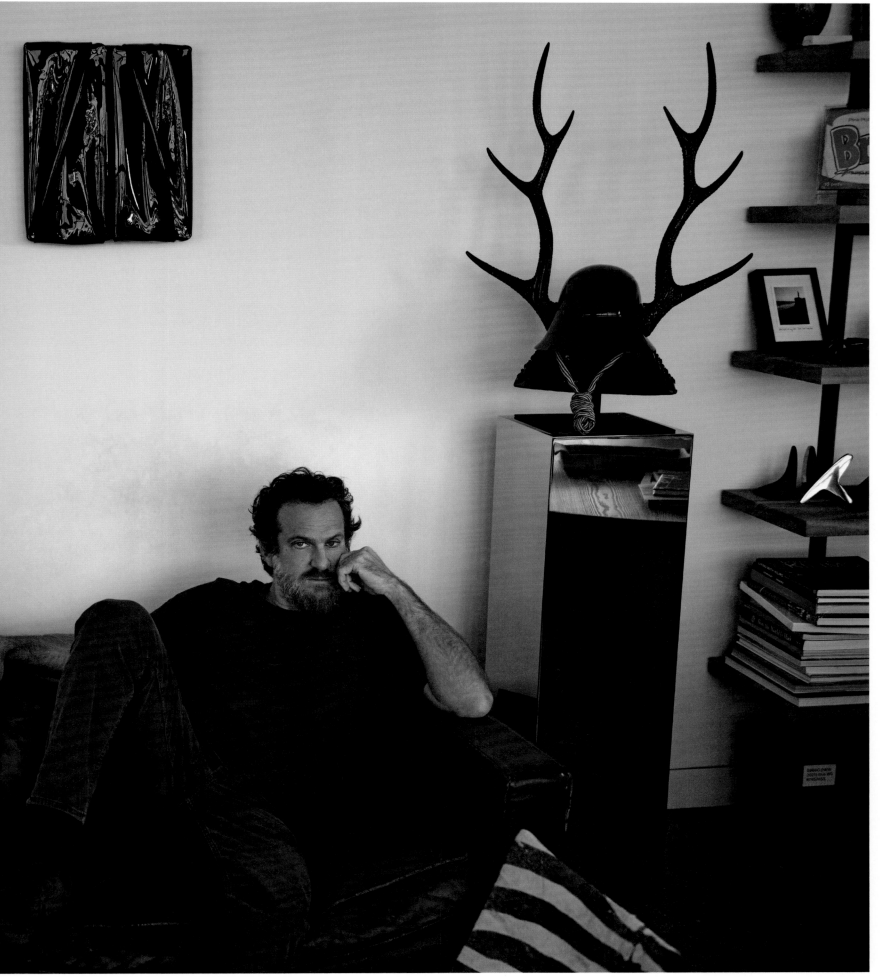

parents, but he was sketching *his* collections. At the time, his background music was speakerphone conference calls with the likes of Neiman Marcus or suppliers in Switzerland, a surround sound of executives raising issues and finding solutions. Evan remembers that, in the early 1990s, most New York businessmen wore cuff links. He remembers saying, "'We need to make them look like a baseball because men like baseball!' This was the perspective of a fourteen-year-old, very matter-of-fact. You ask a kid what to invest in, and they're going to tell you, right at that moment; they're going to tell you what's hot right now. Everyone else will be looking at numbers and algorithms and what to invest in, what's up, what's down, and kids will just be like, 'I really like this thing. I really like it and my friends really like it, so you should do it.'"

This emotional approach to the business certainly helped him develop unconventional skills and an unconventional approach. Evan explains: "This was my sort of journey through the men's business. I had a creative idea. I saw there was a gap in the market. So that's a merchant thinking, 'There's a gap; there's no men's jewelry out there. I want to wear jewelry; my friends want to wear jewelry. I was just in Europe; they're wearing jewelry. Why can't we bring that to the American market?' And we have the distribution for it. So I said, 'I want to make men's jewelry.' And my father said, 'Great. Then draw it.' I drew it. I'm not an amazing illustrator, but I had enough to give to somebody to make it. And he responded, 'Now you have to make it, but you're not going to use the people that we have. You can learn from them, but you can't dictate to them. You can sit alongside them, but I want you to at least take it to the step where it can go into metal and then learn.' I took a year to make my first collection."

After designing a few men's jewelry collections, Evan was able to have his works sold at high-end department stores, like Neiman Marcus, Saks Fifth Avenue, Nordstrom, Bloomingdale's, and almost half of their independent retailers. "I worked on the samples," he explains, adding, "I got manufacturing. I went to the trade shows. I sat with people; I sold them the packages of product. I did the catalogs, the photography—everything you had to learn—and I somehow built a business within the business." Being the "son of" can certainly be difficult, but Evan in no way feels he was a nepo kid. "I had to fight for it, and it was OK. They wanted to integrate me into the business. They wanted to integrate me into the process."

Evan's numbers doubled every year and kept growing exponentially: they now represent a quarter of the company's total business. "I'm safe to say we are the leader in men's jewelry today. At twenty-four, I was burnt out, believe it or not. I just needed to take some time off. And it was a mix of just hard living, being in your twenties, living in New York, partying, hanging out." In 2004, *WWD* reported[5] that Evan's custom-made pieces generated a great buzz, establishing a following with clients such as Kate Moss, who commissioned him to make her a custom-made ring with a sixty-carat onyx grasped by two tiger claws. Later, he also created catwalk pieces for the spring 2005 collection of the trendy New York City–based fashion collective As Four.

The young Evan developed precious partnerships with fashion industry leaders like Nick Sullivan—former fashion director at *Esquire*—and Hal Taylor—who was working at *InStyle* at the time—putting jewelry on men and starting as early as 2008 to advertise men's products. He understood early on who his customer was. He explains, "Magazines back then were

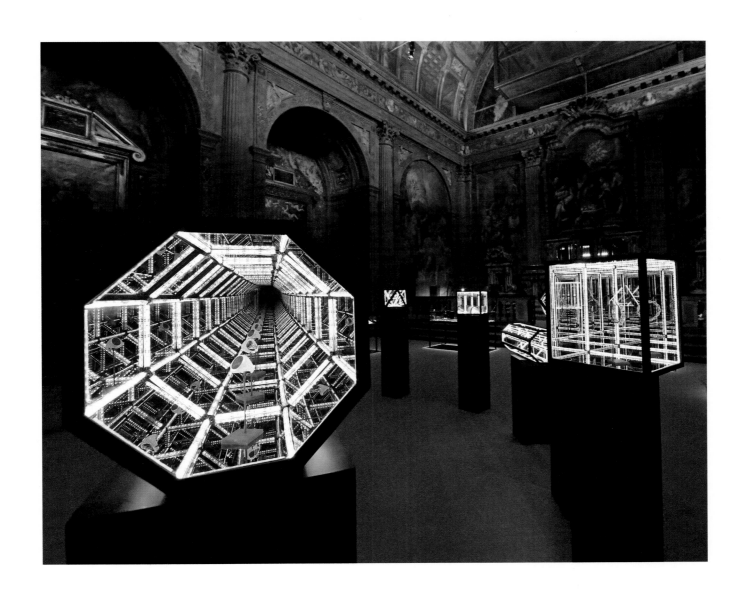

Previous spread: Evan Yurman in his office, New York, 2023. Photographed by Norman Jean Roy.

Opposite, top to bottom: Anthony James portal sculpture for a High Jewelry event at Chiesa di San Paolo Converso, Milan, 2017.

Noumenon, Evan Yurman's design and exhibition space at the Vestry Street headquarters, New York, 2016. Both photographed by Eli Obus.

This page: View of the *David Yurman—Where Design Meets Art* exhibition in Milan, during Men's Fashion Week, Fall/Winter 2017–18.

teaching men how to match their tie with their socks. How to wear a tie, single and a double Windsor. It was basic, khaki pants, blue shirts. The 2000s men's fashion was more dedicated on their day-to-day. I'm not talking about men's high fashion or Milan Fashion Week. It was your everyday guy that we needed to connect with."

When Evan was twenty, his parents received their first of many offers to sell the business. Without any real context, his mother, Sybil, came into his office and sat down very seriously and said to him, "Your father and I would like to know if this business is something you would like to continue." He adds, "They never would've sold it anyways, but it seemed to be a question on their mind. They have never put any pressure on me—it is my choice to be in the business today." Sybil mentioned in the November 2018 issue of *Town & Country*[6] that a third generation may carry on the Yurman legacy, even if neither David nor she would call it a legacy or a heritage. "We never had a desire to have a business, as it were. It was always a way for us to keep painting and sculpting and sustain this making gene. All of us have it in the family," she explained.

In 2006, Evan left the company for a year to apprentice and work under Harlem-based blacksmith-artisan James Garvey. This premeditated break from the brand would be quite beneficial for the potential and future of the brand. "That was a huge turning point in my life. From there I said, 'I think I'm ready to come back to work full-time for my father,' and when I did, I was very organized and methodical. I had a clear vision of what I wanted to do, and while I was doing all of this, I developed this obsession with textures and organic patterns, which I started to incorporate into my designs,"[7] he explains about his formative year as a blacksmith. Constantly exploring new ways to reinvent classic pieces from the archives, like the Cable bracelet, whose original pieces he recast in anodized aluminum—a material he experimented with while developing a high jewelry collection—he also develops his own designs, most notably men's rings, dog tags, and more recently, innovative and bewildering high jewelry—all made in the United States. His experimentations have made it possible to introduce a reworked Cable bracelet in bold and pastel colors, as well as in silver, gold, rose gold, and blackened gold, with limited editions of six covered in white, black, or pavé cognac diamonds.

"I knew how to design," Evan explains. "I knew how to make a product, but I didn't know the business of it. I knew the front of the house. You design, you make, you sample, you manufacture. You have a price point: you try and make it. But I didn't understand how you fund a business, how cash flow works, what the operations are that you need. I had a leg up in that there was a machine already in place, and I built a business from there. And that was something I didn't want to really get into, nor did I really have the interest in figuring out. I was having too much fun. I toyed with the idea of branching out, doing something on my own. But I also watched what it did to my parents, and I saw that it really restricted them from having any so-called normal family life. And I didn't want that. I had my first child at twenty-seven years old. I was traveling, and I was already working a lot."

Evan also knew that if he wanted to do something on his own, to do something different, it was going to require a lot of his involvement and attention. He remembers: "My wife, Ku-Ling, wanted to start a family, and

Opposite: Evan Yurman's personal collection of ancient coins, 2015. Photographed by Robin Broadbent.

Evan Yurman's hand-forged knives, 2008.

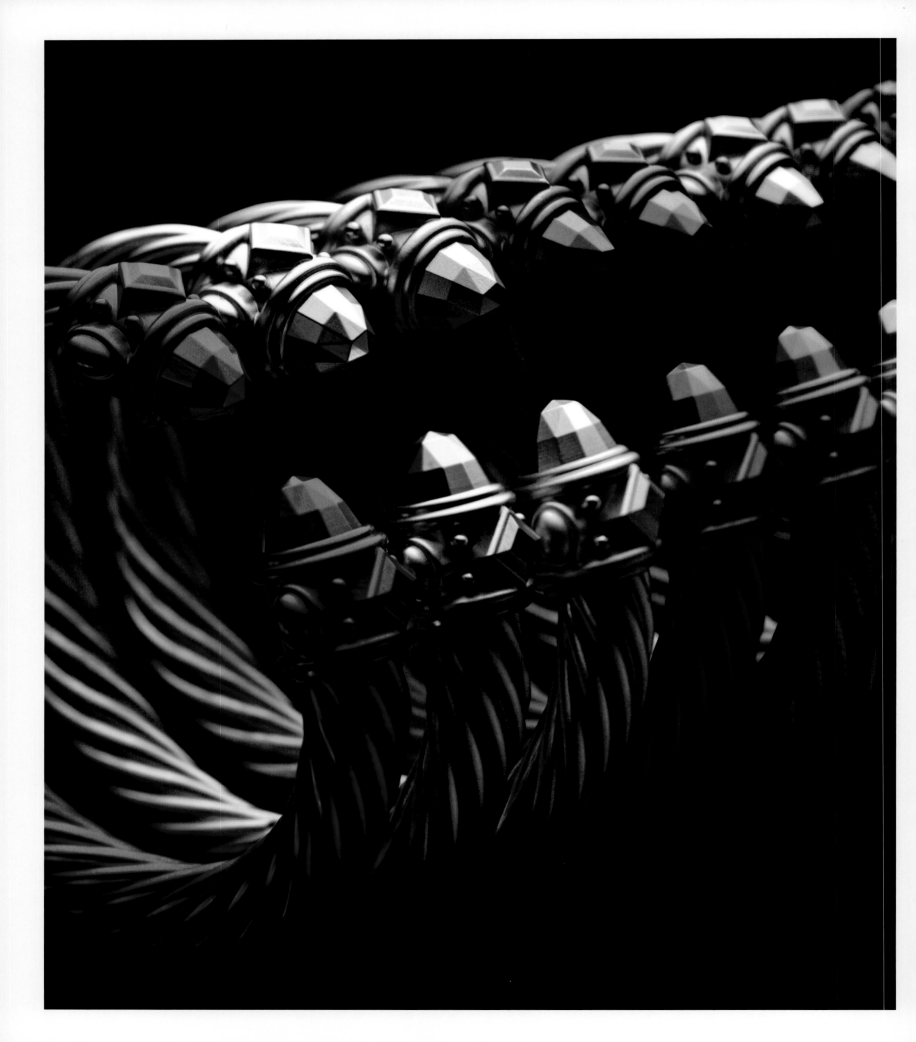

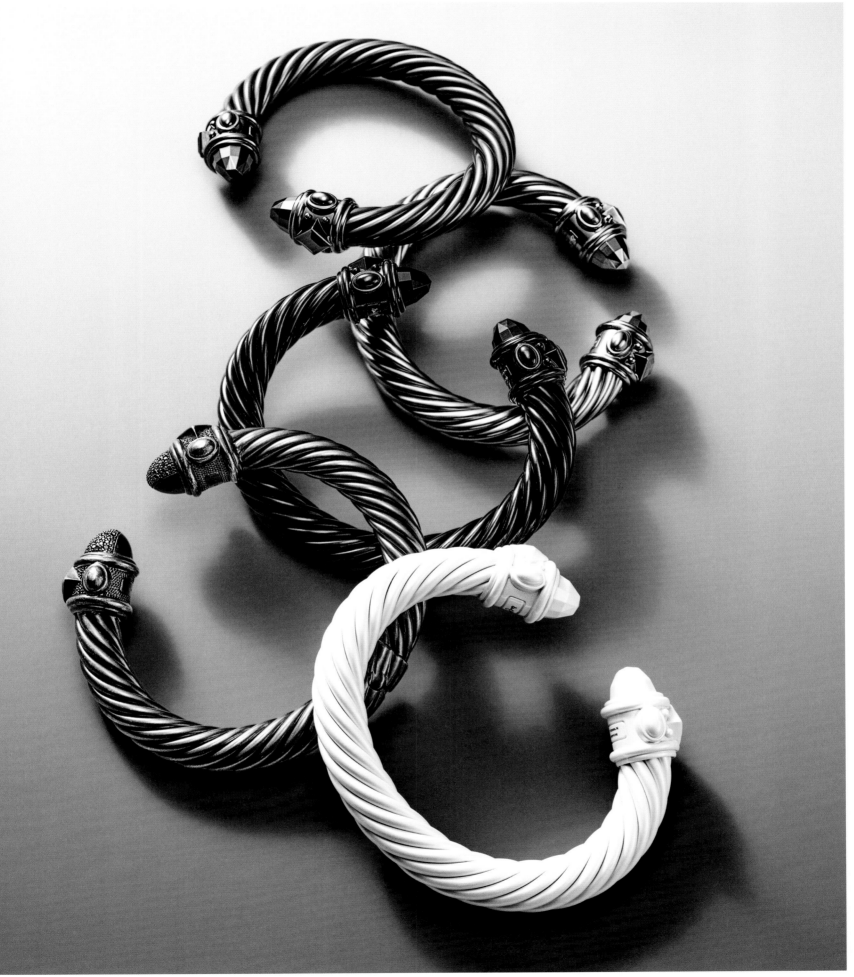

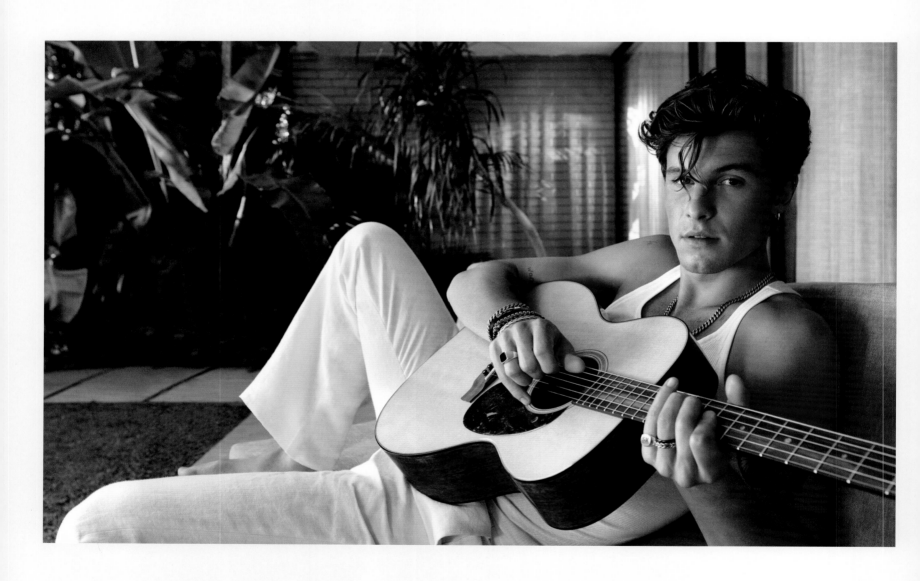

Previous spread, left: Renaissance Cable bracelets in aluminum, 2014.
Photographed by Nathan Copan.

Previous spread, right: Renaissance Cable bracelets in black, white, and gray
aluminum, 2023. Photographed by Emil Larsson.

Shawn Mendes wearing Curb Chain necklace, gold Stax Huggie earring
with black onyx ring, Chevron ring and yellow gold forged carbon ring,
2023. Photographed by Glen Luchford.

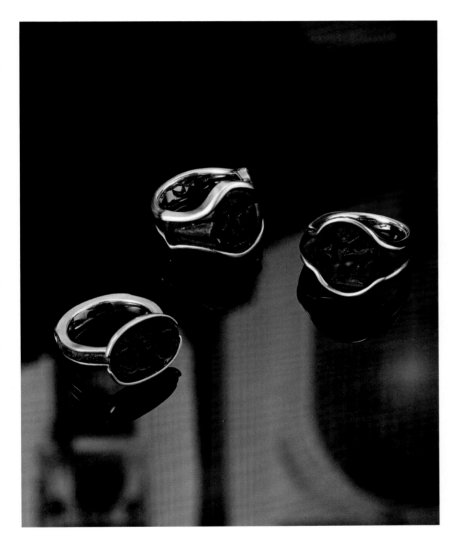

Petrvs rings, 2022.
Photographed by Maxime Poiblanc.

I didn't think the two of those were going to go well together. I watched my parents do it, and I realized I was at a crossroads. I said, 'OK, I like the lifestyle that I'm living. I like the fact that I can be present. I like not having to worry about my business, living on the edge.' Ask anybody. Starting a business is no easy feat, even if you have the leg up, even if you have the knowledge. Think about the number of businesses that are successful. If it were easy, everyone would be successful. It takes knowledge. It takes hard work. It takes passion. It takes a lot of luck, the stars aligning. You could have a great idea, but somebody else could have just as good an idea and be in the right place at the right time. I also thought, you know what, I like this business. I like the customer, and I like the product we make. I like the core values of our designs. It's like bringing artistry and craft and personal expression into jewelry. There was a platform. And I thought to myself I could make this bigger and better and make it available to more people. So that's what I'm doing now."

Back in 2014, in an *Interview* magazine profile, the rising son gave his thoughts on the future of the brand. "My vision for the future of the company is to maintain the core values of the brand," he explained, "while adapting that messaging to be relevant to the times that we live in. I've always thought that my parents' approach to the business has been to build and survive—mine is to build and sustain." Has it changed a decade later? No. Evan's vision of the brand is longevity. It is anchored in the firm belief that legacy brands, like the one he has in his hands, are built on trust and consistency. "A brand that has your name attached to it comes with a lot of responsibility. We have an artistic, design-led philosophy that's more than just marketing and brand-building. We offer our customers wearable art."

When asked how he adapts and how his parents adapt to the perpetual changes of the markets, to social media, to everything from going through a pandemic to the internal reorganization of a company, Evan answers that it is difficult, explaining, "I don't create a business as dynamic as this one with as many different archetypes as customers or a wide range of customer segments by being close-minded to evolutions in the market. I think they know what they know. And if you think about their career in this business, it's been a fifty-year career, so you have five decades of evolution. They had to evolve. I only came in twenty years ago, so they went through three decades of evolution prior to that. Even during my second decade, they had forty years of experience managing this women's business and always having to evolve and to continue identifying new products that were ever-changing. But there was always this core product that drove the business, as well as a core consumer. They know that well, but they also know that there's always going to be something that they don't know, and they want to know about it. Like TikTok. I explained to them that this is purely for the social media audience—it's not for our forty-five-year-old customer who is never actually going to see this but for her daughter who will. So if an idea is explained and quantified and proven out, they're entrepreneurs. They're not suddenly going to be rigid!" Adaptation certainly is the ethos that will guide not only the company but also Evans's vision of the future and of a business grounded in strong values, human connections, and people coming together.

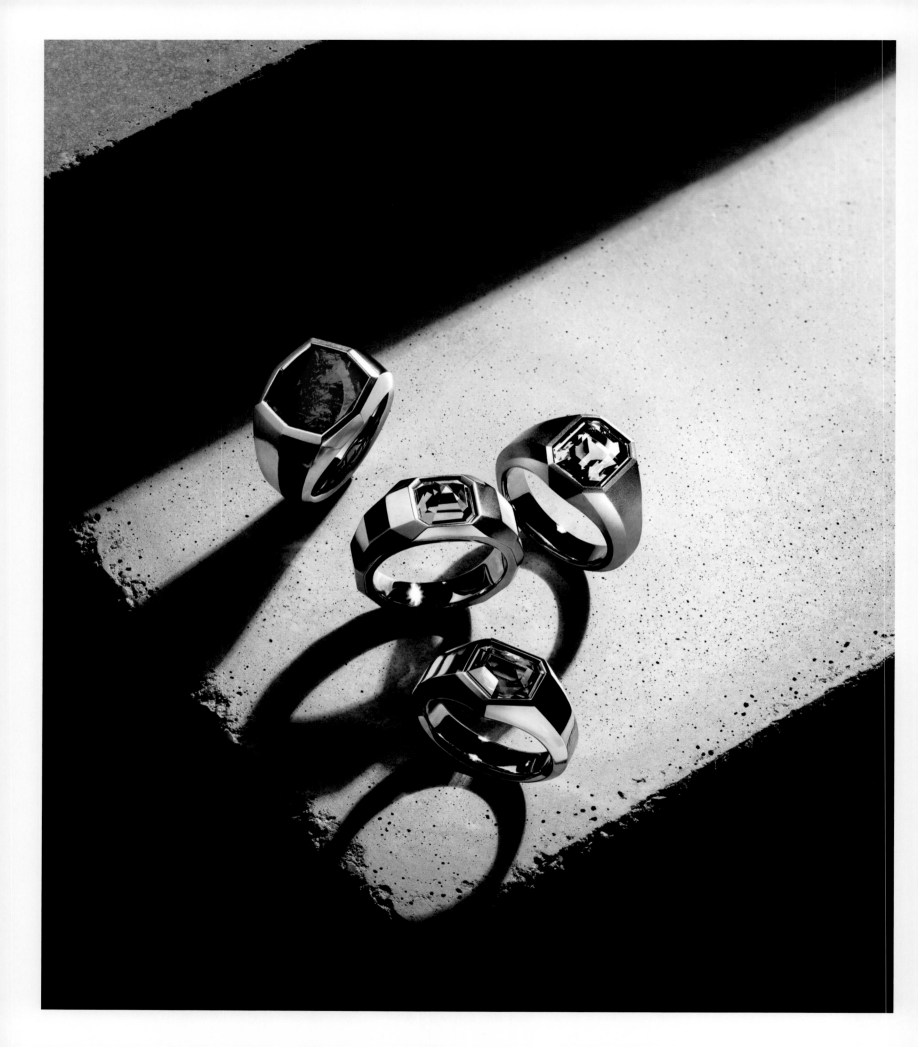

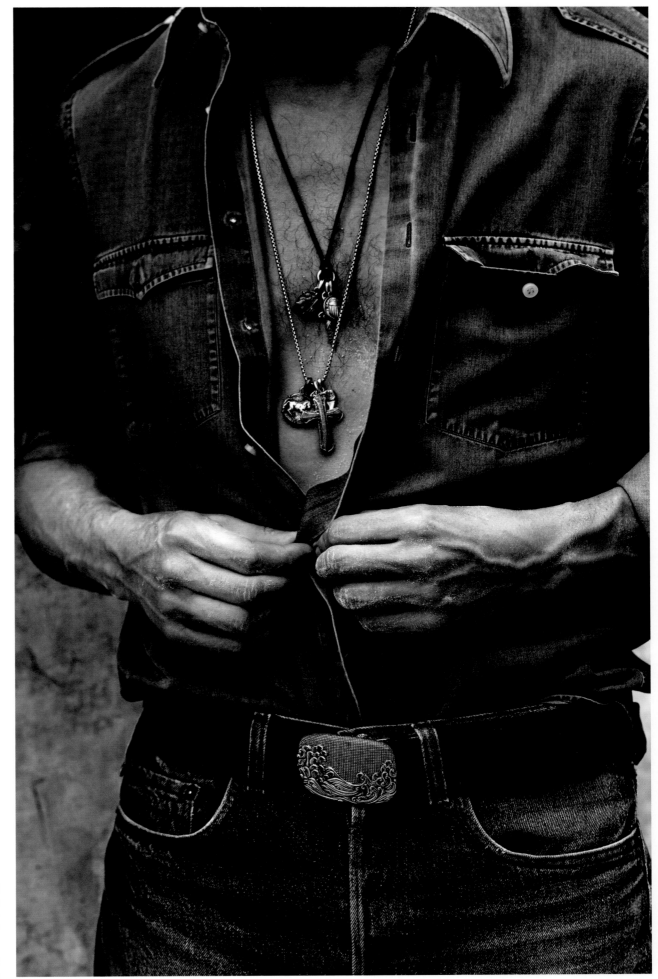

Opposite: Men's band rings made of forged carbon, meteorite, 18-karat gold, and black titanium; and streamline band with pavé-set black diamonds, 2018. Photographed by Nicholas Alan Cope.

Men's amulets on box chains with Wave belt buckle, 2011. Photographed by Cédric Buchet.

The men's division, one of the fastest-growing areas of the business, is known for featuring nontraditional materials such as titanium, carbon fiber, and meteorite. One example is the Exotics collection, which features a selection of exotic natural stones unique in color and pattern (often picked up during the family's annual trips to the Tucson Gem Show), each piece essentially one of a kind. The various stones and materials collected during Evan's travels inspire new design ideas and reinvigorate his passion for creativity.

EXOTICS

Men's rings, 2018.

Opposite: Gold box chain necklace with a gold-forged carbon tag from the Waves Collection, 2018.

Both photographed by Nicholas Alan Cope.

Men's Swiss-made Classic timepiece collection, 2011.

Opposite: Swiss-made limited-edition rose gold
Ancestral timepiece, 2011. Both photographed by
Raymond Meier.

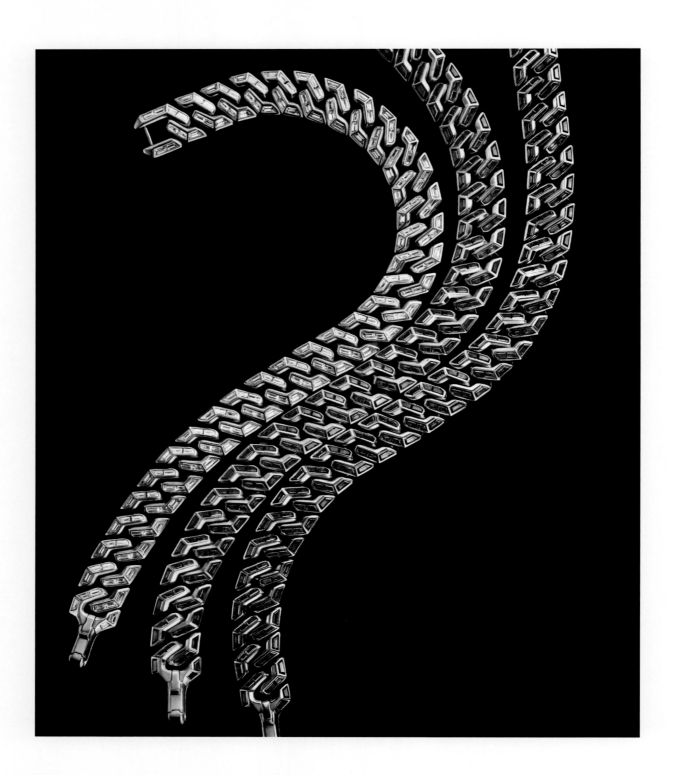

From the Vault Collection (left to right): angular 11mm curb chain bracelet in 18-karat yellow gold with baguette diamonds, with baguette rubies, and in platinum with baguette sapphires, 2023. Photographed by Gary Petersen.

Opposite: Michael B. Jordan wearing 4-carat diamond stud earrings set in white gold, and Vault Collection angular 11mm curb chain bracelet in 18-karat yellow gold with baguette rubies and with baguette diamonds, and in platinum with baguette diamonds, 2023. Photographed by Tyler Mitchell.

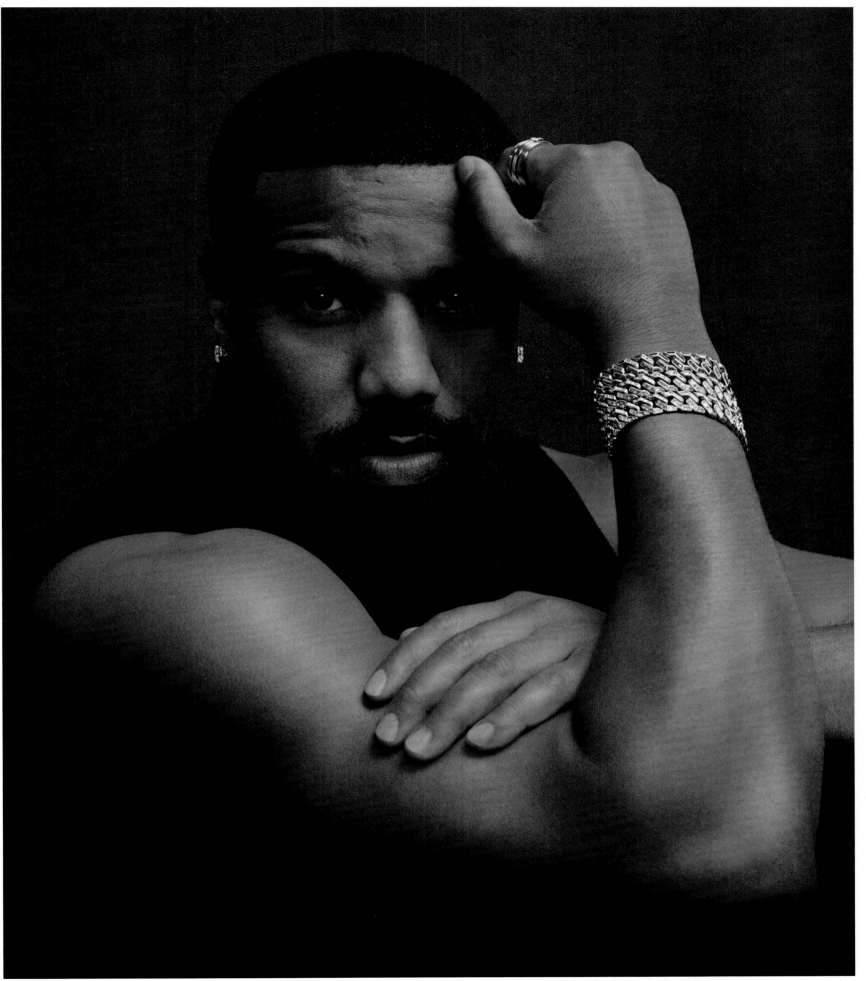

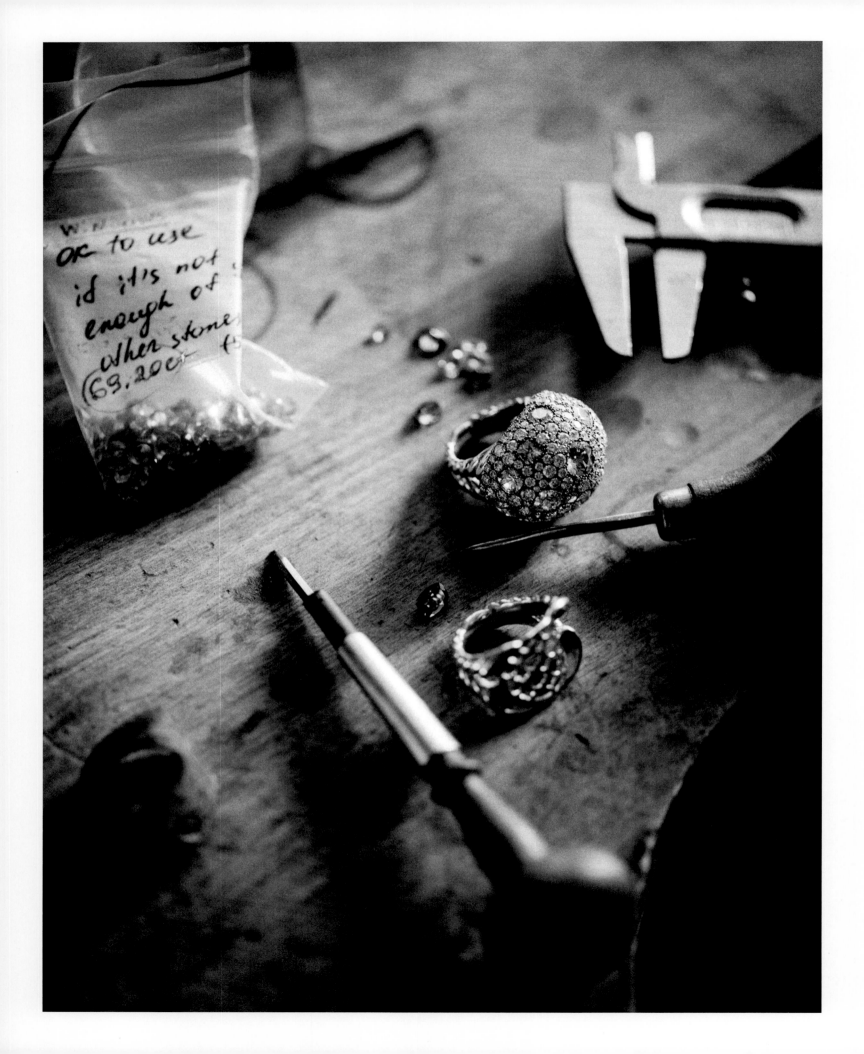

HIGH JEWELRY

David sees, as only an artist can, the emotional play of light over surfaces. "I now found myself doing sculptural jewelry. The same process I used to make sculptures, I did it with bronze." The pieces of jewelry he creates are unique in that they are both sculptural jewelry and high jewelry, even if they contain no rare gems or precious metals.

The Yurmans' artistry has been—and still is—involved with the poetry of time. Time is a powerful subject matter in both jewelry and in the life and evolution of the company itself. Perhaps *timelessness* is a more accurate term. Their son, Evan, put it succinctly: "The beauty of jewelry is that it's everlasting." A passionate collector and connoisseur, Evan tells us: "I have jewelry that's thousands of years old." It is a deeply symbolic art, which for millennia has had ceremonial, religious, magical, and psychological functions. We keep our jewelry in specially designed cases; we choose where and when to wear each piece; we invest in it carefully; we hand it down so it can cascade through the generations. It is a rarefied art that tells the world who we are. The Yurmans understand this intuitively, and it was in this spirit that Evan led the move into high jewelry in 2010.

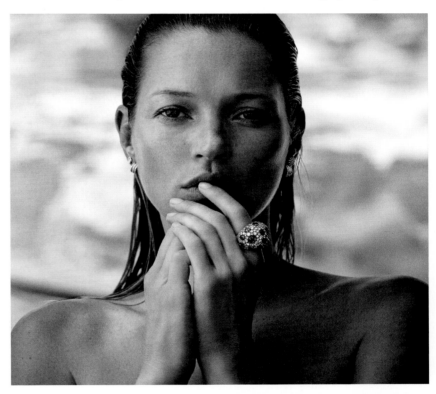

Opposite: High Jewelry Mosaic pavé-set diamond rings, 2014. Photographed by Nathan Copan.

Top: Kate Moss wearing Mosaic dome ring with pavé-set diamonds and gemstones, 2014. Photographed by Peter Lindbergh.

Bottom: Wax carving at the David Yurman atelier, New York, 2016. Photographed by Nathan Copan.

All this implies a very particular approach to design, which starts with a delicate gouache painting of the concept and the cutting-edge insight of Evan, a collector of exceptional gemstones and a visionary of exceptional pieces and collections.

Some pieces beautifully fuse the themes of time and nature. The Slab necklace, a collaboration between father and son, is an informal row of rectangles created from raw emerald slabs whose natural angularity has been left intact. They are interspersed with variegated pillars of gold that play on the Cable theme. The emerald has a sense of landscape; the piece also recalls ancient origins, the circle of green gemstones having the presence of the Stonehenge monoliths. Yet the piece isn't about the past; rather, it has a spontaneity that crosses time and lives comfortably in the contemporary world. The greatest art can normally bridge past and present. Evan has taken the twin concepts of nature and time further in spectacular fashion with the Meteorite Collection, in which timelessness has been given a cosmic dimension with the use of material from meteorites. To own one is to wear a piece of a shooting star.

Opposite: Evan, David, and Sybil Yurman photographed for *Town & Country* magazine, Amagansett, New York, 2018. Photographed by Tiago Molinos.

Top: David Yurman, *Geese Contemplating the Universe*, 1975, Mixed-media collage, Putnam Valley, New York.

Bottom: Family photos in the Yurmans' home, New York, 2023. Photographed by Emil Larsson.

The high jewelry collection is the pinnacle of creative expression and fine craftsmanship: jewelry as high art. Inspired by the endless beauty of the natural world, from flowers to supernovas above and coral beneath, each piece represents both a spectacular flight of fancy and an homage to the eternal. Master jewelers work to bring each vision to fruition using the most precious and innovative materials. Intimate attention is given to every facet, edge, curve, and finish to obtain the highest level of workmanship.

It was around 2010 that high jewelry fully took center stage as a defined phenomenon, brilliantly led by Evan in the spirit of creatively expanding the company's repertoire. His sourcing of exotic stones has been an important part of this entire story. Their natural beauty, symbolic meaning, and aesthetic potential become inspirations for the creation of whole collections. Each stone is handpicked for its color and unique composition, becoming a key design element. The intrinsic value of the gemstones is clear enough: but here it is their intrinsic value that shines. Evan also continues the family tradition of discovering new and unexplored materials not normally used in high jewelry.

Gouaches of unique pieces from High Jewelry Collections (top to bottom): white gold and pavé-set diamonds, red spinel multirow torsade necklace, Artist Series Slab necklace, 2018.

Evan and David Yurman collaborating on designing the Slab necklace at the Vestry Street atelier for the Artist Series, 2018. Photographed by Gary Petersen.

Following spread, left: Unique piece from High Jewelry Collection, Artist Series Slab necklace featuring pink and red tourmalines, and purple sapphires, 2019. Photographed by Maxime Poiblanc.

Following spread, right: Unique piece from High Jewelry Collection, Scribbles necklace made with purple and lavender sapphires, Keshi gray pearls and diamonds, 2017. Photographed by Christopher Bierlein.

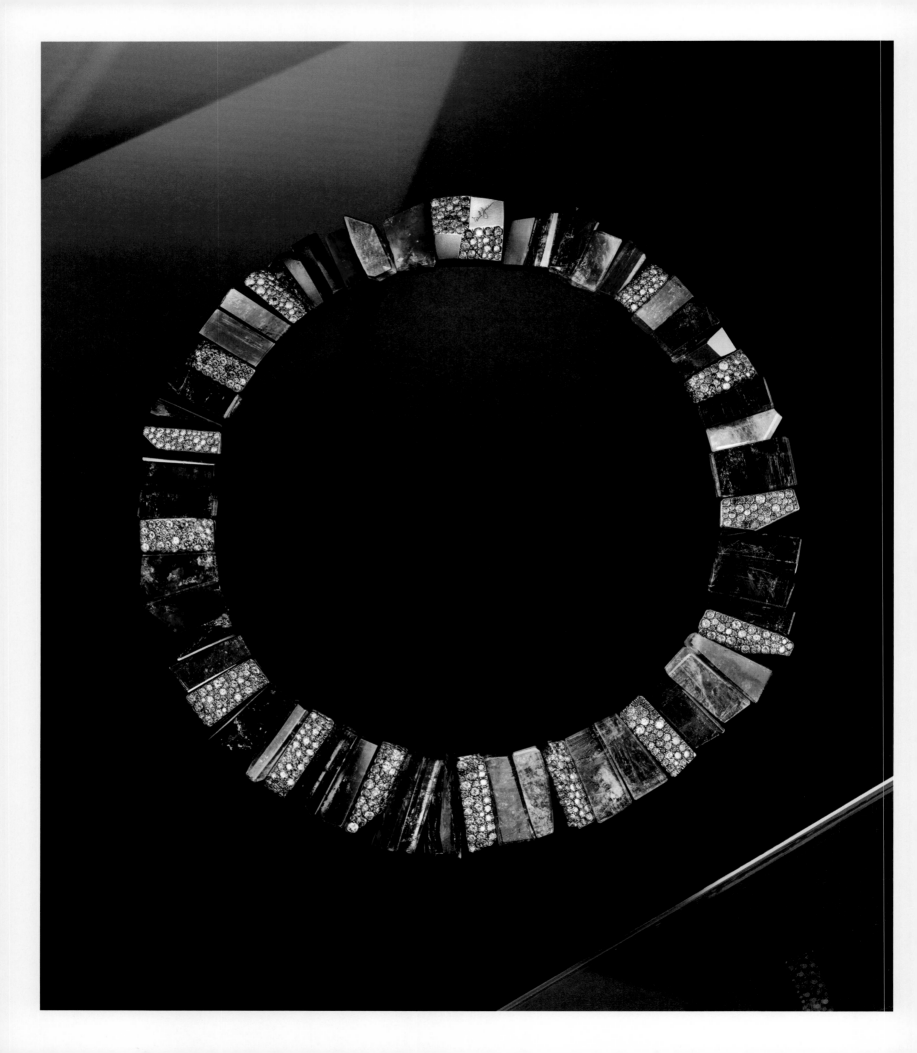

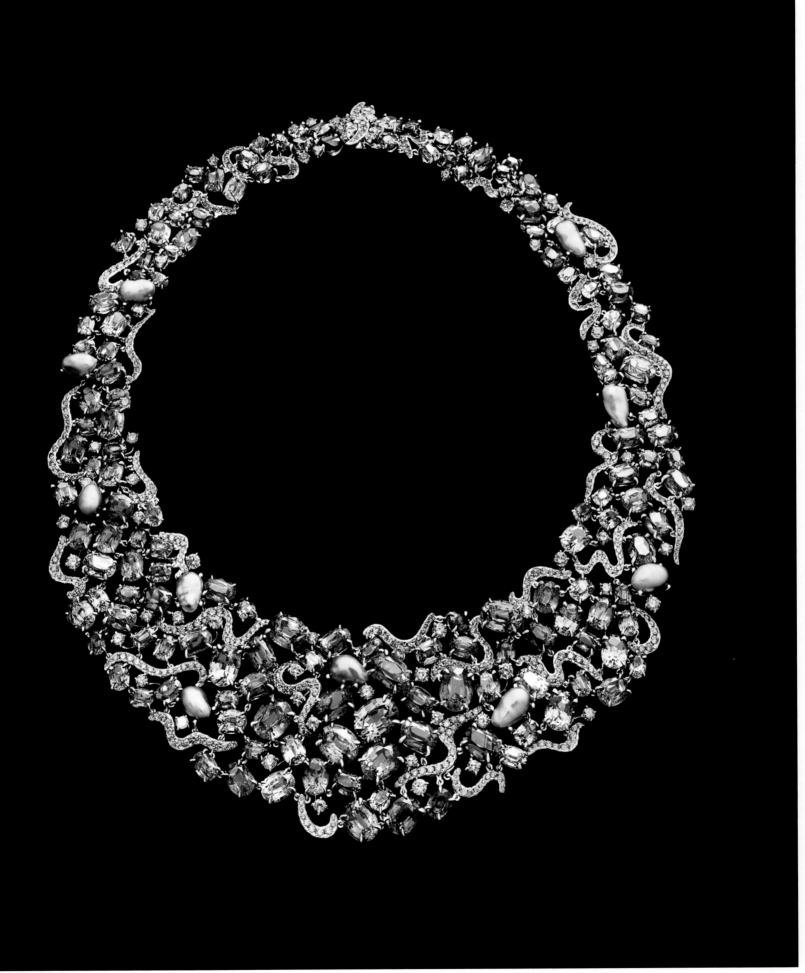

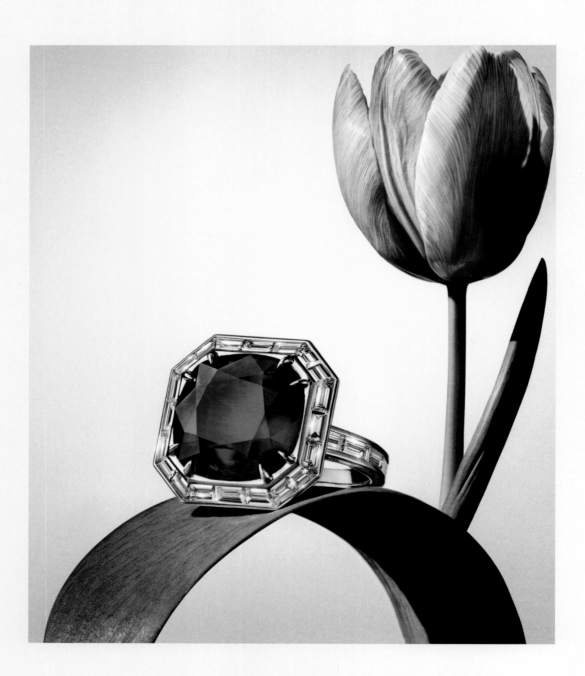

Previous spread: Natalia Vodianova wearing platinum DY crossover engagement ring with DY signature-cut center stone and platinum and diamond wedding band, from the DY Bridal Collection, 2007. Photographed by Peter Lindbergh.

High Jewelry unique piece, Stax ring made in white gold with a 13.42-carat Colombian Emerald and 4.44 carats of diamonds set in white gold, 2021. Photographed by Joel Stans.

Opposite: High Jewelry one-of-a-kind Chinese emerald Slab necklace with yellow sapphires set in 18-karat gold with pavé-set diamonds, 2023. Photographed by Emil Larsson.

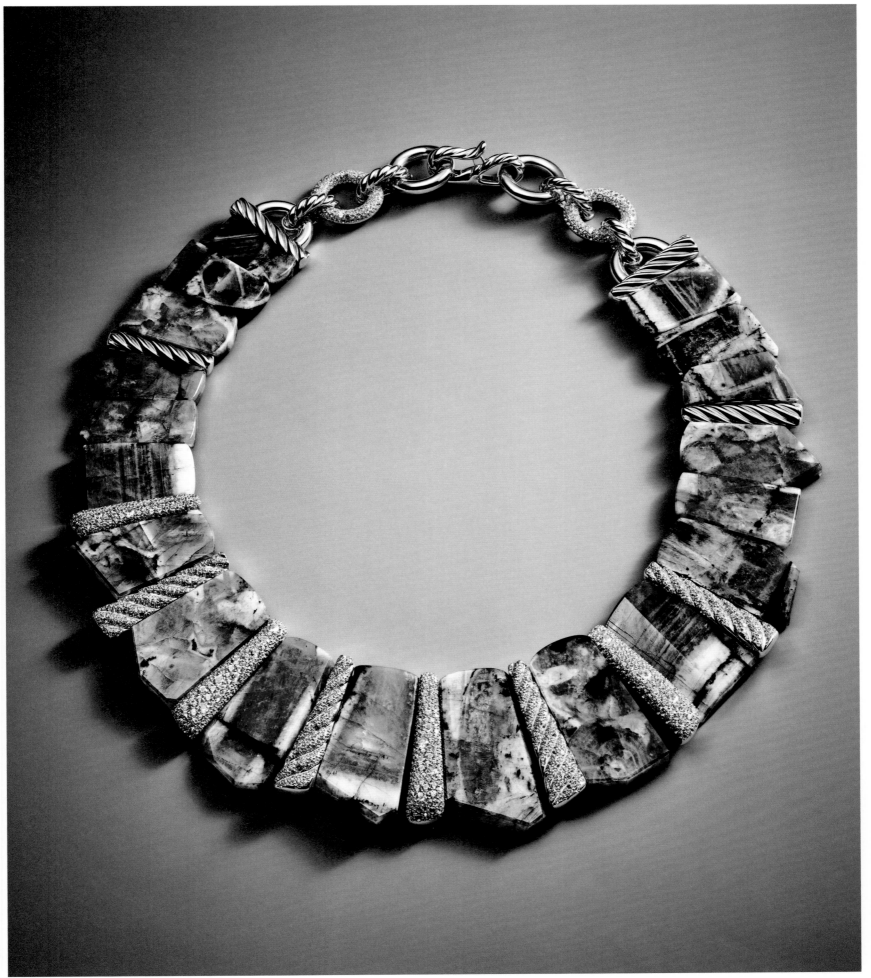

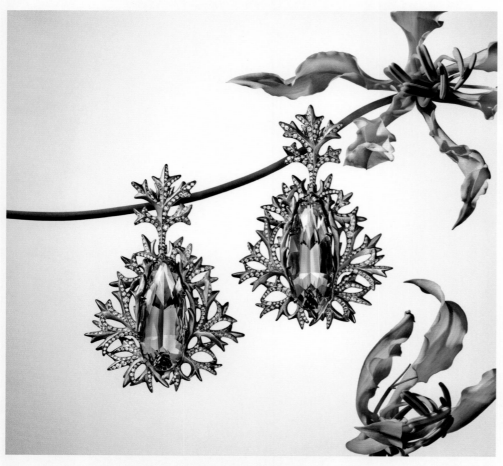

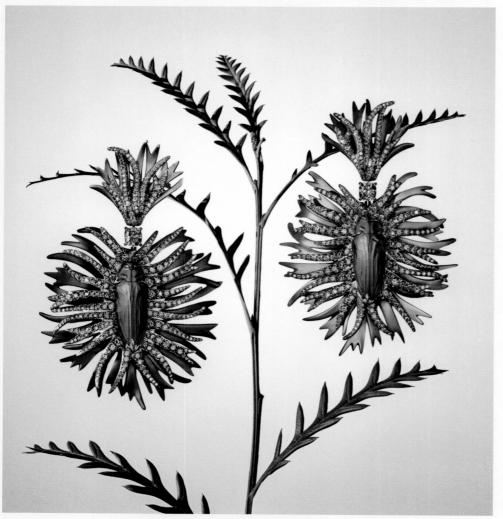

Top: Dianthus drop earrings with two *Belionota sumptuosa* husks preserved in resin, yellow-green anodized aluminum, and 18-karat white and rose gold with cognac diamonds, 2023.

Bottom: Dianthus drop earrings in 18-karat white gold and celadon anodized aluminum with two green beryl stones and diamonds, 2023. Both photographed by Joel Stans.

Opposite: Gisele Bündchen wearing Dianthus drop earrings, 2023. Photographed by Sølve Sundsbø.

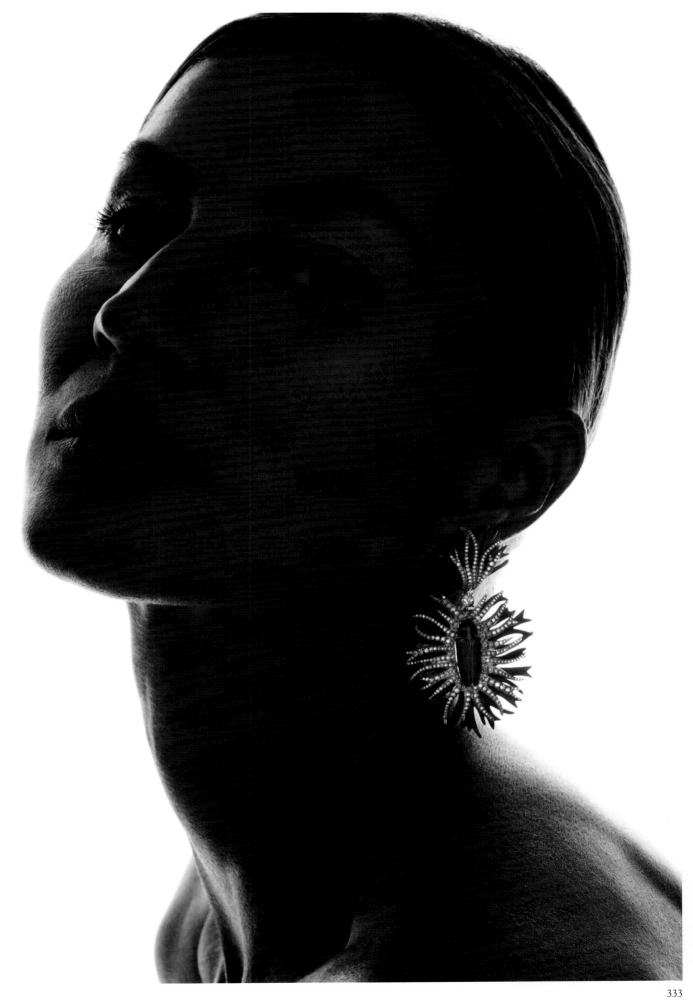

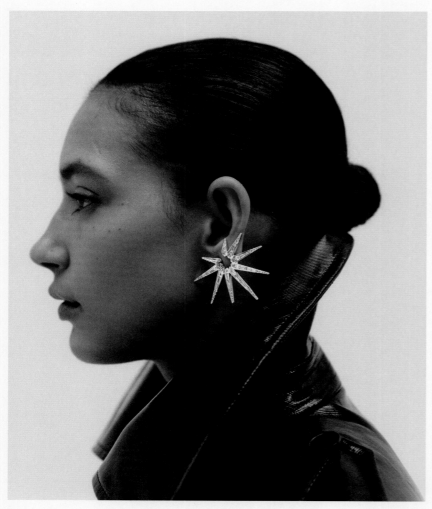

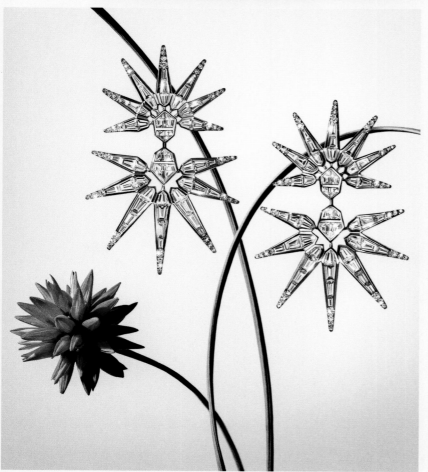

Top: Maria Jose "MJ" Herrera wearing Liberty drop earrings in 18-karat white gold with custom-cut diamonds. Photographed by Nagi Sakai for *WSJ* magazine, June–July 2023.

Bottom: Liberty drop earrings in 18-karat white gold with custom-cut diamonds. Photographed by Joel Stans.

Opposite: Liberty necklace in 18-karat white gold with custom-cut baguette diamonds, 2023. Photographed by Joel Stans.

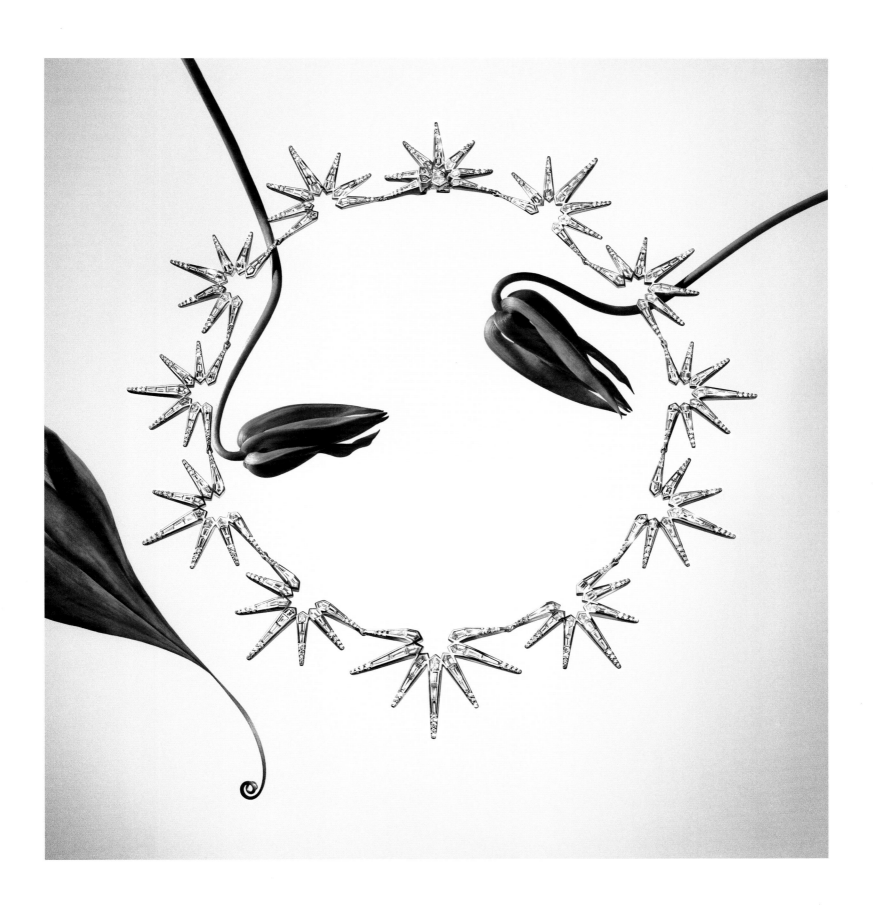

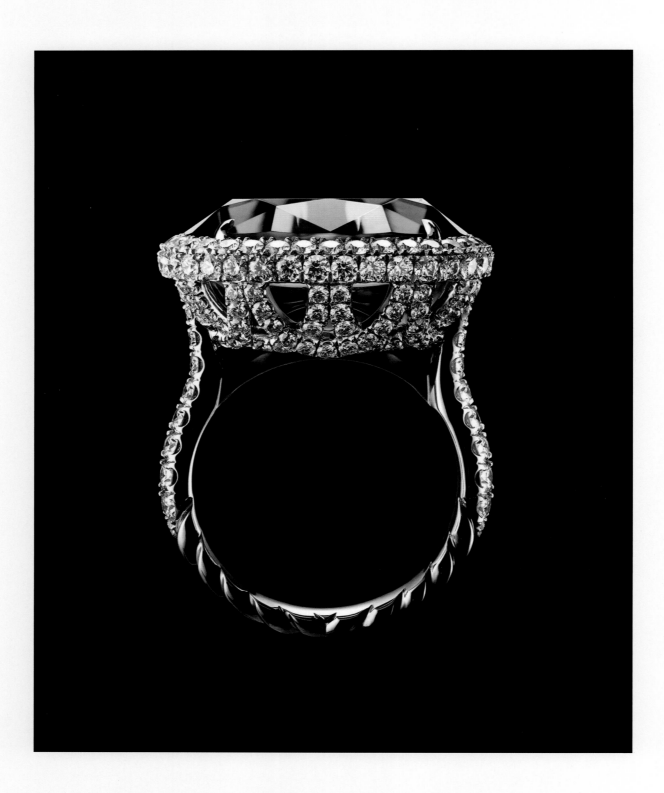

High Jewelry unique piece, platinum, white gold, and pavé-set
diamond ring with peridot and diamonds, 2022. Photographed
by Robin Broadbent.

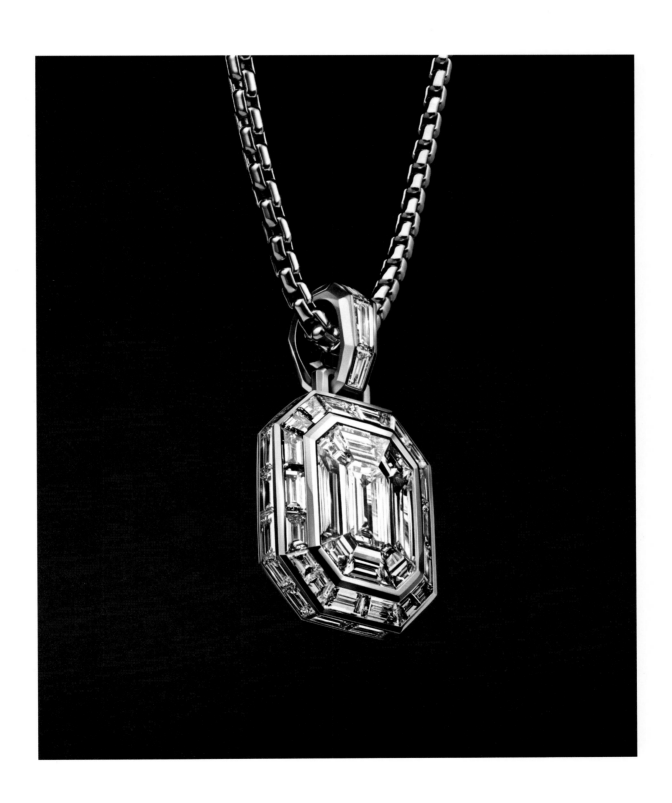

Deco Amulet in platinum and diamonds made of 38 baguettes on
a platinum box chain necklace, 2023. Photographed by Haw Lin.

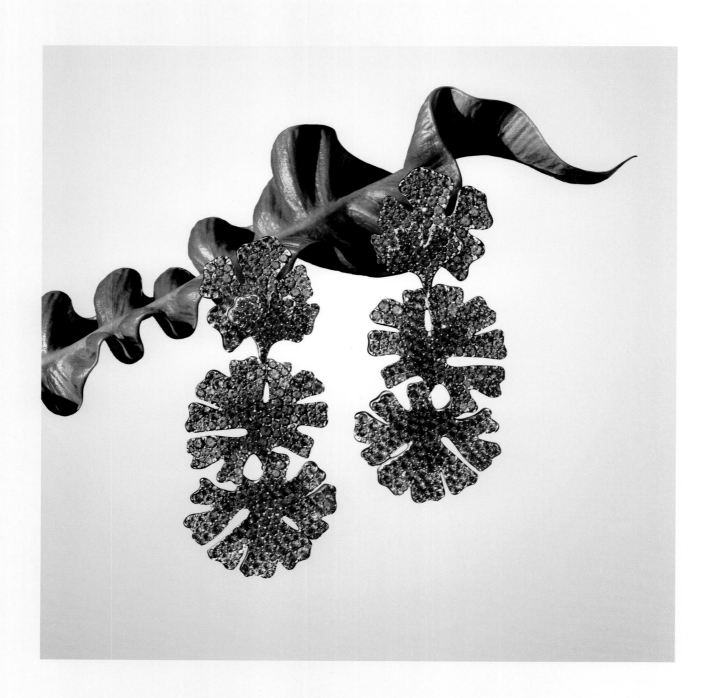

High Jewelry unique piece, Fleurs de Mer Collection white gold and titanium pavé-set seaweed earrings with 8.18 carats of rubies and 17.17 carats of pink sapphires, 2023. Photographed by Joel Stans.

Opposite: High Jewelry unique piece, diamond pavé-set teardrop Mobile earrings in titanium, 18-karat white gold, and diamonds, 2022. Photographed by Maxime Poiblanc.

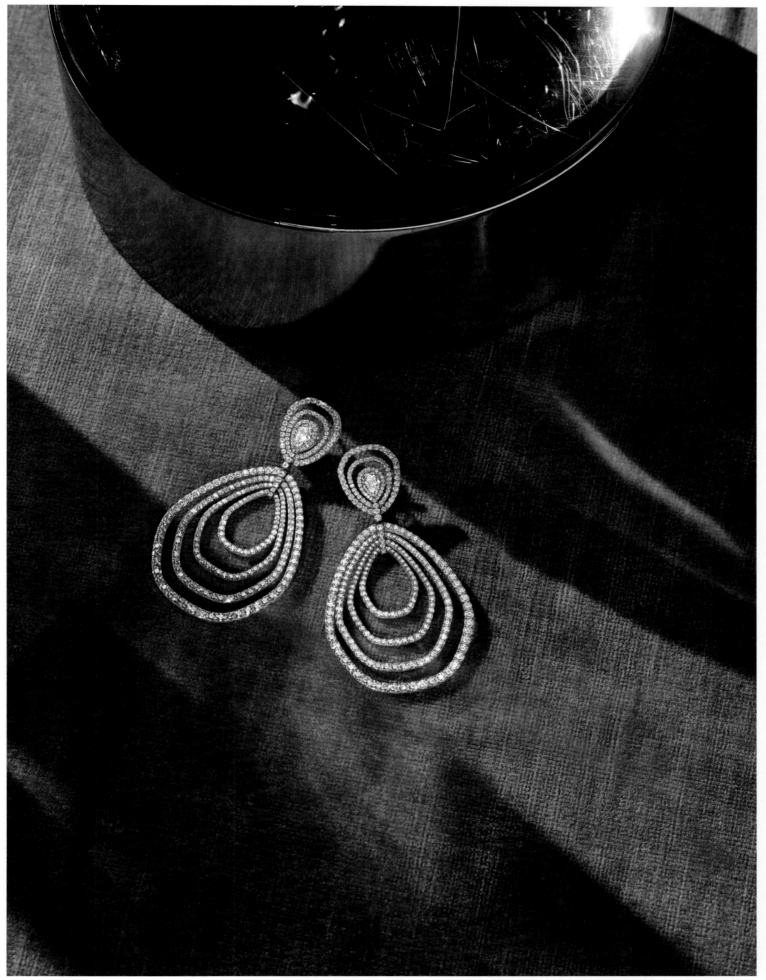

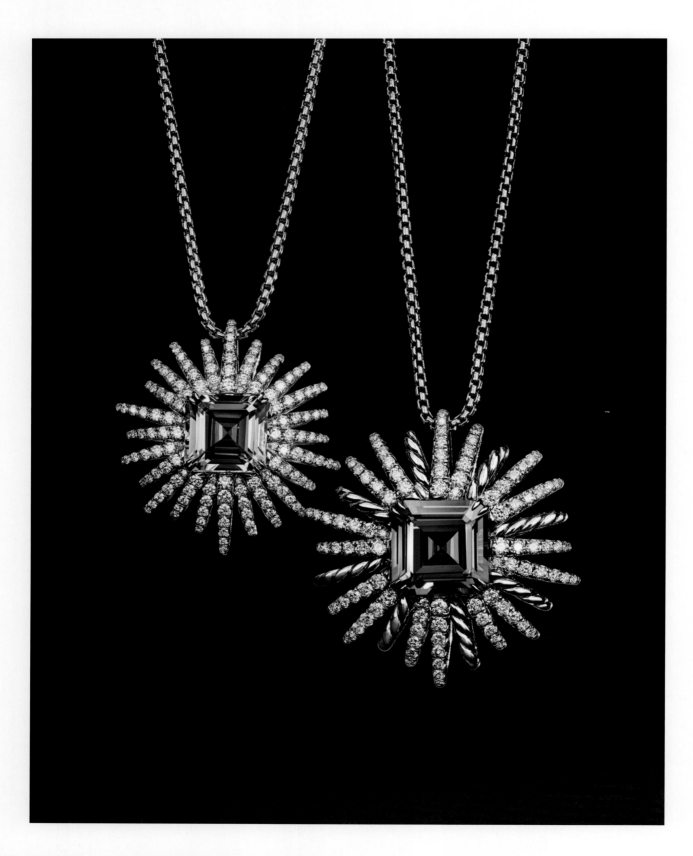

Starburst Collection one-of-a-kind yellow and white gold and pavé-set diamond
pendant necklaces with aquamarines, 2023. Photographed by Emil Larsson.

Opposite: High Jewelry unique piece, pavé-set diamond Oval Link necklace,
2023. Photographed by Haw Lin.

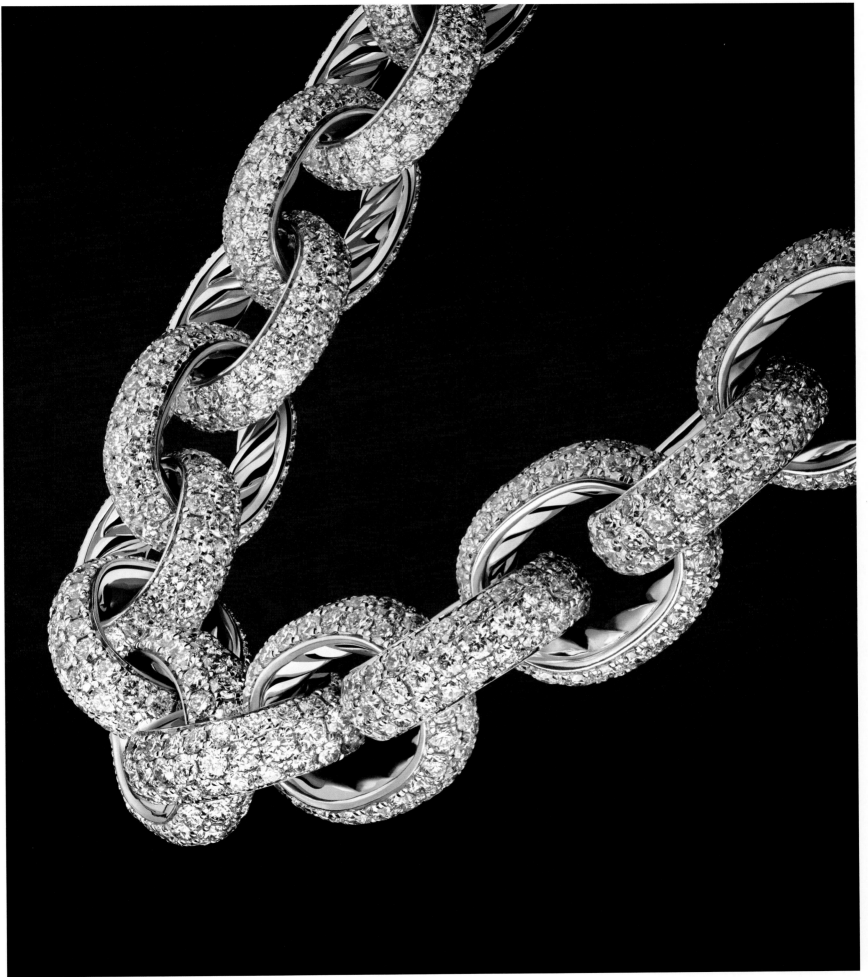

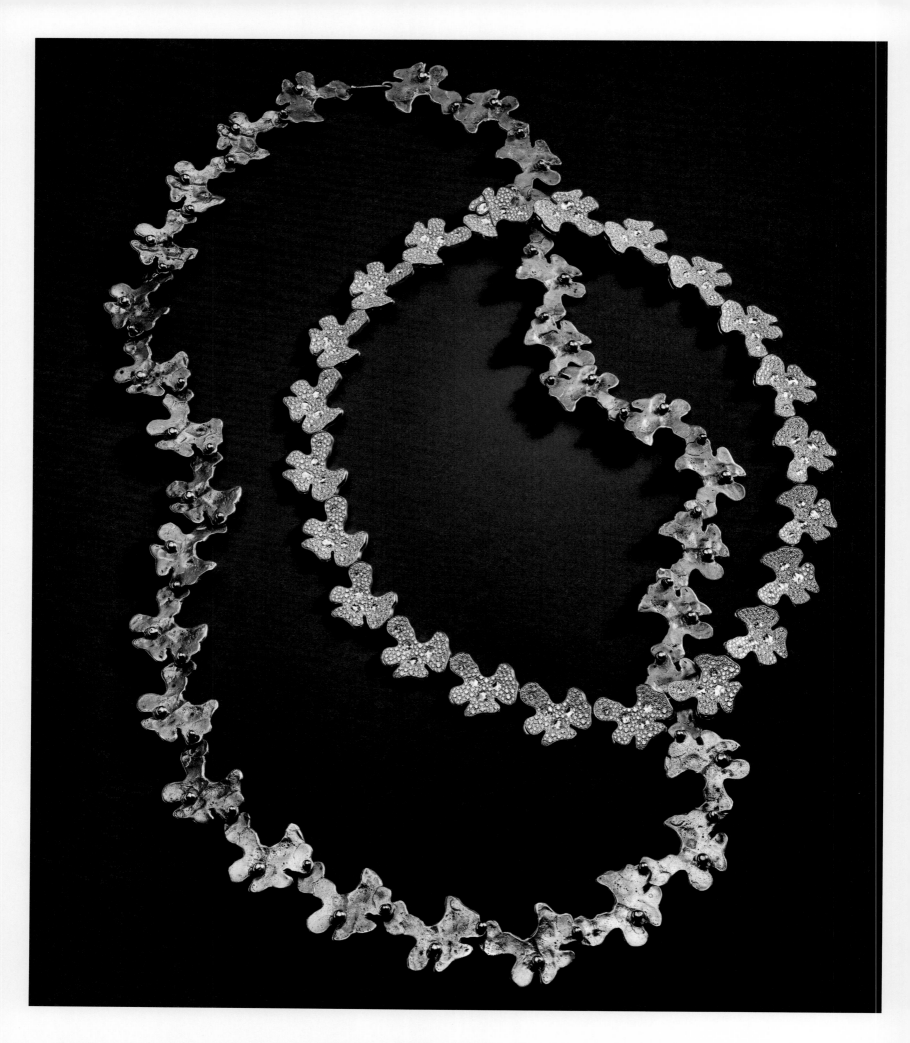

DAY AND NIGHT THEN AND NOW

"I was doing blobs, petals, buckles, folds, and allegories—I was experimenting and finding my way out from sculptural bronze jewelry," explains David when referring to the first Petal necklace he designed for Sybil back in 1973 in Putnam Valley, New York. Each sculptural piece is about storytelling, organic forms evocative of water lilies bathed in golden sunlight or silver moonlight, reminiscent of the sun-filled days when they were surrounded and inspired by nature. It was against this backdrop of frogs and lily ponds in Upstate New York that they developed their craft and art.

In 2017, under Evan's leadership, the high-jewelry design team took inspiration from the original Petal necklace from the 1970s. Small, irregular petal forms were linked together in such a way that they gave a sense not only of leaves but also of living creatures. Almost five decades later, the exceptional savoir faire of the Tribeca atelier craftsmen was fully expressed in the reinterpretation of these shapes, as the necklaces were worked in several fabulous materials, most notably white gold and diamonds or yellow gold and pavé diamonds, sometimes with pearls for the earrings. The Night Petals, with flowers of cuplike gold basking in the sun, appear to float on the neck of the wearer. Inspired by the darkness of the night, they evoke what the eye can capture under the full moon, revealing shapes of nature reflected and glimmering on the water, with a constellation of precious stones. The Night Petals necklace was crafted in blackened white gold with hand-set diamonds, sometimes with a gray Tahitian pearl. The Petals necklaces are similar yet profoundly different. They are about a company with a long history exploring its own heritage and demonstrating the evolution of its own design legacy.

Opposite: High Jewelry unique piece from the Petals Collection, yellow gold and pavé-set diamond necklace, 2016, on top of the original bronze Petal necklace from 1972. Photographed by Emil Larsson.

Gouache of the High Jewelry unique piece from the Petals Collection, yellow gold and pavé-set diamond necklace, 2016.

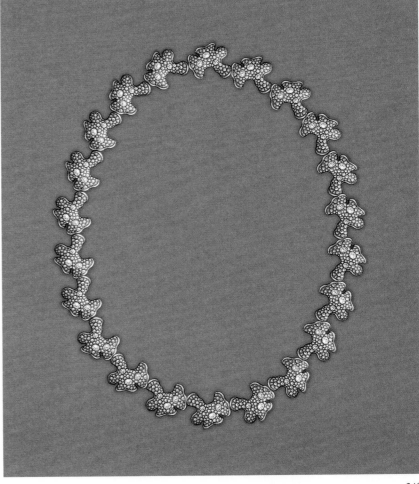

343

A dream you dream alone is only a dream.
A dream you dream together is reality.

John Lennon

Sybil, David, and Evan Yurman in Sybil's office, New York, 2023.
Photographed by Norman Jean Roy.

TIMELINE

1942

David and Sybil are born in New York City.

Both grow up in the Bronx.

1952

David's family moves to New Hyde Park
on Long Island, New York.

David discovers books on the Lascaux caves and
primitive art in his high school library.

1957

Sybil drops out of high school and focuses on art,
painting, and reading the classics.

That same year she moves to Greenwich Village
in New York City.

1959

David travels to Eugene, Oregon, and works
at his father's lumber mill.

He trains for a one-mile race with coach Bill Bowerman,
cofounder of Nike, in Eugene.

David visits his sister in Provincetown,
Rhode Island, and learns direct welding from Cuban
sculptor Ernesto Gonzalez.

Sybil travels to California and meets artists
and poets in the Beat movement, living and working
in Hyphen House located in what will
become Haight-Ashbury.

She works at the jazz club Bop City.

1960

David graduates high school and attends
New York University in downtown New York City,
joining the school's track team.

1961

David works part-time for jeweler Bernie Kelly
in Greenwich Village.

He hitchhikes to California, lives in
Venice Beach, and attends Santa Monica College.

He works at Venice West Cafe,
a Beat coffee shop.

David travels back and forth between Big Sur
and Venice, and also to and from the
East Coast, hitchhiking more than eight times.

Sybil returns to New York and lives in Woodstock.

1962–63

David returns to New York, where he meets
Joan Avnet, a gallery owner in Great Neck, Long Island,
and is introduced to sculptor Jacques Lipchitz.

1964

At the age of twenty-two, David starts a two-year
apprenticeship with Jacques Lipchitz, and at night he
attends the Art Students League of New York.

Sybil moves to Berkeley, California, where
she studies photography, learns raku
pottery, and works at the Berkeley Student Union.

1965

David establishes a sculpture studio on Sullivan Street
in the heart of New York's Greenwich Village.

Bernie Kelly encourages him to create twelve belt buckles,
which David does and starts his first business.

1966

Sybil moves back to New York City and lives
on the Upper West Side.

1967

Sybil moves to Washington, DC,
where she works at the Corcoran Gallery and meets
Japanese potter Shōji Hamada.

Sybil cuts her hair and goes to Ibiza, Spain.

1969

David goes to the Woodstock Music Festival to
sell belts, belt buckles, and jewelry.

He works with Dutch sculptor Hans Van de Bovenkamp.

Sybil starts her *Sky Markings* series of paintings.

Sybil and David meet at Hans Van de Bovenkamp's
Greenwich Village studio on West Tenth Street. David is the
acting foreman and Sybil is hired as their studio assistant.

1970

Sybil continues painting and goes back to school,
attending City University of New York's Hunter College.

David and Sybil spend months together
creating art in Martha's Vineyard, Massachusetts. David
shows his sculpture at the Thomas Ford Gallery there.

David and Sybil decide to live together on
Riverside Drive on New York's West Side, where
David sets up a welding studio.

David apprentices with sculptor Theodore Roszak.

David and Sybil borrow five hundred dollars
to manufacture belt buckles and sell them at the American
Craft Council juried fairs first held in Bennington, Vermont,
where David receives two best-of-show awards.

David designs his first chain links, that Sybil wears as a belt,
and the unique direct-welded Dante necklace.

1973

David and Sybil move to Putnam Valley, New York,
where they start their first jewelry business,
Putnam Art Works, producing buckles and jewelry that
they sell through craft markets.

1975

David designs his first helix gold-and-silver
wired bracelets with gold and gemstone endcaps.

1976

Sybil graduates from the State University of
New York, Purchase, with honors receiving her
Bachelor of Fine Arts degree.

Art collector Roy Neuberger personally invites
Sybil to exhibit her paintings in a one-woman show at the
Neuberger Museum in Purchase, New York.

1977

David participates in the first New Designer
Gallery at the Retail Jewelers of America (RJA)
show in New York City.

1979

David and Sybil get married at the Temple
Emanu-El in New York City.

1980

David and Sybil launch Yurman Designs, Inc.

1982

David and Sybil's son, Evan, is born.

The first Cable bracelet is produced.

Cartier USA commissions David to create a collection.

1987

David Yurman first exhibits at the Baselworld
watch and jewelry show in Switzerland.

1990

David Yurman partners with Neiman Marcus for
a ten-city touring retrospective.

The company's authorization retail
guidelines are created to maintain brand consistency
across stores.

1991

David Yurman is awarded a patent for the highly
flexible cable jewelry material.

1992

The first Cable watch is created.

David Yurman is awarded a patent
for the Cable design.

1993

The company moves to a 7,000-square-foot space on
Madison Avenue in New York City.

1994

David Yurman opens a timepiece office in
La Chaux-de-Fonds, Switzerland.

1997

The Silver Ice Collection is launched, making
David Yurman the first major designer to set diamonds
in sterling silver, a revolution in fine jewelry.

1999

The first David Yurman retail store opens
on Madison Avenue, designed by Dakota Jackson.

David creates the first David Yurman Humanitarian
Award for the GQ Men of the Year award ceremony.
The sculpture is presented to Steven Spielberg,
and a year later to Elton John.

The Angel pin, based on the original sculpture
to benefit Project ALS, is launched.
A year later, its sales are dedicated to benefit the
Elton John AIDS Foundation.

David becomes a board member of the Council of
Fashion Designers of America (CFDA).

2000

The first black-and-white advertising campaign
is launched under the creative direction of
David Lipman and photographed by Peter Lindbergh
with internationally recognized supermodels.

2001

The David and Sybil Yurman Humanitarian and
Arts Foundation is established.

2003

Evan joins the company and becomes Design Director
for Men's Jewelry.

David Yurman headquarters move to Vestry Street.

David Yurman expands watch operations in Switzerland
to develop their fine timepieces collections.

2004

Kate Moss becomes the ambassador of the
brand for the next ten years.

2005

The Frick Collection in New York City hosts
an exhibition celebrating the twenty-fifth anniversary
of David Yurman.

2008

David Yurman fragrance is launched with Clarins.

The David Yurman eyewear collection is launched.

2009

The Classic timepiece for men is introduced.

2010

The Madison Avenue Townhouse flagship boutique
opens in New York City.

Evan introduces high jewelry designs in Basel,
Switzerland.

David Yurman opens a shop-in-shop at Printemps
department store in Paris.

The company introduces the Ladies Classic timepiece.

2013

David Yurman opens its first Canadian
boutique in Toronto.

2015

David Yurman designs the trophy for the Academy
of Country Music Awards in Dallas.

The company opens a boutique at Galeries Lafayette in Paris.

2016

David Yurman receives a design patent for the
ten-millimeter Renaissance Cable.

2017

Rizzoli releases a book dedicated to David Yurman's
signature Cable design.

Evan Yurman collaborates with visual
artist Anthony James for the Where Art Meets Design
exhibition in Milan.

David Yurman is granted a design patent
for signature-cut diamonds.

2018

Evan is named Chief Creative Officer.

2019

David receives an honorary doctor of fine arts degree
from New York's Fashion Institute of Technology and delivers
that year's commencement address.

The David Yurman New York flagship store opens
on East 57th Street and Madison Avenue,
co-designed by Evan Yurman and Michael Gabellini.

2022

The David Yurman flagship store opens in
Paris on rue Saint-Honoré.

David Yurman receives an honorary doctor
of fine arts degree from Savannah College of Art
and Design (SCAD) and delivers that year's
commencement address.

2023

Evan launches the Genesis high jewelry collection.

2024

Evan presents The Vault Collection, a series
of high jewelry pieces for men created with stones
from his personal collection.

David Yurman has 70 boutiques and more
than 234 additional points of sale,
totaling 1,073 employees worldwide.

HONORS

1980

David receives the World Gold Council award for excellence in jewelry design.

David is named Designer of the Year by the Cultured Pearl Associations of America and Japan.

David receives the Intergold Award from the World Gold Council.

2003

David is awarded the Fashion Group International's Stargazer award in Chicago.

2004

David and Sybil receive the Lifetime Achievement Award at the Jewelry Information Center's (JIC) GEM Awards in New York City.

David receives the Savannah College of Art and Design Étoile Award for his contribution to American jewelry design.

Sybil receives the Women's Jewelry Association Hall of Fame Lifetime Achievement Award.

The American Gem Society presents David and Sybil with their Lifetime Achievement Award.

David receives the Human Spirit Award at the Couture Design Awards.

David is honored by the Lab School with its Outstanding Learning Disabled Achievers Award.

2017

Sybil receives the Women's Champion Award by Fashion 4 Development, a United Nations partner for global education.

2019

David receives an honorary doctor of fine arts degree from New York's Fashion Institute of Technology.

2022

David receives an honorary doctor of fine arts degree from Savannah College of Art and Design (SCAD).

SPECIAL THANKS

Special thanks are due to so many people along the way. To creative director David Lipman, who recognized that our brand message was "joy," and led us to Peter Lindbergh, whose work was an honest and transcendent expression of that joy. As a fellow artist, Peter was able to capture emotion and express our feelings in exquisite black-and-white photographs. Our many muses—Kate Moss, Amber Valletta, Naomi Campbell, Patti Hansen, Natalia Vodianova, Naomi Watts, Gisele Bündchen, and all the unforgettable women—in addition to their natural beauty, reflected our values with charm, wit, and style.

Our heartfelt thanks go to the innovators who, every day for decades, fueled and shared our artistic passion designing, engineering, merchandising, marketing, and refining our timeless Cable Collection. Peter Roth, master engineer, has been with us since the day he graduated high school in 1975 at age seventeen. With Peter, we explored and experimented with the Cable design, finding new ways to expand our craft, innovate, and remain true to the art of the hand.

Bill McTighe and Ted Leach were instrumental in the commercial creation of our Cable Collection, together with hundreds of artisans, jewelers, buyers, and suppliers with whom we have collaborated.

To our creative, commercial, and business teams who thoughtfully executed our vision over years: thank you for all your efforts. We would like to also thank all the sales associates in our stores who, over the years, connected with our customers and believed in our vision that David Yurman pieces are about shared moments of joy.

In the beginning there were just a few of us who did everything. Our original team of strong, capable women: Amy Rosi, Janet Hayward, Kate Harrison, Danielle Twersky, Tracy Squillante, Elana Furmansky, and Collete Neyrey. It's amazing how a small, dedicated team can make big dreams come true.

Our merchant leaders Burt Tansky, Michael Gould, Terry Lundgren, and Rosemarie Bravo introduced us to a new world and a new customer, creating a venue for our new category of designer jewelry.

The archive team that preserves our legacy—Richard Barrett, Patty Shragin, Miles Rohan—you are the keepers of our brand DNA, its ethos, and together explored our journey, creating a historic reference and memorializing pivotal moments of our heritage.

As a historian, Paul Greenhalgh—author, museum director, art historian, former director of the Corcoran, Sansbury & Zaha Hadid Foundation, and good friend—placed us in the continuum of jewelry as an art form within the world of craft and commerce.

Everyone who has a family business needs a Hamilton South and a Martin O'Conner, our trusted advisors, who navigate and face any challenges, and smooth out the bumps along the way.

To Murray Kleinrock, Sybil's father and David's "second" father, we feel more than words can say. Murray believed in us from the very beginning and nurtured our joint venture. His poetic vision inspired ours. He was our Virgil, who ferried us through turbulent waters and managed to make what seemed impossible possible.

Coach Shulman, a high school track instructor, raised the bar when others were lowering it. And to our two beloved sisters, Bonnie, our biggest supporter, and Sheila, who shared her love of art and jazz.

To the Kosmic Kowboys who provided time for friendship and to explore our essential connections, horses and nature, and sharing adventures with John "JR" Rosi, Peter "Cody" Bort, Eddie "Reno" Segal, and fellow riders.

For those who made the dream of this book a reality:

Thierry-Maxime Loriot
Editor

Tracy Squillante
Project Director

Nej Redzic
Project Coordinator

Bria Ribitzki
Project Manager

Lee Tucker
Chief Merchant and Product Officer

Richard Barrett
Vice President, Creative Art & Heritage

Miles Rohan
Executive Director of Archive

Alice Morath
Associate Director of Creative & Marketing

Patty Shragin
Archivist Emerita

A special thanks to the image-makers
who created new content for this project:

Emil Larsson

Norman Jean Roy

Paprika, Montreal
Graphic Design

Joanne Lefebvre
President and Account Manager

Louis Gagnon and **Daniel Robitaille**
Creative Directors

Arthur Grivel
Art Director and Lead Designer

www.paprika.com

Phaidon

Keith Fox
Chief Executive Officer

Deborah Aaronson
Vice President, Group Publisher

Lynne Ciccaglione
Executive Editor

Andie Trainer
Senior Production Controller

Judy Moy
Gloss, New York

Bronson Whitford and **Linda Lee**
Copyediting

Sylvia W. Victory
Image Rights

Picture Credits

Every reasonable effort has been made to identify owners of copyright. Errors and omissions will be corrected in subsequent editions.

Numbers indicate page numbers:
t = top; b = bottom; c = center; l = left; r = right

Courtesy American Craft Council Library & Archives: 220 (except c), 221 (except t)

© Lachlan Bailey – Art Partner/Trunk Archive: 294

© Lachlan Bailey – Art Partner/Trunk Archive/ Photo by Eli Obus: 45

Ballantine Books, a division of Penguin Random House LLC: Book cover from *A Confederate General from Big Sur* by Richard Brautigan © 1973: 154r

Dennis Barnard/Fox Photos/Hulton Archive/Getty Images: 173t

Photo by Richard Barrett: 214–15

Dave Bartruff/Danita Delimont, Agent/Alamy Stock Photo: 68t

Photo by Kike Besada: 209

Bettman/Contributor/Getty Images: 172

Photo by Christopher Bierlein: 327

© Robin Broadbent: 306, 336

© Cédric Buchet: 313

© Richard Burbridge/Art + Commerce: 29, 98–99, 103, 206, 244

© Daniel Cano: 208

Cau-Guerin/AbacaPress.com/Alamy Stock Photo: 286t

John Cohen/Getty Images: 123

© Chris Colls: 141

Contraband Collection/Alamy Stock Photo: 220c

© Nathan Copan: 11, 66b, 104, 274b, 308, 320, 321b

© Nicholas Alan Cope: 257, 312, 314–15

Richard Corkery/Getty Images: 289t, 289b

Richard Corkery/New York Daily News Archive via Getty Images: 261l

© Anthony Costifas: 67b

POOL/Jerome Delay/AFP via Getty Images: 20

dianephoto/Alamy Stock Photo: 155c

© Garance Doré: 31

© David Gahr: 169

Archiv Gerstenberg/ullstein bild via Getty Images: 72

© Allen Ginsberg/CORBIS/Corbis via Getty Images: 120

© Allen Ginsberg/Getty Images: 121

grandriver/Getty images: 272t

Photo by Haw Lin: 337, 341

© Geof Kern/Trunk Archive: 245

© Emil Larsson: 12, 14–16, 23, 25, 27, 64–65, 66t, 68c, 69b, 75–76, 88, 107, 143–44, 146, 164, 170, 174–75, 198–200, 203–5, 213, 219, 222–23, 225–27, 233–34, 237, 240–41, 250–51, 275–79, 281–83, 293, 309, 323b, 331, 340, 342

© Peter Lindbergh Foundation: 21, 33, 36–39, 41–44, 46t, 46b, 48–50, 51br, 52–55, 143–44, 145c, 146, 149, 202, 207, 235, 238–39, 243, 258, 262–63, 268, 290–92, 321t, 328–29

All rights Reserved – Estate of Jacques Lipchitz/Digital Image © The Museum of Modern Art/Licensed by SCALA/Art Resource, New York: 168

© Glen Luchford - Art Partner Licensing/Trunk Archive: 147, 310

© Craig McDean/Art + Commerce: 105

Photo by Evan Hunter McKnight: 158t

Patrick McMullan/Getty Images: 289c

© Raymond Meier: 74, 77, 145b, 241, 267, 269, 271, 316–17

© The Metropolitan Museum of Art/Art Resource, New York: 67t, 73

Frank Micelotta/Image Direct: 288

mikroman6/Moment via Getty Images: 158b

© Lewis Mirrett: 34t, 35, 300–1

© Tyler Mitchell – Art Partner/Trunk Archive: 319

© Guido Mocafico: 210, 242

© Tiago Molinos: 322

msvelde/Stockimo/Alamy Stock Photo: 145t

Courtesy *National Jewelry*: 46l

Neue Galerie New York/Art Resource, New York: 22c

© Josh Olins/Trunk Archive: 280

© Gary Petersen: 318, 325

Photo by Maxime Poiblanc: 311–12, 326, 339

Public domain: 68b, 69t

© Estate of Theodore Roszak: 173b

© Norman Jean Roy: 7, 57, 60–61, 136, 229–31, 246–47, 284–85, 296–97, 299, 302–3, 345

© Nagi Sakai – Art Partner Licensing/Trunk Archive: 334t

© Mario Sorrenti – Art Partner/Trunk Archive: 211, 266

Joel Stans: 330, 332, 334b, 335, 338

© Ted Streshinsky/CORBIS/Corbis via Getty Images: 122

© Sølve Sundsbø/Art + Commerce: 333

Courtesy Hans Van de Bovenkamp: 171

Venturelli/Getty Images for David Yurman: 305

Viking Press, a division of Penguin Random House LLC: Book cover from *On the Road* by Jack Kerouac © 1957: 154l

© Lisa Charles Watson: 108–11, 261, 270, back cover

Kevin Winter/Staff/Getty Images: 30

Courtesy *W* magazine: 228

© David Yurman, New York, 2024: 24, 26t, 167, 212, 236, 247r, 323t

© David Yurman, New York, 2004/Photo © Emil Larsson: 12, 21, 27, 152, 156, 159–61, 176–97, 199b, 249

© Sybil and David Yurman Archives, New York, 2024: 17, 22t, 22b, 34br, 40, 51ll, 51trr, 62, 63, 71, 89, 116, 118–19, 140, 150–51, 153–54, 155t, 155b, 157, 162, 163, 165–66, 198r, 216, 218, 221t, 248, 255, 256, 259–60, 264–65, 272–73, 275, 286b, 295, 304, 307, 315, 319, 324, 343

© Sybil Yurman, New York, 2024: 13, 18–19, 28, 58–59, 70, 78–87, 90–97, 100–1, 106, 112–15, 117, 125–35, 137–39, 217, 253–54

Endnotes

1 Rozalia Jovanovic, *David and Sybil Yurman on Love, Life, and Making Jewelry*, Artnet, March 20, 2017, https://news.artnet.com/art-world/david-and-sybil-yurman-888770.

2 Rachel Felder, "David Yurman Jewelry: 'This is an Art Project,'" *New York Times*, December 1, 2017.

3 David Yurman, "David Yurman Has a Side Hustle Creating Themed Scarves, Hats, and Jackets for His Crew of Cowboys," *Surface*, June 14, 2018.

4 Author, "Title of Article," *Forbes*, May 2022.

5 *WWD* Staff, "A Gem of a Son," *WWD*, October 11, 2004, https://wwd.com/fashion-news/fashion-features/a-gem-of-a-son-709656.

6 Eric Maza, "For David Yurman and His Family, the Jewelry Business Was a Way to Keep Creating," *Town & Country*, November 2018.

7 "Influence: Evan Yurman interviewed by Mary-Kate Olsen," *Harper's Bazaar*, 2008.

Phaidon Press Limited
2 Cooperage Yard
London E15 2QR

Phaidon Press Inc.
111 Broadway
New York, NY 10006

phaidon.com

First published 2024
© 2024 David Yurman Enterprises LLC

ISBN 978 1 83866 905 8 (Trade Edition)
ISBN 978 1 83866 912 6 (Luxury Edition)
ISBN 978 1 83866 913 3 (Luxury Signed Edition)

A CIP catalogue record for this book is available from
the British Library and the Library of Congress.

Printed in China

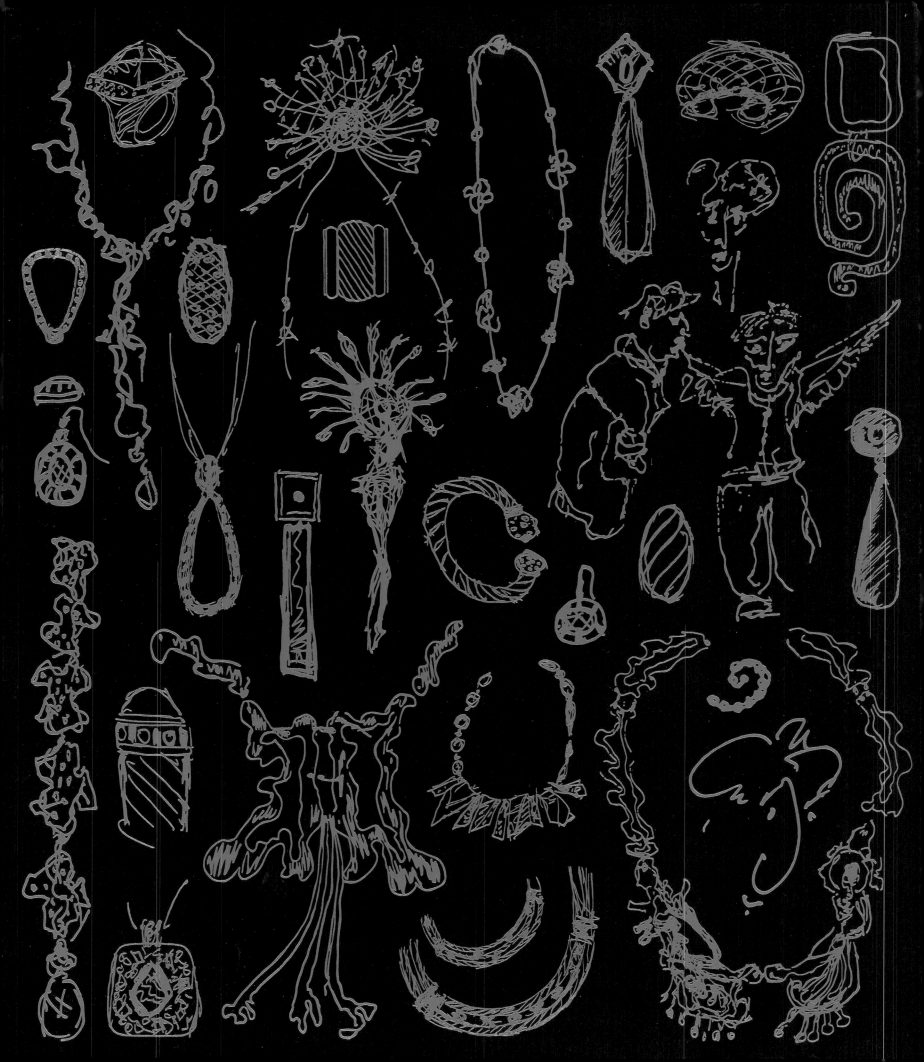